The Familial Gaze

The Familial Gaze

Edited by Marianne Hirsch

Dartmouth College

PUBLISHED BY UNIVERSITY PRESS OF NEW ENGLAND

HANOVER AND LONDON

Dartmouth College

Published by University Press of New England, Hanover, NH 03755

© 1999 by the Trustees of Dartmouth College

Lorie Novak, "Collected Visions," © 1998 Lorie Novak.

Art Spiegelman, "Mein Kampf (My Struggle)," © 1996 Art Spiegelman.

Annette Kuhn, "A Meeting of Two Queens: An Exercise in Memory Work," © 1995 Verso Editions, 6 Meard St., London WC1V 3HR, to whom all requests for permission to reprint the work must be referred.

Printed in the United States of America

5 4 3 2 1

CIP data appear at the end of the book

for

Lotte & Carl

Leo

Alex, Oliver, & Gabriel

Contents

III. *Resisting Images*

Color plates follow page 134.

Preface

This volume originated in an exhibition entitled "The Familial Gaze" and a conference on "Family Pictures/Shapes of Memory" held at Dartmouth College's Hood Museum of Art in the spring of 1996, in the context of a Dartmouth Humanities Institute on "Cultural Memory and the Present." I am grateful to Timothy Rub, my co-curator, and the staff of the Hood Museum for enabling me to participate in this curatorial project and for the beautiful exhibition they put on. Besides the artists represented in this volume, the exhibition featured works by Christian Boltanski, Carrie Mae Weems, Sally Mann, Sarah Wells, and Darrell Ellis. Victor Burgin, Sally Stein, Alison Devine Nordstrom, Sarah Wells, Camille Billops and James Hatch, Michelle Meyers, Deborah Chay, and Cheryl Younger also participated in the conference and helped to make it a powerful and memorable event during which we all discovered the interest and import of cross-disciplinary conversations about family pictures. This volume owes a great deal to their interventions.

I am grateful to the participants in the Humanities Institute for the stimulating discussions about cultural memory that have helped me define the role of photography in the family's private and public self-representation. Besides some of the contributors to this volume, I would like to extend warm thanks to Jonathan Crewe, the institute's co-director, as well as to Carol Bardenstein, Elizabeth Jane Bellamy, Susan Brison, Kate Conley, Lessie Jo Frazier, Gerd Gemünden, Irene Kacandes, Mary Kelley, Tamara Northern, Larry Polansky, Henri Lustiger-Thaler, and Melissa Zeiger.

I am especially grateful to Phil Pochoda, Editorial Director at University Press of New England, for encouraging me to do this volume when I said I would never edit anything again. The contributors to *The Familial Gaze* have made the process an exciting one. But the volume would never have been completed without the practical assistance of Carol Peper, April Ossmann, and Jason Christian. And, without the benefits of the Parents Chair at Dartmouth College, for which I wish to thank the college, I would have lacked the time and the resources to undertake this work, however gratifying.

M.H.

Introduction: Familial Looking

Marianne Hirsch

> "Don't you think that a fiction can suggest a truth?"
> "Maybe but whose truth is it? It's your picture but my image . . . I'm
> really happy to help you with your project. Seriously. I just wanted you
> to know that for the most part that's not me I recognize in those pic-
> tures."

Larry Sultan photographed his aging parents during visits home over a period
of ten years. In his 1992 book *Pictures from Home*, he published some of those
photographs along with his narrative about his parents and reflections on his
project to "capture their existence in order to ward off their future non-
existence."[1] The son makes the images, the parents both help create and resist
his vision of them and possibly also his vision of himself. "Perhaps I'm out to
justify my own life, my choices, by questioning yours," he tells his father.

As carefully staged and choreographed as they are, Sultan's pictures from
home reveal a great deal about family photography both in the work of artists
and in ordinary snapshots taken as part of the fabric of everyday life. We can
read in Sultan's images the multiple looks that circulate within the family, posi-
tioning family members in relation to one another and to the "familial gaze"—
the conventions and ideologies of family through which they see themselves.
The son's look intersects with the father's and the mother's, the look of the hus-
band with the wife's, personal identities encounter professional ones, and indi-
vidual subjects gaze at themselves and at one another across the spans of a life-
time. As they respond to the images, the Sultans reveal the complex
negotiations, however unspoken or unacknowledged, that constitute family
pictures and family life—the struggle for control of image, narrative, and mem-
ory. Like conventional family albums, but more self-consciously so, Sultan's
volume contains fragments and isolated moments, marked by nostalgia and
loss, assembled into narrative drafts by one participant, even as his interpreta-
tion is contested by the others. But Sultan's work is also an important com-
mentary on family albums, an attempt to expand their range beyond the con-
ventional happy representations of family rituals, to expose the darker and
more hidden aspects of family life, the disagreements and compromises that
are most commonly excluded from the family's self-representation. As the
son's image of his parents, it reverses the more conventional look of parents
who take pictures of their children and construct their albums and early narra-
tives, but in this reversal it also connects photographic images even more di-
rectly to loss and mourning.

"It is a worn, hand-colored image of a Vietnamese man, dressed in a military uniform, with a young girl beside him, both seriously regarding the camera. The note that accompanies it reads:

'Dear Sir, For twenty-two years I have carried your picture in my wallet. I was only eighteen years old that day we faced one another on that trail in Chu Lai, Vietnam. Why you didn't take my life, I will never know . . . Forgive me for taking your life, I was reacting the way I was trained, to kill V.C.'"

The American soldier who had removed the photograph from the pocket of the Vietcong soldier he killed left it by Washington's Vietnam Memorial with a letter addressed to his victim. "What does it mean to take a photograph from the dead body of someone one has just killed?" asks Marita Sturken in her discussion of this picture. "Is it an act of remorse or a further violation? The photograph pulls from another place and another life a set of enigmatic and ultimately unknowable stories, each charged with loss. Where is that little girl now, did she survive the war or is she also memorialized here? Why did her father hesitate?" Sturken finds in this image the temporal disjunction that characterizes all acts of photographic looking, the innocent before and the knowing, ironic, retrospective after. She finds also a unique encounter between private images and public meaning. Removed from its immediately personal and more broadly cultural context, this private image acquires a very different set of personal and cultural meanings than it had in its original familial setting. For Richard Luttrell, who kept the photo of his victim for twenty-two years, it signifies both his guilt and his survival. As he looks at the Vietcong man and his daughter in the picture, he thinks of his own daughters and of himself; for him, the two men and the two families have become mirror images facing each other across time and space, across the boundaries of life and death. But at the Wall, and in the book of the collection of objects left there, this photo acquires more symbolic and allegorical meaning; the two men become representatives of their respective cultural groups, of the war, its destruction and survival. The same image is doubly exposed, in the familial setting and in the broader cultural, historical, and political contexts within which family life takes place. The familial gaze is always inflected by numerous other institutional gazes—for Larry Sultan's father Irving, the professional image of the successful business executive; for Richard Luttrell, the military training he received. In the context of this picture's exposition and dissemination, it is also inflected by the memorializing and mourning gazes of the Vietnam Memorial and the museological gaze of the archive of mementos left by the Wall.

After this picture was published, a Vietnamese man recognized his father and contacted Richard Luttrell, who is now planning to travel to Vietnam to return the picture to the family. But, as Sturken clarifies, "There has been some controversy in Vietnam around the image. After Luttrell announced his

intention to return the photo, an article published in Vietnam stated that it was a case of misidentification." The account of this misidentification reveals how readily family photographs provoke identification; their conventional and predictable poses make them largely interchangeable. They carry meaning within the family's own narrative and are emptied of that meaning outside that narrow circle. But family pictures are often so similar, so much shaped by similar conventions, that they are readily available for identification across the broadest and most radical divides—not only between Vietnamese families but even between an American soldier and a Vietcong, one of whom killed the other.

Family photographs trigger in their viewers an inclusive, affiliative look that embraces images of vastly different cultural origins. But familial looking can also function as a screen; the identifications it engenders can be too easy. Luttrell's familial response to the photo of his enemy provides an uncomfortable alibi, erasing agency and responsibility, familializing death and war. As it automatically places individuals into familial relation within a field of vision, familial looking is a powerful, if slippery and often deceptive, instrument of cultural dialogue and cultural memory.[2]

"Mammy and child double portraits are perhaps the most complex and disturbing images from the antebellum period." (Andrea Liss)

"The black teenager's unsmiling face and unflinching gaze at the camera confront us with her discomfort at the role she is required to play, but her torso fades into the image's dark background; she is allowed only enough visibility to serve as a prop for the child she holds erect with her right arm." (Elizabeth Abel)

"The woman is merely the setting, the not-quite-perfect background that needs to be improved. But her body language suggests that she comprehends this expediency and that she resents it." (Laura Wexler)

"As the space between the child and the woman's body indicates, the embrace is a gesture of expertise, not of love; not of 'family' but of subordination, a woman doing her job, and doing it well . . . Most poignant is the other arm, free of child but not of servitude and estrangement. The curve of the arm denotes tension. The hand, a fist clutching the chair's arm, denotes more than the unfamiliarity with the photo session. It denotes unfamiliality, unbelonging, unrelatedness to the mother-child dynamic." (Mieke Bal)

"I assumed this drawing represented a mother. Later, however, I came to realize that this illustration is meant to show a hired nurse." (Joanne Leonard)

Remarkably, a number of the essays in this volume on family photography test the limits of familial representation by focusing on formal portraits of nursemaids, nannies, servants, or slave women (mostly black) holding white infant children on their laps. It is not surprising that these images should attract so much attention in these analyses. These are images that echo the tradition of madonna and child representations; as mother/child images they potentially carry the most powerfully nostalgic and sentimental attachments. But in these pictures, the maternal figure is not a mother but a servant. Her body is often only there as a prop to the child who forms the central focus of the picture. These images challenge traditional representations of mothers and children. The separation between nanny and baby, the adult woman's nonmaternal identity, is particularly poignant in response to the tradition invoked.

The conventional slave and child double portraits mark the boundaries of family, signaling the family album's inclusions and exclusions. More than that, they demonstrate the power of photographic images to support and enforce dominant ideologies. Mostly, as the essays point out, if nannies can nurse the children of their masters or employers, it is because they themselves have infants who are made utterly invisible in this iconographic structure. Familial looking, so powerfully inclusive and identificatory, can also draw its lines of exclusion and disidentification, even as, at the same time, it embraces the nanny/child couple in the web of mother/child iconography. As we reflect on family photos, contradictions such as these repeatedly push us to confront these difficult liminal images.

In portraying a black mother and a white child and in marking that mother as a slave or a servant, the nanny and child portraits uncompromisingly and bluntly point to the family's embeddednesss in a larger political and economic framework, as well as photography's power to reproduce and naturalize it. As Laura Wexler says, "Photography was part of the master narrative that created and cemented cultural and political inequalities of race and class." But these images, more than perhaps any others, raise an additional question: can photographs, the very cultural objects that support dominant ideologies, also be used to resist and contest those ideologies? And how, in these opaque and ultimately flat two-dimensional representations, can this resistance be read?

As we can see from the above quotations, the essays in this volume aim to perceive resistance and to restore agency to the nanny in the picture, and they devise reading strategies that will detect gestures of subversion. Again, power and control of the image are at stake, and that relationship of power and domination can be read in the looks that circulate in the image: the look between photographer and subjects, between the subjects themselves, between those who commissioned the images and the people portrayed and, of course, between the interested reader and the object of her reading. Clearly, also, these looks are gendered and racialized. Deborah Willis, in the essay discussed by Elizabeth Abel, confronts a nanny and child image with a snapshot of herself

and her sister as young girls holding dolls: she holds a black doll, while her sister, like the nanny, holds a white doll. As Willis returns to this image in her present essay, she and Abel stage a complicated scene of cross-historical and cross-racial looking that gives a sense of the intricate and scrupulous readings that such images both enable and demand.[3]

Resistance becomes a question of the very line between visibility and invisibility. Only the most subtle, complex, and multilayered reading practice that consistently confronts personal with cultural, political, and economic meanings will locate the resistant elements of a photographic image and will itself be able to produce resistance to the ideologies supported by the medium. Familial looking is embedded in other extrafamilial looks and gazes that must be confronted with care. Those who analyze the familial gaze must therefore be as self-conscious about their own viewing positions as they are vigilant about the postures they analyze. They must be aware that to look is also, always, to be seen.

These examples indicate the range of images and issues represented and discussed in this book. This is a timely moment to bring together some of the important contemporary work on family photography: the work of artists representing varied media—documentary photography, photo-collage, comics, installations on the World Wide Web—with the work of theorists, writers, and critics from the fields of art history, literature, psychoanalysis, history, and film studies. *The Familial Gaze* points to family photography as a compelling and new cross-disciplinary field of inquiry. Its aim is to occasion a rereading of family photographs and the cultural work they perform. Taken together, these essays and images illuminate family pictures from a number of different angles and provide a context and a vocabulary—a series of recurring questions and problems—with which we can think and talk about such ordinary and seemingly transparent domestic objects as family pictures.

As early as its invention, photography became the dominant medium of formal family portraiture throughout the Western world. But in spite of the enormous changes the institution of family has undergone, nineteenth-century photographic portraits share the conventions of family portraits in painting dating back to the Middle Ages and the Renaissance. As Julia Hirsch shows in her *Family Photographs: Content, Meaning and Effect*, photographic images of the family "describe the family as a state whose ties are rooted in property; the family as a spiritual assembly which is based on moral values; and the family as a bond of feeling which stems from instinct and passion."[4] According to Julia Hirsch, the roots of the modern family portrait are to be found in Renaissance portraiture which, for the first time, represents the family as a self-contained

institution. Early photographers alluded to the traditions of portraiture and thus sustained and perpetuated the formal aesthetic elements of the genre.

But when, in 1888, George Eastman invented the "Kodak"—with the slogan "You push the button, we do the rest"—photography could emancipate itself from its artistic history and become widely and democratically available to anyone. It left the studio and entered the home. In the ensuing century, the camera has become the family's primary instrument of self-knowledge and self-representation—the primary means by which family memory is perpetuated, by which the family's story is told. Formal portraits have virtually been replaced by more casual snapshots that can record the ordinary moments and the minute details of family life. Yet even the speed and simplicity of the process have not radically refocused the convention of familial representation and self-representation.

What can we learn from family pictures, our own or those of others, snapshots or formal portraits? What stories, ultimately, do they tell? The rigid conventions they follow seem to shore up dominant familial myths and ideologies, supporting a circumscribed and static self-representation of the family and closing it off from scrutiny and critique. And yet, as the above examples show, contemporary scholars, critics, and artists have begun to devise a multi-layered reading practice that pierces through the photograph's flat surface.[5] In recent years, the conventions of family photography and the ideologies these conventions express and uphold have been seriously scrutinized and examined. This scrutiny defamiliarizes accepted representations of the family and thus refocuses our ways of seeing it.

The photograph is the site at which numerous looks and gazes intersect: the look exchange between the photographer/camera and the subject; the looks between the subjects within the image; the look of the viewer, which often exceeds and complicates that of the camera and which, in itself, is an infinitely multiple and contradictory series of looks; and the external institutional and ideological gazes in relation to which the act of taking pictures defines itself. The photograph is a document in which this complex exchange of looks and gazes is reflected and can be read.[6]

Thus, when we photograph ourselves in a familial setting, we do not do so in a vacuum; we respond to dominant mythologies of family life, to conceptions we have inherited, to images we see on television, in advertising, in film. These internalized images reflect back on us, deploying a familial gaze that fixes and defines us. But each picture is also the product of other looks and gazes as family members define themselves in relation to each other in the roles they occupy as mother, father, daughter, son, husband, or lover. That process of definition—that familial act of looking—is also recorded visually in photographs. And, as these looks and gazes intersect, they are filtered by various screens that define what and how we might see.[7]

As family pictures have themselves become objects of contemplation in

contemporary artistic, literary, and theoretical work, these multiple and layered aspects of photographs have become more visible. Contemporary artists and writers from numerous American and European cultures and subcultures have used family photographs in their work. They go beyond their conventional and opaque surfaces to expose the complicated stories of familial relation—the passions and problems—that have, for the most part, remained unrepresentable and thus unseen. As they have been able to show the complicated and contradictory workings of photography, they have begun to reveal the pervasiveness as well as the power and influence of photographic images in contemporary visual aesthetics and cultural politics.

Artists, critics, and theorists have thus attempted to use the camera and the family picture as instruments of social questioning. They have interrogated not only the family itself, but its established traditions of representation. They have taken the family out of its monolithic imagery to embed it in a fractured contemporary history shaped by the ideologies of race, ethnicity, gender, class, and sexuality. Exploring the politics of familial representation, they have incorporated the everyday practice of family photography into a layered, exploratory, and self-reflexive aesthetic. Their process of interrogation is particularly important at a moment when "family values" are a powerful political tool and familial images dominate the public spaces we inhabit and the discourses to which we are subject. Embedding family photographs in a comparative and theoretical discourse, and representing them in new artistic work will allow us not only to see them anew, but also to examine the power of the metaphor of family in contemporary cultural discourse.

Three primary areas of focus organize this work of rereading. First, the contributions in this volume address how *photography* functions as a mode of *familial representation* in a specific cultural and historical *context*. Second, as we consider the ways in which family pictures and the notion of family are used in public discourse and exhibition, we can also reread the complex relation between public and private, between the family album and the public memorial, between personal and political expression and meaning. This entails, third, a consideration of the power of convention and the photograph's role as an instrument of familial ideology, and, conversely, the possibility of resisting dominant ideologies through photography.

The book's three parts follow my three foundational examples, the alternative "family album" of Larry Sultan, the "double exposure" of the Vietnamese man's family picture, and the "resisting images" depicting nanny and child.

Part I, "Family Albums," includes a number of readings and rereadings of the family album in its traditional and contemporary manifestations. The essays and images of this section look beyond the surface of ordinary albums to de-familiarize them and the strategies that constrict them. Still, even the less

conventional stories of loss, displacement, and disappointment, of challenge or resistance that emerge situate themselves within the paradigms of a heterosexual family subject to a normative familial gaze. Part I begins with Sultan's "Pictures from Home," followed by Lorie Novak's reflections on the snapshot as a genre of familial representation ranging from her earlier still projections and multimedia installations to "Collected Visions," her interactive World Wide Web installation. Here is a potentially global family album that occasions multiple conversations about family snapshots and reveals their interchangeability. As users submit photo-essays to the website, they often claim images of other families as their own. "For me," says Novak, "this identification with the images of others is the strongest validation of the site." But in his essay on Christian Boltanski's found family albums of Nazis, Ernst van Alphen reveals the profoundly problematic aspects of the familial looks that structure family albums. As familiality is projected onto the portrayed subjects and the viewer is drawn into a familial network of looking, it becomes impossible to recognize criminal personalities, to distinguish between victims and perpetrators even of the most heinous and unimaginable crimes. The commonality Novak sees as a strength of family pictures, van Alphen reveals as their dangerous capacity to lie.

Like Larry Sultan's, Nancy Miller's interest in pictures derives from the perspective of the adult child reflecting on parental aging and death. A reader of images and not a photographer, Miller uses her childhood pictures in the writing of memoir, as do the other memoirists she discusses. Photos bring the past into the present; they facilitate the work of memory. In Miller's family, Daddy took the pictures and directed the scenes, but memoir, she insists, "is reediting the movie that is the way we remember our life's story . . . [it] is the triumph of the child's view of the past." Perusing her own childhood images she finds the mother/daughter strife she remembers but, to her surprise, she also finds unexpected images of ecstatic connection. Stunningly present, these childhood images uncannily erase the temporal distances between child and adult, death and life.

While Miller is the daughter looking at images of herself and her mother taken by her father, Jane Gallop writes in the voice of "the mother" who, as the "prime photographed subject," rarely gets to speak for herself. The mother, like the person who is photographed, is a "subject who is becoming an object," and Gallop explores with stunning subtlety what that process of objectification feels like. But, as the mother who observes and who writes, she has already resisted this objectification and reinstated herself as subject. The unconventional images she discusses are taken by her partner, the photographer Dick Blau, and in the essay we witness the delicate negotiations between them and the audiences they imagine and construct for his pictures. Like Sultan and Miller, Gallop and Blau are conscious of the activity of staging that is basic to the familial scene of photography, and they are conscious, as well, of the dual

role each plays—as photographer and subject, and as parents to the children depicted. In their work on and with family pictures, and especially as they confront the choices of publication and exhibition, Gallop and Blau find themselves balancing professional with personal concerns, honesty and ambition with care. "Family photography is not just about how the family looks in the pictures; it's also about how the pictures look in the family."

Valerie Smith's "Photography, Narrative, and Ideology" discusses the films of Camille Billops and James Hatch, another husband/wife team who, like Blau and Gallop, also document family life in visual and narrative form, themselves refocusing and undermining the 1950s photographs and home movies of Billops's stepfather, Walter Dotson. Smith's analysis introduces a series of essays in the volume by both black and white writers and artists that deal with African-American family images, mostly feminist rereadings of representations of black mothers. She shows why Billops and Hatch need to supplement and complicate a documentary photographic aesthetic in their desire to critique "monolithic, romanticized notions of black maternity." Thus, in these films, personal photographs move from the domestic to the public sphere.

This is also the case for Art Spiegelman who, in his brief memoir text "Mein Kampf (My Struggle)" shows how the family is embedded in a larger history inflecting and complicating the familial gaze. Spiegelman finds himself in the position of both son and father, reflecting on the role of photographs in facilitating memory—"often they only help me remember seeing the photos before." Standing in front of doors marked "repressed memories," "erotic memories," "neurotic memories," and "childhood memories," Spiegelman is struggling to find the keys that would open them. But as the linear sequence of his comix is interrupted by two snapshots, we wonder whether these photographs might not themselves be the open doors to the past, with its fears and desires, its nightmares and fantasies. This in spite of their obviously staged quality—both are dress-up photos of children in superhero costumes. But Spiegelman's is more than a personal or family memoir: his text is framed by the chilling repeated fact that circumscribes his own life and the lives of his children: "My parents survived Auschwitz"; "Two of their grandparents survived Auschwitz."

Part II, "Double Exposures, " includes a number of images and essays that, like Smith's and Spiegelman's, confront personal memory with public history. More pointedly than in the first section, family pictures and albums are here placed within their larger historical and political context, allowing us to reread them from yet a different set of vantage points. This section begins with two images by Albert Chong, "The Sisters" and "Aunt Winnie's Story": "A few years ago my mother sent me the only remaining picture of herself as a child—an old torn and yellowing photograph of three girls . . . She asked me to repair the picture. I could not heal it, but I could rephotograph it incorporating the torn area of the image." By reconstructing the picture itself, by surrounding it with dried flowers, utensils, cowry shells, little dolls, and by writing the story of the image

on its carefully crafted copper frame, Chong scrupulously directs the viewer's response to his text. The familial nature of the image is not enough for Chong; he does not trust that, in a world in which, as he insists, very few historical photographs contain people of color, it will evoke in his viewers feelings of identification or associations with their own family images. He does not trust that, through a more generalized familial act of looking, his mother's or aunt's distant culture will be connected to the culture of the viewers he addresses, in his terms, "white civilization." Chong needs to tell Aunt Winnie's story, both visually and textually, so that she will be seen and recognized in her historical and familial role. In remaking these pictures into shrine-like ritual spaces, Chong wishes to ensure that their personal meaning to him and his mother and aunt will be translated and communicated.

In "A Search for Self: The Photograph and Black Family Life," Deborah Willis meditates on her long-standing analytic, artistic, and curatorial work with African-American photographs and the reasons she sees them as such significant objects of study for historians and artists alike. Willis, like Chong, sees photographs as important affirmative instruments in the personal and cultural construction of black identity. In her reading, sitters have traditionally exercised significant control over the making and dissemination of their images, and contemporary artists, like Clarissa Sligh, have explored the complex negotiations between the personal and the cultural meanings of these historical images. Willis's important work, like Chong's, is a work of "cultural retrieval" and her essay lays out the many registers in which such work must take place—autobiographical and biographical, documentary and analytical, private and public, dispassionate and engaged. She thus gives us important tools for reading the multiple meanings of individual images, and the ways in which meanings shift in different contexts.

Willis's work, along with Carrie Mae Weems's "(Untitled) Kitchen Table Series" and an essay by bell hooks, is itself discussed in Elizabeth Abel's illuminating "Domestic Borders, Cultural Boundaries: African-American Feminists Re-view the Family." "If family photography typically serves to perpetuate conservative social values and traditions, do its politics change when survival is at stake?" Abel asks in reference to the role of photographs in the work of African-American feminists' reflections on the family. Abel's subtle readings reveal, first, the gendered dimensions of looking in the representations of father/photographers in Willis and hooks, and the reframing of the paternal look in Weems, and, second, the racial dimensions of the gaze that invariably subjects African-American domestic spaces to white scrutiny. In Abel's reading, Weems refuses and reverses both the paternal gaze and the white familial gaze mediated by the father, making visible an African-American female subjectivity that can be both sexual and maternal.

Chong's images of mothers, as well as Smith's, Willis's, and Abel's essays, set the stage for the impassioned analysis by Deborah McDowell of contempo-

rary postmortem photographs of black homicide victims appearing in journalis-
tic accounts. Here again, as in van Alphen's essay on Nazi albums, we become
acutely conscious of the deceptions made possible by the familial frame. Most
often, these teenage boys are represented with their mourning mothers in the
iconography of revised pietà, in which the murdered son cannot act as savior.
The obsessive concentration on the grieving mother and thus on the familial
effects of these deaths, as well as the rhetoric of mourning in which they are
encased, McDowell carefully argues, disguise the larger social and political
story and, especially, the agency of these crimes. To familialize death is to nor-
malize it. The American familial gaze has constructed the black family as a so-
cial problem and a matriarchy and these images underwrite these conceptions.
McDowell's essay, however, goes beyond these objectifying depictions of griev-
ing mothers, to trace the mothers' own resistance and agency, their refusal to
be seen only as victims, their use of these same images as weapons for social
change.

Like McDowell's "Viewing the Remains," Marita Sturken's "The Image as
Memorial" explores the connections between photography, mourning, and
memory. Sturken confronts the pictures left at the Vietnam memorial with
the photographs in the AIDS quilt and photographic images used to search
for missing children. Like Novak's and van Alphen's, Sturken's analysis em-
phasizes the availability of family images for too easy a process of identifica-
tion, their dangerous openness to multiple and often competing and contra-
dictory meanings, as well as their ability to normalize and thus to erase
political differences.

The two memoir texts that close this section are founded on readings of
photographs and albums. Each also shows the interconnection of personal and
family memory with public, political, and economic history. Annette Kuhn's
"exercise in memory work" peruses a childhood photograph on the day of
Queen Elizabeth's coronation and reflects on the powerful metaphor of family
that can deceptively project the emotions of home and domesticity over the
entire British empire. Again, the lies that support the metaphor of family and
that that metaphor in turn supports emerge with striking clarity. And, in "The
Album and the Crossing," Leo Spitzer provides the graphic illustration of the
notion of "double exposure." The album he reads is of his parents' refugee emi-
gration from Austria during the Nazi era. In spite of their flight and the death
of a beloved father on board the ship, the images show smiling travelers on a
sea journey. Only when a picture falls out of the album does Spitzer find the
more sinister messages written on the back, the messages through which these
personal photographs have become important cultural documents. This dis-
junction between the character of the image and the caption raises provocative
questions about the circumscribed conventions of family photographs and the
limited stories they can tell.

After this double rereading of albums and photographs, Part III, "Resisting

Images," reads in a more concentrated fashion the capacities of photographs to resist and contest the very familial ideologies that the medium of family photography supports. Examining the familial frame closely, these essays attempt to theorize or to demonstrate what might allow us to see beyond or outside it. Mieke Bal's "All in the Family: Familiarity and Estrangement According to Marcel Proust" constitutes the most ambitious theoretical attempt to define just such an "alternative visual domain." Proust's novel provides her with the ground against which she can read her own family snapshots, even as her snapshots offer a space of otherness in the reading of Proust. Together, these texts supply the occasion for a reading of the snapshot as surface, and thus as unknowability, and refusal to fix. Snapshots can reveal an alterity, an unfamiliarity that can pierce through a very fixed and all-too-knowable familial identity. In Proust that space on the edge of the family is lesbian and homosexual sexuality, made visible only by escaping or openly contesting the familial gaze. Thus Bal's essay, along with Sturken's reading of the AIDS quilt, initiates a discussion of queerness in relation to the normative family, one that most of the essays in this volume, and the volume as a whole, do not adequately pursue. Thus Bal also shows why we cling to the conventional familial look as a source of meaning and knowing: freed of it, the object of the look falls apart into a series of meaningless gestures. When Proust's Marcel observes his grandmother when she is unaware of his presence in the room and does not compose herself in response to his gaze, she looks to him like a vulgar old woman, a stranger.

Laura Wexler's "Seeing Sentiment: Photography, Race, and the Innocent Eye" also takes us to the edges of the familial by examining nineteenth-century photographic representations of servants and slaves in the context of formal family portraiture. Wexler looks in particular at the capacity of the slave woman to escape the subjugating and dominating white familial gaze and to move from backdrop to center of the image. She thus continues the discussion of black maternity begun by Smith, Chong, Willis, Abel, and McDowell. But cultural critics, Wexler argues, have mostly refused to perceive the resisting capacity of photographs. She terms their refusal "anekphrasis"—the unwillingness to read historical photographs and consider them as documents of political resistance. Like Abel, Willis, and McDowell, Wexler convincingly shows that one can locate resistance in the participation of black subjects in their own images, even if they are the objects of cross-racial looking.

The representation of the black maternal subject is interrogated yet again in a contemporary context in Andrea Liss's discussion of Renée Cox's striking self-portraits taken during her pregnancy and with her young son. Liss sees these in relation to the images of slaves with their white charges and traces Cox's efforts to counteract this long-standing and debilitating iconography by making visible what our culture has radically disguised: the black maternal *and* sexual body. And she does so without opening herself to appropriation. As Liss shows, Cox not only allows herself to be seen; vulnerable, moving, open, as

well as angry and defiant, she also looks back. Joanne Leonard, like Cox, is also a photographer as well as a mother. In images and words, she recounts, as a white woman of upper-class origins, her struggle with dominant images of maternity in her life and her work. Only the medium of collage allows her to engage in a dialogue between idealized mythologies, the texture of everyday life and a radical reenvisioning of the lives of women as mothers and as daughters.

The concluding two essays in the volume use family photographs to engage a broader political arena, the political strategies of the religious right and the effects of child pornography legislation. The ordinary conventional family pictures from the 1950s used by Jim Dobson to affirm the family values of his "Focus on the Family" are in his view images that resist what he perceives as the secular liberal humanist conspiracy that pervades the contemporary United States. Ann Burlein's essay shows the danger of these images which, because of the reception of photographs as straightforward documents, can present a myth of the family as a lost reality. Family photos thus become the vehicles for a false nostalgia for "the way we never were." They enable Dobson to privatize and familialize important social issues, removing their political edge. Burlein demonstrates the difficulties of resistance within the space of the familial gaze.

Anne Higonnet's concluding essay also focuses on the devastating effects of the literal reading of photographic images for their truth value, as documents of actions. In debates around child pornography, the images themselves, as images, are never part of the discussion, she reports. They are assumed to be transparent documents of child abuse. But Higonnet contextualizes this reading by tracing, historically, very different forms of reception of Edward Weston's nude images of his young son Neil. Only recently would Neil's nudity even have been noticed—earlier criticism focused entirely on aesthetic and formal questions. And only Higonnet herself reads the *Neil* images as *family* pictures, as documents of parental passion for the child's body. Even while distancing itself from the indexical reading of images that so many of the essays in this volume uphold, Higonnet's essay itself is a moving record of her own maternal passion and longing, her own reading of children's images as parental projections of desire mixed with fear, protectiveness, and fantasy.

Higonnet thus returns us to one of the dominant looks explored in this book: the look at the child by either the parent, the adult looking back at his or her own child image, or the theorist who analyzes the public use of images of children. When we "put ourselves in the picture," we tend to do so as parents or as children, and the familial look is often the protective look at the body of the child. Thus it is no surprise that one of the primary intertexts of these essays is Roland Barthes's *Camera Lucida*,[8] which represents even the writer's mother as a young child, a portrayal repeated in Chong's "The Sisters." But as they look at the little girls who are their mothers with a reversed parental look, both Barthes and Chong also imagine their mothers looking back at them,

across enormous spans of time and generations. They remind us that seeing is always mutual, if not always equal. "Yet in these photographs of my mother there was always a place set apart, reserved and preserved: the brightness of her eyes" (*Camera Lucida*, 66), Barthes writes. We find this desire for a maternal look as well as actual accounts of mothers and fathers looking in most of the essays in this volume. The images reproduced and discussed all contain the double vulnerability, the desired mutuality, the too-fixed and yet unsatisfying instants of connection expressed in Barthes's and Chong's maternal portraits.

This predominance of images of children, and the looks exchanged with them, illustrates perhaps the particularities of the familial gaze we are confronting as we think about family pictures at the present historical and cultural moment. They allow us to recognize the energies and fantasies, the fears and vulnerabilities we project onto family pictures. The essays in this volume uncompromisingly demonstrate that if we are to reorient the familial gaze and break through the confines of its frame, we must recognize both the strong seductions and the deceptions fostered by familial looking. They urge us to examine how it works in order to be able to defamiliarize it. But they also enjoin us, in the process, to preserve the emotional power of the looks that circulate in the family. Thus they provide no less than alternative ways of seeing.

NOTES

1. Larry Sultan, *Pictures from Home* (New York: Harry N. Abrams, Inc., 1992).

2. For a fuller discussion of the notion of "familial gaze" and "familial look," see Marianne Hirsch, *Family Frames: Photography, Narrative and Postmemory* (Cambridge: Harvard University Press, 1997).

3. See Elizabeth Abel's work on cross-racial looking both in her essay in this volume and in her work in progress, "Signs of the Times: The Visual Politics of Jim Crow."

4. Julia Hirsch, *Family Photographs: Content, Meaning and Effect* (Oxford: Oxford University Press, 1981), 15.

5. For other critical and personal analyses of family photographs, see Julia Hirsch; Marianne Hirsch; Jo Spence and Patricia Holland, eds., *Family Snaps: The Meanings of Domestic Photography* (London: Virago Press, 1991); Deborah Willis, ed., *Picturing Us: African American Identity in Photography* (New York: The New Press, 1994); Annette Kuhn, *Family Secrets: Acts of Memory and Imagination* (London: Verso, 1995); Carol Mavor, *Pleasures Taken: Performances of Sexuality and Loss in Victorian Photographs* (Durham: Duke University Press, 1995). A number of exhibitions and artist catalogues could also be consulted.

6. For detailed discussions of this exchange, see Victor Burgin, "Looking at Photographs," in his *Thinking Photography* (London: Macmillan, 1982) and Catherine Lutz and Jane Collins, *Reading National Geographic* (Chicago: University of Chicago Press, 1993), especially the chapter entitled "The Photograph as an Intersection of Gazes."

7. For distinctions between the gaze, look, and screen see Jacques Lacan, *Four Fundamental Concepts of Psychoanalysis*, trans. Alan Sheridan (New York: Norton, 1978) and Kaja Silverman's readings of Lacan in *Male Subjectivity at the Margins* (New York: Routledge, 1992) and *The Threshold of the Visible World* (New York: Routledge, 1996).

8. For a recent account of the centrality of Barthes's book to the contemporary discussion of photography, see Jean-Michel Rabaté, ed., *Writing the Image after Roland Barthes* (Philadelphia: University of Pennsylvania Press, 1997).

I. Family Albums

Pictures from Home

LARRY SULTAN

Ideas for Photographs:

Dad looking like Johnny Carson
Mom looking up—photographed from high vantage point
 (like in the movie still)
Walking the dog at night
Mom at work, at the office or at an open house
Where are pictures of them with their kids?
Still-life of dresser or desk
Dad looking to the side with sloppy background, maybe car
Shaking hands
Project the Dale Carnegie photograph and do
 portrait of dad standing in front of it
Close-up, looking to the side
Mom opening up curtain
At the water, fishing
Pictures of me?

When I got off the plane in Los Angeles and walked to the baggage claim, he was looking for me at another airline. I took a moment to look at him; I hadn't seen him since he had come out of the hospital. He had on a blue sweatshirt, Levi's, and tennis shoes. He had lost weight.

As we are walking to the parking lot he asks me if he is limping. It seems like every time I see him he asks me this. He makes me stand in parking lots and then he walks toward me as if I were a policeman giving a sobriety test.

"How bad am I limping?"

I tell him he has a bad limp.

"How bad?"

"Well, it's noticeable."

Now he adjusts his walk and makes me watch him again. I put my bags down.

"Now is it noticeable?"

"Yeah, it looks like you're limping."

"How bad?"

"You're crazy."

Later in the car we talk about how you measure a limp. He clarifies the issue with his usual candor: "Tell me the truth, do I walk like an old man?"

Three days later when he takes me to the airport he tells me: "I'm so glad you were here to witness the fact that I don't look seventy or act seventy or feel seventy, but I made seventy. For three days now I've been seventy years old and it doesn't mean shit."

My mom tells me, "Those newspapers of his drive me crazy. The big investor. I don't think he even reads them. If he kept them in his study that would be fine, but they're all over the dining-room table and the living-room table and the kitchen counter. They're stacked on the floor by the bed, on the living-room chair, on the stool in the kitchen. Do you know that we eat on those papers? They have become our dining mats. I'm serious.

"We have this big house. With you kids gone all we have is empty bedrooms. We have no family left. Now it's a house filled with newspapers."

He says, "When I lost my first $30,000, I said to Jean, 'It's sad, I could have given that money to the kids.' When it became $70,000, I thought, 'Christ, I could have bought a Rolls.' When it became $100,000, I turned to Jean and asked, 'Are there bullets in this gun?'"

"In the morning I go out to the driveway and get the newspaper. I read it while I'm eating breakfast. She'll be having her juice and while she drinks it she looks out the window. She'll start talking but I'm not sure if it's to me or to herself. She says that she has to call this person or that person and do this particular thing. Throughout the day she'll walk around the house saying this, and I hear

[Plate 1.] Also see the color plates
section following page 134.

it so often that I find myself getting sucked in, and without giving it much
thought I'm asking, 'Did you call so-and-so?'

"And she'll say no.

"And I'll ask her, 'Why not? When are you going to call her?'

"And she answers, 'As soon as I do this and that.' And then I'm getting more
involved.

"Day after day it continues. She's got to call so-and-so, but in the meantime
she's on to the next week where she has to go to the cleaners and call a differ-
ent so-and-so, and she can't do the things she says she has to do next week be-
cause she's doing the things she said she would do last week, things that she
couldn't get around to doing.

"Do you know what I'm saying? I really try to just take care of my own things
and not get involved, but if I hear someone say for seven straight days that they
have to call somebody, at a weak point I forget myself and say 'Did you call?'

"'No.'

"'Well, for Christ's sake, call her,' and, wham, there I am, caught in the
senseless stream of someone else's errands.

"The day-to-day stuff builds up over time. We're talking fifty-six years. We
never, or I should say rarely, ever argue. We have nothing to argue about—never
about finances, or work, or you guys. I tell her, 'You're the only one who cares;
no one outside of family gives a damn about me or you; everyone is only inter-
ested in their own lives.' I've recognized this and understood it for a while, and
that's why I'm reluctant to go out and socialize. Most people are so self-centered
that they're not interested in anything outside of themselves, and so opinion-
ated that you can no more talk to them than to a radio. It's not that I need an in-
depth conversation, just a little understanding. And that's difficult to find.

"So your mother is my best friend, but the truth is, that trust is a fragile thing
and can be easily broken. Our real problem is how I get irritated and how that
can escalate. It's mostly about how she denies the truth. It begins so trivially.

"I'll say, 'Jean, stop rubbing your eyes.'

"And she'll look at me and say, 'I'm not rubbing my eyes.'

"I'm watching her rub her eyes and I tell her, 'Jean, don't make a fool of yourself.' But she'll go on denying it, and that's it for me. It builds so damn fast that it would take a fire hose to put it out. The tension and irritation take me over and I lose control. It gets worse if I've been drinking. I guess what happens is that most of the time I let this stuff slide. Every day I pass over it, and when I have a few drinks I can't swallow any more of it—it all comes up."

She says, "I know better and I should learn to bite my tongue. But it's gotten to the point where I don't know what to say to him. I can't even ask him how he did at golf because, God forbid, if he shot a bad game, he'll take it out on me.

"Really, sometimes he can be very sweet, but other times I feel that I have to tiptoe around him, that any moment he'll turn on me. You know that look of his, it burns right through you. He gives me that look and I feel like I'm lying no matter what I'm saying."

"He told me that I should see a therapist, that I needed help. I said, 'You go, I have nothing to say to a therapist.' And he said, 'Don't worry, I'll make you a list.' It sounds to me like he wants me to go to a mechanic for a tune-up. 'Fine, let's both go,' I said. But he'll never go, he's got too much pride. Besides, he thinks that I'm the one with the problems."

I can picture my mother going to a therapist with my father's list, scrawled notes like the ones he makes to guide her through the morass of household business—phone calls to the electrician, the escrow officer, the neighborhood security service. After each call he interrogates her and, more often than not, offers corrections that serve as future instructions. She works for my father.

What would be on that list?

I imagine it to be an unusual form of therapy, one in which my mother reports back to my father after each session. He is waiting for her in the kitchen with an evening drink. Dan Rather's voice speaking to no one in the next room. With little prompting she tells my father her version of the session. I imagine my mother, who does play fast and loose with the truth, making most of it up. It would come out all at once—an elaborate collage of what she thinks he'd like to hear and what she'd secretly like to tell him. He circles back on it, trying to give it a familiar shape, one that is coherent and manageable. Without fear or blame she invents the words of the therapist and, with them, tells him the truth. The more I think about it, the more it seems to me that this therapy is exactly what my mother needs. She would finally have not only an ally but a mouthpiece as well.

Last year, at our annual family reunion at Lake Tahoe, I sneaked into their bedroom while my mother was taking her afternoon nap. I stood by the door for several minutes to be sure that she was asleep and then carefully tiptoed over to the bed. She was lying on her stomach with her head turned toward me. I was so apprehensive of waking her that I breathed in rhythm with her. Standing at the foot of the bed, I realized that I had never seen the underside of her foot. I had my camera, so I photographed it. I could see the slight grass stains from walking barefoot that morning to the lake.

[Plate 2.] Also see the color plates section following page 134.

[Plate 3.] Also see the color plates section following page 134.

I wanted to photograph it again and again, to use up an entire roll of film. Then it struck me that she was not really asleep, that her breathing, like mine, was controlled. We were co-conspirators. Just as I was secretly photographing, she was secretly awake.

She felt me looking.

Mom calls and tells me that the pictures that I made of her for the real-estate section of the *Los Angeles Times* are so miserable that she refused to tell anyone that I had made them, and when asked about them she said that she had to hire some hack photographer because I was unavailable. I can hear her trying to disguise her anger, but it comes through. "Here I am top saleswoman in the office and I'm the only one in the newspaper that doesn't even look like a sales agent. Who would buy a house from someone who looks so severe? It doesn't even look like me. I hate that picture."

My father shares her feelings about many of my pictures:

"I don't know what you're doing. You seem to be just as confused as I am. I mean you pussyfoot around; half of the time the tape recorder doesn't work and you want me to repeat conversations that occurred spontaneously, and on the other hand you take the same picture over and over again and you're still not happy with the results. It doesn't make a lot of sense to me. I don't know what you're after. What's the big deal?"

I tell him, "A lot of the time it doesn't make sense to me either. All I know is that every time I try to make a photograph, you give me that steely-eyed look. You know it; penetrating but impenetrable, tough and in control. Or you shove your hands in your pockets and gaze off into some mythical future, which for some reason is about 45 degrees to my left. It's like you're acting the role of the

[Plate 4.] Also see the color plates section following page 134.

heroic executive in an annual report, or in a diorama on success. Maybe you're looking for a public image of yourself and I'm interested in something more private, in what happens between events—that brief moment between thoughts when you forget yourself."

"All I know is that when you photograph me I feel everything leave me. The blood drains from my face, my eyelids droop, my thoughts disappear. I can feel my facial muscles go limp. All you have to do is to give me that one cue, 'Don't smile,' and zap. Nothing. That's what you get."

"No. What I get is an image of you that you don't like. Doesn't it come down to vanity and power? A question of how you look and who determines that, who's in control of the image?"

"Of course, it's about control, that's what I'm saying. Either you don't know what you're doing or you don't take enough control. It's like a director who films actors when they're standing around between scenes. No wonder I look lost in your pictures—you leave me in the middle of nowhere.

"I don't mean to sound so critical. I'm just trying to understand what you see in certain pictures. Like that one you took last time you were here. I can't figure out why you asked me to dress up in a suit, write on a piece of backdrop paper as though I was giving a lecture and then photograph me standing there with a pen in my hand looking confused, like I didn't know what I was talking about? I didn't even spell that word correctly: it's 'empathize' not 'empathy,' a verb rather than a noun."

"That's what I like about the picture. I thought that the error is an important detail, one that reveals a basic human quality. Do you think it diminishes you, makes you seem foolish?"

[Plate 5.] Also see the color plates section following page 134.

"I wouldn't go that far. But that's not the way I would have set it up. My image of someone giving a lecture is to have them project confidence and knowledge. In your picture, I look frightened by the very point I'm trying to make."

"Exactly. That particular picture was inspired by the Dale Carnegie course, and by all the lectures you gave me when I was a kid. I can't name it, but some emotion has seeped into the self that you wanted to project and caused a disturbance. I didn't notice it when I was taking the picture, but when I saw the print, I was reminded of something you once told me, that your success and efforts have been primarily motivated by fear. Maybe there's a little of that in the photograph. It's like a tear in the image that shows both who you think you should be and who you are."

"That sounds good but I think it's a load of crap. If anything, the picture shows how strained and artificial the situation was that you set up."

"Sure, it was a charade, but I'm talking about how the image is read rather than what literally was going on when it was made. There's a difference. Don't you think that a fiction can suggest a truth?"

"Maybe, but whose truth is it? It's your picture but my image. Like the photograph of me sitting on the bed; maybe I'm a little bored but I'm not melancholy, longing for the old days of Schick or waiting for death."

"There are no clear lines—I don't know where you stop and I start. And it's crossed my mind that perhaps I'm out to justify my own life, my choices, by questioning yours. Perhaps I'm avenging an old wound."

"If that's true, there is one photograph that settles the score. I hate it even more

that the one of me sitting on the bed or standing in front of the writing. It's
that picture of me swinging the golf club inside the condo in Palm Springs.
I'm sure you have very high-minded interests in the image and the implica-
tions of swinging a club with the television on and the curtains drawn, but for
me the picture is pure description. It's such a shitty swing that I cringe every
time I see it . . .

* "Look, I don't care what you do as long as it's successful. You worry too much.*
I'm really happy to help with your project. Seriously, I just wanted you to know that
for the most part that's not me I recognize in those pictures."

They have finally moved from Los Angeles to Palm Desert, a few miles from
Palm Springs. To get to their house we drive down Bob Hope Drive to Dinah
Shore and then turn onto Frank Sinatra Boulevard, streets lined with palm
trees and oleander hedges. Surrounded by the blazing desert sands, we pass
oasis after oasis, the lush green fairways of the golf courses and the housing
compounds that encircle them. Instead of the heavenly garden, nature has
been transformed and tamed into the country club: Sunrise West, The Lakes,
Rancho Mirage, Mesquite. Each with a guard at the front gate and a foun-
tain. The temperature is almost 120 degrees, but no one seems to mind. There
is a drought in California, but there is plenty of water flowing here in the
desert.

I have spent months trying to talk them out of this move. I thought that
spending entire days together in the monotony of the desert, and the fran-
chised culture that supports it, would only aggravate their difficulties. I was
filled with frightening images of them sitting in an air-conditioned house
watching television all day without saying a word to each other.

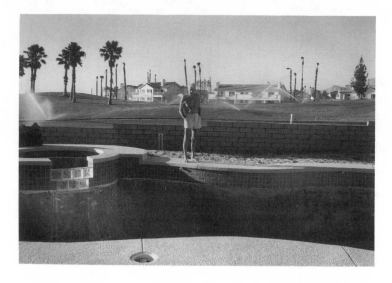

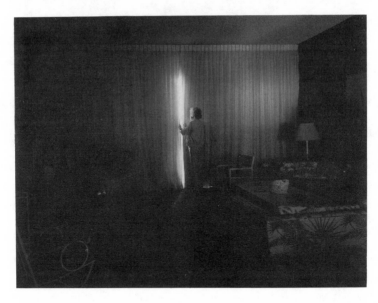

My fears proved to be unfounded. They love the desert. They look out of their backyard at the golf course and sip drinks while sitting by their pool or in their Jacuzzi and watch the stars come out. They go on daily walks together around the golf course. In the past year, my mother has had a radical mastectomy and my father a prostate operation, but both claim to feel great. What's most surprising is that spending all their time together seems to have improved their relationship. With their desert tans and exercise programs, they haven't looked better in years.

Sitting out by the pool, he tells me that he's become obsessed with the obits.

"I could care less about the accounts of these people's lives; what moves they made, how much money or how many children they left behind. I care only about their age. It gets scary when most of them are younger than me. I wish we would have moved to the desert years ago. Now all I ask for is ten more years. Ten years to enjoy this place."

Later in the day I photograph him carrying his dog, a gold retriever, over the low adobe wall that separates the backyard from the golf course. He turns to me and says, "Just two old friends going over the wall."

As we walk over the greens he asks me about my project:

"I can't believe that you're still taking pictures. I thought you had finished with all of that. You're not procrastinating are you, waiting for me to die so that your book has a dramatic ending?"

I tell him, "No, that's too predictable. But I am waiting around for an ending, and just think—the longer I wait, the younger the pictures of you will look."

"You better not wait too long. And listen, I hope you're not going to end your book with one of those pictures of despair."

"It depends what you call a picture of despair. The image I had in mind seems to be about memory and reflection, like looking back on your life."

"Oh Jesus, not another one of those."

Collected Visions

LORIE NOVAK

snapshot n. (1808) : a quick shot (as with a rifle) made without delib-
erate aim with the sights
1. a casual photograph made by rapid exposure and usually with a
small hand-held camera
2. a brief or transitory view, also: a mere segment
　　　　　　　　　—Webster's Third New International Dictionary

I am fascinated by the way a snapshot can make "a brief or transitory view"
permanent, capturing "mere segments" of life that could be easily forgotten
and freezing them for inspection. I am the oldest of three girls and was the
most photographed. I pore over my snapshots, intrigued by how I presented
myself to the camera, how my parents saw me, saw our family, and then how I
perceived the world when I first got a camera. I have a love/hate relationship
with my family photographs. They speak to me about the hopes, joys, and suf-
ferings of my family, but I am aware of how much was left out of our documen-
tation. I am also repelled by the abundance of stereotypical feminine poses.
Where is the evidence of struggle? "Family collections [of photographs] are
never just memories. Their disconnected points offer glimpses of many pos-
sible pasts, and yet, in our longing for narratives, for a way of telling the past
that will make sense in the present we know, we strive to organize these traces,
to fill in the gaps."[1]

I have hunted through drawers and boxes, searching for photographs that

reveal narratives other than the ones in our albums. I find images of awkward moments and unflattering poses that are often more revealing than the ones framed on the walls and presented in photo albums. Were these images not as important to remember?

> Yet I am not convinced that we should simply blame photography for the narrowness of its conventional pictures of family life. Indeed, the very determination to put a brave face on things, to show us all smiling as our teeth chattered on the frozen windswept beach or at the washed-out picnic, only demonstrates our more or less desperate desire to be happy: a dumb, clumsy inchoate awareness that *somehow* life could be better than it is.[2]

Thinking about what was and was not photographed in my family and how those choices influenced my memories and sense of self intrigues me and fuels my work.

The photographs of my childhood did not really interest me until I was in my late twenties. It was the early 1980s; I had recently completed graduate school and was starting to teach photography. Looking at these childhood images again, I felt as if I were seeing them for the first time. I used some of them in my work and embarked upon an artistic journey I continue today. Little did I know that this was the beginning of an obsession with family photographs that would culminate in a project as extensive as my *Collected Visions* World Wide Web project. Using snapshots and stories from more than three hundred people, *Collected Visions* (http://cvisions.cat.nyu.edu) is an interactive website that explores how family photographs shape our memories. The concept for *Collected Visions* grew out of my photographs and installations from the early 1980s to the present that use family photographs[3] to explore relationships between personal and collective memory.

I began my artistic career in the late 1970s photographing interiors (living rooms, bedrooms, kitchens) altered by colored lights and slide projections of shadows, light patterns, and landscapes. One day I projected an old family slide on a wall in my apartment. There I was as a child, looming like a ghost. The floating image had a dream/nightmare-like quality, and I felt as if I were making a memory materialize. These images from my past were immensely evocative. The rooms became a stage, and the projections of family photographs the players. This was a turning point in my work (illus. 1).

By 1983, I was creating color photographs of empty rooms in which superimposed "projections" form the visual analogue for psychological and emotional states. Using several projectors to project slides of my family photographs, I created installations specifically for the vantage point of the camera. Differences in time and distance diminished as I layered projected photographic fragments of my past. I grew up in suburban Los Angeles, and my family has

1. *The Barbeque.* Color photograph, 18 × 18".
© Lorie Novak/Swanstock 1983.

taken and preserved many hundreds of evocative and classically American photographs. From these, I chose images not for their autobiographical content but for the emotions they evoked and what they suggested about familial relationships, memory, childhood, hopes, and dreams (plate 6).

In 1986, I began to incorporate projections of images from the media (newspapers, magazines, TV) into my installations. This let me place my family photographs against a backdrop of images from our culture and be more specific in addressing the relationship between the personal and the collective. We experience much of history as photographic moments, and these images from our cultural consciousness can trigger our personal memories in ways that our own snapshots often cannot. They evoke a more specific sense of time. For instance, the photograph of President Kennedy slumped in his car in Dallas is a clearer photographic image in my mind than my family photographs from 1963. When I look at the Kennedy photograph, more memories from that period of my life are roused than when I see images of myself at age nine.

In 1987–88, I created *Critical Distance*,[4] my first slide installation made to be experienced in its projected form. In my slide installations, larger-than-life images dissolve into each other as they are projected into darkened rooms. The space is transformed as slides cover entire walls, appear on the floor, and move across corners. The continuous emerging and dissolving of images in a

[Plate 6.] *Eye Window*. Color photograph, 36" × 30". © Lorie Novak/
Swanstock 1987. Also see the color plates section following page 134.
I created "Eye Window" while in residence at the MacDowell Colony in
Peterborough, New Hampshire, in 1987. The central projected image is a
photograph of me at two years old. I am clutching my mother and about to
burst into tears. I have used this image in several constructed photographs. I
am drawn to it because it depicts a sense of fear rarely seen in family photo-
graphs. You cannot see my eyes, but my downturned mouth suggests sad-
ness. My mother appears happy and calm. My two-year-old eyes become
windows, no longer making contact with the viewer. Like a photograph's
frame, the windows reveal the world. The image is tightly composed, imply-
ing a closed world. The only way out is through my 'eyes.' An out-of-focus,
contemporary self-portrait floats to the left of my mother's head. My hand
grabbing my mother's shirt appears to pull at my neck in another self-por-
trait floating above my hand. The past pulls at the present.

darkened room evoke the sensation of thoughts rising and falling in the mind.
Exploiting the power of the transitions as one image fades into another, I ex-
panded my ideas concerning the relationships between historical imagery
(collective memory) and private imagery (personal memory).

In *Critical Distance* and my next two installations, *Traces*, 1990–91,[5] and
Playback, 1992,[6] I combined my family snapshots with historical media im-
agery drawn from books, magazines, newspapers, and television dating back to

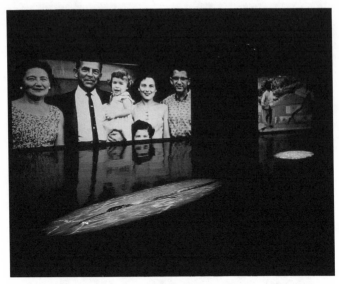

2. Lorie Novak, excerpt from *Traces*, slide and sound installation, 1990–91. Installation view from the University Art Museum, California State University at Long Beach, wall images 9' × 20'. Photo by David Familian.

World War II. For all of these pieces, I selected media images that are widely recognizable to emphasize the power of our collective memories. Exaggerated by the scale of the projections, the scan lines of the TV imagery and the screen-generated dot pattern of magazine and newspaper photographs reveal the image sources. The family photographs have no screen, and thus appear to be more real. By carefully juxtaposing the historical images, less traditional photographs I found deep in my family's archives, and contemporary self-portraits, I disrupt this myth of "reality" and the image of the conflict-free family that so many of the snapshots suggest.

Traces (illus. 2), which requires ten projectors to display eight hundred slide images, is my most ambitious slide and sound installation. Two ten-minute sequences are projected floor-to-ceiling on the back wall of two adjacent spaces. Both sequences contain my family photographs slowly dissolving into each other. One of the sequences also includes images from the media, intercut with the family photographs at a faster rate. Projected into an opposing corner are dissolving images of a hand shown turning the pages of three photo albums. The architecture of the corner approximates the shape of an open book, and the perspective is constructed so that the viewer feels as if she or he is looking over the shoulder of the person leafing through the photo albums. On the floor, a woman appears to be swimming between two pools, acting as the traveler between the three projected sequences. A sound loop of a rippling stream activates the space. The sound was inspired by rushing water one hears

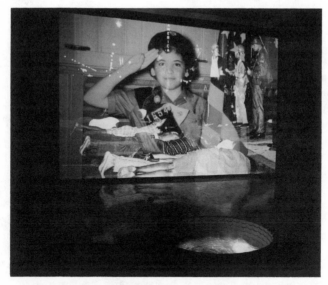

3. Lorie Novak, excerpt from *Playback*, slide and sound installation, 1992. Installation view (mid dissolve) from the Southeast Museum of Photography, Daytona Beach, Florida, wall image 10' × 15'.

in the ruins of a first-century Roman house buried two stories beneath the Church of San Clemente in Rome. The sound of the water acts as a layer of history, providing a physical reminder of the past.

In the slide and sound installation *Playback* (illus. 3), the sound is supplied by a live radio scan of several preprogrammed stations, alternating between music (oldies and contemporary), news, and talk shows—the audio equivalents of the types of imagery used. Although the scan is very much in the present, what we hear refers to the past. A blue plastic child's wading pool sits on the floor, while continuously dissolving images of children jumping and splashing in water are projected over and over again, hinting at a rougher journey than the one in *Traces*. At the same time, a fifteen-minute sequence of 120 slides is projected onto the entire back wall of the gallery forming the focal point of *Playback*. The sequence opens with images of my hand picking up family photographs—images of my lost childhood—which dissolve back and forth into newspaper images of people holding snapshots of deceased or missing relatives. These images dissolve into images of my family from the 1940s and images from World War II, followed by increasingly more recent images as the sequence continues chronologically up to the present. I update both the personal and public images each time *Playback* is exhibited, which gives it a diaristic quality and makes it my most autobiographical work.

In my search for new ways to examine my personal images against those of our culture, I realized I could use other people's family photographs in much

the same way that I used images from the media. Because I come from a family of all girls (sisters, cousins, and nieces), I started by collecting snapshots from women. I wanted to see if other women's images were like mine. Would they be more authentic? I collected snapshots from approximately one hundred women and girls of varied backgrounds and generations and created the three-part slide installation *Collected Visions I*, 1993–94.[7] With music by Elizabeth Brown, *Collected Visions I* examines the representation of women and girls in family photographs. I collected snapshots from my friends and family, from students and colleagues at New York University and from women involved with the Houston Center for Photography, where the installation was initially exhibited. They all delved deep into their family archives, providing me with a wide range of images dating from the 1940s to the 1990s depicting women from varied geographical, generational, ethnic, and social backgrounds. Parts I and II—ten-minute sequences of slide images examining the representation of girlhood and the experience of coming of age—are projected on adjacent walls in a corner of a gallery. Part III—a twenty-minute chronological sequence of girls age one through adolescence simply standing before the camera—is projected on adjacent walls in the opposite corner.

Elizabeth Brown's music is written for flute, glass harmonica, cello, and viola d'amore, and is melancholic in tone. Elizabeth created a score that "would sound like something you remembered or dreamed about [and be] mesmerizing rather than grab attention at any one point."[8] The music, which has a sadness that expresses yearning and loss, extended the emotional depth of the piece.

The similarity of so many of the images I collected was striking, especially in the ways that they only hinted at the female experience of coming of age. Except for clues of dress or format (black-and-white versus color, white border on the print versus no border), the differences in how girls and women present themselves in family photographs from the 1950s and 1960s as compared to the 1980s and 1990s are far less apparent than I expected, given the changes in women's roles and the influence of feminism over this forty-year period. Subtleties of gaze and gesture suggest the ways in which girls find their voices. A photo of a smiling girl gazing directly into the camera and with her hands placed playfully or defiantly on her hips reads quite differently from one where the same smiling girl has clenched fists or hands politely folded on her lap. Enough women gave me photographs that are not stereotypically feminine so that, strategically placed, they penetrate the many smiling faces and cute poses found in the majority of the images. To further emphasize the complexities of representation, I overlay several of the snapshots with photographs of my hands holding one of several open books by and about women including *A Room of One's Own, Little Women, Talking Back*, and *Writing a Woman's Life*. With young girls' faces seeming to peer through the pages of the books, the resulting hybrid images propose alternate narratives from the traditional ones conveyed in so many of the photographs.

As I travel with my installations, people always talk to me about their family photographs. Their stories reveal so much about photography's relationship to memory and the family. I knew I had to include some of these narratives in my next piece. I also realized that I wanted to enlarge the scope of the piece to include images from men and boys as well as from women and girls. I began collecting snapshots from men as I was installing *Collected Visions I* in Houston in May 1993. With the focus no longer solely on girlhood, I could take a broader look at the cultural significance of family photographs. I had thousands of casual snapshots and posed portraits depicting home life, familial relationships, celebrations, rituals, vacations, children at play, awkward adolescence, and much more. What I saw in these photographs were the dreams, disappointments, joys, tensions, and stereotypes of modern culture. Without realizing it, I was laying the foundation for what would become the *Collected Visions* website.

The mixture of images, music, and voices that I envisioned for this new project demanded a time-based medium more sophisticated than the slide installation. Digital and video technologies appealed to me because of their potential for flexible recombination of image and sound. I would also have the ability to create a digital archive of my growing snapshot collection. Conceptually, these technologies were a logical next step, since television has become a new medium for the family album. Transferring old slides and 8mm films to video, using home video cameras, and digitizing images onto photo CDs are becoming commonplace practices.

An invitation in the spring of 1995 to propose a project to the Center for Advanced Technology at New York University came at a most opportune time. Through sponsorship by the center, I teamed up with sound designer Clilly Castiglia, web designer Betsey Kershaw, and programmer Kerry O'Neill to create the *Collected Visions* website. Coming from different fields, we were able to ask questions and push the project in ways that none of us could have achieved working on our own. *Collected Visions* was launched in May 1996 in conjunction with the "Family Pictures: Shapes of Memory Conference" at Dartmouth College (illus. 4).

A mantle with framed photographs is the navigational base of the site. *search archive / create essay* brings visitors to the growing database of photographs. After choosing images (their own or those of others), visitors to the website are provided with tools to write, design, and submit a photo essay for exhibition in the *Collected Visions Gallery*. The *CV Gallery* showcases selections of submitted essays with changing exhibitions every four to eight weeks. The *Collected Visions Museum* is an archive of the essays from past exhibitions. The *resources* section contains an interdisciplinary bibliography dealing with family photographs, memory, and similar issues as well as related Web links. *Submit snapshots* gives instructions for contributing photos to the archive via the Web or by mail. *Positive Visions*, is an archive of essays and images about people infected with and affected by HIV/AIDS. It was launched on December

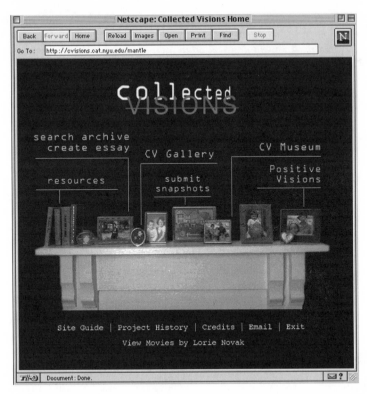

4. *Collected Visions* website navigation page. Design by Betsey Kershaw.

1, 1996 in conjunction with the 8th Annual Day Without Art and World AIDS Day.[9] The mantle also links to a selection of QuickTime movies I created with sound designer Clilly Castiglia using images from the *Collected Visions* archive and collected audio recollections.

The most significant aspect of *Collected Visions* is the ability it gives people to submit images to the archive and to create photo stories. As of January 1998, the archive contained more than twelve hundred photographs submitted by approximately three hundred people. The site's archive can be searched by various categories—who is in the photograph, genres of photographs, time period, or donor of the images. (See the *Collected Visions Search Form.*) The parameters for searching are determined by the content of the photographs. The search form is designed so that new categories can be added when they present themselves, as more photographs from a larger audience are contributed to the archive. As the result of recent contributions, the categories "funeral," "at work," and "altered snapshot" have recently been added. When the photographs fall into multiple categories, all applicable classifications are checked. I have also been obtaining additional information about the submitted images,

including the country in which the photograph was taken, the age of children in the photograph, and the type of setting (urban, suburban, rural) as well as any interesting story or facts associated with the image.

Collected Visions Search Form

Who is in the photograph?

☐ girl or woman alone

☐ boy or man alone

☐ mother and children

☐ father and children

☐ parents and children

☐ extended family

☐ couple

☐ grandparents and grandchildren

☐ sisters

☐ brothers

☐ brothers and sisters

☐ pets

☐ friends (all female)

☐ friends (all male)

☐ friends

What types of photographs do you want to see?

☐ dressed up (in formal clothes)

☐ fantasy dress up / Halloween

☐ graduation

☐ celebration

☐ birthday party

☐ family reunion

☐ wedding

☐ religious ceremony

☐ on vacation

☐ at work

☐ at the beach or pool

☐ children with toys

☐ people with animals

☐ holding guns

☐ sports

☐ wearing sunglasses

☐ school picture

☐ in photo studio

☐ posed portrait

☐ at home

☐ playing music

☐ on telephone

☐ holding camera

☐ child with school project or trophy

☐ child's first steps

☐ in uniform (scouts, army, sports, etc.)

☐ playing outdoors

☐ altered snapshot

☐ hands on hips or by side

☐ crying or pouting

☐ funeral

Do you want to limit your search by the time period of the photograph?

Before 1920	☐ Early 1940s	☐ Early 1960s	☐ Early 1980s
1920s	☐ Late 1940s	☐ Late 1960s	☐ Late 1980s
Early 1930s	☐ Early 1950s	☐ Early 1970s	☐ Early 1990s
Late 1930s	☐ Late 1950s	☐ Late 1970s	☐ Late 1990s

Do you want to see photographs you submitted?

Donor Last name _____ Donor First name _____

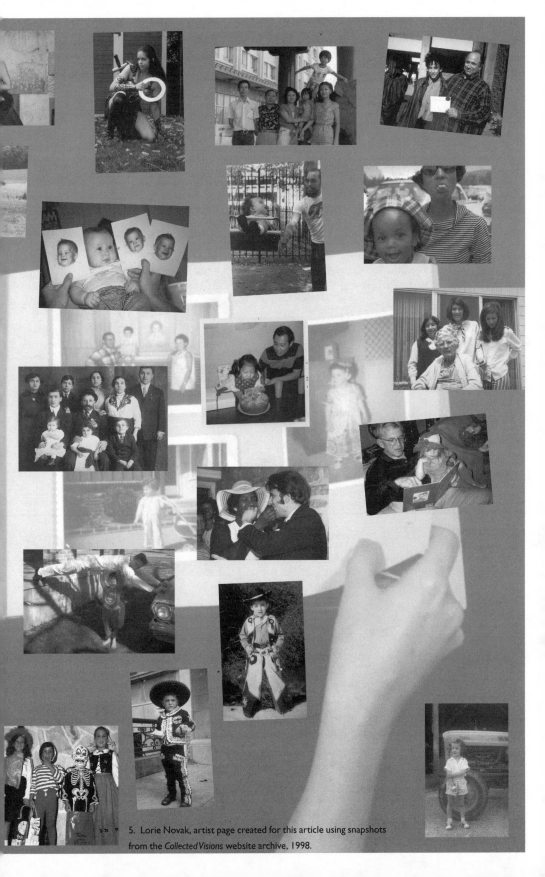

5. Lorie Novak, artist page created for this article using snapshots from the *Collected Visions* website archive, 1998.

After searching the archive, choosing images, and writing a text, participants are asked to choose colors for the text and background before submitting their essay for possible exhibition in the *Collected Visions Gallery* (illus. 5). Currently, I am curating all gallery exhibitions. I look for essays that use photographs as springboards for recollections, question the meaning and veracity of the images, and talk about images in ways that have never occurred to me. It is essential that the gallery contain multiple voices and points of view. I check for submissions daily, looking forward to the influx of new and diverse stories with great anticipation.[10]

The majority of the people submitting essays have written about photographs that are not their own. As exemplified in the following excerpts from selected submitted essays, some authors write about photographs of others as if they were their own, while others confess that the photo could have been theirs but is not.

This is a photo of me and my younger sister. No, not really. But if it were, I'd be the pediatrician, like our father, and she'd be the patient my dad would have to leave dinner to visit at the hospital.
—excerpted from the essay *Will She Get Better?*

I picked this picture because it looks like my school portrait from third grade. I had a similar hairstyle, one that my mother prided herself on because she cut it herself and the blunt cut was perfectly straight.
—excerpted from the essay *She looks like I did then*

This is me and my sister Alex, last Thanksgiving.[11] She is always after me to make something of my life, she doesn't respect the choices I've made.
—excerpted from the essay *I hate the Holidays*

I have a photo of my mother that is almost identical to this image. It was taken in the 40s by her mother.
—excerpted from the essay *Are You My Mother?*

For me, this identification with the images of others is the strongest validation of the site. Even authors who contribute images of their own usually choose to relate a personal story to or project their feelings onto anonymous images.[12]

Maybe writing about the resonant images of others frees authors from the personal baggage surrounding their own photographs and allows them to be more revealing. Our own images are often tied up in family legend with conversations about family photographs frequently accompanied by embellishment and invention. Photographs and the narratives they inspire can become

substitutes for memories of actual events. Anyone who has posed for a happy group snapshot at a stressful family event understands how photographs can be fabricated, and in time, alter memories.

> CALVIN: This is what I like about photography. People think cameras always tell the truth. They think the camera is a dispassionate machine that records only facts, but really cameras lie all the time! Select the facts and you manipulate the truth! For example, I've cleared off this corner of my bed. Take a picture of me here, but crop out all the mess around me, so it looks like I keep my room tidy.
> HOBBES: Is this even legal?
> CALVIN: Wait, let me comb my hair and put on a tie.[13]

When people talk to me about their memories of their family photographs, they often go into great detail about snapshots they can no longer find. Some question if these photographs ever really existed. The *Collected Visions* archive allows visitors to find images that evoke memories of their own family events that were never photographed. Memories associated with these "lost" images are often more vivid than the ones in the family photo albums. Perhaps this explains part of the lure of writing about the images of others.

As exhibitions in the gallery change, the essays are archived in the *Museum*. Much like departments in a traditional museum, the *CV Museum* is divided into sections (illus. 6). These include: "childhood memories," "family folklore," "family secrets," "beyond description," and "fantasies." *Will She Get Better?* and *Are You My Mother?* for example, can be found under "family folklore," *She looks like I did then* under "childhood memories," and *I hate the Holidays* under "family secrets." Like the rest of the site, this structure can be adapted when the need arises.

Interspersed throughout the site are rotating quotations about photographs and memory drawn from the wealth of writing about family photographs. For example, as you enter the gallery you might come across Calvin and Hobbes's dialogue about photography, a quotation from Susan Sontag ("A family's photograph album is generally about the extended family—and often, is all that remains of it"[14]), or one from bell hooks ("Although my sisters and I look at this snapshot and see the same man, we do not see him in the same way. Our 'reading' and experience of this image is shaped by our relationship to him, the world of childhood and the images that make our life what it is now"[15]). If you choose a combination in your search query that produces no photographs, the following quotation from Annette Kuhn appears: "What happens, then, if we take absences, silences, as evidence?"[16] The sources for the quotations are referenced in the extensive bibliography in the *resources* section. The quotations

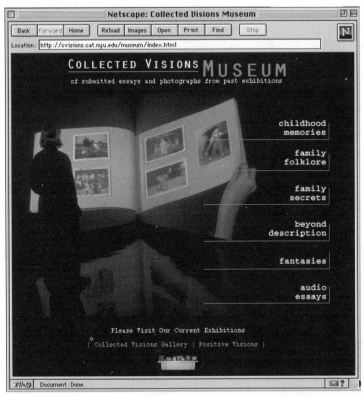

6. *Collected Visions Museum* web page; the hand turning the page of the photo album is an excerpt from the slide installation *Traces*. Design by Lorie Novak and Betsey Kershaw.

are used in a manner similar to the overlay of open books in *Collected Visions I* —to raise questions about how we think about family photographs in particular and photography and representation in general.

Realizing this complex project in this new medium has been extremely stimulating as well as frustrating. The nonlinear quality of the Web and the ways pages can be linked together is unlike any installation or exhibition I have ever designed. The ability to continually change and expand the site is exciting but time-consuming. With continual technological advances, there is always the lure of improving the site. As a visual artist, I am used to determining exactly how my work looks. On the Web, appearances change depending on how many colors a monitor can support, the power and speed of the computer, the type of Web browser, etc.

In conjunction with the website, I am exploring the possibilities of a large-scale projected video installation using digital video-editing software to combine the collected snapshots and audio recollections. The fluid and ephemeral

nature of projected video, the juxtaposition of images, and the overlapping of spoken words and music will work together to create an experience that conveys the emotional and psychological power of memory. Here, unlike the website, I can have complete artistic control. Again, I am collaborating with Elizabeth Brown and Clilly Castiglia to create the audio component. Clilly Castiglia and I have been recording children and adults speaking about their memorable snapshots and the power these images hold for them, and lamenting unphotographed events from their past. We have already used fragments of these recordings to create audio essays and QuickTime movies on the website. With these stories, we are creating an audio component that not only explores the power of family photographs but also examines the truths and fictions behind them.

After experiencing the installation, viewers will be able to explore the website at a computer kiosk. An attached scanner will allow visitors to contribute images to the website and to future sequences of the installation. I envision computer kiosks containing the website and a scanner installed not only at museums but at public venues such as libraries, historical societies, and shopping centers. At some sites, a recording station will be set up to collect audio recollections. I feel it is crucial to expand the audience for *Collected Visions* beyond those people who have access to computers, scanners, and the Web, in order to have a real dialogue about the power of family photographs. To encourage diversity, I am inviting others to organize exhibitions for the *Collected Visions Gallery* that are culturally, historically, or regionally specific.

Collected Visions is now in its second year. The eighth exhibition of essays debuted January 1, 1998, and over one hundred essays are posted throughout the site. In 1997, three thousand to five thousand people visited each month. There is much more "surfing," however, than real participation. At this point, the number of essays submitted range from three to twenty a month. This ratio of passive to active participation is frustrating—it is not the global discussion about family photographs I envisioned. The view of a World Wide Web fostering interactive dialogues may be a myth, in keeping with the older myth of the connected family. I also question what the effect is of viewing all these snapshots out of context on a computer screen. I hope that the numbers and variety of photographs in the archive, the database information, and the site's interactive component will work together to provide context for the photographs and information about the different roles family photographs play in our lives.

Collected Visions will remain on the Web through the turn of the century, giving it time to grow and become more inclusive. I see it as a fitting millennium project. The still photograph has been the dominant pictorial document of this century and most likely will not be of the next. In all likelihood, as the family photograph is replaced by new forms of record keeping, it will be even

more romanticized than it is today. The accumulation of stories on *Collected Visions* will confront this romanticism and help to penetrate the narrow view of the family that so many snapshots suggest. With submissions via the Web and computer kiosks over a five-year period, *Collected Visions* and its archive will serve as a testimony to the multiple visions of how we view snapshots and family photographs at this time in history.

NOTES

My thanks to the Rockefeller Foundation for the time to reflect and develop this essay during a residency at The Bellagio Study and Conference Center in April 1997.

1. Patricia Holland, "History, Memory, and the Family Album," in *Family Snaps: The Meanings of Domestic Photography*, ed. Jo Spence and Patricia Holland (London: Virago, 1991), 1.

2. Simon Watney, "Ordinary Boys," in *Family Snaps*, 30.

3. I use the terms "snapshot" and "family photograph" loosely. I am interested in images that are either posed or candid, and that define an individual both within and separate from the family. Family to me includes all loved ones—friends as well as pets.

4. *Critical Distance* was commissioned by Independent Curators Inc. for the traveling exhibition *The Presence of Absence: New Installations*, 1989–93, curated by Nina Felshin.

5. *Traces* was commissioned by the University Art Museum at California State University, Long Beach, and exhibited there as *Centric 42*, January through March, 1991, and at the Museum of Contemporary Art in Chicago, Illinois, as *Options 43*, December 1991 through January 1992. Brochures with an essay by Diana duPont were published in conjunction with both exhibitions.

6. *Playback* was commissioned by The Southeast Museum of Photography in Daytona Beach, Florida, for the traveling exhibition *Betrayal of Means/Means of Betrayal*, accompanied by an exhibition catalogue with an essay by curator Janie Cohen.

7. *Collected Visions I* was commissioned by the Houston Center for Photography in Houston, Texas, and exhibited there in May 1993. A revised version was shown in the exhibition *Imagining Families: Images and Voices* at the National African American Museum Project at the Smithsonian Institution in Washington, D.C., August 1994 through February 1995.

8. Excerpt from Elizabeth Brown's artist statement in the exhibition catalogue *Imagining Families: Images and Voices* (Smithsonian Institution, 1994), 42.

9. *Positive Visions* links to the *Day Without Art* website (http://www.creativetime.org/dwa) which contains an extensive list of links to HIV/AIDS resources all over the world.

10. The section of the site where essays are submitted is secure, accessible only by password.

11. The two women in the photograph are actually my own sisters Karen and Patricia.

12. Although I know which writers submitted stories about their own images and which have not, the author's relationship to the photographs is not disclosed.

13. An excerpt from a Calvin and Hobbes cartoon by Bill Watterson in *The Days Are Just Packed: A Calvin and Hobbes Collection* (Kansas City: Andrews and McMeel, A Universal Press Syndicate Co., 1993), 148.

14. Susan Sontag, *On Photography* (New York: Dell Publishing, 1977), 9.

15. bell hooks, "In Our Glory," in *Picturing Us: African American Identity in Photography*, ed. Deborah Willis (New York: The New Press, 1994), 44.

16. Annette Kuhn, *Family Secrets: Acts of Memory and Imagination* (London: New York: Verso, 1995), 13.

 Nazism in the Family Album:
Christian Boltanski's *Sans Souci*

ERNST VAN ALPHEN

In his installations, photographs, and other works, the French artist Christian Boltanski adopts and explores the rules of representation formulated by many Holocaust commentators. He consistently uses modes of representation that most promise to provide an objective, truthful account of past reality. His installations consist of vitrines, collections of photographic portraits, archives, and inventories. All these genres are privileged within the historical paradigm; they seem to embody the possibility of reconstructing the past, of making the past present solemnly and seriously. However, Boltanski's consistent use of these historical genres reveals something else.

His acts of reconstruction and making the past present hit us with the awareness that what is being reconstructed is lost, that what we see is based on lies, or that we don't see anything new, or unknown, but that we can only recognize what we already know in the reconstructions of an alien past. All three effects undermine our expectations of historical modes of representation. In this paper I will focus on Boltanski's use of one particular mode of representation, the photographic family portrait. His book *Sans Souci* will be central in this analysis. In this book, found snapshots of several Nazi families have been reproduced. Although the represented people probably did not know each other, the book presents itself as a traditional photo album of one family. As in "real" photo albums, semitransparent sheets are inserted between the pages (illus. 1).

Photographs in this chapter are reproduced with permission from Christian Boltanski, *Sans Souci* (Frankfurt am Main: Portikus/Köln, Walter König, 1991).

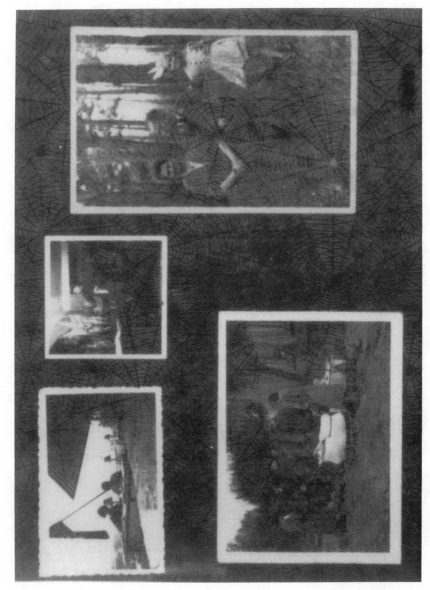

1. Christian Boltanski, page from *Sans Souci* (Frankfurt am Main: Portikus/Köln, Walter König, 1991). Courtesy Marian Goodman Gallery, New York.

Boltanski's explorations of the family album in *Sans Souci* cannot be seen apart from his other explorations of the photographic portrait. In different ways they all amount to a reconsideration of the cultural and historical functions that we bestow on family portraits. So before I discuss the more specific issue of family portraits and Boltanski's disenchanting use of the genre, I will dwell on the more general issue of the portrait.[1]

But Boltanski's work not only challenges traditional notions of family portraiture, it also forces us to reconsider the absolute authority of historical modes of representation in the ways we commemorate the Holocaust. Boltanski reaches an uncanny conclusion by suggesting that the photographic portrait is not primarily a remedy against the massive loss of the Holocaust, a way of making present those who were killed, but that it is also a reenactment of the Holocaust. When he foregrounds the photographic portrait as a technical apparatus that mechanically transforms subjects into objects, presence into absence, or as an apparatus that can only produce lies, then we must conclude that this mode fails in re-presenting the Holocaust. Instead, it uncannily upholds principles that defined the Holocaust.

The pictorial genre of the portrait, whether painterly or photographic, doubly epitomizes the cornerstone of bourgeois Western culture. The uniqueness of the individual and his accomplishments are central in that culture. And in the portrait, originality comes in twice. The portrait is highly esteemed as a genre because, according to the standard view, in a successful portrait the viewer is confronted not only with the "original," "unique" subjectivity of the portrayer, but also with that of a portrayed.

The genre of the portrait depends heavily on specific notions of the human subject and of the practice of representation. As for the represented object, it implies, for instance, that subjectivity can be equated with notions like "self," "personality," or "individuality." The portrayed person's subjectivity is then defined in its uniqueness and originality, rather than in its social connections; it is seen as his or her interior essence or presence, rather than as a moment of short duration in a differential process. The subject's continuity or discontinuity with others is denied in order to present the subject as personality. One may ask if this view does justice even to the traditional practitioner of the genre.

As for the representation itself, the kind of notion we get from this view of the characteristics of the portrait is equally specific. It implies that the portrait *refers* to a human being who is (was) present outside the portrait. A recent book on portraiture makes this notion of the portrait explicit on its first page: "Fundamental to portraits as a distinct genre in the vast repertoire of artistic representation is the necessity of expressing this intended relationship between the portrait image and the human original."[2]

The artistic portrait differs, however, from the photographic portrait as used in legal and medical institutions, by doing slightly more than just referring to somebody. It is more than documentation.[3] The portrayer proves her/his originality and artistic power by *consolidating* the "self" of the portrayed. Although the portrait refers to an original self already present, this self needs its portrayal in order to increase its own being. The portrayer has enriched the interiority of the portrayed's "self" by bestowing exterior form to it. For, without outer form the uniqueness of the subject's essence could be doubted. The artistic portrayer proves her/his own uniqueness by providing this proof.

By consolidating the self, portraiture gives authority not only to the portrayed self, but also to the mimetic conception of artistic representation which enables that increase in authority. Since no pictorial genre depends as much on mimetic referentiality as the traditional portrait, portraiture becomes the emblem of that concept. The German philosopher Hans-Georg Gadamer is a clear spokesman for this exemplary status of the portrait:

> The portrait is only an intensified form of the general nature of a picture. Every picture is an increase of being and is essentially determined as representation, as coming-to-presentation. In the special case of the portrait this representation acquires a personal significance, in that here an individual is presented in a representative way. For this means that the man represented represents himself in his portrait and is represented by his portrait. The portrait is not only a picture and certainly not only a copy, it belongs to the present or to the present memory of the man represented. This is its real nature. To this extent the portrait is a special case of the general ontological value assigned to the picture as such. What comes into being in it is not already contained in what his acquaintances see in the sitter.[4]

In the portrait, Gadamer claims, an individual is represented not as idealized, nor in an incidental moment, but in "the essential quality of his true appearance."

This description of the portrait as exemplum of the (artistic) picture shows the contradictory nature of mimetic representation. It shows how the traditional notion of the portrait depends on the rhetorical strategy of mimesis, that is, of a strategy of make-believe.[5] Let us read Gadamer's argument in more detail. In the portrait, more than in any other kind of picture, an "increase of being" comes about. This increase of being turns out to be the essential quality of the true appearance of the sitter. The portrait refers to this sitter who exists outside the work. Since the sitter exists outside the work, we may assume that her/his essence also exists outside the work.[6]

This implies that the portrait brings with it two referents. The first is the portrayed as body, as profile, as material form. The second is the essential quality of

the sitter, her or his unique authenticity.[7] Within the traditional notion of the portrait, it is almost a truism to say that the strength of a portrait is being judged in relation to this essential quality, not just in relation to the looks or appearance of a person. This explains, for instance, the possibility of negative judgments of photographic portraits. Although a camera captures the material reality of a person automatically and maximally, the photographer has as many problems in capturing a sitter's "essence" as a painter does. The camera is not, as one might assume, the traditional portrayer's ideal tool, because the essential quality of the sitter can only be caught by the artist, not by the camera.

But in Gadamer's text we don't read about an essential quality which has been captured. The essential quality of the sitter is the increase of being, that is *produced* by the portrayer in the portrait: "What comes into being in it is not already contained in what his acquaintances see in the sitter."[8] The portrayer makes visible the inner essence of the sitter and this visualizing act is creative and productive. It is more than a passive rendering or capturing of what was already there, although interior and hence invisible. The portrayer gives this interiority an outer form so that we viewers can see it. This outer form is then the signifier of the signified, of the sitter's inner essence.

What to do with the surplus of the increase of being? Gadamer *makes us believe* that what comes into being in the portrait is the same as the referent or origin of the painting. Semiotically speaking, he presumes *a unity* between signifier and signified, between increase in being and the essential quality of the sitter. By presuming that unity he denies that the increase of being is a surplus. By doing that Gadamer exemplifies the semiotic economy of mimetic representation. This economy involves a straightforward relationship between signifier and signified.

This identity between signifier and signified is not inevitable. Andrew Benjamin historicizes the kind of semiotic conception, which also underlies Gadamer's view, in the following terms:

> The signifier can be viewed as representing the signified. Their unity is then the sign. The possibility of unity is based on the assumed essential homogeneity of the signified. The sign in its unity must represent the singularity of the signified. It is thus that authenticity is interpolated into the relationship between the elements of the sign. Even though the signifier and the signified can never be the same, there is, none the less, a boundary which transgressed would render the relationship unauthentic. (62)

Most surprisingly in this argument, Benjamin attributes authenticity neither to the signifier nor to the signified, but to the special relationship between the two. In the case of the portrait, this semiotic economy implies that the qualifications "authenticity," "uniqueness," or "originality" do not belong to the

portrayed subject or to the portrait or portrayer, but to the mode of representation that makes us believe that signifier and signified form a unity. In connection with the issue of authority, this entails a socially embedded conception: the bourgeois self depends on a specific mode of representation for its authenticity.

The link between a mimetic rhetoric and the production of authority can be illustrated with the example of Rembrandt. We think we know the face of the self-portraitist Rembrandt, even though other painters have presented a face of Rembrandt quite different from his self-portrait, just because we adopt the mimetic way of reading when we look at Rembrandt self-portraits.[9] Perhaps Lievens's or Flinck's Rembrandts are closer to what the artist "really" looked like, but how can we mistrust such a great artist to tell us the truth about himself?

Now my earlier remark that the portrait embodies a dual project, becomes clearer, because more specific: the portrait gives authority to the portrayed subject as well as to mimetic representation. The illusion of the presence and authenticity of the portrayed subject presupposes, however, belief in the unity of signifier and signified. As soon as this unity is challenged, the homogeneity and the authenticity of the portrayed subject falls apart.

This is exactly what happens in Boltanski's works with portraits. He mercilessly challenges the unity between the photographic signifier and its signified. He does that by focusing on the idea of reference, the presumed fundamental premise of the portrait genre as well as of photography. In his works referentiality has become an object of intense scrutiny. Boltanski is very outspoken in his desire to "capture reality." Many of his works consist of rephotographed "found" snapshots. The "capturing of reality" happens twice in these works, not only by using found, captured images, but also by photographing them, which doubles the gesture of capturing.

He incorporates these photographs in larger installations. In his *The 62 Members of the Mickey Mouse Club* (1972), for instance, he presents rephotographed pictures of children which he had collected when he was eleven years old (illus. 2). The original photos were pictured in the children's magazine *Mickey Mouse Club*. The children had sent in a picture that best represented them. We see them smiling, well-groomed, or with their favorite toy or animal. Seventeen years after he collected the pictures, watching them, Boltanski is confronted with the incapacity of these images to refer: "Today they must all be about my age, but I can't learn what has become of them. The picture that remains of them does not correspond any more with reality, and all these children's faces have disappeared."[10] Because of the passing of time and the fact that the portrayed people have aged, the photographs no longer correspond to an existing reality. That is why these portraits signify not "presence," but exactly the opposite: absence. If there were "interiority" or "essence" in a photographic portrait, as traditional beliefs about photography as well as about

portraiture would have it, these photographs should still enable Boltanski to get in touch with the represented children. But they don't. They evoke only absence.

In some of his later works Boltanski intensifies this effect of absence by enlarging the photos so much that most details disappear. The eyes, noses, and mouths become dark holes, the faces white sheets. These blow-ups produce what I would like to call a "Holocaust effect." They remind us of pictures of survivors of the Holocaust just after they were released. In these works Boltanski refers to the Holocaust not merely by choosing images of Jewish children, as he did for his *Chases High School* (illus. 3) and *Monuments* (illus. 4). It is not evoked by means of reference. It is produced as an effect, *tout court*.

The importance and possibilities of dealing with the Holocaust in a nonreferential or historical way is provocatively addressed by Boltanski in his work *The Dead Swiss* (1990). For this work he cut out illustrated obituaries from a Swiss newspaper. The photographs of the recently deceased were usually snapshots or studio portraits taken in order to commemorate events such as a wedding or a graduation. Just as in his other works in which he used photographs, Boltanski here reshot the already grainy images, enlarging them slightly beyond life size. The near life-size portraits, as well as his decision to present portraits of Swiss instead of Jews, was intended to evoke normality. These portraits did not refer to humans who were victimized in an unimaginable way, nor did they refer to the absoluteness or overwhelming power of death. Boltanski said of this work, "Before, I did pieces with dead Jews but "dead" and "Jew" go too well together. There is nothing more normal than the Swiss. There is no reason for them to die, so they are more terrifying in a way. They are us."[11] Boltanski has done everything to make identification and correspondence possible between the living spectators and the images of dead Swiss represented, however, as alive. The images are life-size and they connote life instead of death. Nevertheless, two features of this work make the Holocaust effect unavoidable. The sheer number of similar portraits evoke the dehumanization of the Holocaust. While the portrait as genre evokes the idea of individual identity, the multiplication of portraits transforms the idea of individuality into anonymity. It is precisely this transformation that happens while looking at the work. Therefore, the work can be seen as a reenactment of one of the principles that defines the Holocaust: the mechanical transformation of subjects into objects.

Seeing the first image, one is able to activate the traditional beliefs in the capacities of portraiture; one is in touch with the presence of a unique individual being. Seeing more of them, all similar, or ultimately, all the same, one realizes that the opposite effect has taken over. The sameness of all the faces is enforced by the fact that the photographs have been enlarged: individual features disappear in that process. One is confronted with the absence of the presence of unique human beings. One sees a collection of interchangeable objects. This transformation in one's experience as a spectator reenacts the

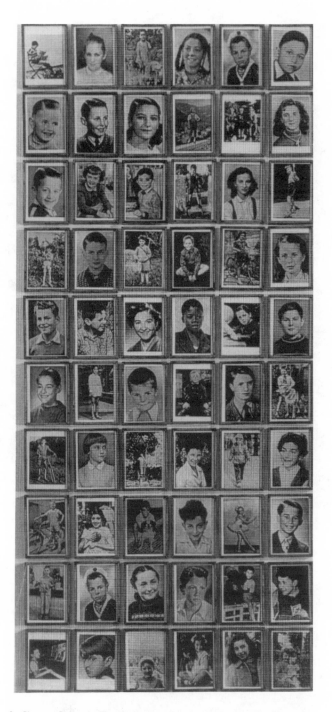

2. Christian Boltanski, *The 62 Members of the Mickey Mouse Club*, 1972. Ydessa Hendeles, Toronto. Courtesy Marian Goodman Gallery, New York.

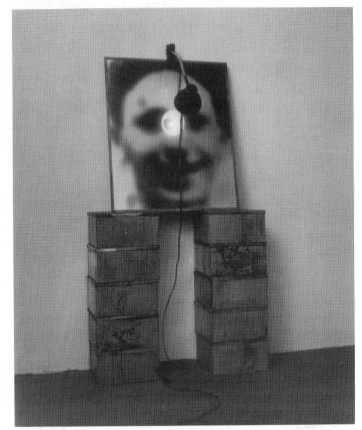

3. Christian Boltanski, *Chases High School*, detail, 1988. Courtesy Marian Goodman Gallery, New York.

Holocaust. This reenactment is an *effect*, not a representation; it *does* something instead of showing it.

The Holocaust effect undercuts two elements of the standard view of the portrait. By representing these people as (almost) dead, Boltanski hits us with the feeling of massive loss and absence. By producing the awareness of the absence of the people whose representation we can still see in the photographs, he foregrounds the idea that the photographs have no referent. And by representing these human beings in the "Nazi mode," that is, without any individual features, he undermines the idea of the "presence" in the portrait of an individual. All the portraits are interchangeable; the portrayed have become anonymous. They all evoke absence, absence of a referent outside the image, as well as absence of "presence" in the image.

About his *Monuments* (1986), for which he used a photograph of himself and of seventeen classmates, Boltanski says the following:

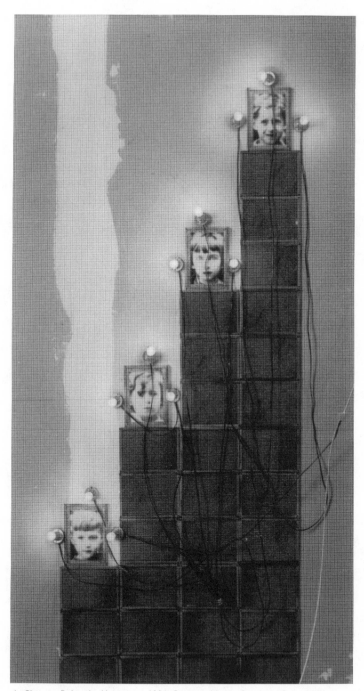

4. Christian Boltanski, *Monuments*, 1986. Courtesy Marian Goodman Gallery, New

Of all these children, among whom I found myself, one of whom was probably the girl I loved, I don't remember any of their names, I don't remember anything more than the faces on the photograph. It could be said that they disappeared from my memory, that this period of time was dead. Because now these children must be adults, about whom I know nothing. This is why I felt the need to pay homage to these "dead," who in this image, all look more or less the same, like cadavers.[12]

The photographs don't help him to bring back the memories of his classmates. He calls his classmates "cadavers," because the portraits of them are dead. The portraits are dead because they don't provide presence or reference. He only remembers that which the picture offers in its plain materiality as a signifier: faces. He clearly denies any "increase of being."

The dead portraits are in tension with another important element of his installations. These are often framed as monuments, as memorials, as altars or as shrines (*Monuments* [1985], *Monument* [1986], *Monuments: The Children of Dijon* [1986], *Monument (Odessa)* [1991], *The Dead Swiss* [1991]). The portraits are in many cases lit by naked bulbs as if to represent candles, to emphasize the work's status as memorial or shrine. The framings make the intention of the installation explicit: these works want to remember, to memorialize, or to keep in touch with the subjects portrayed. The photographs, however, are in conflict with this stated intention; they are not able to make the portrayed subject present. They evoke absence. That is why the memorials are memorials not so much of a dead person, or even of a past phase of somebody's life, but of a dead pictorial genre. The photographic portrait is memorialized in its failure to fulfil its traditional promises.

Boltanski has also made works with photographs that seem to make a slightly different point about the genre of the photographic portrait; as a consequence, the Holocaust effect is evoked on the basis of a different mechanism there. For the works *The Archives: Détective* (1987) and *Réserve: Détective* (1988), he used images from the French tabloid *Détective*. This journal reproduces photographs of murderers and their victims. In *The Archives*, he used the images rephotographed and enlarged; for *Réserve*, he used the newspaper images themselves. He taped the clippings onto the front of cardboard cartons on which a random date from 1972 was also written. The cartons were stacked on crudely constructed wooden shelves. It was intimated that the cartons contained documents concerning the individuals whose images were taped to the outside.

But since one was not supposed to open the cartons, it was impossible to relate the documents to the images. And as is often the case in Boltanski's work, this work is not a "real" archive, but only has an archival effect. In reality the boxes contained only unrelated newspaper stories. But let us take its effect seriously. Separating image from text makes it impossible to distinguish the

murderers from the murdered. We see only smiling individuals. It is not pos-
sible to recognize criminal personalities in the portraits. Another part of the
same installation foregrounded even more explicitly the failure to distinguish
the criminal personality from its victims. The installation consisted not only of
four wooden shelves with the cardboard boxes, but also of twelve framed col-
lages of the photographs with clamp-on lamps. These lamps created the con-
notation of interrogation and scrutiny. The portraits were being interrogated as
if they had to reveal their truth—but again without success. We don't see the
difference between murderer and murdered. This is a disturbing statement
about portraiture as well as about photography: neither genre nor medium is
able to provide the presence of someone's subjectivity. Genre and medium
have turned the subjects into objects. The only things we see are faces.

Boltanski reaches a similar effect in some works for which he used the
snapshots from German family photo albums he found at a flea market. Critic
Lynn Gumpert, in *Christian Boltanski*, says the following about these family
albums:

> Like the snapshots of the *Family D.*, these albums documented the
> lives of ordinary people during extraordinary times. Among the ritual-
> ized shots of birthdays and anniversaries were uniformed Nazi sol-
> diers—smiling and holding babies, happy, it seems, to have a respite
> from their duties. (143)

Boltanski used the photographs in his work *Conversation Piece* (1991), but also
in his book *Sans Souci* (1991). As I already mentioned, in this book, found
snapshots of several Nazi families have been reproduced (illus. 5). The Nazi
soldiers in these photographs do not show any signs or symptoms of the ideol-
ogy and destruction they partake of. We see only affectionate friends, lovers,
husbands, and fathers. The intriguing and disturbing effect of *Sans Souci* is
caused by the fact that traditional meanings of the family photo album over-
rule the subjectivities that we expect to be represented *in* the snapshots.

The title of Boltanski's family album refers to the summer palace in Pots-
dam, not far from Berlin, designed by the Prussian king Frederick the Great.
Although the original plan of the resort was sketched by King Frederick him-
self, his court architect Knobelsdorff was responsible for the final designs. The
summer palace, one of the major monuments of eighteenth-century European
architecture, has often been praised for its human scale; it is neither too mon-
umental nor too large to be comprehended at once. It is charming because it
has about it a sense of intimacy and comfort.

Boltanski's family album evokes exactly this aspect of intimacy and com-
fort. We see Nazi soldiers back from the front, from their work in the camps,
or other affairs of national importance. They are in the intimacy of their family
or surrounded with close friends. The relaxed atmosphere that we associate

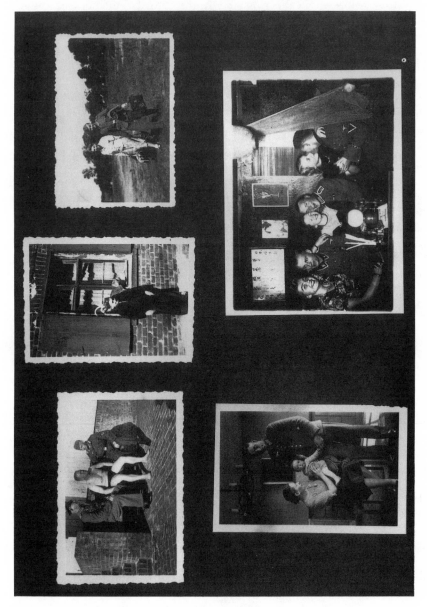

5. Christian Boltanski, page from *Sans Souci* (Frankfurt am Main: Portikus/Köln, Walter König, 1991). Courtesy Marian Goodman Gallery, New York.

6. Christian Boltanski, page from *Sans Souci* (Frankfurt am Main: Portikus/Köln, Walter König, 1991). Courtesy Marian Goodman Gallery, New York.

with summer resorts (like Sans Souci) can also be found in the middle-class environment of Nazi soldiers. We see the Nazis in the comfort of their retreat: with their families.

The concept of the "familial gaze," developed by Marianne Hirsch in her book *Family Frames: Narrative, Photography and Postmemory*, enables me to explain this "disappearance" or "neutralization" of Nazi subjects when they are portrayed as part of family portraits.[13] According to Hirsch, family portraits are images of a particular kind, eliciting specifically relational forms of reading. "Recognizing an image as *familial* elicits a specific kind of readerly or spectorial look, an *affiliative look* through which we are sutured into the image and through which we adopt the image into our own familial narrative."[14] This familial gazing can only be pursued to its full end when looking at an image of one's own family. Only in that case can the looker relate other images and information of family history to the image. But even when looking at family portraits of somebody else, the familial gaze is activated. We almost immediately assume the potentiality of a whole network of familial relations and an intertextual network of family pictures. The familial gaze, enacted by family portraits, projects familiality onto the portrayed subjects, but also draws the looker into this network of familiality.

What is fundamental to the familial look is that it constitutes subjectivity as the product of familial relations. This implies at the same time that it masks or misrecognizes individual, political, or social aspects of subjectivity, which are not seen as shaping and constituting the family as such. Through a superb reading of *The Family Album of Lucybelle Crater* of American photographer Ralph Eugene Meatyard, Hirsch shows how the familial gaze not only constitutes subjectivity, but is at the same time a misrecognition of it.[15] All of the characters in Meatyard's family photographs wear masks. According to Hirsch, Meatyard's pictures are an ironic comment on the conventions of family photography, foregrounding the conviction that "identity is no longer individual but defined by the mask of familial relation and of photographic convention." The familial portraits inscribe the portrayed subjects into conventional narratives. The masks are protective screens and disguises, hiding the individual faces and expressions.

This reading of the familial as a mask or protective screen strongly resonates with Boltanski's family album *Sans Souci* (illus. 6). Although Boltanski does not use masks in a literal sense, the conventions of the family portrait and album work as masks: they mask the fact that the fathers, lovers, and sons in Boltanski's images are also Nazi subjects. Of course we see them in their Nazi uniforms, but we "forget" what kind of world or personality is represented by these uniforms. We are drawn into the world of their families, not into the one of their politics, their ideologies, their occupations.

In her book on Boltanski, Gumpert reads the impossibility of recognizing the Nazi character or Nazi subjectivity in these pieces as Boltanski's lack of interest in ascribing blame to the Nazis. He is presumed to "underscore the

potential evil that resides in us all" (143). Boltanski's works, then, would make a general claim about humankind.

Gumpert's reading seems implausible to me because of its neglect of the mode of this artistic practice itself. For she ignores the fact that these works all consist of photographic portraits. She quotes a remark of Boltanski that allegedly illustrates his intentions behind works like *Conversation Piece* and *Sans Souci*. In 1987, when the trial of the infamous Nazi war criminal Klaus Barbie in Lyons was recorded in all the newspapers and on television, Boltanski said, "Barbie has the face of a Nobel Peace Prize winner. It would be easier if a terrible person had a terrible face."[16]

With this remark, however, Boltanski is not claiming that potential evil hides in us all. On the contrary, he labels one specific person, namely Klaus Barbie, as a terrible person. His remark broaches the problem that this terrible subjectivity cannot be recognized when we see this person as an image in newspapers, on television, or even when we see him in person. In the process of representing the terrible subject Barbie as an image, he is transformed into something else and he loses his terribleness.

In an interview with Delphine Renard, Boltanski gives an explanation for this transformation of a subjectivity into something else when a person is portrayed photographically. He provides this explanation in the context of discussing his photographic works in general, not merely those with images of murderers or Nazi soldiers. "In most of my photographic pieces," he says, "I have manipulated the quality of evidence that people assign to photography, in order to subvert it, or to show that photography lies—that what it conveys is not reality but a set of cultural codes."[17] In the case of *Sans Souci*, it is very clear which set of cultural codes blocks access to the subjects as Nazis. It is the family album as a traditional medium bound up in a fixed set of meanings. This implies that the snapshots that fill family albums do the opposite of capturing and representing the reality of a family. In Boltanski's own words: "I had become aware that in photography, and particularly in amateur photography, the photographer no longer attempts to capture reality: he attempts to reproduce a pre-existing and culturally imposed image."[18] Boltanski had foregrounded this aspect of amateur photography in a series of works from the mid-seventies. They consisted of color photographs with titles such as *Les Images modèles* and *Les Images stimulis*. Within the first series, for instance, he made a work together with his wife Annette Messager about honeymoon clichés. Instead of expressing personal visions, "honeymooners" usually replicate preexisting images. In *Les Images modèles*, Boltanski showed that the amateur photographer "generates copies of culturally-specified models, many of which are derived from art-historical precedents, such as sunlit landscapes or picnic outings seen in Impressionist paintings" (Gumpert, 60).

In *Les Images stimulis*, Boltanski showed not amateur-like, but professional looking photographs of everyday items, such as cookies, a plastic pistol, a con-

tainer of yoghurt. These items were always centred against dark background paper. With these objects, which belong to the life of all children, he aimed at triggering collective experiences, namely memories of childhood. In Boltanski's own words:

> I don't want viewers to discover; I want them to recognize. For me, a work is in part created by the people who look at it, who "read" it with the aid of their own experiences. I called one of my series *Stimulating Images* to suggest that what is being shown is only a stimulant: it permits each spectator to feel something different. In more general terms I would say that in life we always try to match what we see with what we know. If I show a photograph of the beach at Berck, one person will recognize it as the beach at Dinan, and another as the beach at Granville. (Quoted in Gumpert, 62)

Boltanski says, in fact, that we do not really look. We do not see anything *in* the image. The image produces, however, memories of situations or places which are similar to what we see in the image. We are not led into the image, we are led back into our memories.

Our inability to see anything that we do not also recognize explains the disappearance of the Nazi personality in the family album. We recognize only what we have in common with them. We see only familial circumstances.

The photographic portrait fails to fulfill its promises now in another way. According to traditional views, the photographic portrait captures the reality and truth of somebody's subjectivity; it makes the portrayed subject present. Most of Boltanski's photographic works confront their viewers, however, with absence instead of with presence; with objects instead of with subjects; with cadavers instead of with living human beings. But the photographic pieces with images of murderers or Nazi soldiers confront us not with absence, but rather with lies. With these works Boltanski makes the point not that Nazi soldiers were also loving husbands or fathers, but that we cannot capture the reality of the Nazi subject by means of the photographic medium. We end up with lies or our own projections when we try to do it that way.

By showing that photography is a medium of lies, Boltanski creates another Holocaust effect. This time he reenacts not Nazism's absolute dehumanization, but another aspect of Nazism which is also an intrinsic feature of the Holocaust. Boltanski confronts the viewers of his works with a mechanism that consistently produces deceit and lies. He stimulates viewers to activate the cultural codes of the family album, which projects false meanings, lies, on the portrayed subjects. By adopting these cultural codes, it is as if we, as viewers, are placed in the shoes of the Nazi soldiers who believed that they were decent citizens by doing what they were doing; the people who believed that *Arbeit macht frei*—the most famous Nazi lie.

NOTES

1. For a more elaborate theoretical investigation of the portrait, see my article, "The Portrait's Dispersal: Concepts of Representation and Subjectivity in Contemporary Portraiture," in *Portraiture: Facing the Subject*, ed. Joanna Woodall (Manchester: Manchester University Press, 1997), 239–56. A more extensive discussion of Boltanski's work in relation to discussions about Holocaust representation can be found in my book *Caught by History: Holocaust Effects in Contemporary Art, Literature and Theory* (Stanford: Stanford University Press, 1997).

2. Richard Brilliant, *Portraiture* (London: Reaktion Books; Cambridge: Harvard University Press, 1991), 7.

3. For the use of the photographic portrait in medical and legal institutions, see John Tagg, *The Burden of Representation: Essays on Photography and Histories* (Amherst: University of Massachusetts Press, 1988) and Allan Sekula, "The Body and the Archive," in *The Contest of Meaning. Critical Histories of Photography*, ed. Richard Bolton (Cambridge, Mass.: MIT Press, 1989). Sekula argues that the photographic portrait extends and degrades a traditional function of artistic portraiture, that of providing the ceremonial presentation of the bourgeois self. "Photography came to establish and delimit the terrain of the *other*, to define both the *generalized look*—the typology—and the *contingent instance* of deviance and social pathology" (345).

4. Hans-Georg Gadamer *Truth and Method* (New York: Continuum, 1975), 131.

5. See Kendall L. Walton, *Mimesis as Make-Believe* (Cambridge: Harvard University Press, 1993).

6. Brilliant sees the portrait as a transcendent entity: "Portraits concentrate memory images into a single, transcendent entity; they consolidate many possible, even legitimate, representations into one, a constant image that captures the consistency of the person, portrayed over time but in one time, the present, and potentially, forever" ("Portraits: A Recurrent Genre in World Art" in *Likeness and Beyond: Portraits from Africa and the World*, ed. Jean M. Borgatti and Richard Brilliant [New York: The Center for African Art, 1990], 13.) I contend that his transcendent entity, the result of the concentration of several images into one, is based on the same representational logic as Gadamer's "increase of being."

7. See Andrew Benjamin, "Betraying Faces: Lucian Freud's Self-Portraits" in *Art, Mimesis and the Avant-Garde* (London and New York: Routledge, 1991). Benjamin discusses the semantic economy of mimetic representation from a philosophical perspective. I follow here the main points of his argument.

8. Ibid., 132.

9. This example is mentioned by Svetlana Alpers in *Rembrandt's Enterprise: The Studio and the Market* (Chicago: University of Chicago Press, 1988). For a study of Rembrandt's self-portraits, see H. Perry Chapman, *Rembrandt's Self-Portraits* (Princeton, N.J.: Princeton University Press, 1990). A semiotic perspective on his self-portraits, related to psychoanalysis, is proposed by Bal in *Reading "Rembrandt": Beyond the Word-Image Opposition* (Cambridge: Cambridge University Press, 1991).

10. Boltanski, in *Monumente, eine fast zufällige Ausstellung von Denkmälern in der*

zeitgenössischen Kunst (Düsseldorf: Städtische Kunsthalle, 1973); quoted in Lynn Gumpert, *Christian Boltanski* (Paris: Flammarion, 1994).

11. Georgia Mash, "The White and the Black," 36. Quoted in Lynn Gumpert, *Christian Boltanski*, (Paris: Flammarion, 1994), 128.

12. Interview with Christian Boltanski by Démosthènes Davvetas, *New Art* 1 (October 1986), 20; quoted in Lynn Gumpert, *Christian Boltanski*.

13. Marianne Hirsch, *Family Frames: Narrative, Photography and Postmemory* (Cambridge: Harvard University Press, 1997).

14. Hirsch, "Masking the Subject," *in Family Frames*, 93.

15. Ralph Eugene Meatyard, *The Family Album of Lucybelle Crater* (New York: The Jargon Society; distributed by The Book Organization, Millerton, N.Y., 1974)

16. Boltanski, quoted in René van Praag, "Century '87, een expositie van 'ideetjes,'" *Het Vrije Volk*, Aug. 28, 1987.

17. Delphine Renard, "Interview with Christian Boltanski," 1984, quoted in Lynn Gumpert, *Christian Boltanski*, 176.

18. Delphine Renard, "Interview with Christian Boltanski," *Boltanski*, exhibition catalogue (Paris: Musée National d'Art Moderne, Centre Georges Pompidou, 1984), 7.

Putting Ourselves in the Picture:
Memoirs and Mourning

Nancy K. Miller

Whose story is it?

Like all autobiographers, authors and contemporary family memoirs draw their material from the chronicles of family life. But in reclaiming their personal history as they try to recapture the family past, memoir writers necessarily blur the lines between autobiography and biography, self and other, especially when a child tells the parent's story. In the century of the camera, this reconfiguration of a shared narrative often enlists images—snapshots from the family album—in order to retrieve a past that is ours but not ours alone. In family memoirs, the photographs are usually described in their absence, though pictures frequently appear on the book's cover, as if to remind the reader browsing in the nonfiction section that this is or *was* the real thing.[1] (In the case of famous authors, or famous parents of authors, photographs typically appear within the book as well, to satisfy a more general public curiosity about celebrities.)

The family memoir's auto/biographical photographs emerge also from another body of memory, a series of images attached to a visual narrative. In the twentieth century, family memoirs bear an eerie kinship to home movies, literally or metaphorically. We tend to remember our childhood generically as if it were a home movie—birthdays, summer vacations, snowstorms. Video versions of domestic pastoral. The art of the memoir, we could say, extending the metaphor, entails reediting the movie, putting pastoral up against history.

If we former kids star in these scenes from family life, we are no less framed by a parental, usual paternal, gaze. Whose story is it? If the memoir of a parent's death is always the story of at least two lives—told and telling—it is

also always the triumph of the child's view of the past. The child who looked at the camera now looks back at the person who held it. In a parallel reversal, the rapid frames are returned to stills—photographs arrested in their own time and space and then subjected to the art of interpretation. The process of scrutinizing the photograph to document a past that is at once personal and collective is a form of what Annette Kuhn in *Family Secrets* calls "memory work"—a rereading of the past through its recorded images, a practice of engagement with a cultural history committed to "unearthing and making public untold stories.[2] Recalled in the pages of the book, glossed in detail or simply alluded to, photographs of family members both memorialize the past and give new meaning to crucial configurations in the family plot. Like photographs, images from the movie—our storehouse of visual narrative memory—force us to confront at once the fixity of history and the inevitable fluidity of memory work that rewrites the past in the present tense. In life you can't freeze the frame with impunity—even when, as in the case of the memoirs I discuss here, you tell a story about death.

Patrimony is Philip Roth's narrative—he calls it a "true story"—of a father's dying and the legacy of that experience for the son who survives to tell the tale.[3] The meaning of patrimony is defined in a famous scene (the one reviewers unfailingly retained) where the son cleans up the mess after his father has an accident in the bathroom.

> You clean up your father's shit because it has to be cleaned up, but in the aftermath of cleaning it up, everything that's there to feel is felt as never before. It wasn't the first time that I'd understood this either: once you sidestep disgust and ignore nausea and plunge past those phobias that are fortified like taboos, there's an awful lot of life to cherish ... And *why* this was right and as it should be couldn't have been plainer to me, now that the job was done. So *that* was the patrimony. And not because cleaning it up was symbolic of something else but because it wasn't, because it was nothing less or more than the lived reality that it was. (175, 176)

Roth asks us to ground the idea of patrimony in this homely image of domestic care, but the photograph on the book's cover also invites us to consider more broadly the emotional logic of patrimony: those bonds that connect the generations, however ambivalently. Roth's memoir, like all autobiographical narratives, is a story of relation, and an act of *realization*. By realization I mean the act of trying to reimagine your parent as a person within the terms of your unchosen attachment. This conscious process is an adult reenactment of what Jessica Benjamin calls "mutual recognition," the earlier acknowledgment—largely unconscious—between a child and a parent that their identities are forged in relation. The family memoir reveals the ways this relation is revisited

over time, in a history of complex negotiation, especially when the history has been a troubled one.[4]

Family photographs, as Marianne Hirsch shows in *Family Frames* and Kuhn in *Family Secrets*, offer information about these degrees of attachment and separation that we measure according to readable social and visual codes. By taking the picture, parents consciously and unconsciously rehearse the drama of related identities. In a way the photo *is* the relation. Replaced in memoirs, the family picture supplements the written self; in the memoir, the photos, visible or invisible, lure the reader into thinking that now she really is *seeing* you, the autobiographical you that is sketched out on the page in words, the you attached by the camera to your other.

A framed photo of Herman Roth and his two sons posed in a row of descending size occupies the center of the cover. The snapshot separates the name Roth from the title of the memoir. The picture was taken in New Jersey on a family vacation. Herman looks directly into the camera ahead and smiles confidently. He stands smiling and erect behind his sons, his muscular arms hanging down straight at his sides. In front of him, Sandy, the older brother, arms akimbo, rests his hands protectively on the shoulders of his little brother; he smiles sweetly, head slightly tilted to one side. Low man on the totem pole, Philip, age four, arms at his sides like his father, looks out of the portrait, away from the camera, as though already tempted by another scene, mischief outside the frame of the picture. Roth reads the portrait from the bottom up: "The three of us rise upward to form a V, my two tiny sandals its pointed base, and the width of my father's solid shoulders . . . the letter's two impressive serifs . . . There we are, the male line, unimpaired and happy, ascending from nascency to maturity!" V for Victory, he adds, for Verticality (230). Symbolic masculine identity, or if we start the photo-reading a little higher up, above the sandals, from the tiny penis delineated in Philip's shorts to the paternal ideal, the father as rock. In the background, a female figure, a neighbor, perhaps, walks by the line-up of the Roth men, outside the focus of male bonds—an inquiring gaze caught by the shot. Is Mom taking the picture? In the memoir, as in the photo, we don't always know who puts whom in the picture—who reveals and who is revealed.

Sometimes the memoir seems one long caption to snapshots of a lost childhood. Toward the end of the memoir, just before Roth's father's death, the photo appears in the narrative and is given its meaning. Roth studies the family photo, a "fifty-two-year-old snapshot," that all three men had enlarged, framed, and displayed in their houses. He interprets the pose as a human chain that linked him as a child to his father in a show of masculine solidarity. Now an adult confronted with the signs of his father's irreversible physical collapse, Roth studies the photograph, as if this could revive the father of childhood, realign him with the dying man, immobilized on the sofa in his living room: "I could even believe (or make myself believe) that our lives only seemed to have filtered through time, that everything was actually happening

simultaneously, that I was as much back in Bradley with him towering over me as here in Elizabeth with him all but broken at my feet" (231). The photograph emphasizes the seductive force of the image over time; we can almost believe that the past is present. Almost. "Photography's relation to loss and death," Marianne Hirsch argues in *Family Frames*, entails bringing the past back like a ghost, but "emphasizing at the same time, its irreversible pastness"; the absent subjects present in the photographs will not return. The task for the writer of the memoir dealing with a dead or declining parent is to invoke the play of these two temporalities: what happened to the dashing father of my childhood? Vertical or horizontal Daddy? Old mother or "Maman darling"?

Why, Simone de Beauvoir asks as a middle-aged daughter, toward the end of her memoir, "Why did my mother's death shake me so deeply?"[5] There is no photograph on the cover of *A Very Easy Death*, Simone de Beauvoir's wrenching account of her mother's death from cancer, but a crucial analysis of the mother/daughter relation takes place through Beauvoir's reading of mother/daughter images. While Roth meditates on a single portrait of family connection, Beauvoir chooses not one photograph but two—embodiments of separateness and division to represent her ambivalent relation to her mother, past and present. And though Beauvoir's sister, like Roth's brother, figures significantly by counterpoint in the narrative, she does not appear at this moment of mother/daughter confusion; this is not the Beauvoir women, the female line, "unimpaired and happy," but Beauvoir and her mother, locked into generational unhappiness.

> The "Maman darling" of the days when I was ten can no longer be told from the inimical woman who oppressed my adolescence; I wept for both of them when I wept for my old mother. I thought I had made up my mind about our failure and accepted it; but its sadness comes back to my heart. There are photographs of both of us, taken at about the same time: I am eighteen, she is nearly forty. Today I could almost be her mother and the grandmother of that sad-eyed girl. I am so sorry for them—for me because I am so young and I understand nothing; for her because her future is closed and she has never understood anything. But I would not know how to advise them. It was not in my power to wipe out the unhappinesses in her childhood that condemned Maman to make me unhappy and to suffer in her turn for having done so. For if she embittered several years of my life, I certainly paid her back though I did not set out to do so. (103)

In a rare play on a possible maternal identity for herself, through the photographs Beauvoir reimagines herself as her mother's mother and her own grandmother. But this is not a happy solution: even in her fantasized wisdom, she is powerless to make the images speak to each other.

Is there a female equivalent to patrimony? Luce Irigaray stages the legacy in an imaginary dialogue between mother and daughter: "With your milk, mother, I swallowed ice," the daughter begins.[6] Nurturance, as Beauvoir might have said, does not come naturally. When Beauvoir looks back over her child-hood and adolescence, she sees disconnection and repudiation. Getting even, settling scores. If we were still making puns as we did in the old days of seven-ties feminism, I'd propose "(m)acrimony."

Roth longs to close the gap between his father and himself, and thus erase time; Beauvoir needs the distance of the gap to survive in the present. Beau-voir, whose writing has always reflected an absolute determination to see the truth (in this case her belief that family sentiment is based largely on ideolo-gies or repression) resists the lure of filial piety. Nonetheless, like Roth she is finally moved beyond the expectations of her history by the vision of her mother's broken and defeated body. "My despair escaped from my control: someone other than myself was weeping in me" (31). Who is this *someone other* lodged in herself? Faced with my mother's suffering, Beauvoir seems to be ask-ing, who am I? Roth wants to see his father as one (as in the sex that *is* one . . .) but Beauvoir's vision of her mother, not unlike her *Second Sex* analysis of woman in Western culture, is dual: cherished and reviled, sacred and repug-nant. Mother and daughter are caught in that dilemma.

The two photographs embody the divide that separates the two women, mother and daughter, but also splits each pair in two: the good mother and the bad, the dutiful daughter and the rebellious one. Their story is one of failed connections between generations of women. Even in the present tense of writ-ing, incomprehension remains. I would not know how to advise them. Two women who don't understand each other, who are destined as women to miss each other. Each one longs for the other's recognition. Each one withholds it because of her history, her childhood.

There's a color photograph that captures the state of the war between my mother and me in the mid-sixties. We are standing in the airport—Orly, I think, or maybe Heathrow. My parents have visited me in Europe where I've been living for several years despite their desire for me to return home. I'm saying good-bye to my mother, and, judging from the snarl that distorts my mouth, she is telling me something I don't want to hear. I'm standing in the light, wearing dark glasses, glamorously, I hope, and a scarf arranged in a kind of turban à la Beauvoir to keep my straight-ened hair from frizzing. My mother is silhouetted in the shadow. She is about the age I am today. Despite her superior bone structure, I can see on her face, then, the collapse along the jaw line I now read on mine; I am holding a gloved hand across my body, she is holding a purse against hers. In the photograph the two women are looking at each other across the divide of generations, each alone in her struggle. In the background of the space between them, a man in an orange jacket leans against the ticket counter. Staring straight ahead, he is waiting. For what, for whom?

My father likes this picture, which he had enlarged from a color slide and framed. It's a good picture, he says.

In photographs, mothers and daughters negotiate the right distance for their relationship whether they look at each other or not. This activity takes place on two separate fronts even if it is captured by a single camera. In Carolyn Steedman's *Landscape for a Good Woman: A Story of Two Lives*—a book about an English working-class childhood and also a critique of American feminist theory—the mother/daughter negotiation of boundaries inhabits the heart of this auto/biographical experiment.[7] Shortly before *Landscape for a Good Woman*, Steedman published an essay-length version of the memoir with that same title in a collection of personal histories called *Truth, Dare or Promise: Girls Growing up in the Fifties*.[8] For that version, Steedman provided, as did the other contributors, a snapshot from a fifties childhood. Steedman chose the picture of a little girl with a huge head of blond curly hair and a neatly ironed pinafore sitting outdoors on the grass next to her mother (illus. 1). Her mother is wearing a printed floral dress, a necklace that appears to be a string of pearls, and a two-toned, broad-brimmed straw hat. The fuzzy halo of the child's bright hair is echoed by the trees behind it, while the mother's face remains shadowed; the mother's hair appears dark against the light interior of the hat, patterned with rings like Saturn. Mother and daughter are seated on a picnic blanket and long shoots of grass grow tall around its edges. The caption states: "Post-war picnic, 1950, me and my mother" (107). The landscape reads like pastoral.

When I originally commented on this photograph, I described the mother and daughter as sitting on a "lawn" in summer (I guess it could be spring), the little girl playing with a doll on her lap. I concluded by saying, "At this level of detail (the photo is pretty much of a blur), class assignment is indecipherable." As it turned out, it was only indecipherable to me as an American viewer. When I presented these images at Warwick University (May 1997), Steedman, who is a member of the history faculty there, emended my reading. The "lawn," she explained with an edge of irritation, is not a lawn but Barnes Common, a public park in southwest London; she is playing not with a doll, but a cup made of Bakelite. These details of the photograph are clear in the actual photo, she insisted, and were essential to the picture's meaning for her. Steedman remarked, with a touch of humor, that in the picture she was cleaning the cup, thus proving that even from an early age she believed that one should do one's own housework. She also pointed out that her mother was reading a tabloid, an obvious class marker. Steedman assumed that by "lawn" I meant the grass in front of a private home, thus transforming her working-class reality through the lens of my middle-class assumption about the picnic site—and of the mother and daughter relation posed there. It looks to me now (or is it still?) as though the little girl is playing with a doll, perhaps cleaning the cup to

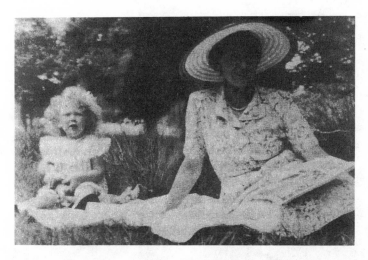

1. "Post-war picnic, 1950, me and my mother." From *Truth, Dare or Promise: Girls Growing up in the Fifties*, ed. Liz Heron (Boston: Little Brown, 1985/1992), p. 107. Courtesy Carolyn Steedman/Virago Press.

feed the doll. Whatever the interpretation, the photograph belies the violence between mother and daughter that informs and indeed structures the memoir. The mother and daughter seem at ease in each other's presence—though they are sitting at a distance from each other. The little girl looks into the camera with a slightly startled look; the mother looks off to the side with a smile. (According to the family chronology, the mother has not yet given birth to Steedman's baby sister. Possibly, she is pregnant.) Although the differences in our readings of this photograph can be explained in many ways—notably, around a problem of translation (the American usage of the word "lawn," which can mean a public or private stretch of grass), a family photograph is always going to have a particularly intense emotional investment for a family member, not to mention the subject. When as an outsider I interpret Steedman's childhood, I can't help importing meaning from my own—in identification (two little blond girls, a baby sister, a difficult mother) or in counterdistinction (national history, professional discipline, class allegiance).

When I was finishing the manuscript of my book on memoirs, *Bequest and Betrayal*, I decided to add pictures from my family album. While the question of the photograph in the memoir as genre had not been my central focus in the book, photographs are almost by definition a mediation between present and past emotion—the whole subject, of course, of *Camera Lucida*, and a central preoccupation of any autobiographical undertaking. Suddenly it seemed important to include photographs that would somehow embody more fully the autobiographical work that had driven the project from the beginning, a project about the boundaries between past and present time; the act of

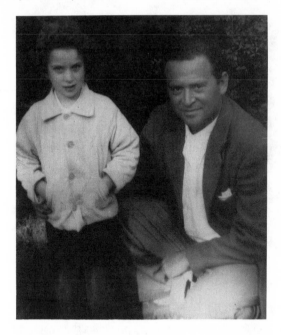

2. With my father, 1945.

remembrance inherent in the memoir treks back and forth over that shifting ground. Yes, I was analyzing the story of others, their lives, the death of their parents, their photographs, but my own narrative of loss shaped my reading as a literary critic. If metaphorically I had been putting myself in the picture all along, now I was putting my pictures in the book.[9]

Which pictures? My first impulse was to put just one picture of my father and me as a frontispiece to the entire book (there are now seven photographs, one at the beginning of each chapter). It was a photograph I loved, one of a very small number taken by a photographer who was not a family member, and it evoked my fondest idea of myself: Daddy's girl (illus. 2). In the picture, shot in Riverside Park, I am standing at age four with my hands in the pockets of my corduroy jacket, looking hesitantly at the camera, while my father, kneeling by my side, holds me protectively. He holds me to him under the pocket into which I've tucked my hands; and he assumes the pose of a confidently handsome man as he looks right into the camera. I've always loved this picture, both as a composition and as a print; entirely different in size and finish from the little glossy snapshots in the album, it fixes me for eternity alone with Daddy. This is the Daddy of my dreams, dressed elegantly in an immaculate white shirt, a white handkerchief in the jacket pocket. My father myself, my father to myself. There's a father/daughter picture very much in the spirit of my own on the cover of Kuhn's *Family Secrets* (the photo also reappears without comment, in the Acknowledgments section) (illus. 3). Little Annette is younger than I am in my Oedipal photo, and has been placed on a table so that

the father/daughter faces are almost aligned—you can follow the shared resemblance defined in the fold of their eyes. But the point that connects the photographs for me is the father's hand as it wraps around the child's arm to hold her. Like me, this little girl looks slightly skeptical about posing, dressed up as she is with a ribbon in her hair. Her father, Harry Kuhn, a photographer, whom she thanks for sharing his enthusiasm about photographs with her, looks skeptical too, though not, I think, about the child Annette he holds close at his side and protects with his touch. Who is taking this picture?

Friends reading the manuscript of *Bequest and Betrayal* protested about the exclusively paternal bond. What about your mother, they asked indignantly? Forced to acknowledge that this book was as much about losing my mother as it was about losing my father, I reluctantly went back to the albums for a picture of me with my mother. Although I could not have said then what it was that I was looking for, the photograph I finally chose (illus. 4), I now see, expresses something of our relation quite different from the struggle I portray in the book (as was true of Carolyn Steedman's picnic picture). In the snapshot I chose, I am seventeen and a half months old (it's written in my father's hand on the back of the photograph). August 15, 1942, and my mother is holding me in a children's pool at the Jersey shore, as I "swim."

I am held securely but at the same time I'm in motion—at least my pre-Oedipal self thinks I'm swimming, and so do I. My dark-haired mother, wearing a dress bathing suit that reveals her tan line and her cleavage, has me firmly in hand. She looks mildly amused (she has a slight smile) to be standing in the kiddy pool, but it's hard to read her expression since she is also wearing

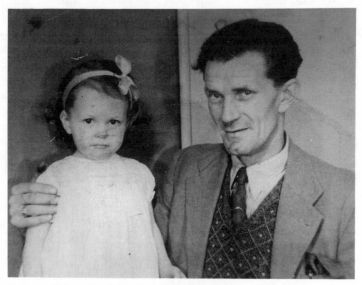

3. Annette Kuhn and her father, Harry Kuhn. Photo © Annette Kuhn.

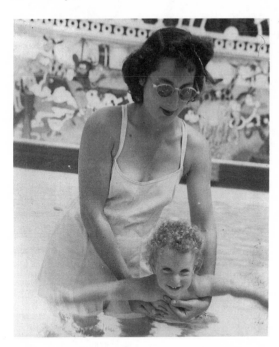

4. With my mother at the Jersey shore, summer 1942.

dark sunglasses. She is looking down at me; I'm gazing joyfully at the camera: Daddy, look at me! When I study this picture, I feel both happy and sad. Happy because this picture records a mother/daughter moment of connection and pleasure, sad because no matter how hard I try, I can't remember feeling this. Who is the mother I mourn? The old woman before my eyes in memory, or the glamorous young woman holding a tiny me? I don't remember that "me" and I do not remember this mother, the good mother, the "Maman darling" of childhood who Beauvoir briefly imagined had melded with the hostile woman of her adolescent and adult struggles. This picture is precious evidence of a tenderness that vanished, I tend to think, with the birth of my sister. Leafing through that version of the story, I hear my mother saying to herself as she performs her motherhood with me in the pool, "I'd rather be playing tennis." She had told us so many times how boring it was to be the mother of two little children, how she thought she was losing her mind, that I believed her. The little black-and-white picture tells me as well that despite my long history of denial, I had something to lose—Mommy!—and that I've never stopped trying to retrieve that watery bond. My father, I'm sure, would use the picture to remind me what a good mother I had. And maybe I did, even if it was he who put us together in his picture. Against a mural of cartoon animals, a woman shows that she is a "good mother"; and I can see now that the little girl knows this in her face and in the energy of her chubby little arms as they skim the water, splashing and making ripples. If we return to Beauvoir's reading of the two

photographs, we might note in passing the extent to which, in memoirs, the daughter's conscious recreation of the past relation with the mother often overlays the happier pre-Oedipal baby girlhood with an adolescent and adult anger. The visible photographs, seen in tension with the narrative, bring this dissonance out in subtle and poignant ways. (I write this passage in puzzlement fifty-five years to the day from the date on the back of the photograph.)

Both Carolyn Steedman and Adrienne Rich recount a palpable shift away from the mother's body and date it with the birth of their little sisters. In both cases we're dealing, as Steedman put it in a parenthetical (Freudian) aside, with "an old, conventional story, every eldest daughter's tale" (55). Sisters and fathers play out the familiar dramas of the Oedipal plot. "I don't remember," Rich writes in *Of Woman Born*, "when it was that my mother's feminine sensuousness, the reality of her body, began to give way for me to the charisma of my father's assertive mind and temperament; perhaps when my sister was just born, and he began teaching me to read."[10] Before the little sister arrived on the scene. Before the expulsion from Eden that came with a sister's birth.

"When I was three before my sister was born, I had this dream"—this is the sentence and the dream form which the life writing of Steedman's *Landscape* emerged in its original essay form (103). The dream is about women wanting things, in this case a New Look coat. The reconstruction of the dream provides the structure of the memoir, the memory of Steedman's mother complaining that the little girl and her sister were "two living barriers to twenty yards of cloth" (105). The children versus the New Look coat. It's only later that the daughter learns the name of the coat's fabric: gabardine. The language of my own childhood returns: gabardine, serge, melton. The fabrics of identity. Tailored mysteries.

My mother's father wanted to put the shtetl behind him. He believed in the education plot, the Jewish immigrant rise through the next generation: four children, the boys a lawyer and a doctor, the girls, schoolteachers. Grandpa, the story goes, was ambitious. Chamber music at home. Ballet lessons. All paid for out of the tailor's shop one flight up on West 35th Street. When these adult children were starting their own families in the late 1930s and early 1940s, Grandpa rented a large house on the Jersey shore. The three married but impecunious offspring summered together in rented splendor, subsidized by the earnings of the bachelor doctor son. The women looked after their new babies, the men commuted to the city. My father was a fledgling lawyer, operating on promise; my parents barely met the rent, they said. My mother worked for my uncle the doctor to make ends meet. And yet she has a black maid at home who cleans, cooks, and looked after me (there was a "maid's room" in the apartment) but my mother also returned bottles to the grocery store for the deposit, sewed her own clothes and shopped for bargains on 14th Street. I wore beautiful pinafores, and later coats made by my grandfather.

Home movies. The summer of 1941. The camera pans over beds of red tulips

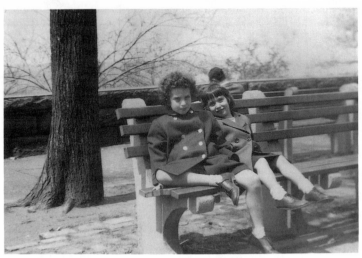

5. With my sister, Ronna, in Riverside Park, New York, 1948.

that border a huge white Victorian house. On the lawn of luxury, I receive,
according to the handwriting on the yellow Kodak box, a manicure from my
mother. I am six months old. Uncle Dave drives up in his convertible, with the
top down. He opens his doctor's bag. Say ah.

The summer of 1942. I'm a toddler with creases in my thighs. I'm the only girl,
with three boy cousins. My uncle rubs me against his face, waltzes me in the sun.
My grandparents fondle me. I am passed from one set of arms to another. I look
into the camera—my father's gaze—and I smile, trustingly. I splash around in
the water and pretend to swim. It's Kodak technicolor, my skin is the color of
Melba toast, my eyes are green, and, amazingly, I'm blond.

The summer of 1944. My sister Ronna and my cousin Carol have entered the
scene. My hair has turned brown. Paradise is lost. Have I not spent my entire life
trying to get back to that moment—the face of a little girl whose father and
mother loved her, only her? Whom did she love?

Here's a picture of my sister and me, the Kipnis girls, in 1948 when I'm
seven and she's four (illus. 5). It's winter in New York and we are sitting on a
bench in Riverside Park. The trees are bare and we look a little cold. We are
dressed in almost matching double-breasted coats made by my grandfather,
and beautiful bone buttons (if I could get close enough, I'd see handsewn but-
tonholes). We are both wearing brown oxfords and white ankle socks. My sis-
ter is flirting with the camera (Daddy), tilting her head toward my shoulder.
Seven-year-old Nancy is not happy to be in the picture. Her frown resembles
the scowl of her contemporary Bob Dylan (then Robert Allen Zimmerman).

This picture reminds me of the torment inflicted by my father when trying to make me smile: he sang Frank Sinatra's popular postwar melody for his daughter, "Nancy (with the Laughin' Face)"; he even bought the record.

When it came time to think about the cover of the book then called in my mind *Dead Parents*, my editor said that she would like to see a family photograph of the four of us. Looking through the albums, I was surprised to discover how few there were. I proposed one from childhood and one from adulthood. We agreed that the photograph in which my sister and I were in our twenties came closer to the family I describe than the more beautiful professionally posed image from the forties. The picture we chose was one where the four of us are standing in the front yard of a cottage in Provincetown (Cape Cod, Massachusetts) that my parents rented for over two decades until my mother's death. We both liked the feel of the sixties produced by the abbreviated hemlines of the dresses, especially since by the end of the sixties the family image was badly cracked, as were many others, by the strains of the social and sexual revolution.

Several weeks after our discussion of the cover, I received an image in the mail. There had been four people in the snapshot. The designers cropped off the heads of the family photo at the top of the cover and blew up three heads below. My face was missing from the picture. The book that at last had a title acceptable to marketing, *Bequest and Betrayal*, was designated as an edited collection, and my name was printed in lower case (another narcissistic wound). Stunned by the elimination of my head, I spent twenty-four hours trying to decide whether the elimination of my face, as well as the description of the book, was deliberate. After all, they had made one postmodern decision to decapitate the human subject, and through the invocation of movie frames—the contrast between what's sharp (the original photo) and what's blurry (the blown-up faces)—suggested the instability of memory work. Why not push the postmodern to the end and figure the death of the author? Maybe, but there was no way I was going to have my sister's face blown up between those of my mother and father as though *she* were the heroine of this story. This was my old nightmare of displacement brought back to life: my sister has pushed me out of the picture. It turned out, of course, that the designers, not having read the book, had eliminated the author, without thinking that to eliminate anyone from a photograph would have consequences. The fact that they had arrived at the home-movie effect was an accident. The cover was corrected but not before, through another error, bound galleys were sent out to reviewers, and several ads were placed describing my autobiographical project as an edited collection.

Putting yourself in the picture—or getting cropped out of it—is no laughing matter when family photographs are presented for public scrutiny.

In *Mein Kampf* (*My Struggle*), a recent autobiographical sequence included in this volume, where he portrays himself leafing through a family album, Art Spiegelman remarks with a slightly ironic edge: "Snapshots illuminate my past like flares in the darkness . . . Although often they only help me remember having seen the photos before!" (In *Maus* Spiegelman inserted three photographs into the drawn images. One shows the author's hand holding a snapshot of his mother, ten years before her suicide. This particular section of the memoir comes from an earlier period in Spiegelman's career, which he replaces in the *Maus* material as it was. The photograph is the trace of the living mother who has become the ghost haunting the narrative of the parents' story.) I had this very sensation of a literal déjà vu when I produced my own home movie. After emptying my parents' apartment, I found myself in possession of a large box of movies, all taken by my father. One weekend, I rented a projector and worked my way through the individual reels. In most cases, I had seen the movies before *en famille*, as we were growing up; this time I was seeing them from another angle of vision—alone in my darkened study after the death of my parents. I had the films, now arranged in chronological order, put on a single video, so that I could review them more easily, moving forward and backward in time. I quickly realized that the edited home movies were essential to my own memoir project because they allowed—or was it forced?—me to take another look at the family stories I remembered.[11] But what the moving images dramatized for the memoirs I was dealing with—those by other writers and my own—was the *temporal dissonance* of autobiographical images: seeing yourself in relation to those parents now dead and living in your head even as you write. ("Missing Parents" was another rejected book title.) Are these young people really your parents? Are your parents less dead because they are still present on the screen?

At a Thanksgiving dinner a few years ago, my aunt Evelyn, who has become famously forgetful, took me by surprise. "How are your parents?" she asked. Thinking I had not understood her question (I was dumbfounded), she added helpfully, "You know, Mollie and Lou." Mollie and Lou?! "Yes, I know," I replied, wondering whether to continue, "They're dead. Mollie died right after Al." (Al was my mother's brother.) "Oh, that's right," she agreed brightly, and then asked about my sister. For a moment, I confess, caught by the simplicity of my aunt's query, I wasn't sure myself. When *are* our parents dead?

Watching home movies was always, my mother used to complain, "such a production." Unearthing the ancient projector buried at the back of the closet, finding the screen, threading the film. The film would jam or break. Sighs. Groans. My father's fault. When the big white dots exploded on the screen indicating that the movie was over, my sister and I would run to the bathroom. Since each film lasted only a few minutes, and there was no way to freeze the frame, each moment

*was no more than the glimpse of a past already not remembered. ("Don't you re-
member the dollhouse Grandpa built for you, the swing?") No matter how long I
longed for my little princess past, I could not bring back the sensation of what it
meant to be blond in a family of dark-haired people, and to be at the center of so
much love.*

*The earliest home movies star me, true, but they also star Mommy, and soon
enough feature my adorable little sister, the gushy baby, I called her, as I kneaded
her delectable flesh. It's my life, yes, but I'm not alone. We're all in this together.
And Daddy's taking the pictures.*

I remember the scene of watching these movies far better than I can re-
member starring in them or revisiting the other actors in the family drama.
Like Spiegelman, I think that mostly we see ourselves seeing the movie—in
the past. But with luck and persistence, sometimes in the dark, through an act
of imagination we succeed in putting ourselves fleetingly back into the time of
the picture. The home movie, like the photograph, is always doomed to ambiv-
alent viewing: that past is and isn't gone, you do and don't look like you, your
parents are and aren't alive. I return to visit intermittently but I wouldn't want
to live there.

NOTES

My title is borrowed from the late photographer Jo Spence's *Putting Myself in the
Picture* (London: Camden Press, 1986).

1. This essay is indebted to Marianne Hirsch's pioneering work on the use of photo-
graphs in literary texts and in visual culture more generally: *Family Frames: Photogra-
phy, Narrative and Postmemory* (Cambridge: Harvard University Press, 1997). Hirsch
shares, as I do, Roland Barthes's somewhat surprising belief in reference—the famous
"this has been"—as the essential effect of photography.

2. Annette Kuhn, *Family Secrets: Acts of Memory and Imagination* (London and
New York: Verso, 1995), 8. Kuhn connects her notion of memory work to Carolyn
Steedman's autobiographical acts in her mother/daughter self-portrait, *Landscape for a
Good Woman: A Story of Two Lives* (London: Virago Press, 1985), and extends the defi-
nition through Steedman's words: "lives for which the interpretive devices of the cul-
ture don't quite work" (5).

3. Philip Roth, *Patrimony: A True Story* (New York: Simon and Schuster, 1991). In
the essay that follows, I have excerpted passages from my *Bequest and Betrayal: Memoirs
of a Parent's Death* (New York and Oxford: Oxford University Press, 1996) and integrated

them with new material about the autobiographical effects of photographs in memoirs. The book deals with the loss of a parent by writers in middle age.

4. Jessica Benjamin, *Like Subjects, Love Objects: Essays on Recognition and Sexual Difference* (New Haven and London: Yale University Press, 1995).

5. Simone de Beauvoir, *A Very Easy Death*, trans. Patrick O'Brian (New York: Pantheon, 1965), 102.

6. Luce Irigaray, "And the One Doesn't Stir Without the Other," trans. Hélène Wenzel, *Signs* 7, no. 1 (1981): 60–67.

7. Carolyn K. Steedman, *Landscape for a Good Woman: A Story of Two Lives* (New Brunswick: Rutgers University Press, 1987).

8. Carolyn K. Steedman, "Landscape for a Good Woman," in *Truth, Dare or Promise: Girls Growing up in the Fifties*, ed. Liz Heron (London: Virago, 1985, 1992).

9. I'd like to thank Susan Gubar for suggesting, with her characteristic tact and flair, that I include personal photographs within the book.

10. Adrienne Rich, *Of Woman Born: Motherhood as Experience and Institution* (New York: W. W. Norton, 1976; rpt. 1986), 219.

11. Often the snapshots in the family album seemed to have been taken at the same time as the movies. The most striking difference was less the movement of the images than the fact of color. All the photographs were in black and white, the movies were in color, surprisingly excellent, sharp color. Yes, my mother's hair was black, even, as she always insisted, blue-black. Yes, I was a cheerful little girl who loved the water.

Observations of a Mother

JANE GALLOP

PHOTOS BY DICK BLAU

Photography, according to Roland Barthes, can be considered from three possible points of view. First, of course, is the photographer's point of view. At the beginning of *Camera Lucida*, his book on photography, Barthes tells us that he "could not join the troupe of those (the majority) who deal with Photography-according-to-the-Photographer" because he does not take pictures.[1] While for many this would not in fact pose a major obstacle to adopting such a perspective, Barthes is committed to grounding his study in his own subjective experience. Thus he restricts himself to the two remaining standpoints: that of the person photographed and that of the person who looks at photos.

Barthes's next chapter, entitled "He Who Is Photographed," talks about how he feels when being photographed and when looking at pictures of himself. The following chapter, "The *Spectator*," turns to the third perspective. And the rest of the book, forty-two more chapters, never departs from that third perspective.

With this preponderance of "the spectator," the single chapter devoted to the photographed subject becomes no more than a fleeting memory. I want here to pick up the position *Camera Lucida* briefly assumes and then drops. If, according to Barthes, photography is most often treated from the photographer's point of view, almost all the rest of the writing on photography is surely from the perspective of what he calls the "spectator," whether the latter be art historian, critic, or amateur. Formal discourse on photography is rarely from the standpoint of the photographed subject. Although all three points of view are, for Barthes, subjective, there may be something about the

second point of view that is most troublingly personal, anecdotal, self-concerned. It may be the position from which it is most difficult to claim valid general insights. Perhaps that is why Barthes—who is, to be sure, darlingly subjective in this book—drops it like a hot potato.

Later, in the second half of the book, long after he is comfortably ensconced in his role as spectator, Barthes definitively if subjectively locates the essence of photography in one specific picture: "Something like an essence of the Photograph floated in this particular picture. I therefore decided to 'derive' all Photography from the only photograph which assuredly existed for me" (73). That singular photo is a picture of Barthes's mother. Given the exemplary status of this picture, we might say that in *Camera Lucida* the quintessential photographed subject is the mother.

Barthes would resist my last phrase—not "the mother," but rather "my mother," he would say. And he does say that quite emphatically in the text: "[nor] would I reduce my mother to the Mother . . . In the Mother, there was a radiant, irreducible core: my mother . . . To the Mother-as-Good, she had added that grace of being an individual soul" (74–75). If I don't here respect Barthes's otherwise quite moving insistence on his mother's singularity, it is because in examining the photographed subject in *Camera Lucida*, I am struck by its similarity to the position of the mother or, as Barthes would say, "the Mother."

Back in the only chapter where Barthes inhabits the position of "He Who Is Photographed," he writes: "the Photograph represents that very subtle moment when . . . I am neither subject nor object but a subject who feels he is becoming an object" (14). In the course of the book, "He Who Is Photographed" becomes "She Who Is Photographed"; the son flees this position and attaches it definitively to his mother. Upon rereading Barthes's description of the experience of being photographed, I notice that it might also describe the experience of being a mother ("I am a subject who feels she is becoming an object").

I want to pick up the perspective Barthes drops, to pick it up where he has dropped it, in the mother's lap. I want to pick it up as the mother's perspective, and try to inhabit it for a while. I'd like to write about photography from the standpoint of the photographed mother.

In *Camera Lucida*, that position is characteristically silent: not only is his mother dead at the time of the book's writing, but, he tells us, "during the whole of our life together, she never made a single 'observation'" (69). The mother is defined in this book precisely as never doing that which the author does—observe and comment. In fact, the very paragraph in which Barthes praises his mother for refraining from ever making "observations" begins with the words "I observed," to refer to what he saw when he looked at her in the photograph.[2] He observes; she does not; she is observed.

Barthes's mother, the subject of the quintessential photograph, makes no comment. Barthes himself begins to speak of his experience of being photographed and then changes the subject. If the position of the photographed

subject seems to lead to silence in this book, it is surely because it is a position where the subject feels himself becoming an object. Unlike a subject, an object does not speak. I can't help thinking that the experience of the subject's becoming an object fits all too well with the movement in the book by which "*He* Who Is Photographed" becomes "She," offering an example of the classic gendering of subject and object.

This classic gendering comes with the standard Freudian package. *Camera Lucida* has occasion to quote Freud on the Mother (40), and, although Barthes's use of psychoanalysis is typically delicate and unsystematic, the book still jibes with the usual psychoanalytic view of the family, in which the subject is the son and the object the mother. And so I find in *Camera Lucida* the predictable but nonetheless troubling scenario by which the man saves his subjectivity, his voice, by palming off the risk of becoming an object onto the mother.

Predictable is indeed the word for it: since I am both a psychoanalytic and a feminist critic, it is all too predictable that I should produce such a reading. If that were all there was to my reading of *Camera Lucida*, it would certainly not be worth doing here. Although I have been disrespectful in reducing his finely sketched mother to the Mother, I want to stop now and pay my respects to Barthes, to assume my debt to this book, and to reveal why I'm talking about it here, at the beginning of this essay.

My suggestion that Barthes abandons an uncomfortable position should be placed in the context of my admiration for *Camera Lucida*'s considerable daring, for its presumption that his subjective experience counts as knowledge for others. That he might shy away from one of the strands of that experience is of niggling concern when compared to the path he opens up for those of us who, like Barthes, would presume that our subjective experience—particularly our subjective experience of photography—might also count as knowledge.

If I begin here with a reading of *Camera Lucida*, it is, to be sure, in order to make myself more comfortable. It allows me to begin by showing you my professional persona, the feminist and psychoanalytic critic, the reader of Roland Barthes, the very sort of person authorized to make observations in a book published by a university press. But my reading of Barthes is also a way of deferring, offsetting, hedging the writing I have committed myself to here. I have contracted to write here not as a reader of Barthes, not as a professor of theory, but as a photographed mother. And—whereas doing a reading of Barthes makes it easy to write, words and ideas fairly tumbling onto the screen—the thought of publishing a text about photographs of me and my children threatens to reduce me to silence.

It is no wonder that I turn to *Camera Lucida*. I've written on Barthes's book before, the only other time I wrote about photography. That piece appeared in a book with a photograph on its cover, a photograph of a birth.[3] The mother in the birth photograph could certainly be seen as a subject becoming an object: while her body looms large in the photo, she has no head; in fact everyone in

1. Dick Blau, 1995.

the picture has a head (nurse, baby, doctor) except the mother. While her head is missing, there is a head attached to her body, her son's (the picture was taken at the moment his head emerged from the "birth canal"). I spoke about this photograph in that book, but I did not mention that I was the mother in the picture. Rather than speak as the photographed subject, like Barthes I made observations from the spectator's point of view.

Since it's already been published, I'm not reproducing that photo here; I would like instead to show you another photograph of the subject becoming a mother, one that even more dramatically portrays the mother as object (illus. 1). I suppose I could say that this is a picture of me, but that doesn't feel right. I would be more comfortable saying it's a picture of my belly, which makes it more a picture of something attached to me. I'm eight months pregnant, at my monthly obstetrical check-up, where I've gone with Dick Blau, the father, who took this picture, as he did the one on the book cover, and as he did all the photographs I will discuss here.

I take this picture as the very emblem of the mother becoming an object because of the measuring tape, because of the way we think of numbers as the very measure of "objectivity." Since I've already invoked the feminist critique of the objectification of women (in my reading of *Camera Lucida* above), and since I'm talking about being turned into an object, you might think that I'm complaining here about being objectified. So I want to make it clear that I'm not complaining. In fact, I'm bragging.

I like to call this photo "The Prize Watermelon." I imagine the viewer impressed by my belly's size; I imagine it being measured at the county fair; when I show you this photograph, I'm proudly displaying the big belly I grew.

My caption for the photograph suggests a relation to my body somehow like a farmer's relation to her prized produce. This is a way of embracing my objectification, not simply becoming an object, but rather doubling into subject and object: I am at once the farmer and her watermelon. Putting my "fruitfulness" on display, I am, in short, proud to be a mother.

The desire to be a mother (which I would here distinguish from the desire to have a child) might be precisely the wish to become this sort of impressive object: the sort of object that, according to psychoanalysis, our mothers once were for us. While such fantasies are common, they seem better left unspoken. Like Barthes, we prefer to admire the silent mother. To speak one's pleasure in being taken for that magical object called Mother is to display an unsightly narcissism, a narcissism which may be inevitable when the photographed mother speaks.

Narcissism is indeed the word for it. The photographed subject speaks from a position that is literally narcissistic, the position of someone looking at an image of herself. I see now why Barthes might have fled that position. To remain too long, to be too interested in one's own image, is to fall into the trap of Narcissus.

When Barthes does briefly discuss photographs of himself, he complains that he never likes them. I imagine this is the most common sort of observation made by the photographed subject: she is most likely to say "I don't like that picture of me." While this is undoubtedly a resistance to objectification (that object is not me), it might also be a strategy to evade Narcissus's fate. We gaze at our image and insistently reject it, refusing to love it.

While this might get us out of the classic position of Narcissus, it leaves us with a common form of vanity. In his chapter on "He Who Is Photographed" Barthes writes: "What I want . . . is that my image . . . should always coincide with my (profound) 'self' " (12). We reject our images because we would so love to see our "self";[4] our rejection of our images actually manifests our love for our self.

Barthes's complaint goes on to specify that his image and his self "never coincide" because the image is "heavy" while his self is "light."[5] Barthes's writing, whatever the topic, quite consistently privileges the light over the heavy, and here as elsewhere the pair of terms carries a range of symbolic and figurative meanings.[6] But when he uses these terms to reject his photographic image, their concrete sense comes to mind. For all its theoretical subtlety, his complaint thus recalls one of the more common themes of vanity[7] and prompts me to show you a photograph I had decided not to include, an otherwise wonderful picture, though I don't like how heavy I look in it (illus. 2).

A few years ago Dick showed this photograph in Europe and came home to report that a psychoanalyst had found its Oedipal resonances disturbing. I

2. Dick Blau, 1991.

liked the idea of shocking a psychoanalyst, but a month or so later as Dick was preparing to exhibit this same picture here in Milwaukee, I realized that I too was disturbed by the photo. While I did not mind people knowing that my son and I lie around naked together, I didn't exactly like the idea of neighbors and colleagues seeing my unduly large belly. In this one, no tape measure and no pride; I'm not pregnant.

My feelings about this photograph contrast neatly with my exhibitionist pleasure in "The Prize Watermelon": whereas the tumescent belly fills me with pride, I feel shame in displaying one that is soft and flaccid. In the first picture, my belly sticks up; in the second, my breasts hang down. Such corporeal ups and downs are not without relation to the light and the heavy—the light rises, the heavy sinks. I'm struck by the phallic dimensions of my pride and shame. While my narcissism delights in the image of me as phallic mother, my vanity shrinks from the sight of my fallen flesh.

The photograph that shames me has given us serious and repeated pause. Dick and I keep finding ourselves unable to decide whether to show it—no other photo has caused us this kind of trouble. Throughout our conversations about it, we have not been disagreeing with one another; rather we have both been of two minds about what to do. The issues are always the same: both of us really like this photograph as statement and composition, but neither of us likes how heavy I look in it. Three years ago when Dick was preparing to exhibit locally, we had several such discussions, going back and forth about what

to do. Finally we decided that not to show this unflattering image betrayed the spirit of naked honesty that is one of our family values; so we showed it.

Nevertheless, just last week we had the same discussion about whether or not to include it in this essay. And we seemed to reach a decision not to show it. We reasoned that, whereas an exhibit was ephemeral, once the photo was published it would be in a sense permanently on display—and that seemed like just too much exposure.

What clinched my decision not to publish this picture was imaging my parents' horror at seeing it, at seeing me expose myself that way, in public. (Since I now seem to have decided to publish it, I hope my parents never find this essay.) The thought of my parents as spectators suggests the peculiar way in which this is a "family photograph." A conventional family photograph is precisely the sort of thing one would send to relatives who live out of town: grandparents would want a photo of their daughter and grandson. They would want it not only to look at it themselves, but to show their friends, to show off. The family photograph conventionally traffics in bragging and pride.

The photo of Max and me on the couch is not the sort of thing grandparents show their friends, and thus not a conventional family photo. But my vision of parental shame reveals that this photograph still functions within the realm of the family. Family photos are in fact all about showing, about taking the privacy of family life and exhibiting it to a public gaze (if only to friends and relatives). The family photo is intended to induce pride by showing a private life for public admiration, but the family photo can also produce shame by exhibiting privates that shouldn't be seen in public.

Although I seem to have decided to publish this picture, I'd like to focus on the repeated difficulty of that decision. I take the repetition as a sign that my problem with this photograph—whatever fantasies I might have of bold decisiveness—is just not going to go away. And I wonder if what troubles me about this photo may not, after all, be related to what troubled the psychoanalyst.

When the psychoanalyst saw this picture of a son and a mother lying naked together, he thought about the Oedipus complex. The Oedipus complex makes the mother's body taboo, prohibits our finding it desirable; the taboo makes us uncomfortable with the mother's nakedness, introduces an element of disgust into our viewing of that body. Perhaps my objection to the picture seems different because I am viewing it from the perspective of the photographed mother; I experience the disgust at that naked body as my own shame. But I'm struck by how the foci of that shame (the large, soft belly and breasts) are the very parts of the body most connoted maternal. Is this body undesirable because, looking too maternal, it elicits the Oedipal taboo?

While I don't want to discount this Oedipal reading of my shame, I also must confess that for me it makes the photo less, not more, disturbing. Interpreting the body's excesses as generically maternal tempers the shame I feel about the specificity of that body as my own. Barthes insisted that we

not reduce his mother to the Mother. Although earlier I chose to make theoretical hay by not respecting his insistence, I want here to return to his caution because I see how my theorizing is not only reductive but defensive. Contemplating a photo of his mother, Barthes observes that, beyond the Mother, his mother "had added that grace of being an individual soul." I must likewise admit here that to the generic problem of seeing the Mother naked, this photograph adds the shame of my individual body, its particular weight.

Reducing my body to that of the Mother makes it easier for me to bear its heaviness. Barthes, on the other hand, finds the mother a heavy, crude concept, which his particular mother lightens by "adding grace." *Camera Lucida* tells the story of how Barthes looked through and rejected a slew of pictures of his mother until he finally found the one photograph which for him exemplified both her and photography. Only one of the photographs could coincide with her self, her individual soul. And that was a picture of her as a little girl.

"Starting from her latest image . . . I arrived . . . at the image of a child: I stare intensely at the Sovereign Good of childhood, of the mother, of the mother-as-child" (71). To the Mother, this image adds the grace and lightness of the child. In a way, the picture of Max and me on the couch does the same thing. But rather than the mother-as-child, here we see the mother-and-child, the child's lightness juxtaposed with the mother's heaviness. As I look at this photo, I find myself sharing Barthes's preference for lightness, experiencing the difference between these two bodies as my lack, thanks perhaps to an aesthetic that reinforces the sense that more is less.

What disturbs me in this spectacle of a mother's body and a child's body naked together is not, *pace* the psychoanalyst, the possibility of incest. When I see those bodies together, framed by the symmetries of the windows, mirroring each other in the similarity of their position, that mirroring makes comparison and contrast inevitable. And I suffer from the comparison.

The insistent symmetry of this photograph creates the expectation of balance between the two bodies and produces an uncomfortable awareness of their difference. My sense of shame at looking so different from Max here perhaps explains why another photograph of the two of us, one where we look strikingly similar, gives me so much pleasure (illus. 3).

In this picture, we are no longer so indecently exposed. While the living room photo is suffused with the light of the outside world, its large windows open, the bathroom's single window is dark and closed. Here in the most private part of the home, nakedness returns to its proper place, not only because nakedness belongs in the bathroom rather than in the relatively public space of the living room, but because now only the child is naked. Conventional family photos show naked children, not naked parents, and the classic place for the naked child is the bathtub.

The two photos frame us quite differently. While Max and I are together on the black couch, he is alone in the white bathtub. In the bath photo, Max and I

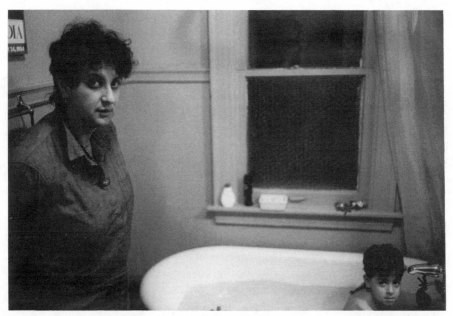

3. Dick Blau, 1990.

are balanced in opposite corners of the frame: my head in the upper left, his in the lower right. The symmetries of this composition do not demand equivalence between our two bodies but benefit instead from our relative sizes. Rather than face each other, Max and I face the same way. Our bodies seem not disproportionate but literally in proportion: he reproduces me in miniature.

A friend of mine calls this "the picture where Max and Jane have the same face."[8] While on the couch the bodies shock and their difference unsettles, here in the bathroom it's the faces. Their similarity is positively uncanny.

"In a certain photograph," writes Barthes, "I have my father's sister's 'mug.'"[9] This sentence is *Camera Lucida*'s only mention of a photo of Barthes outside the chapter "He Who Is Photographed." It appears in a chapter called "Lineage," in the middle of a passage that proposes that "the Photograph sometimes makes appear . . . a genetic feature . . . The Photograph gives a little truth . . . the truth of lineage" (103).

Earlier in the book, Barthes says he does not want to write about the institution of the family (74); "Lineage" deals with the family not as institution, but as something genetic, bodily, biological. And this animal sense of family echoes in the word Barthes uses for the face he shares with his aunt. "Mug" here translates the French "museau," which is slang for human face but more commonly and literally means "muzzle" or "snout," the front part of certain animals' heads. Barthes's muzzle reminds me that our household name for the picture of Max and me in the bathroom is "The Wolf Family."

Our pet title for the photo picks up on the striking family resemblance between Max and me. If, as my friend says, Max and I have the same face, it's not only because we look alike but also because we're making the same face. With two such similar faces making the same expression, the expression itself seems to be a genetic feature, its hostility an instinctual response.

While the genetic resemblance makes this unquestionably an image of family, this is not an orthodox family photo. Although suspicion and hostility are frequently experienced in families, they are not usually represented in family photographs. The subjects here are too unsociable for a proper family image and seem to resist, or at least resent, being photographed.

The idea of a "wolf family" suggests that here the family is not domesticated but rather captured by the photographic gaze. The mother and child look like unwilling subjects of display, resentful of the photograph's trespass into this private space. Our look says, "Get out of here."

Lying on the couch, the mother and child expose too much for a polite family photograph; here we are too protective of our privacy. Although our bodies are conventionally decent in this picture, our faces suggest something was not meant to be seen. If family photography makes the private public and sociable, this picture sees that as an intrusion.

The intrusion begins with the photographer; he is the object of our hostile gaze. While here the photographer is literally the father, the "wolf family" views him as an outsider, not a member of the pack. And Max's striking appearance as my reproduction in miniature even suggests the father's genetic irrelevance.

In most families, the father is the photographer. Not usually in the pictures, the father-photographer stands outside the image of the family. He is not simply outside the image but its master: the father-photographer directs the family picture, framing and composing the mother and children.

As a father photographing his family, Dick has assumed this role. Because his family photographs are his artwork, the role is exacerbated. In taking photographs of his family life intended for exhibition, publication, and even sale, he raises the public-private stakes implicit in all family photography. Making images of his family for public display, Dick places himself between family and world, representing both the family to the world and the intrusion of the world into the family. This is a pretty damn conventional role for a father to play.

All the players in the bath photo—father, mother, child—are in our most traditional places. But in portraying the mother and child's resentment of the father, this is hardly a conventional family picture. With its combination of traditional roles and hostile resistance, "The Wolf Family" could be said to expose the patriarchal relations underpinning polite family photography.

The subjects' hostility may also suggest another equally conventional if not so photogenic dynamic. The father-photographer has entered a space of mother-son intimacy and that intrusion is resented: "Go away so we can be alone together." Perhaps that psychoanalyst was right to worry about Max and me.

If I've come close to concurring with the psychoanalyst, it may be because up till now I haven't been speaking from my experience as subject; I've been reading this photograph as a spectator instead. I'm beginning to see how easy it is to slip into that position. Let me now speak as the photographed mother.

While as a spectator I find myself producing feminist and psychoanalytic readings, as the mother I see in this picture the texture of our home life. The photograph was taken on a Sunday evening during Max's weekly bath. I'm usually the one giving him his bath, and often, when Dick's finished the dishes, he appears in the bathroom, camera in hand. I am generally glad to see him arrive with his camera, always hoping for another beautiful picture of my son, but sometimes I do get annoyed if he gets in the way as I'm washing Max's hair. I don't remember the actual moment of this picture, or why I regarded Dick with such hostility. Just recently he and I were talking about the photograph because I thought I would include it here, and I voiced my puzzlement at Max's and my expression: "Were we angry at you that evening?" Dick laughed: "I made you two look at me that way." He explained that he opened the bathroom door and commanded us to look at him, knowing that a command would produce in both of us the same immediate, instinctive response—momentary but dramatic hostility. Dick used to be a theater director, and he knows how to get what he wants from actors. By sounding like a patriarch, he produced a tableau of resentment from the subjects of patriarchal authority. The response was so fleeting, I never even knew I'd participated in a drama.

"I imagine," writes Barthes, "that the essential gesture of the [photographer] is to surprise something or someone . . . revealing what was so well hidden that the actor himself was unaware or unconscious of it" (32). The word "actor" here suggests Barthes shares Dick's understanding of the affinity between photographer and theater director.

If Barthes had said "the person" rather than "the actor," this revelation of something "unconscious" would lead to a psychoanalytic version of truth, to the kind of Oedipal reading with which I briefly flirted. When we read that something "well hidden" has been revealed, we tend to take this as the very sign of truth, but Barthes's word "actor" implies that what is revealed is not a personal truth, but something the person lends her body to portray.

Which doesn't mean it isn't true, but that it is true the way theater can be true: resonant human truths are portrayed even though the actors are conventionally "lying," that is, speaking in character rather than as themselves. The patriarchal melodrama in the bath photo does not reveal some personal truth about Max and me but is rather a piece of theater we have enacted all unawares. Although as a spectator I can appreciate the truth of this drama, it is not part of my experience as a subject.

Family photographs are normally taken to represent the particular family. But Dick didn't shoot "The Wolf Family" solely for that reason. Seeing the bathroom as a set and us as a theater troupe, he stages an archetypal family.

Not a conventional family portrait, "The Wolf Family" instead portrays the conventional family.

Dick's theatrical sense of the family probably has something to do with his having grown up in the theater: his mother is an actress, his father a director. But *Camera Lucida*'s use of the word "actor" to describe the photographed subject, as well as its consistent use of "spectator" to name the photo's viewer, means that Dick's theatrical sense of photography is not simply idiosyncratic. At the very least it suggests a congruence between Dick and Barthes, who tells us in his autobiography that "the Theater" is "[a]t the crossroads of [his] entire *oeuvre*," that "spectacle is the universal category" in which he sees the world.[10]

Dick has always said that his photography derives from his work in theater, but I never understood what he meant by this until I brought Barthes's description of the photographer to bear on Dick's photography. That *Camera Lucida* should help me appreciate Dick's perspective is ironic. Dick does not like this book; he is offended by its dismissal of the photographer's point of view. As a matter of fact, it occurs to me that I may have chosen to approach Dick's photos with Barthes's book in hand precisely because of this resistance to the photographer's point of view.

At the beginning of *Camera Lucida*, Barthes proclaims his independence from "the troupe who deal with Photography-according-to-the-Photographer" (10). But ten chapters later he makes an exception to that rule: "I imagine (this is all I can do, since I am not a photographer) that the essential gesture of the [photographer] is to surprise something or someone (through the little hole of the camera), and that this gesture is therefore perfect when it is performed unbeknownst to the subject being photographed" (32).

Unlike Barthes, I don't have to imagine the photographer's gesture. Another photograph of Max and me actually shows Dick taking our picture, thanks to a mirror (illus. 4). In this photo neither Max nor I manifest any awareness of Dick, who is behind us, his one visible eye shut, the other presumably looking through his Leica which is focused on us.

This picture seems to reflect the structure of the classic family photograph. By including his image, Dick lets us see the father-photographer, the figure conventionally left outside the frame, observing unobserved. The viewer can see him here looking at the subjects who aren't looking at him.

Once again, we are all three in our most traditional places. The baby narcissistically contemplates his own image; the mother holds and supports her son, gazing admiringly at his image; the father is at a distance, capturing mother and child with his technology but not touching us, not interacting with us. The entire little family is centered on the baby's image, mother and father both helping construct that image in their typically differing ways.

Although I'm not sure how much I like seeing myself as the conventional mother here, I really like the shirt I'm wearing. As frivolous as it might seem, I connect the writing on my shirt with Dick's sporting a camera. Not just Mom

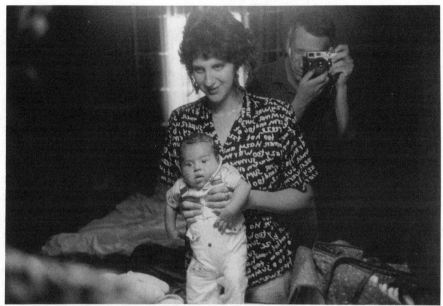

4. Dick Blau, 1986.

and Dad here, we both display the means of our expression, the symbols of our respective trades: this photo includes not only the father-photographer but also the mother-writer. While no one else may be able to read the shirt this way, I like to think it says that the woman in this 1986 photo is not just the baby's proud mother but also the author of a book on Jacques Lacan, which came out a few months before Max did.

Perhaps that explains why I see this photograph as a dramatization of Lacan's "Mirror Stage."[11] "The Mirror Stage" is about the moment in which the baby meets his image. Lacan specifies that the baby looking at himself in the mirror cannot yet stand on his own, but is standing with the help of "some support, human or artificial." The support makes possible an image that is more mature, more together, more erect than the baby really is. In this photo, Max is two and a half months old; it would be nearly a year until he could stand on his own. In this photo, I play the quintessential supporting role for his false and narcissistically pleasing image of self.

As it turns out, Barthes too associates Lacan's "mirror stage" with a family photograph. In his autobiography, underneath a photo of a woman holding a baby, Barthes has placed the caption "The mirror stage: 'you are that.'"[12] The baby is presumably Barthes, the woman his mother; their gazes are aimed in the same direction. The caption implies that, like Max and me, Barthes and his mother are both looking at the baby's mirror image.

The caption further suggests that the mother is saying "you are that," thus

teaching the baby to recognize his image as himself.[13] This gently reinterprets Lacan's formulation, giving the mother a leading role in the historic moment when the baby takes his image for himself. Because Baby Barthes in the photo is not pretending to stand, not producing an image that pretends to more than he can really accomplish, the moment does not carry the Lacanian sense of the image's tragic falsity and the mother's role seems innocuous enough.

Looking back at Max and me in the mirror, I see myself like Barthes's mother taking the active role. But Max *is* "standing," and my activity does not seem so innocent. Lacan locates the onset of the mirror stage at around six months of age, when a baby first wants to be seen standing. Here, more than three months ahead of schedule, it must have been my idea to stand him up. In this picture I can see myself as the worst sort of pushy mirror-stage mother.

Barthes's use of "the mirror stage" shows us the mother in a scene usually imaged as a solo performance. A closer look would discern yet another presence, beyond the mother-child dyad. This third presence appears in the sentence that "The Mirror Stage" uses to introduce its description of the infant confronting his image: "This event," writes Lacan, "has often made me reflect upon the startling spectacle of the infant in front of the mirror" (1). The third figure—the one who views the spectacle, finds it "startling," and "reflects upon" it—is Lacan himself, whose reflection has brought us "the mirror stage," his most famous theoretical contribution.

Dick's mirror photo shows something like the "spectacle" Lacan "often reflects upon." But this mirror image also includes the gaze that reflects upon the spectacle. When I imagine that this photo represents Lacan's "Mirror Stage," I like to think that Dick's inclusion of himself as part of the image somehow reveals Lacan's theoretical gaze, bringing the third player in the drama to the stage, allowing us to see the shadowy figure who observes the well-lit image of baby and supporting mother. And this strikes me as a more complete picture of the system that supports the baby's image.

Reading the photo as a further elaboration of the mirror stage depends upon seeing the father-photographer as somehow analogous with the psychoanalytic theorist. I find this analogy enormously seductive, whispering a grand theorization that would connect the mirror stage to both family photography and the Oedipal triangle. I start to fantasize myself as the author of the great psychoanalytic theory of images, which would explain how the image of the self is constructed in the family. But as soon as I try to work it out, the fantasy fades and my writing grinds to a halt.

Perhaps there is a less grandiose, more idiosyncratic explanation for why I see the father's place in this photo as Lacan's place. Years ago I wrote a book about French feminism and psychoanalysis in which I staged the relation between the two in Oedipal terms, casting Lacan in the role of the father. At the time I was not a mother and the Oedipal relation I was interested in was not the classic one that's been dogging me here, but the daughter's version. I

5. Dick Blau, 1978.

was writing that book at the moment I met Dick. One day, looking at his photographs, I found this picture I thought would be perfect for the cover of the book I planned to call *The Daughter's Seduction* (illus. 5).

That's Dick's daughter in the foreground, the very image of girl beauty and innocence, lost in her contemplation of a few wisps of grass. Like the mirror stage photo, this one has a foreground and a background, and like Max and me in the mirror, Anna seems oblivious to what is behind her. Once again the background contains an image of the father. On the ground, in a posture that seems somehow reminiscent of lovers, is a father and a daughter—Dick's best friend Jake and Jake's daughter Laura, Anna's best friend. I see this romantic background as the unconscious, dreamlike in its softer focus and gorgeous light. The daughter, innocent in the foreground, seems unaware of the Oedipal scene behind her.

Although there are no mirrors here, Dick has found another way to include the father in the image. In place of the mirror, he has a stand-in—a figure identified with himself, both as his best friend and as the father of a daughter. The relation between the background father-and-daughter could be said to mirror the relation between the unseen father-photographer and his daughter. The inclusion of the father in the image allows the photo to dramatize and gloss the erotic exchange that appears in its more conventional form in the foreground, where the father-photographer focuses our gaze on his daughter's delectable skin, sensuous hair, and pouty lips.

The image in the foreground belongs to a large and over-familiar genre: fathers' adoring photos of their daughters' innocent beauty. The background stages the unconscious of the genre. Juxtaposing the manifest and the latent, this photograph both reproduces that genre and reflects upon the taboo eros that underlies it.

While my relation to this picture was not familial, it was immediate and intense: I had professional designs upon it. I thought it the very image of "the daughter's seduction," with its different levels echoing the ambiguities and psychoanalytic resonances of the writing I was doing. I wanted it for my book's cover and asked Dick if I could use it. At first he liked the idea, but a couple of days later he told me that, as much as he regretted it, he couldn't let me use the photo. What stopped him was the thought of Anna.

Not the girl in the image, taken a few years before our conversation, but the girl in his life. Anna and I hadn't yet met, and he was afraid she might not like gracing the cover of a book called *The Daughter's Seduction*. As much as he wanted us to publish together, he wanted more to avoid anything that might make Anna resent me. The photographer wanted to publish this picture; the father cared more about his daughter's feelings.

The father won out. Which suggests that, however much these photos are Dick's artistic work, they are also still very much family photographs. Not simply because they are images of family members, but because they never can be completely outside the family. Family photography is not just about how the family looks in the pictures; it's also about how the pictures look in the family. And as great as Anna would have looked on the cover of my book, the fact of her appearance there might not have looked so good to her.

Like all the photographs I've discussed here, this one portrays people Dick loves while at the same time catching those loved ones in poses that convey classic family dramas. When I asked to put this picture on the book cover, I wasn't thinking about his family and its actual dramas, about Anna's real relation to her father; I only saw this picture as an eloquent portrayal of the generic daughter's Oedipus complex.

My theoretical gaze also sees *Camera Lucida* as perfectly Oedipal. Like the psychoanalyst viewing Max and me on the couch, I feel mildly and agreeably scandalized when I read in that book that Barthes lived with his mother his whole life (75). But in the very same chapter that contains this confession, I notice he insists that while such a theoretical understanding can explain the "generality," "the Mother," it misses *his* mother, the individual being he loved: "it is because she was who she was that I lived with her" (75).

In a startling move, Barthes does not show us the photograph of his mother that he makes central to the book, the picture that for him captures both the essence of the woman he loved all his life and the theoretical essence of photography. "I cannot reproduce the Winter Garden Photograph," baldly asserts Barthes (73) about the photograph he devotes pages to describing and

6. Dick Blau, 1997.

analyzing, thereby adding to his analysis an absolute insistence on its, and her, singularity. While the book's lengthy discussion of this photograph in fact makes theory by seeing generalities in the picture, Barthes's refusal to show it resists its reduction to those generalities: "no more than I would reduce my family to the Family, would I reduce my mother to the Mother" (74).

The theoretical designs I had on Dick's picture of Anna correspond to the relation Barthes's reader would have to the picture of his mother. Back then, Dick's photos were for me only portraits of "the Family," not of "my family." Now I no longer have the luxury of forgetting the particular family, and I find my responses as a reader don't jibe that well with my responses as a mother. The reader sees the generic drama of family; the mother thinks of the individuals.

In drafting this essay, I have experienced the split between mother and critic most acutely when choosing which photographs to write about. In the hope of creating a text that would be valued professionally, I have made my pictorial choices based on theoretical and writerly demands. But as a mother this leaves me with a problem.

I haven't shown you my daughter. She was the seed in "The Prize Watermelon," but now she's a girl out in the world, a wonderful girl who hasn't yet remarked that I have pictures of only her big brother on the walls of my study, none of her. I'm hoping to get some of her up before she notices.

Since I'm even prouder of her than I was of my protruding belly, it would give me pleasure to show her to you. But what really compels me to do so is

imagining her reading this some day. How could I explain to her that I sacrificed her for compositional unity? As I was writing this essay, I kept trying to find a way to get from the themes of this text to a picture of her; I never did. So, although it may be bad form, before I go, I gotta show you my Ruby (illus. 6).

Notes

1. Roland Barthes, *Camera Lucida: Reflections on Photography*, trans. Richard Howard (New York: Hill and Wang, 1981), 9–10.

2. Roland Barthes, *La Chambre claire: Note sur la photographie* (Paris: Gallimard Seuil, 1980), 107–109. The original French has the verb "observer," an exact cognate of our English verb "observe" to match the later "observation" (in both languages). The English translator has obscured the resonance by translating the initial verb as "I studied."

3. Jane Gallop, "The Prick of the Object," in *Thinking Through the Body* (New York: Columbia University Press, 1988), 149–60.

4. Barthes's French word "moi" could also be given the more psychoanalytic translation "ego," *Chambre claire*, 26.

5. In the context of photography, it must be noted that the French word he uses, "léger," unlike its English translation, does not mean the opposite of dark but only the opposite of heavy (*Camera Lucida*, 12; *Chambre claire*, 27).

6. "Heavy," for example, is in this passage linked to "motionless" and the ideological; "light" to dispersion and the "zero degree."

7. This is, to be sure, a theme for Barthes as well. In his autobiography, he places this caption above a photograph of himself as a young boy: "Sudden mutation of the body: changing (or appearing to change) from slender to plump. Ever since, perpetual struggle with this body to return it to its essential slenderness"—*Roland Barthes*, Roland Barthes, trans. Richard Howard (Berkeley: University of California Press, 1994), 30.

8. Lynne Joyrich, various personal conversations.

9. *Camera Lucida*, 103; *Chambre claire*, 161, translation modified.

10. Barthes, *Roland Barthes*, 177.

11. Jacques Lacan, "The mirror stage as formative of the function of the I as revealed in psychoanalytic experience," in *Ecrits: A Selection*, trans. Alan Sheridan (New York: Norton, 1977), 1–7.

12. *Roland Barthes par Roland Barthes* (Paris: Seuil, 1975), 25; translation, 20; translation modified. The phrase in quotation marks (originally "Tu es cela") can be found in Lacan's "Mirror Stage," where it also appears in quotation marks (*Ecrits*, 7).

13. In *Camera Lucida*, Barthes dislikes his image because it doesn't correspond with his "self." Here, in a book published five years earlier, we see his mother imposing the equation of self and image upon him. It is probably worth noting that between the writing of the two books, Barthes's mother has died.

Photography, Narrative, and Ideology in *Suzanne Suzanne* and *Finding Christa* by Camille Billops and James V. Hatch

VALERIE SMITH

Throughout her career as a filmmaker, Camille Billops has been compelled by ideas about families. In different ways, each of her four films engages questions concerning the meaning of family, practices of representing family, and the consequences of keeping family secrets; moreover, each uses members of the filmmaker's family on both sides of the camera. In this essay I focus on her first and third films, *Suzanne Suzanne* and *Finding Christa*, works that directly address how family photographs and home movies enshrine ideologies of family. I consider how Billops and her co-director, James V. Hatch, use and undermine photographs and home movies in their critiques of middle-class respectability and romanticized notions of black maternity.[1]

An award-winning director and acclaimed printmaker, sculptor, muralist, and photographer, Billops is the younger daughter of parents who migrated to Los Angeles from South Carolina and Texas in the 1920s. Her mother was a seamstress and dress designer, maid and defense plant worker; her father was a chef and merchant seaman. She traces her own creativity to these early influences. Not only did her parents transform food and fabric into sites of aesthetic expression, but they, like many migrants, cherished family pictures for a variety of reasons. It may well be the case that, as bell hooks argues, for black people in the pre–civil rights era, taking and displaying photographs was a way of resisting popular representations of African-Americans—images that exaggerated features for comic purposes, that sentimentalized exploitative labor conditions, or that "documented" pseudoscientific theories of racial difference. In other words, they may well have cherished these images because they

subtly challenged the ways in which photographs were used to underwrite discourses of racial and sexual domination.[2]

But family photographs were important to these and other migrants for additional reasons. Indeed, they might be seen to figure prominently in the twinned journeys associated with migration narratives. First, they helped to shrink the distance the migrants had traveled.[3] Photographs of friends and relatives—either deceased or left behind—wove the past and faraway homeplaces into the imaginations of their children born in the urban North, West, and Midwest. And second, the photographs parents regularly took of themselves and their children documented for them, their descendants, and those from whom they were separated, their incremental rise to and beyond lower-middle-class respectability.

The archive of still images in the Billops family was supplemented by a rich assortment of Bell and Howell home movies in the forties and fifties after Billops's father died. Her stepfather regularly captured on film special events that displayed the outward, material signs of their rising fortunes: homes, cars, furniture, decorations, festivities, and intact families.

Billops was well on her way to fulfilling her destiny as a middle-class young African-American woman of the mid-1950s until her last year in college. As a senior majoring in education, she became pregnant and her fiancé disappeared. She had her baby, finished college, and began to teach. But by the time her daughter, Christa, had turned four, Billops had decided that her life was too confining. She put Christa up for adoption, dedicated herself to her painting, sculpture, and printmaking, and traveled with James V. Hatch, the playwright, critic, biographer, and professor of literature and theater whom she later married. Together they founded and continue to operate the Hatch-Billops Collection in New York City, which contains well over a thousand interviews with artists in all disciplines, and documents African-American theater, literature, painting, sculpture, dance, music, and photography. Together they have made four films.

Suzanne Suzanne (1982) investigates the experience of drug abuse and domestic violence in the family of Billops's sister Billie. *Older Women and Love* (1987), inspired by the relationship between Billops's octogenarian Aunt Eula and a younger man, explores the erotic lives of older women. *Finding Christa* (1991), which won the Grand Jury Award in the documentary category of the 1992 Sundance Film Festival, centers on Billops's decision to give her daughter up for adoption and on the reunion between the two women twenty-one years later. Their most recent film, *The KKK Boutique Ain't Just Rednecks* (1994), in many ways departs from the style and content of the earlier work. Although several family members appear on camera, *The KKK Boutique* is a docu-fantasy that takes a group of characters on a symbolic journey into the recesses of their ideas and prejudices about race, gender, sexuality, and class. At present, Billops and Hatch are working on a film called *String of Pearls* that links vignettes about constructing ideas of masculinity in both of their families.

Suzanne Suzanne

A 16mm, black-and-white documentary film shot mostly in 1977 and released in 1982, *Suzanne Suzanne* locates an account of physical and drug abuse in a specific family within a more expansive critique of the nuclear family. The demystification both of this family and of the idea of the middle-class nuclear family is achieved within the context of a nonfiction film that destabilizes the very status of the truth itself.

The extracinematic circumstances that led to the production of *Suzanne Suzanne* remind us that no documentary is ever "true" or "objective"; "the truth" is always constructed. Billops and Hatch undertook this film intending it to be the story of Billops's niece Suzanne Browning's battle against drug addiction. During the course of their interviews with Suzanne and other relatives, the story of Suzanne's and her mother's—Billops's sister Billie's—experiences of abuse emerged. The film that was to situate Suzanne as a recovered drug addict thus became also, if not instead, an exploration of the suffering to which women are vulnerable in the nuclear family. The filmmakers then constructed an implicit narrative forged from sequencing, cross-cutting, and the interpolation of still photographs and footage from home movies that identifies domestic violence as a major factor in Suzanne's addiction.

The film begins with a still photograph of Brownie (the abusive husband and father) lying in repose in his coffin. First in a voice-over and then on camera, Suzanne reflects on her turbulent and ambivalent relationship with her father. In the opening sequence, Suzanne's comments are cross-cut with her mother's on-camera reflections about her own profoundly mixed feelings about her late husband. Throughout much of the film, in scenes shot in and around the family home in Los Angeles, Suzanne, Billie, Michael (their respective brother and son), and the grandparents answer Billops's questions about topics such as the importance of fashion and beauty to the women in the household; Suzanne's addiction and criminal behavior; and Brownie's abuse of his wife and daughter. The characters for the most part speak to Billops, the co-director and interviewer. However, in two powerful scenes that occur late in the film, Billie and Suzanne talk to each other in a stylized sequence. In these scenes, the two women seem to acknowledge for the first time the relationship between their experiences of abuse.

The film is composed of at least three different representational modes: twenty-five still photographs; eight clips from Bell and Howell home movies taken by Walter ("Mr.") Dotson, Billie's and Billops's stepfather; and the frame of the film, which includes the interviews and the music and possesses the authority of sound.[4] By negotiating the relationship among these three modes through juxtaposition and cross-cutting, the filmmakers produce their cinematic narrative as well as the critique that underlies that narrative.

In an interview with playwright/director George C. Wolfe, Billops says that she and Hatch "could not arrive at what the film was about until [she] told their editor . . . about Mr. Dotson's home movies." She continues: "These were the missing pieces that gave the film its focus . . . [The home movies] gave the family a history."[5] The footage and photographs certainly place the characters within a generational, class, and regional context. They also produce much of the narrative tension in the film, by prompting questions about how the beaming young girl shown at age eight becomes the adult addict, how the seemingly stable family becomes fractured.

What is perhaps most striking about these interpolated images is their familiarity. Several fix moments that have become ritualized within the construction of the nuclear family. Pictures of Brownie smiling, embracing his children; footage of the family off to church in their Sunday best; a photograph of the dead Brownie lying in repose in his open coffin; footage of Billie holding Camille's infant daughter, Christa—all establish the family in familiar middle-class respectability. They document the first and second generation of migrants positioning themselves within the narrative of American success. These pieces of documentary evidence thus memorialize a picture-perfect family, one whose history might be reconstructed out of the photographic record of public events: holiday celebrations, deaths, births, and so on.

And yet, it is precisely the familiarity of these images that the film contests. If viewers were to rely solely upon spoken critiques of the family romance, we would perhaps be less likely to consider our own implication in what Annette Kuhn calls "the signification process."[6] However, the silent record of the still photographs and the home movies encodes a subtext of family stability and safety that viewers recognize and interpret and that Billops and Hatch's film challenges. By juxtaposing Suzanne's and Billie's stories with the images from the family history, Billops and Hatch prompt viewers to question both the process by which we attribute meanings to images as well as the overdetermined, explanatory power of certain rituals. Perhaps more important, the use of these materials enables the film to address at once the pathology of this particular family and the nature of the oppressive cultural weight that the image of the nuclear family bears.

The inequitable distribution of authority and resources within families, which can allow husbands to exercize excessive power over their wives and children, is here the most obvious cause of Suzanne's addiction. However, the internalized effects of the commodification of women's bodies within a gendered and racialized hierarchy may have contributed to her problem as well. The world of fashion and beauty culture as represented in the film clearly provided an opportunity for women to control their labor and express their creativity. Billie and her mother, Alma, share a gift for sewing and fashion design; both love the opportunity for self-display that performing in fashion shows

grants them. These activities are thus to some degree emancipatory. But they also contribute to a climate in which women and children are objectified and valued on the basis of their appearance.

Within the film, Michael, Suzanne's brother, is prized both because of his status as only son and eldest child, and also because he has inherited his mother's good looks. He is introduced as Suzanne's "handsome brother," and three times he is shot grooming his oversized moustache in the bathroom mirror. Clearly delighted with his appearance, he grows and waxes a moustache that is a virtual parody of itself, and takes pride in the comments his mother wrote in his baby book. Suzanne, on the other hand, says that she grew up believing herself to be ugly. She inherited Browning, not Billops features—what she calls "puffy eyes, sorta set back into the head." The still photographs suggest that her sense of being unattractive may bear a particular racial valence, for she has broader features, coarser hair, and darker skin than does her mother. While Michael can delight in Billie's obvious pride in his good looks, Suzanne recalls the humiliation of being considered less attractive than her mother.

In one scene, Billie applies makeup to Suzanne's face while the two of them discuss their appearances. Visually and discursively, this scene dramatizes the extent to which Suzanne may have felt betrayed by her mother. It recalls an earlier counterpart in which Billie applies makeup to her mother Alma's face while both look directly into the camera. In that earlier instance, Billie bends over Alma's shoulder to apply her blush; the two women are thus positioned so that both may be introduced to the viewer. In the latter scene, however, which focuses explicitly on the issue of appearance, Suzanne's face is turned away, hidden from the camera while her mother, facing the camera, applies her makeup. The staging here allows greater access to Billie's confident subjectivity while concealing and thereby reinforcing Suzanne's expression of her self-loathing. Furthermore, it provides a visual counterpart for the story Billie and Suzanne recount during the scene.

Here the two women describe how Suzanne's friends responded upon first meeting her:

> BILLIE: In the very beginning, I didn't really pay that much attention to it. But then, later on, I began to watch Suzanne's face when she would say to her friends, "I want you to meet my mother." And they'd say, "Oh, how do you do Mrs. Browning?" And then they'd turn and say, "Well, what the hell ever happened to you?" And that would just really get to me. I didn't like it, because they were making too much of a comparison. And I realized at that time that Suzanne did not like that at all.
>
> CAMILLE BILLOPS: Suzanne, did you believe that?
>
> SUZANNE: What they were saying? Sure. You know, I knew it. Because

when I looked at my mom . . . you know my mother was beautiful
. . . you know she's still a beautiful woman. You know, I got a really
big complex from that. I thought I was extremely ugly.

By the standard of physical attractiveness, Suzanne always loses to her
mother. Billie seems curiously unaware of the destructive power of her invest-
ment in appearance. Her disapproval of Suzanne's friends' response to her ex-
poses her insensitivity—she only noticed that the comparison between her
daughter's and her own looks was inappropriate when she perceived Suzanne's
pain, when she realized that "Suzanne did not like that at all." Tellingly, on the
heels of Suzanne's admission that she felt less attractive than her mother, Bil-
lie boasts about having entered the Mrs. America contest of 1979. The se-
quencing here—the makeup scene, Billie's displaying of her beauty pageant
photograph, Michael's grooming of his moustache—exemplifies the causal
links that the filmmakers sought to establish and suggests a closer connection
between mother and son than between mother and daughter. Through staging
and juxtaposition, then, the filmmakers impose a specific interpretation upon
the experiences described.

Mr. Dotson's Bell and Howell home movies dramatize the commodification
of women and children that Billops and Hatch's film critiques. Virtually all of
the footage from these films centers on women and children, under the pro-
prietary, controlling gaze of the male—the absent father—behind the camera.
Displayed in Easter finery or in scenes of domestic bliss, they are signs of the
family's, particularly the father's, achievement.

Suzanne Suzanne, in contrast, is the product not of the father behind the
camera but of a daughter with her partner/co-director, and cinematographer.
Here, women and children are not silent collaborators within a family ro-
mance. Rather, they speak in response to questions that Billops poses or that
they pose themselves. Moreover, while cinematographer Dion Hatch, James
Hatch's son, like Mr. Dotson, is not visible within this film, Billops, one of two
producer/directors, is both audible and, more important, visible. Twice, she
appears standing side by side in the mirror with Michael. The image of a
woman with braids and a faint but discernible moustache, standing beside a
man waxing his moustache, helps to deconstruct conventional standards of
beauty that the film problematizes elsewhere.[7]

The sight of Billops in the mirror reminds the viewer of the constructed-
ness of the film and the cinematic process. It is also a figure for the black fem-
inist intervention within received family narratives. Simultaneously director
and subject, relative and observer, insider and outsider, she occupies the posi-
tion from which the multifarious manipulations of parents, sons, and daugh-
ters can be made visible.

Through juxtapositions and self-conscious interrogations of its material,
then, *Suzanne Suzanne* problematizes the potentially destructive nature of the

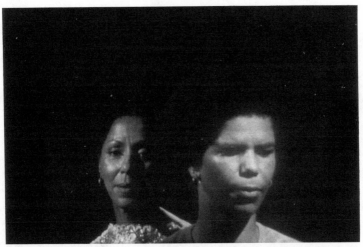

I. Billie and Suzanne. *Suzanne, Suzanne* (1982), 16 mm film by Camille Billops and James V. Hatch. Photo © 1982 Camille Billops.

middle-class nuclear family; the film's discourses work to dismantle the image of the ideal family created by the photographs and home movies. Indeed, the inclusion of these materials in the film interrogates their very status as evidence. However much one might wish to read photographic images as denotative, like the techniques of cinematic or literary realism, they represent a body of conventions that privileges particular ideological positions. The shot of Alma and her granddaughters going off to church—the one in an elegant suit, the other in dresses with crinoline slips—memorializes an eminently readable image of family harmony, recalling the popular conception of the family that stays together because it prays together. Given the subtext of family violence, however, this Bell and Howell moment suggests the central role of performance and imitation in the ways that families, like individuals, construct their identities.

These considerations about the place of performance within real life, and about the artificiality of documentary evidence, shape the ways we interpret the two scenes between Billie and Suzanne that are set in a darkened room, with the two women, shot from mid-chest up, simultaneously facing the camera.[8] This darkened space provides an alternative to the domestic locations used for the rest of the film—rooms that recall the past history of family relations. In striking contrast to the scenes that are shot in and around Alma and Walter Dotson's Los Angeles home, these dark, stark, partially scripted scenes are constructed as pivotal and self-consciously dramatic. In this setting, the relationship between mother and daughter is altered dramatically (illus. I).

Billops says that Hatch provided Suzanne with a list of questions to ask her mother in these scenes. One such question is the one with which Suzanne begins: "Do you love me?" By providing Suzanne with a list of questions, Hatch

and Billops allow her to assume the role of interviewer. But at some point, Billops says, Suzanne began to ask her own questions, assuming the role of both interviewer and writer. This recollection is confirmed by the transcript of unused footage from an interview in which Suzanne admits that she used this occasion to ask some of her own questions:

> BILLIE [BB]: I knew that in the very beginning it was going to stir up something, but I thought, well Suzanne and I, we have never really talked . . . I didn't know what was going to happen . . . Yesterday . . . the last thing I ever wanted to do was to cry . . . I didn't know that she was going to ask me about did I know what it felt like to be on death row . . .
>
> SUZANNE: . . . It wasn't Jim . . . I told you Sunday, I have questions—of my own. You know, there's like a lot of things that come to my head. You know, and I wanted an answer . . . I was there to ask some of those things.

Up until the exchange between Billie and Suzanne that we see in the film, the family members have, for the most part, answered the questions that are asked of them. But here Suzanne takes advantage of the context to address her own nagging concerns. And Billie uses the occasion to tell her own story. When Suzanne asks, for instance, if she'd like to know what it felt like to wait on death row, Billie doesn't really respond to her, but rather explains both to herself and to her daughter why she would retreat into the shower whenever Brownie came home, answering the question she had posed indirectly earlier in the film.[9]

The staging of these scenes calls attention to their artificiality even as their sheer emotional power bestows upon them a quality of authenticity. I'm tempted to begin to read these scenes as "real" from the moment when Suzanne asks if Billie's beatings were like being on death row. At this point, Billie's head shifts and her facial expression changes, apparently signalling a recognition of their shared circumstances. Not only were both victims of physical violence, but both also endured the psychological terror of imagining and awaiting each episode of Brownie's abuse. The sense of process evident here is coded as being more authentic than the communication that occurs in the rest of the film. But the very fact that the film exists within a frame that questions the domain of "the real" renders such discriminations specious. These scenes in the darkened space suggest minimally, however, that to the extent that domestic relations are captured (if not fabricated) in our interactions with private as well as public media, they might be reconstituted as well through the intervention of the artificial.

Suzanne Suzanne constitutes a cinematic discourse that interrogates a host of interconnections, those between cultural circumstances and individual

responsibility, documents and ideology, truth and artificiality, and, indirectly, racism and misogyny. The film seeks to disrupt the façade of orderly respectability that depends upon the conspiracy of silence within the family. Yet nowhere is the tension between the disruptive power of the cinematic process and the seductive power of the family romance more evident than at the end of *Suzanne Suzanne*, where the film appears to satisfy viewers' desire for closure and healing.[10]

In the second of the "staged" scenes between Suzanne and Billie, Suzanne partially faces her mother and tells her about one particular beating when Brownie whipped her until she bled. This description is particularly harrowing, yet Billie seeks to recuperate Brownie's behavior by reassuring Suzanne that she was her father's favorite. Billie's explanation pales when contrasted with this vivid account; the juxtaposition reveals the price narrators and viewers alike pay for narrative closure and the sentimentalization of family.

Finding Christa

By addressing the subject of domestic violence, *Suzanne Suzanne* takes on a topic that has only recently become speakable in representations of families. *Finding Christa* is even more daring, for, as Barbara Lekatsas has written, "a mother who gives up her child is considered even lower on the scale of civilization than a brutal father."[11]

The account of Billops's relationship to her own daughter, Christa Victoria, lurks on the periphery of the first film. Christa appears as an infant and toddler in photographs and clips from home movies; Billops and Christa sing the title song together. In *Finding Christa*, Billops and Hatch bridge the gap between the wistful image captured on screen and the haunting voice heard at the beginning and end of *Suzanne Suzanne*.

Finding Christa, also shot in 16mm, opens with a photograph of the four-year-old Christa as she appeared shortly before Billops gave her up for adoption (illus. 2). In the voice-over, the adult Christa speaks in a plaintive voice, which reveals her sense of longing and betrayal: "My last memory of you is when you drove off and left me at the Children's Home Society. I didn't understand why you left me. I felt so alone. Why did you leave me? It's been so long since I felt complete." The first portion of the film seeks to answer Christa's question.

The narrative present begins in Billops and Hatch's loft in New York, where Billops plays for her friend, photographer Coreen Simpson, the tape she received from Christa after a separation of more than twenty years. Billops explains the decision to put Christa up for adoption calmly and directly, saying: "I was trying to give her something else, because I felt she needed a mother and a father. I'm sorry about the pain it caused Christa as a young child, but I'm not sorry about the act."

2. Christa. *Finding Christa* (1991), 16mm film by Camille Billops and James V. Hatch. Photo © 1960 Camille Billops.

The film then takes viewers back to the community in Los Angeles where Billops and her family lived and where she made her choice. As they do in *Suzanne Suzanne*, photographs and footage from home movies here too recreate the apparent joys of this family's life in the late fifties. Clips from Billops's baby shower and still pictures of Christa being bathed and playing under the Christmas tree conjure up a picture-perfect family. Yet interviews with friends and relatives confirm Billops's account of the limited options available to single mothers at the time. In one striking moment, Billops reflects upon the fact that although those close to her did not want her to give up the child, no one offered to keep Christa or was able to assist her in meaningful ways.

The reasons behind Billops's choice are as varied as the range of voices that contribute to the narrative. From testimonies conveyed through interviews, we learn that she gave Christa up because she recognized that she would not be a good mother; she lacked sufficient family support; and she wanted to be free to develop her talents as a visual artist. Her cousin Bertha believes that she gave up her child in order to be with Hatch.

Back in the loft, Billops reveals to Simpson and to George C. Wolfe some of her anxieties about being reunited with her daughter. Wolfe assumes that Billops is eager to meet Christa. But Simpson, who was herself given up for

adoption as a child and who tried unsuccessfully to reestablish contact with her mother, understands Billops's conflicting emotions.

Until this point, the film has relied upon conventional documentary techniques such as archival footage, interviews, and still images. But here, the film moves into what Lekatsas calls "a surreal theatrical interlude"[12] in which Wolfe, Billops, and Christa perform. This scene dramatizes the fear Billops cannot articulate verbally: meeting Christa means confronting her own failure as a mother.

In this interlude, Wolfe plays the role of the emcee at a mother-daughter recital for which Billops is auditioning. Billops, dressed in a frilly, white dress with a blue sash and waving a feather boa, attempts to lip-synch to her own voice yodelling on the soundtrack while a pianist, seated behind her, accompanies her (illus. 3). Billops is clearly uncomfortable in this role, however, and the emcee signals his displeasure. As Billops takes her bow and turns to thank the pianist, she discovers, to her horror, that the accompanist is her daughter dressed in man's clothing. This scene takes the place of the process of Billops's deliberation. Shortly thereafter, the camera cuts back to her in her loft. In a voice-over, she tells Simpson that she has decided to let Christa visit. She then gallops down the hallway to the sound of her own yodelling, linking her spoken words with the anxieties performed in the interlude.

3. Camille. *Finding Christa* (1991), 16mm film by Camille Billops and James V. Hatch. Photo © 1991 Camille Billops.

The first section of the film thus focuses on Billops's story. The second, in contrast, centers more on Christa, describing her life after she was left at the Children's Home Society. Through interviews with Christa, her adoptive siblings, and her adoptive mother, Margaret Liebig, we learn that she found what appears to be a nurturing, loving family. Margaret's dreams for herself had long included not only motherhood, but specifically adoption. After having had four children of her own, she adopted Christa to "satisfy this aching that was in [her] heart."

Margaret is also a singer; she encouraged Christa's love of music. Notwithstanding this support and nurturance, Christa is haunted by deep-seated frustrations dramatized in pantomimed home video sequences. Margaret says that she prompted Christa to find her biological mother in the hopes that that experience would bring her some contentment.

Billops's and Christa's reunion is played out in several scenes, including the filmed first meeting at Newark Airport (with the taped first phone conversation playing in the voice-over); a filmed party in the New York loft; and re-enactments of crucial moments in their reconnection. The decision to work with reenactments was at least partly circumstantial; the filmmakers decided to make the movie several years after the initial reunion, when Christa and Billops had had a chance to adjust to each other.

The film does not idealize the reconnection of mother and daughter, for Billops and Christa continue to have radically different needs. Billops continues, as Marianne Hirsch has put it, "to voice women's need for adventure and their exclusion from what she refers to as 'the news.'"[13] She ran away from the narrative consolidated by the family pictures. In contrast, Christa is desperately in need of the very relations Billops seeks to escape. As Margaret puts it, Christa missed "somebody to identify with," and by that, Hirsch rightly argues, "she means baby pictures and family photographs . . . The implication is that Christa will not recover until she, too, can read her history and constitute herself through such pictures, until . . . she can connect her present self to a past image of herself."[14]

The film is full of the still photographs and home movies Christa needs in order to reconstruct her personal and familial past. But the reenactments and interludes are the places where past and present tensions threaten to bleed through chronological order and recognizable features. In a stylized scene that follows shortly after a dramatic reenactment, Christa and Billops exchange memories and look at photographs as if they are playing cards or reading tarot cards. This sequence juxtaposes Christa's need to know and belong with Billops's need to draw and maintain boundaries. It establishes rivalries between mother and daughter, and hints even at a competition between the two mothers.

Margaret, the adoptive mother, conforms more to the familiar type of the black mother than Billops does. She has the physical appearance: she is

rounder than Billops, and possesses a ready, easy smile. She weeps almost immediately after she appears on camera and is openly affectionate. In contrast, Billops resolutely does not cry on camera. Indeed, as Hirsch points out, she even tries to distract her sister Josie when Josie threatens to break down. And she and Christa both remark that she doesn't like to be touched.

One might be tempted to say that when compared to Billops, Margaret seems to be the authentic black maternal voice in the film. But I would suggest instead that the construction and placement of her character and the responses she evokes should prompt us not to believe in her authenticity, but rather to scrutinize our own investment in the narrative and emotional weight of black maternity.

As was the case with *Suzanne Suzanne*, the visual style of *Finding Christa* thus complements its thematic and ideological concerns. The interweaving of interviews and archival footage presents one set of facts, but truths too intimate for direct testimony and too private for the spectatorial gaze are encoded in the hallucinatory interludes. In both films, stagey sequences question and contest the truth claims of still photographs and home movies, the stock in trade of the documentary mode. The very presence of the interludes reminds us that the more familiar representations adhere to certain conventions and are thus constructions in their own right. While they may point to the way things might have been, and they invoke the dreams that the past held dear, they can never fix a vision of the way things used to be.

For generations, photographs and home movies have knit dispersed family members together and marked their acquisition of material comforts. Having seen through the narratives these images manufactured, Billops uses her moving pictures to re-collect the stories shrouded in silence and secrecy. In this regard, her films may be seen to document yet another stage in the migrants' journey. For they show family members separated by violence and dashed hopes returning to and reclaiming the past as they venture into the uncharted territory of renewed relationships with one another.

Notes

1. The films of Billops and Hatch are available from Third World Newsreel, 335 West 38th Street, Fifth Floor, New York, NY 10018. Related essays have appeared in *Multiple Voices in Feminist Film Criticism*, ed. Diane Carson, Linda Dittmar, and Janice Welch (Minneapolis: University of Minnesota Press, 1994), and in *Black Film Review* 7, no. 2 (1993).

2. Bell hooks, "In Our Glory: Photography and Black Life," in *Picturing Us: African American Identity in Photography*, ed. Deborah Willis (New York: The New Press, 1994), 43–53. See also Deborah Willis's essay in this volume.

3. See Marianne Hirsch's eloquent reflection on the ability of photographs to link dispersed families in *Family Frames: Photography, Narrative and Postmemory* (Cambridge: Harvard University Press, 1997), xi–xii.

4. Theresa L. Johnson produces this numerical breakdown in her unpublished essay, "*Suzanne Suzanne*: Oral History in a Visual Frame."

5. George C. Wolfe, "Camille Billops," *A Journal for the Artist* 6 (Spring 1986): 27.

6. Annette Kuhn, "Textual Politics," in *Issues in Feminist Film Criticism*, ed. Patricia Erens (Bloomington: Indiana University Press, 1990), 250.

7. I am grateful to Elizabeth Gregory for calling this detail to my attention.

8. First Leo Spitzer and then other viewers have remarked to me that the artificiality of this scene is heightened by the fact that the positioning of Billie and Suzanne within the frame recalls a similar scene within Ingmar Bergman's *Persona*.

9. Earlier in the film Billie says, "No matter what time it was . . . the minute I heard [Brownie's] car door slam, I knew that he was drunk. So immediately, I'd get up and go get in the shower and cut the water on. I don't know what the water was doing for me, but I think it gave me time to compose my thoughts so I would have an answer for him, because I didn't know what he was going to say."

10. I thank Patricia Schechter for this observation.

11. Barbara Lekatsas, "Encounters: The Film Odyssey of Camille Billops," *Black American Literature Forum* 25 (Summer 1991): 398.

12. Lekatsas, "Encounters," 400.

13. Hirsch, *Family Frames*, 181.

14. Ibid.

Mein Kampf (My Struggle)

Art Spiegelman

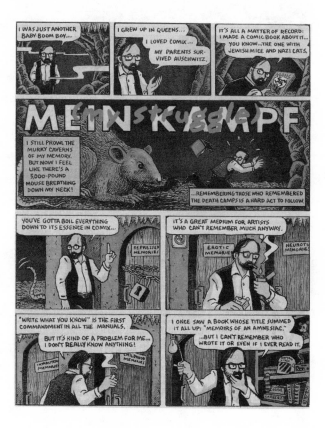

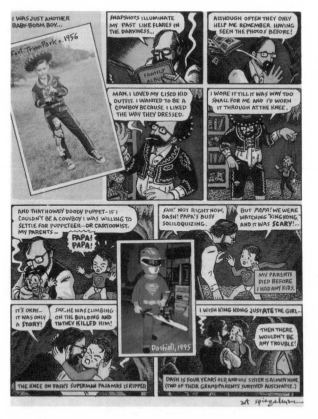

[Plate 8.] © Art Spiegelman. Also see the color plates section following page 134.

II. Double Exposures

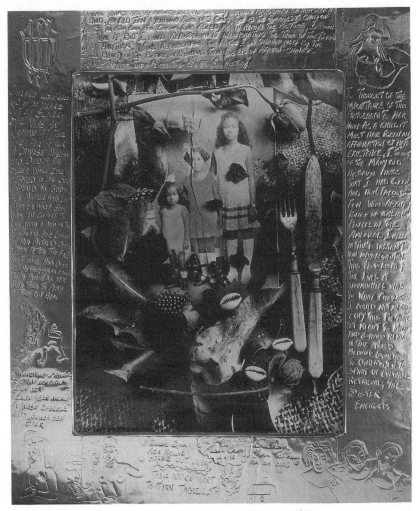

[Plate 9.] The Sisters, 1986. Also see the color plates section following p. 134.

The Sisters and Aunt Winnie

ALBERT CHONG

The Sisters

Several years ago, my mother sent me the only remaining picture of herself as a child—an old torn and yellowing photograph of three girls. She is the smallest child in the picture; the other two girls are her cousins. She asked me to repair the picture. I could not heal it, but I could rephotograph it incorporating the torn area of the image.

While rephotographing the picture, I became overwhelmed by the simple beauty of the image in its recording of three sisters of African-Chinese ancestry as they poised themselves for history. Jamaica was a mere sixty years out of slavery, and she was an orphan at the time. Her father, a Chinese musician, had died in his sleep while she played in the bed around his body. Her mother had left Jamaica when she was an infant to live with a man in Honduras. She learned of her mother's death months after the fact—that she had died of hemorrhaging caused by fright, as her man tried to play a joke on her.

I thought of the importance of this photograph to her, how as a child it must have been an affirmation of her existence, if only to her. I thought of the many old historical photographs I had seen, and of the fact that few contained people of color. I realized in that instant how inconsequential this photograph, and the lives that it illuminates, were to white civilization. I knew that I could not merely copy this picture, that it meant too much and should remain in the world meaning something to others. In this spirit of cultural retrieval, The Sisters emerged.

Aunt Winnie's Story

As Told to My Sister Marie Sang Demato by Winnifred Lynn

Winnifred Lynn was eighty years old on October 30th, 1994. Aunt Maudie (her mother's sister), the first person she remembers living with, told her that she was born in 1914 in Vere, Clarendon. She was born first, then her twin brother was born and died soon after birth. She remembers them saying that "your mother began throwing herself from side to side on the bed and died after the boy baby." Actually, I guess, in childbirth or shortly after giving birth.

She was sent to Kingston to live with her Aunt (Eva Florence Crawford), whom she called "Miss Clarke" (Mavis's mother). Her father, a full Chinese man named Thomas Lynn, whom she called "Papa Tom" (Our maternal grandfather), was a businessman and a musician who played a flute. He was living with Louise Hinds ("Aunt Lou," Momma's mother, our maternal grandmother) in Kingston. After a while she went to live with her father and Aunt Lou, who did not like her and treated her like Cinderella.

Aunt Winnie had to carry heavy baskets with fried fritters and food to deliver to the people who worked on the wharf, while her sister Peggy carried the money. Aunt Lou did not want to buy her shoes and clothes and sometimes would not send her to school. When Aunt Winnie went to visit Miss Clarke, she would buy her things and dress her up, even though she had other children (Aunt Beryl, Uncle Dudley and Miss May, Baby Bonty's mother, I mean Raymond—he would have a fit if we called him by that nickname).

Papa Tom took care of everyone "As most Chinese men always take care of their family and easy with money." Her father was a kind, quiet man who suffered ridicule because he had to raise a "black baby" after his marriage to Aunt Lou, who obviously was not his because she was having an affair with Douce (Beryl's father, who it seems was the person Aunt Lou really loved, and who eventually caused her death in Spanish Guiana).

Anyway, the Chinese men in the community would make fun of him and say how he was being fooled. After he gave up his shop, he used to do "Pickapow" (a kind of Chinese gambling, with thin parchment-like paper written in Chinese), which was illegal. One morning, Aunt Winnie went to her stepmother, Aunt Lou, and told her "Papa Tom look sick, he looks funny and not moving." Aunt Lou said "nothing wrong with him." Aunt Winnie went back to her father's room and saw him kind of shudder and shake and she was afraid and went outside and called a Chinese lady next door this time. That was it, her father was dead too, she had no one left.

People say her father was poisoned and when the police came they shouted out "Where de Chini-man de, dat dem poison." She remembers at her father's funeral the old people passing her over her father's body (superstitious ritual—so that she wouldn't follow her father in Death too).

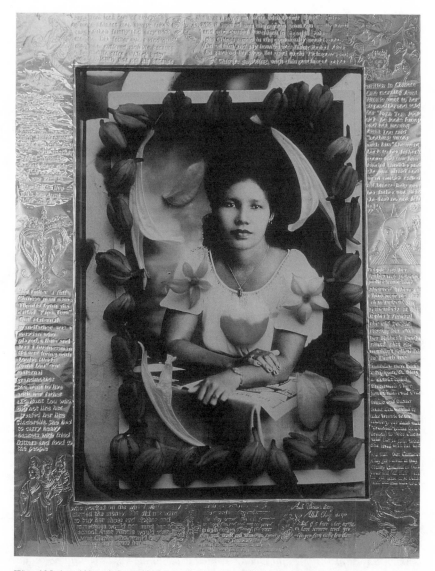

[Plate 10.] Aunt Winnie's Story, 1997. Also see the color plates section following p. 134.

 Aunt Lou decided to move back to Highgate, St. Mary (all Momma's family
came from a district called Fraserwood). Their family names were Fraser, Hinds,
and Baxter. Aunt Tunnie, who is well into her eighties, says that the family is so
big, don't get involved with anyone with those surnames. Aunt Lou wanted to
take Winnie to the country with her (she don't know why) but her dead mother
"dreamed" (came in a dream) to Miss Clarke and told her "since Tom dead why
Eva don't take Winnie? So Miss Clarke went to get Winnie. She lived with her

until she met Dadda (Mr. Cameron). They got married at Holy Trinity Cathedral on North Street and had their wedding reception at our house, at 30 Pembroke Road, and lived there for a while until they moved out on their own.

The private and sensitive part: Dadda was her true love. Through some misunderstanding and someone else they parted. She left Jamaica to sort of forget him and each was too proud to try to make up. Through the years they each would ask me "How is Miss Lynn" or "How is Mr. Cameron, and take this shirt for him for me." Aunt Winnie got married to Uncle Victor to stay in the United States and never really loved him in a passionate way. She once broke down in tears and asked me if I knew what it's like to have someone touch you all the time when you don't really love them (sort of like the Bridges of Madison County).

Uncle Victor was always trying to be funny to get her attention which sometimes annoyed her. Uncle Victor is now in his late nineties and when he became really senile and couldn't help himself he would sometimes lash out at her. I guess he knew too that she didn't really love him. Anyway she is very devoted to him (I guess because she felt guilty that she never felt the same way for him). Uncle Henry and him were in the army in Jamaica, when Uncle Victor was in his teens, I think. How about reincarnation? My guess is that she will probably get married to Dadda in the next life.

Now my side, what I can remember: Growing up, Aunt Winnie was "my other mother." She always wanted children and this was one of the tragedies in her life. When they said there was a ghost in our house at Pembroke Road who was making me sick and I needed a "change," they sent me to live with her and Dadda at Gadpile Avenue (on the side of Tropical Theatre) on Slipe Road (I think to this day when I hear "Die Fledermaus," a Strauss waltz, I always remember that house, because it was the opening song they played before the movies started). She shared a house with Miss Clarke and Mavis.

When Charles (Hubert's father) once hit me, she and Momma got into such a temper when I called them. I remember her telling him, "this is my child, the only thing I didn't do was have birth pangs, but I could kill you, and I will do it if you touch her again."

Aunt Winnie bought my wedding gown and sent it down to Jamaica when I was getting married to Clive. She was heartbroken because St. Luke's Hospital would not give her the time to come down for the wedding. There was even a rumor that Aunt Winnie and Dadda wanted to adopt me but Papa said no (how about that?). After Uncle Victor retired from Knickerbocker Bank and got really old, we thought it would be better for them to live closer, so Cavell got them to sell their house on Burke Avenue and buy a co-op on 54th Street. Mavis is her executrix but now she is older, she gets a little anxious. I promised her that wherever I move to when I leave New York, she will live with me. Aunt Winnie is like the Kissinger in the Family. She is the only one who Junie still talks to without animosity.

A Search for Self:
The Photograph and Black Family Life

DEBORAH WILLIS

As the first girl and third child of six children, I had no competition being
the keeper of our family photograph album. Snapshots were tucked in
drawers all over the house. I collected and put them together. I found, in
somebody's trash, a big heavy book that had been used for Christmas card
samples. Before pasting the photographs down, I spent weeks arranging
and rearranging the pictures to compose a story about my family life.[1]

So wrote photo-artist Clarissa T. Sligh in *Liberating Memory*, affirming the cen-
trality of photographs in the lives of African-American families. Reconstructing
her family photographs since 1981, Sligh's work is informed by memory, story-
telling, and archival images.

The photograph has long been used as an instrument of memory in the pri-
vate and public life of the family. This paper will present several readings of
how family photographs include and reveal provocative testimonies about fam-
ily realities. In reading African-American photographs in particular, the context
of production, reception, and recollection needs to be specified and analyzed.

1

The photograph has affected and transformed the lives of many black families,
particularly through the ways in which studio photographers photographed
black families in urban centers. As a curator and photographer, I interviewed
over twenty photographers who lived and worked in the 1920s as well as a

countless number of contemporary photographers who continue to aim the camera at the black community. A large number of them believe that photography is a self-conscious medium, and that their sitters and/or subjects have openly participated in the construction of their own image. As social historian Douglas Daniels observes,

> The photographs [of black San Franciscans] enabled me to visualize individuals' dress, posture, and bearing, and to compare these images with the stereotypes found in popular and scholarly literature, in cartoons, and in their written records.[2]

A number of black people felt that there were no representative images of their experiences published in periodicals or on postcards. Thus some felt it necessary to address this visual omission by setting up photography studios, writing editorials, and posing for the camera.

Testimonials were published in Crisis magazine in a 1915 advertisement for portraits of famous African-Americans produced by black photographer C. M. Battey. The series was entitled "Our Heroes of Destiny." These statements provide us with a sense of the need for this type of photographic imagery. The portraits were made of famous sitters such as Booker T. Washington, president and founder of Tuskegee Institute; poet Paul L. Dunbar; Frederick Douglass; and Reconstruction congressmen Blanche Bruce and John Mercer Langston.

Rev. Dr. Reverdy C. Ransom, New York City, says:
 "Your splendid production of 'Our Heroes of Destiny' marks the year of perpetuating characteristic and faithful likenesses of the famous men and women of our race, to be handed down to young generations, inspiring them with ideals which if carefully nurtured in their young lives will in their mature ages prove excellent examples of pure and dignified manhood and womanhood. No home where there is a child should be without a copy of this excellent work, and no parent that feels the love and loyalty of higher race development should fail to teach the child of their homes the meaning of the lives of these five men."

Mrs. Blanche K. Bruce, Washington, D.C., says:
 "I am indeed glad to say that 'Our Heroes of Destiny' is the most creditable work of art that has yet been produced of and for our people. The life likeness of the entire group is exceedingly good. It is a fitting memorial worthy to be in every home.
 "If we are to perpetuate the memories of our own great men, it must be by keeping their portraits ever before our youth, and familiarizing them with the true meaning of their lives."[3]

This essay begins to tell us "how" and "why" blacks have represented themselves so widely in photography. Yet does it tell us what black families feel or what their aspirations are? What do these photographs reveal about the sitter, the collector, or the photographer? How and why and by whom are they displayed or preserved? What narratives do we project onto these images as we view them today? And what stories can they tell us?

2

As I continue to assess the cultural value of the photographic medium and its impact on contemporary society, I would argue that the works of the noted contemporary photographer Clarissa Sligh, who is looking at her own family image and its construction, addresses the photographic experience of many black families who were photographed in the nineteenth and twentieth centuries.

Clarissa Sligh incorporates family stories and social politics into her art, inviting her audience to gaze into experiences—both collective and individual—of African-Americans who lived in segregated communities in the South. In shifting attention away from her personal experiences, she is able to analyze other shared experiences of black children across generations. She is well aware of the importance of the role she plays in preserving these family records, and in her art she places this story and stories of other African-American families within the larger picture of American history.

> The first time I constructed photographic images, the family was my point of departure. I came to it from making super-8 films, so I had a narrative focus that continued. It was easy, because in high school, I'd shot and developed photographs, and I had been the keeper of my family's albums. Back then, in the 1950s, I wanted to create a positive image of the black American family—but it was based on the stereotype of the white American family. I rarely saw anything positive about blacks in the newspaper. Making a family album was, for me, a reaction to all the negative imagery that was in the daily newspapers, one way of resisting those stereotypes.[4]

As she combines family photographs, history, and lived experiences, Sligh uses techniques of manipulation to look beyond the surface of the images. In the mid-1980s, Sligh traveled to North Carolina (her maternal family's home) to visit relatives, interview undertakers, and take photographs of neighbors. She made copies of family photographs and researched in courthouse archives, eventually obtaining copies of her family's cohabitation papers,[5] marriage licenses, and death certificates.

I recognized my grandmother's signature on a marriage license, which had the names of "her" parents . . . I felt my roots extending deeper and deeper . . . After that trip, I began reading slaves' accounts of their lives so I could get a picture—not only of how hard things were, I wanted to find out what kept them "human." What were their hopes? How did they function? How did they see themselves? What behavior patterns might have been passed down to me?[6]

In one of her most provocative series titled *Reading Dick and Jane with Me*, Sligh cogently reconstructs the images of Dick and Jane with snapshots from her family album. The standard American public school Dick-and-Jane-type readers, which were published from 1935 to 1965, presented what was perceived as the typical white, middle-class American family, living a relatively trouble-free life. *Reading Dick and Jane With Me* is an illustrated artist-book seen through the eyes of a black woman artist who spent her own childhood growing up poor in the American South of the 1940s and 1950s (illus. 1 and 2). It is a combination of lively repetitive words, photographs, and drawings. The repetition of words is a motif that appears in a lot of Sligh's work.

In my work in general, the words that get repeated are often all I have. It's like being stuck in a crack on a spinning record, but those are words that resonate throughout my whole body. I know it's a door to something, but I usually don't have a clue as to what that might be.[7]

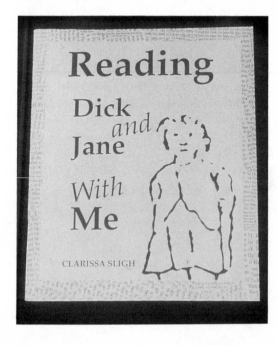

1. Title page from Dick and Jane Series, *You Play in Your Good Clothes*, by Clarissa Sligh. 1989. Visual Studies Workshop.
Courtesy of the artist.

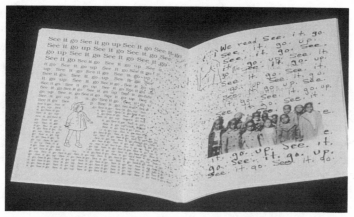

2. From Dick and Jane Series, *We Read See, It, Go,* by Clarissa Sligh. 1989. Visual Studies Workshop. Courtesy of the artist.

When she entered school, Sligh knew how to read full sentences and was confused by the short simple sentences spoken by Dick and Jane. The book thus undermined Sligh's own experience as a reader. In her work, Sligh reads the images of Dick and Jane, inserts words on each page, such as, "You play in your good clothes every page. We must keep ours nice for Sunday School Days." By making the black child visible, she directs us to the psychological effect that primary school readers had on black children. On the pages with the sentences, "See it go See it go up See it go," she writes in faint letters, "We don't talk like that, but, we try to read it anyhow."[8]

> As a young Black child, before I could even think, I was told how bad things are out there in the world for us. It was a fear put into me to prepare me for the real world. Since we couldn't talk about it, since no one could relate to our hurt or pain, we learned to be silent, to hide our disappointments, to hide our anger at the distortion of our identity and the exclusion of our reality.[9]

Sligh's work is significant not only because she addresses the unconscious experiences of racism and sexism, but also because she reconstructs her own actual experiences and those of many others who can identify with her.

As a baby boomer, who grew up in the North in the fifties and sixties in a segregated neighborhood, my life was complicated by having supportive black teachers and mean, degrading white counselors. Along with Sligh, I questioned the portrayals of Dick and Jane and how different their lives were from our own. In contrast, the young photographer and writer Carla Williams was raised in an increasingly integrated Los Angeles community in the seventies and eighties as part of "Generation X." Her intriguing reading of Sligh's *Dick*

and Jane series presents a different sort of frankness. Williams's analysis high-lights the implicit sexuality in Sligh's work. In addition, she writes about how sexual abuse and desire in some families is transmitted in subtle language.

It is difficult—if not impossible—these days to read a *Dick and Jane* primer with an innocent eye. In fact Sligh's text is more innocuous than is some of what actually appeared in the books. Witness the following excerpts from the 1956 edition of *The New We Come and Go*, from the first story, "Come":

COME, SALLY.
COME, COME.
OH, SALLY.
COME, COME.
COME, COME, COME.

and from the story "See Jane Go":

OH, SALLY.
SEE JANE GO DOWN.
DOWN, DOWN, DOWN.
SEE JANE GO DOWN.

and from, "See It Work":

FATHER SAID, LOOK, SALLY.
SEE SOMETHING BIG.
YOU CAN SEE IT WORK.
UP, UP IT COMES.
SEE IT WORK.
SALLY SAID, SEE IT WORK.
WORK, WORK, WORK.[10]

Race is not the only factor in Williams's examination of Sligh's work. She al-lows us to find in photographic images a nexus of the interrelations of race, sexuality, and class.

Sligh's own family photographs, particularly those made of the children in her family, became the focus of her examination. The childlike written text be-gins large across the top of the page, changing in scale as the words move down the page. Sligh's series begins with her own renderings of Dick, Jane, and Spot; on the opposing pages she includes her family snapshots with re-worked text. *Run Dick Run* presents a haunting image which includes a group of single photographs and a childlike figure wearing a mask resembling a Ku

Klux Klan hood. She invites the viewer to ponder the notion of what running means to black children in the South and the playful running in the *Dick and Jane* reader. I am not implying that black children did not run and play, but fear was always a factor in rural areas in the South. In her attempt to empower the children in her series, Sligh writes:

These stories seem more real than us.
Everybody is so perfect.
Everybody is so right.
Who we are begins to slip away.
When our school books sound like we should be that way.
Could we be that way.

The therapeutic effects of Sligh's translation of Dick and Jane and the resulting positive, nonstereotyped black images of black Americans are examples of how the self can be reinvented as well as empowered through photographs.

3

Historically many black sitters wanted to celebrate their achievements and create a sense of self-worth in their posing. Black photographers like James Van-DerZee (New York) visually transformed the stereotypes of blacks. VanDerZee's portrait of his cousin Susan Porter demonstrates this self-consciousness. She is well-dressed, well-coifed. She is reading sheet music. The wallpaper is elaborate and the paintings on the wall suggest that she is a collector of fine art. As Mary Schmidt Campbell suggests in looking at the transformative qualities of VanDerZee's photographs, it was partially real pride and partially carefully constructed artifice.[11] The sitter provided the pride, and the black photographer provided the artifice. The black photographer was aware of his/her role of preserving a *likeness*.

Art historian Barry Gaither writes:

Photographers played an integral role in how Blacks visualized themselves in the 1920s. Photographs provide accessible imagery for virtually all levels of the community. Photographers were therefore natural witnesses to an extraordinary banquet of lives, from great public occasions such as the return of World War I black regiments to intimate events such as the funeral of a child. The photographer, with reasonable technical expertise, could not only document events, he could also project how the client wants to remember the event. Reflecting their close relationship with clients, photographers gave direct expression to client visualizations.[12]

I Sell the Shadow to Support the Substance.

SOJOURNER TRUTH.

3. Sojourner Truth, abolitionist, 1864. Gelatin silver print. Photographer unknown. National Portrait Gallery, Smithsonian Institution.

One famous sitter who stressed the control of her image was Sojourner Truth (illus. 3). Historian Nell Irvin Painter's recently published biography of Sojourner Truth includes an insightful chapter on photography entitled "Truth in Photographs."

Her favorite photographs, taken in Detroit in early 1864, are conventional portraits. Most of them are cartes-de-visite [calling cards] in the vernacular style, showing no landscape. The props are standard: her own knitting and objects supplied by the photographer (a book and flowers) as simplified tokens of leisure and feminine gentility. As in her other photographs, Truth wears expertly tailored clothing made of handsome, substantial material, here the black or gray and white she favored for public speaking. Sometimes she is dressed in the Quaker-style clothing that feminists and antislavery lecturers wore to

distinguish themselves from showily dressed actresses, their less rep-
utable colleagues in female public performance . . . In later
photographs, Truth poses in the fashionable clothing she learned to
wear in Washington, the only indication that association with middle-
class blacks—whom she herself does not mention—might have
altered her personal aesthetic.[13]

Yet, Truth used the medium not only to record and create a constructed self
but also to create an audience for her work. In effect, Truth sold her images in
order to support herself. She lectured on the conditions of slavery to groups
throughout the free states. Painter writes of Truth: "She . . . asked readers to
purchase her photograph, in nineteenth-century parlance, her 'shadow.' Col-
leagues should buy her carte-de-visite, she said, because 'I am living on my
shadow.' "[14] The caption on her cartes-de-visite and larger cabinet cards read "I
sell the shadow to support the substance. SOJOURNER TRUTH."

For the most part, however, studio portraits of African-Americans were
commissioned for personal collections, although photographs of well-known
black personalities were bought and sold as art, traded as cartes-de-visites,
and published in books and periodicals. As soon as studios opened in Amer-
ica, the art of portrait-making became a respectable business. By 1840, thou-
sands of Americans (black and white) were producing daguerreotypes. Al-
though there are several books and articles written about the early
advancements made in the art of photography, few written records exist con-
cerning the value of the medium to African-Americans as subjects. A few ex-
ceptions include a moving account researched by Jeanne Moutoussamy-Ashe
in her book *Viewfinders: Black Women Photographers*, in which she relates a
poignant story of an enslaved woman in 1859:

Louisa Picquet was born a slave and was separated at the age of four-
teen from her mother, Elizabeth Ramsey. The two managed to maintain
communication through letters written by others, with the permission
of their white slave masters. They frequently requested photographs
from one another, for this was becoming a common way for people to
keep mementos of each other, although it was not a common practice
among slaves. In fact, it was a rarity and was only done with the money
and permission of the slave owner.
 In one letter, Mrs. Ramsey wrote:

March 8, 1859
Whorton, Texas

My Dear Daughter,
I want you to have your ambrotype taken also your children and send

them to me I would give this world to see you and my sweet little children; my god bless you my dear child and protect you is my prayer.
Your Affectioned Mother

Elizabeth Ramsey

In a second letter, written after the daughter answered her mother's letter and also requested a daguerreotype, the enslaved mother answers her daughter's letter, writing,

It is not in our power to comply with your request in regard to the daguerreotypes this time, we shall move to Matagorde shortly, there I can comply with your request.

Elizabeth Ramsey

In a letter to Louisa, the owner of Elizabeth Ramsey wrote:

I send you by this mail a daguerreotype likeness of your mother and brother, which I hope you will receive. Your mother received yours in a damaged condition . . .
Respec'y yours,

A. C. Horton

In a letter he wrote for Louisa Picquet (circa 1860), the Reverend M. R. Mattison of the A.M.E. Church described the daguerreotypes as "both taken on one plate, mother and son, and are set forth in their best possible gear, to impress us in the North with the superior condition of the slave over the free colored people." In this case, photography was used by the slave owner as a way of making others think slaves were better off than free persons.[15] Family relationships are used as part of the slave owners' discourse of self-justification. These letters express the important and multiple uses of visual culture and the urgent impact of the image. Unfortunately, the images are not housed in any known public or private collections.

4

Family collections, as in the case of my own family, include photographs of every aspect of black rural and urban life in America, including political and social life, fraternal organizations, education, families, architecture, and military, artistic, and social activities, such as sports and public pageantry. Most

photographs produced in the early years were made to commemorate a special occasion in the sitter's public and family life, such as achieving social/political status, or courtship, marriage, birth, and death.

The research of Douglas Daniels has demonstrated that photographs provide important documents for the historian:

> While historians have used literary documents to depict Blacks as help-less subjects, photographs allow us to see many of them as confident human beings. Occupation, income, education, and similar variables are important for assessing accomplishments and status, but I would also emphasize the public image or self-image that is presented. Scholars can use photographs to study historically "inarticulate" segments of our population. Since most ordinary Americans leave few, if any, written records—diaries, autobiographical memoirs, or letters—historians and others must start taking seriously such seemingly inconsequential material as family photographs, snapshots, and albums . . . For understanding the self-image of Blacks, photographs are especially useful when they are portraits approved by the subjects because they find the likenesses flattering.[16]

For many black photographers, the warm, supportive family is central to the life of the African-American community, and they never tire of exploring it as a subject, from the earliest images made of black families, through count-less wedding portraits, to poignant photographs of parents holding their children. As Daniels stresses, we must analyze the relationship between photographers and their clientele. James Baldwin, writing about the residents of Harlem in his memoir *Nobody Knows My Name*, suggested that,

> They struggle to instill in their children some sense of dignity which will help the child to survive. This means, of course, that they must struggle, solidly, incessantly to keep this sense alive in themselves.[17]

The fruits of this observation can be seen in the works of black photographers who document the family.

Photographic curator Peter Galassi offers an analysis of family photographs that closely expresses my own thoughts:

> Perhaps the most ubiquitous of all photographs, snapshots are also the most hermetic. To the insider, to the member of the family, snapshots are keys that open reservoirs of memory and feeling. To the outsider, who does not recognize the faces or know the stories, they are forever opaque. At the same time, because we all have snapshots of our own, and thus know the habit of understanding them, we all are equipped to

4. Great Uncle, World War I.
Courtesy of Willis-Kennedy Family
Collection.

imagine ourselves into the snapshots of others, into the dreams and the
passions they conceal.[18]

As I write about photographic images that relate to family stories, I often en-
counter poets, writers, painters, and photographers who also use the family
theme to contextualize their art form. Studying photographs as a point of de-
parture has inspired me to reflect on my own family pictures and to place
them into my artwork.

I am intrigued by two photographs that are in my own family album. One
photograph is of my great uncle (illus. 4). My paternal grandfather's brother,
who fought in France in World War I, posed for a photographer in Virginia
upon his return from war. He is in full uniform and holds a pistol. The studio is
draped in the fashion of the period. The pattern on the rug is a bit distracting.
My great uncle's gaze speaks of loneliness, but, the uniform informs us of a
bond with other men. His eyes are my eyes. Large and silent.

5. Thomas M. Willis, World War II. Courtesy of Willis-Kennedy Family Collection.

My father sent his own portrait home to my mother, his new bride (illus. 5 and 6). His pose is full of hope and pride. His adventure of leaving home to join the war and travel around the world was a story told throughout my childhood. He is holding a real rifle and is also in full dress. My father in combat helmet, looking directly into the camera, appears to be sending home a message. Could the message be that he is finally preparing for war? As with other black soldiers in World War II, he was given a wooden rifle to practice with, as the government did not give black men real rifles and ammunition in war game simulations. He signs the photograph, "your hubby." The photograph printed on a post card was made in Germany. My mother sent him a photograph of herself standing in a photographer's studio, smiling and sending a silent mesage to him. Probably "come home safe."

After my father's untimely death in 1990, I found myself searching through his trunk of photographs in an attempt to preserve his memory. I was struck by the range of photographs he produced and tucked away. They were images of graduations, weddings, family reunions, funerals, birthday parties, as well as other family occasions. I constructed a quilt about a photograph taken by my father the day after Christmas in 1955, a snapshot of my sister, Yvonne, and myself at the ages of seven and five (illus. 7). My sister and I posed for the camera holding our brand new Christmas presents, dolls. As I looked at the snapshot, I saw that our smiles were wide as we sat before Daddy's camera. We are seated on a sofa and my father's flowered wallpaper seems to clash with our dresses. I remember helping my father paint glue on the living room wallpaper. Both of us

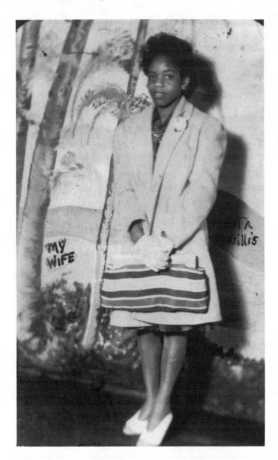

6. Portrait of my mother, Ruth Willis. Courtesy of Willis-Kennedy Family Collection.

are wearing plaid dresses with wide collars. I am on the left, holding the black, brown-eyed doll, and my sister is cradling the white, blue-eyed, blond doll. I had no recollection of posing for this photograph, but I do remember the dolls. When I look at this image today, I reflect on the "Dolls Test" devised by black psychologists Kenneth and Mamie Clark.[19] In an attempt to investigate the development of racial identification and preference in African-American children, the Clarks performed a test in which black children were asked to select a white or black doll to play with. Results of the test showed that the black children, ranging in age from five to seven, clearly rejected the brown-colored doll, preferring the white one. The test asked the black children to select the doll that was most like them. Other directions included:

Give me the doll that you like to play with or the doll you like best; Give me the doll that is the nice doll; Give me the doll that looks bad; or Give me the doll that is a nice color.

7. Deborah Willis and Yvonne Willis, sisters, 1955. Photo: Thomas Willis. Courtesy of Willis-Kennedy Family Collection.

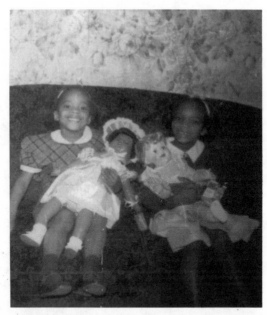

The majority of the African-American children who took the test indicated an overwhelming preference for the white doll—as synonymous with the nice doll, with nice color, the doll they "liked" the best.

In looking at this snapshot, I find it a real-life, personal illustration of this test. I wonder now when I became aware of racial identification in toys. This photograph also allowed me to recall a disturbing incident, one that I became aware of in the middle of a lecture at the University of Colorado in Boulder in April 1996. As I began to describe the photograph during the lecture, I suddenly remembered that I had a friend in elementary school named Susan. All I remember about her was her blue eyes and her long, bushy, blonde ponytail. Her family was the only white family on the block. Many of my parents' friends termed them the "last ones left." We played together when we were five and attended kindergarten; but once we entered the first grade, our lives changed. I do not know why, but I recalled standing on her doorstep asking her to come out to play and her father coming to the door and saying very rudely that she could not play with me anymore. I now remember feeling rejected and confused and innocently asked, "Why?" He said loudly that she could not play with "niggers." What a shock for me! I did not know what that word meant, but I somehow knew it was a dirty word. I did not move. I sat on her step crying. All of this happened as I pushed on to the next slide, trying not to let the audience know that I had slipped back into a childhood memory. As I attempt to reread this photographic memory, I see the black doll as a projection of the loss of a friend.

5

The societal pressures to create representative images of black men, women, and children resulted in the success of black studio portraiture throughout this country. Black studio photographers, working under strained social conditions, offered a profound opportunity to transform images of their black communities. Angela Davis offers this analysis of this period in black photo history:

> As they [black photographers] worked with their cameras, selecting their subjects, composing their images, how were they affected by the raging violence of racist mobs, those black massacres euphemistically known as "race riots?" . . . did any of the early twentieth century Black photographers attempt to record images reflecting the omnipresent and devastating racism of those years? . . . What Afro-American photographers sought to forge true black images, pictures whose creative power could expose and condemn the evolving visual mythology of racism?[20]

The implicit racial content of family photographs by Clarissa Sligh and James VanDerZee can be contrasted with the messages conveyed by stereotyped images and the mythology they create. Photographer Christian Walker's own personal observation about his family album underscores the conflictual situation facing black photographic subjects:

> In every African American family album there is an image that points to what James Baldwin has identified as the "Negro's past of rope, fire, humiliation, castration, and death." It is in those aging and fading pictures of relatives, living and dead, that one finds the underlying nature of self-actualization and its antecedent, the internalization of oppression. In my family album the most joyous photographs were of those relatives who seemed to have survived the subjugations of race, color, and class. Yet for me, the images that held the most dramatic power were those of relatives who had chosen to live and love primarily in a white social context and who were, subsequently, plagued by breakdowns and dysfunctions.[21]

Mixed messages are encoded in every photographic image by historical evidence, the contemporary viewer's understanding of material culture, and the nuance of personal experiences. In my own family album, the most significant photographs were of those relatives who seemed to be the ones chosen to document the commonplace moments, the daily rituals—the messages from the front, or the gift of two dolls.

NOTES

1. Clarissa T. Sligh, "Reliving My Mother's Struggle," in *Liberating Memory: Our Work and Our Working-Class Consciousness*, ed. Janet Zandy (New Brunswick, N.J.: Rutgers University Press, 1994), 255.

2. Douglas Henry Daniels, *Pioneer Urbanites: A Social and Cultural History of Black San Francisco* (Philadelphia: Temple University Press, 1980), 11.

3. Quoted in Deborah Willis-Thomas, *Black Photographers 1840–1940: A Bio-Bibliography* (New York: Garland Publishing, 1985).

4. Interview with Clarissa Sligh, August 25, 1995.

5. In the state of North Carolina, enslaved Africans were not permitted to marry; however, their owners allowed them to live together, provided that they register their relationship every five years in the county courthouse.

6. Interview with Clarissa Sligh, August 30, 1995.

7. Ibid.

8. Ibid.

9. Quoted in Deborah Willis, "Clarissa Sligh," *Aperture* 139 (Winter 1995): 11.

10. Carla Williams, "Reading Deeper: The Legacy of Dick and Jane in the work of Clarissa Sligh," *IMAGE* 38, nos. 3–4 (1995): 4–5.

11. Mary Schmidt Campbell, "Introduction," *Harlem Renaissance: Art of Black America* (New York: Abrams, 1986), 36.

12. Barry Gaither, "Imagining, Identity and African-American Art or, It's Me You See!" in *Convergence: 8 Photographers*, exhibition catalog (Photographic Resource Center, Boston University, December, 1990), 10.

13. Nell Irvin Painter, *Sojourner Truth: A Life, A Symbol* (New York: Norton, 1996), 186.

14. Ibid., 197.

15. Jeanne Moutoussamy-Ashe, *Viewfinders: Black Women Photographers* (New York: Dodd-Mead 1986), 6.

16. Daniels, *Pioneer Urbanites*, 9.

17. James Baldwin, *Nobody Knows My Name* (New York: 1961), 129.

18. Peter Galassi, *Pleasures and Terrors of Domestic Comfort* (New York: The Museum of Modern Art, 1991), 11.

19. Psychologist Kenneth Clark, along with his wife, were the social scientists behind the *Brown v. Board of Education* decision. Clark provided the evidence, cited by the justices, that segregated schooling is psychologically damaging to black children. More information about the Clarks can be found in Gerald Markowitz and David Rosner, *Children, Race, and Power: Kenneth and Mamie Clark's Northside Center* (Charlottesville: University of Virginia Press, 1996).

20. Angela Davis, "Photography and Afro-American History," in *A Century of Black Photographers: 1840–1960* (Providence: Museum of Art, Rhode Island School of Design, 1983), 27.

21. Christian Walker, "Gazing Colored: A Family Album," in *Picturing Us: African American Identity in Photography*, ed. Deborah Willis (New York: The New Press, 1994), 66.

Domestic Borders, Cultural Boundaries: Black Feminists Re-view the Family

ELIZABETH ABEL

If family photography typically serves to perpetuate conservative social values and traditions, do its politics change when survival is at stake?[1] Picturing the African-American families that have long served as a primary refuge from and target of racial abuse would seem a crucial way of honoring the social relations that have enabled survival against the odds. Systematically pathologized as fractured, disorderly, dysfunctional, and destitute, as lacking both the structure and the substance of familiality, as the deviant other of the white middle-class norm, the black families that have also been the site and source of cultural renewal demand an affirmative point of view. But in what terms and at what cost?[2]

Gender is immediately and complexly at issue here. For if the conventions of family photography must be critiqued as the products and servants of patriarchy, should we disparage whatever authority they confer on those fathers whose putative absence or weakness (their famous "emasculation") has been the linchpin of attacks on the black family? Black feminist cultural critics are thus positioned delicately, especially since the photographers who were their cultural and sometimes biological fathers were the first to give visibility, and thereby greater legitimacy, to the sustaining structures of African-American families. Yet by enabling these structures to be more distinctly seen, these photographing fathers also enabled their aspiring female heirs to produce a sharper gender critique. Adopting the paternal vantage point gave daughters a clearer vision of the familial roles through which women were confined and a way to gain some detachment from the position of their mothers. Daughters couldn't simply assume the paternal vantage point, however, for endorsing the

paternal gaze required that they be its object rather than its subject. The African-American daughter who sidesteppped conventional gender roles as a route to and consequence of the paternal perspective on the family could find herself consigned by this perspective to a passive, asexual, domesticated—and whitened—femininity.

The father-daughter nexus thus limns some crucial fault lines in African-American family photography. In its most innovative and unfettered mode, best exemplified by the emotional intimacy of Roy DeCarava's photographs, made famous through their publication in *The Sweet Flypaper of Life*, the capture of private and spontaneous moments on film makes more visible the distinctive shapes and textures of African-American domestic life.[3] Generations of professional and amateur black photographers derived inspiration from the warmth and informality of DeCarava's photographs, yet also succumbed to pressures to use the camera to affirm traditional patriarchal structures and authority in order to counter the alleged deformation of black families. In these more defensive and daily practices, black family photography paradoxically effaced, rather than expressed, cultural specificity by mapping the visual conventions of the white middle-class family onto more extensive, variable, and fluid kinship relations.[4] At the heart of these conventions is domestic ideology. There is thus considerably more at stake for black feminist daughters than for their white counterparts. Subject to more stringent and persuasive prohibitions against undermining the disenfranchised black father's authority, they also risk more by submitting to a patriarchal vision that threatens to resubject them to the norms of white femininity with which they are already assaulted by the dominant culture (at times with their mothers' complicity). The daughter's visual affiliation with the father thus offers a sobering counternarrative to the more familiar and salutary discourse of voice that affiliates African-American daughters with their biological and cultural mothers. Whereas an oral matrilineage has served as a powerful figure and conduit of cultural continuity, the visual dynamics between fathers and daughters provide a flashpoint for the pressures of mimesis that the dominant culture brings to bear on the self-representation of African-American families.[5]

I hope in this essay to anchor some of these speculations in readings of a few nodal texts, or at least a few nodes within these texts, which analyze or stage the intersections of culture and gender in photographs of African-American families. In the early 1990s, a new discourse emerges: composed within a few years of each other, Deborah Willis's introduction to her pathbreaking anthology *Picturing Us: African American Identity in Photography* (1994), bell hooks's contribution to that anthology, "In Our Glory: Photography and Black Life," and Carrie Mae Weems's phototext *Untitled* (Kitchen Table Series) (1990) conduct an implicit conversation about photography's crucial role in representing families which both instantiate cultural boundaries and constitute a site where these boundaries are invariably, yet variously, transgressed. Products of a particular

cultural moment, these texts are nevertheless not circumscribed by it. Whereas Willis and hooks reflect on their conflictual relation to the paternal gaze in their childhood homes in the 1950s, Weems radically appropriates this gaze to interrogate the sexual politics between adult women and men who try to make a home together in the 1990s. The Kitchen Table Series offers a final rehearsal and unraveling of the family romance. By shifting to a mature female perspective, that of a woman who happens also to be a mother, Weems also reinterprets racism's gendered lines of access to the home: as the dynamics of the gaze are feminized, voice becomes a primary conduit for the dominant culture's pressures on men. Bringing together the two cultural critics' retrospective gazes with the photographer's self-consciously feminist images that question how family in the 1990s might be staged thus enables us to extend our gaze in two directions: backward toward the fortification of the patriarchal family as a bulwark against racism in the segregated culture of the middle of the century and forward toward reconfigurations of race and gender at the century's end. Far from comprehensive, these brief but intricate textual moments offer at least some starting points for thinking about the shifting relations among domestic borders, cultural boundaries, and African-American photography in the second half of the twentieth century.

My own authority to speculate on these issues is dubious at best, at worst a reinstatement of what hooks decries as a "white colonizing eye, a white supremacist gaze."[6] As one (however idiosyncratic and dissident) incarnation of white femininity, I risk reproducing the visual power relations that the texts I analyze are working to undo. I would hope, however, that by foregrounding and theorizing the perspective of an avowed outsider, I will not so much neutralize the politics of cross-racial viewing as give them greater visibility. This project is clearly no substitute for the perspective of the authoritative insider, the vantage point that Weems singles out for praise in the work of DeCarava as an intimacy with the "idiosyncratic gestures and rituals" of black culture that recognizes how these rituals emerge "out of the peculiar social, economic and cultural conditions that mould black people."[7] But perhaps my standpoint offers something different by shifting our gaze from the particulars of cultural interiors to the pressures that come from the outside. My estrangement from the inner sanctum of this family circle may enable me to see what is alien inside.

1

Deborah Willis opens her introduction to her landmark collection *Picturing Us: African American Identity in Photography* with a landmark moment in her own development and that of black photography: her discovery, at age seven, of the just-published collaborative volume, *The Sweet Flypaper of Life*, with photographs by Roy DeCarava and text by Langston Hughes. It was a transformative

moment in her own life as well as in that of black photography. "I was excited to see the photographs: it was the first book I had ever seen with 'colored' people in it—people that I recognized, people that reminded me of my own family . . . For me a veil was lifted."[8] DeCarava's photographs lift a DuBoisian veil of whiteness that has shielded black people from their own experience—but only by imposing a more permeable veil that, by representing black experience, allows it to be seen.

This mediated access to vision is gendered in Willis's account.[9] The public collaboration of DeCarava and Hughes is reiterated in a private collaboration between her father's cousin, the official family photographer with a commercial studio near the house, and her father, a "serious amateur photographer" whose pictures his young daughter loved to arrange in an album she modelled on *The Sweet Flypaper of Life* (4). Willis embeds this narrative of visuality within a differently gendered story, which precedes it and shifts the significance of its terms.

> In 1955, when I was seven years old, my mother decided that she wanted
> to be a beautician and enrolled in the Apex Beauty School on South
> Broad Street in Philadelphia. My Mom had three daughters, four sisters,
> four aunts, nieces, a mother, and grandmother. All of them supported
> her interest in becoming a hairdresser. Still, a few were a little skeptical
> when Mom wanted to put a hot comb to their roots. Her daughters,
> however, had no choice; we had to experience that "rite of passage."
>
> Nineteen fifty-five was also the year Langston Hughes and Roy De-
> Carava published *The Sweetflypaper of Life*. (3)

Willis opens her autobiographical introduction to *Picturing Us* with this intensively, almost redundantly, female kinship world whose aesthetic medium is the female body. Why, we might ask, is this the scene she chooses to launch her account of her professional trajectory? The sequence itself offers a clue: representation provides an exit from a claustrophobic feminine immediacy. The narrative juxtaposes the weekly bodily rites of the "kitchen" where her mother "did hair" with the weekly ritual trip to the public library where Willis discovers DeCarava, and contrasts the disciplinary hot comb of the mother with the liberating lens of the father. The two narratives converge in Willis's account of "reading" DeCarava's photographs in the kitchen while awaiting her dreaded turn for hair straightening and listening to her sister or cousin wail; entering the realm of lighting and pose she finds with delight in the photographs appears to have the effect of endlessly deferring or displacing bodily pain, for Willis never describes her own subjection to the hot comb. Rather than granting direct access to the body, lifting the white veil transpires through an alternative textuality that mediates the relation to the body: the section and day that open in kitchen conclude with a return to library: "I made it a point

from that day in 1955 on to continue to look for books that were about black people and to look at photographs that told or reflected our stories" (4).

The relation to the female body, of course, was always already mediated in ways that further complicate this picture of race and gender. The hair rituals of the kitchen are a resonant but multivalent metonymy of black domestic culture, for they constitute at once a scene of cultural specificity and of cultural domination, a paradox well captured in Willis's description of her mother putting the hot comb to the female clan's "roots."[10] Straightening out the roots is also deracinating them. The "rite of passage" to which these black girls are subjected initiates an adulthood shaped in part by norms of white femininity. These norms have already infiltrated the psyche of the seven-year-old Willis, who voices her thrill at discovering DeCarava's black female subjects—"black women in tight sweaters dancing sensually"—in terms of their resemblance to "the movies of Marilyn Monroe!" an irony heightened by the comparison's location immediately before the figure of the veil. The female body that grounds cultural identity is also a point of cultural pressure and vulnerability.

The interaction between the mediating vision of the fathers and the bodily practices of the mothers as equally complex and inevitably imperfect sites of authenticity crystalizes in the opening photograph of the essay (and the volume), the image that stands as the representation of the family and serves as a visual point of origin for Willis's professional engagement with photography. The "Untitled Snapshot of My Sister Yvonne and Me," taken by Willis's father the day after Christmas in 1955 (and included with Willis's essay in this volume on p. 121), shows two captivating little girls smiling broadly at the camera and holding on their laps the dolls they have just received. Deborah, whose smile is slightly broader, cradles a brown-skinned, dark-haired doll in her left arm; Yvonne holds a fair-skinned, blonde doll in her right arm. Drawing on the famous dolls test that Kenneth and Mamie Clark devised in the 1950s to document racism's effect on the self-image of black children, Willis emphasizes her unusual childhood ability to identify with brown skin positively; unlike Yvonne, who along with the great majority of African-American children in the 1950s, has succumbed to the colonizing influence of whiteness, Deborah has always resistantly preferred the dark-complexioned doll.[11] Taken the same year as her discovery of DeCarava, Thomas Willis's photograph, his daughter concludes, "offers insight into [her] early interest in understanding African American material culture" (6).

The photograph itself, however, tells a somewhat more troubling story. Unlike DeCarava, Thomas Willis has not so much displaced the white veil as demonstrated how it has divided the black female child from herself and intruded between the future mother and her image of her child. Yet Willis's photograph does not repudiate that intrusion: by lovingly embracing both daughters, the paternal image resists, as well as mandates, one daughter's dedication to expunging the emblem of white femininity. In contrast to *her* verbal rhetoric

of difference (between black and white, her sister and herself), *his* visual rhet-
oric emphasizes contiguity and slippage. The paired little girls seated side by
side on the couch share a strong family resemblance, and the two dolls, whose
heads appear to touch, are contrasted in color but similar in size, features, and
demeanor; the differences between them are only skin deep—these dolls
model only superficially different versions of the domesticated femininity both
little girls embrace.[12] Whereas Deborah deflects the paternal gaze to refocus
on the black-identified child's singularity and vocation, the photograph's
metonymic linkages suggest the costs of trying to excise the next of kin. In this
rendition of the father's legacy, gaining distance from the proximate female
body implies dislocating the (suspect, vulnerable) body closest to—perhaps
not fully separate from—one's own in the effort to rectify, rather than to repre-
sent, the white penetration of the African-American home.

The repressed returns in the essay's final photograph: *Daguerreotype Por-
trait of Young Black Girl Holding a White Baby, c. 1850s* (illus. 1). Willis's intro-
duction to *Picturing Us* moves backward in time through a visual history of
lynching, beating, and degradation to culminate in this haunting image, self-
consciously and multiply framed in graduated shapes and kinds of wood that
direct our eyes to the pair at the center, where a young African-American
woman, herself still a child, is framed by her function as a nanny for a formally
dressed and posed white baby girl whose ivory skin is illuminated by the light
source to her right; the white child's expressionless face and slightly unfo-
cused gaze reinforce the doll-like impression she creates. The black teenager's
unsmiling face and unflinching gaze at the camera confront us with her dis-
comfort at the role she is required to play, but her torso fades into the image's
dark background; she is allowed only enough visibility to serve as a prop for the
child she holds erect with her right arm. (When I first read this essay on a
plane trip, a flight attendant peering over my shoulder commented, "I don't
mean to eavesdrop, but that sure is a beautiful picture. Oh! I didn't see there
was a lady in the background. I just love the frame.") Rather than displacing
this scene of subjection, the essay is drawn back to an image of the sister who
holds a white baby doll on her lap. The white child in the black family and the
black child in the white family converge in the same cross-racial female pair.
Produced a hundred years before Thomas Willis's photograph, the daguerreo-
type frames the text with an elaborately framed image that exposes the roots
and tenacity of the white doll's affective claim. As the "Young Black Girl," slave
or servant, from the 1850s looks forward and backward to the young black girl
of the 1950s, the essay's visual frame complicates its verbal pledge to picturing
an uncontaminated cultural terrain. The mobile positions generated by
Willis's multiple loyalties shift, in the course of her analysis, from a paternal
identification that seems to offer some remove from, but also to reiterate, the
female body's subjection to contradictory regimes, to an identification with the
sister, literal or figurative, whose body is the target of those competing claims.

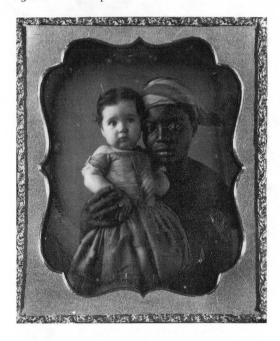

1. Daguerreotype *Portrait of Young Black Girl Holding a White Baby*, c. 1850s. Photographer unknown. Courtesy The J. Paul Getty Museum, Los Angeles.

2

Willis opens her preface to *Picturing Us* by recalling a conversation with bell hooks about hooks's recently published book *Black Looks: Race and Representation*: "We talked for a long time about why it was so important that we think and write critically about images and how they affect the African American community" (ix). "In Our Glory: Photography and Black Life," hooks's contribution to *Picturing Us*, completes that conversation intertextually.[13] Like Willis, hooks grounds her essay in her childhood discovery of black photography's oppositional authority. The shift in locale from Willis's Philadelphia (and DeCarava's Harlem) to the rural South of hooks's childhood in the 1950s produces an even stronger faith in that authority. As a more overtly hostile outside world presses in on the segregated African-American community, the black veil thickens into a wall, and the two-dimensional photo text evolves into the wrap-around, three-dimensional space—at once sheltering and expansive—of the picture gallery.

> The walls and walls of images in southern black homes were sites of resistance. They constituted private, black-owned and -operated gallery space where images could be displayed, shown to friends and strangers. These walls were a space where, in the midst of segregation, the hardship of apartheid, dehumanization could be countered . . . Right now, I

long for those walls, those curatorial spaces in the home that express
our will to make and display images. (47–50)

Lining the walls of the home with family photographs transforms domestic en-
closure into a gallery of cultural knowledge and possibility. Untroubled by the
split between the private kitchen and the public library, the home is here the
site of a fully developed interiority, a self-contained world whose self-
representation pushes back the forces of ghettoization, a harmonious cultural
domain that undoes the ravages of time by spatializing history and heals the
ravages of racism by affirming the complexities of body and being.

Whose home is this that functions so richly as a figure and source of cul-
tural integrity? In hooks's text it is both generic and specific: a typical southern
home and the particular southern home that belonged to her grandparents
rather than to her parents. It is thus a specific generational site, which be-
comes a specific gender site as well, for the initial reference to her grandpar-
ents—"every wall and corner of my grandparents' (and most everybody else's)
home was lined with photographs"—quickly shifts to a focus on her grand-
mother: "Sarah Oldham, my mother's mother, was a keeper of walls. Through-
out our childhood, visits to her house were like trips to a gallery or museum—
experiences we did not have because of racial segregation" (49–50). Rather
than enlisting the paternal gaze to provide a perspective on black experience,
hooks evacuates the men from a female safe space, all the safer for not being
the space she actually inhabits. Generationally distanced, linked to the past,
and purged of bodily immediacy, it is the home of the artistic maternal grand-
mother, a quiltmaker who arranges photographs with the same care that she
lays out quilts, rather than the veil of the fathers, that mediates the relation to
the kitchen and the mother whom hooks mentions only once and only as "that
image of the woman we did not want to become"(43).[14] It is under the aegis of
her grandmother that hooks encounters a culturally distinctive family photog-
raphy: "images of the dead as they lay serene, beautiful and still in caskets"—a
genre made familiar by VanDerZee—and "endless portraits of newborns" cover
every wall of her home (49).[15] Unspecified (perhaps because they are male?)
photographers and the grandmother's curatorial hand have collaborated in lift-
ing these unnamed photographic subjects from their biological families and as-
signing them their enduring place at opposite poles of the generational spec-
trum. Hooks's preference for the beauty of the newly dead over the
redundance of the newly born, and the unremarked absence of all the inter-
vening life stages and relations, underscores her attraction to specific forms of
cultural production over the ideology and iconography of social reproduction.

There is only one hint of threat to this cultural safe space, one sign of seep-
age through the picture gallery walls. The camera's very adeptness as an oppo-
sitional tool, an instrument through which to contest the stereotypes mass-
produced on the cultural outside, encourages a potentially overpowering

visual plenitude in the cultural interior. "When the psychohistory of a people is marked by ongoing loss, when entire histories are denied, hidden, erased, documentation may become an obsession . . . generations of black folks emerging from such a history of loss became passionately obsessed with cameras," hooks explains, commenting in passing two paragraphs later, "I was somewhat awed and frightened at times by our extended family's emphasis on picture taking" (48–49). Although hooks doesn't specify the source of her fear, the obsessiveness to which she calls attention suggests a risk of representational excess, a danger, perhaps, of implosion, of crowded walls threatening to cave in figuratively under the weight of pictured history on the child struggling to position herself vis-à-vis these visual genealogies. It is thus the intensity, rather than the mode, of representation that betrays the dominant culture's pressure on the female-curated home. This pressure finds a more compliant point of entry to the paternal home.

It is in her own childhood home, where the gendering of photographic activity is made explicit, that it is also made oppressive. "Our father was definitely the 'picture-takin' man.' For a long time cameras were both mysterious and off-limits for the rest of us . . . In charge of capturing our family history with the camera, he called and took the shots . . . I hated it. I hated posing. I hated cameras. I hated the images they produced" (49). The father's exclusive power over the camera, unmediated by the grandmother's hand, transforms an instrument of oppositionality into an agent of coercion and death that has no yield in immortality. As the scene is elaborated in *Bone Black: Memories of Girlhood*, the camera is represented as a coffin-like "black box" wielded by the European colonizers rather than the colonized, and its representative (although resistant) subject is the maternal grandmother who explains about an alienating photograph of her that "picture taking is no innocent act—that it is a dangerously subtle way we drive our souls into extinction" by fixing images of the body (46). Sarah Oldham's implied revenge is to wrest control from the hands of the others (reading the scenes in *Bone Black* and "In Our Glory" together collapses the patriarchs with the colonizers) by selecting and displaying photographs in her home according to her own lights; bell hooks's revenge, in an echo of Willis, is to become a critic of visual culture. Hooks's father, however, unlike Willis's, is an obstacle, not aid, to his daughter's vocation. In contrast to Willis, who sees herself as an object of the paternal gaze only as a springboard to seeing how this image portends her future behind the lens, hooks feels captive to the paternal-as-colonial gaze.

The scenes of family photography hooks recalls emphasize alignment and seriality. "We constantly were lined up for picture taking," she laments immediately after describing her father's control over the representation of family history. As revised in *Bone Black*, the scene implies some maternal complicity in this narrative of childhood captivity, in which the reiterated "shots" call attention to the camera's similarity to the gun: "They are making us children

stand endlessly still while they take shot after shot—birthdays, Easter, Sunday, Christmas" (47). Both versions insist that family photography reproduces social reproduction according to the calendar of social time. The sequence of progeny and the sequence of holidays converge in the display of social normativity.[16] Denied individuality not (as in the grandmaternal picture gallery) in the interest of aesthetic transcendence, but rather in the interest of assuming an appointed place in the exhibit of abundant but orderly generativity, hooks resents being used to bolster her parents' biological and class status. For whose gaze is this display of a black working-class family clad in the ideological garments of respectability? Although hooks seems to want to encompass all African-American homes in her figure of the sheltering gallery walls, her account of photography's purpose in her own family implies that any anxious father's eyes may serve as lenses for a "white supremacist gaze."

Perhaps this is why the essay begins with a different and highly charged image of hooks's father. Here, in the only photograph that is actually reproduced within the essay, we see Veodis Watkins as the object rather than the subject of the gaze, a smiling young man in a white T-shirt standing in a pool hall "before marriage, before us, his seven children, before our presence in his life forced him to leave behind the carefree masculine identity this pose conveys" (43). Although the "In Our Glory" of the essay's title ostensibly refers to the collectivity of black family life, the phrase's only actual referents are two decidedly nonfamilial representations that constitute the "our" quite differently: this snapshot of a pre-paternal Veodis Watkins "in his glory" and a companion image (presumably taken by her father) of hooks as Gloria Watkins (her given name) in *her* glory as a little girl in a "cowgirl outfit, white ruffled blouse, vest, fringed skirt, my one gun and my boots . . . all that I wanted to be in my imagination . . . 'in my glory'" (45). Painfully yet perhaps inevitably lost when transported on a visit to relatives, this fondly remembered icon of the "me of me"—of defiant, transgressive yet seductive femininity—is the antithesis of filiality. Juxtaposed and yoked through their evocation as images that have "embraced" hooks "like arms that would not let go," these photographs of solitary individuals are rendered with a detail and intensity quite different from the family photographs that are so summarily and generically described (44). The glory of the nonpaternal father and the cowgirl daughter, whose ruffled white blouse both mirrors and modulates his T-shirt, is to roam outside the walls of the family: undomesticated, unsocialized, rebels against the disciplinary functions of the domestic roles that subject her to him and him to paternality. These paired photographs mark a dream, a possibility, of a father-daughter romance outside a whitewashed family. If the glory of black life attaches to these images, is it because blackness as well as glory reside outside the family?

Yes, if spontaneity and vividness are signs of racial authenticity; but also no, since the visual embrace of father and daughter simply transposes the classic

Oedipal romance from the hothouse of the European family to the western plains of fantasy. The visual transactions between father and daughter thus crystalize the unstable boundaries between constructions of race and family. These boundaries become yet more fluid when the father-daughter dyad is triangulated by rivalry not with the invisible mother, but with the more aggressive sister V., the original and exclusive owner of the treasured image of Veodis, whose legacy seems to be transmitted verbally as well in her initial V. Transposing this photograph to a visual affiliation of glory with young Gloria entails prying a copy loose from the uncooperative V., who refuses to duplicate the image for hooks but, with seemingly deliberate spite, sends a copy instead to another sister, G., who, repelled by its unabashed masculinity, willingly passes it on to hooks. The photograph of Veodis thus circulates as a token of desire (perhaps because the embodied father was so unavailable). Placing it at the head of her essay displays hooks's victory over V. But this victory is never fully won: by incorporating the story of struggle within the display of ownership, along with the information that the trophy displayed is a duplicate, hooks writes into her text a shadow version of her romance with her father. In the slippages between the sister stories racial interiors and exteriors collapse and shift.

"Always a daddy's girl. I was not surprised that my sister V. became a lesbian, or that her lovers were always white women" (43). The stunningly ambiguous non sequiturs of the essay's opening lines ring the changes on sisterhood and race. Who is the daddy's girl in this family? Both daughters, presumably, but differently. The rules of syntax (as well as the rest of the essay) force us to read hooks as the daddy's girl she accuses her sister just as plausibly of being, but the daddy-daughter turf is racialized reversibly. The extrafamilial terrain of personal and racial authenticity on which hooks imagines her true relation to her father shifts in her discourse on her father and her sister to a space of familial and racial treachery. V. presumably becomes a lover of white women by identifying with the desire of her father as a desire for white femininity. But whereas in relation to herself hooks locates this desire in the African-American imitation of the patriarchal family, in relation to her sister she views it as the imitation of the father's wayward desires away from both race and family: V.'s "worship of daddy and her passion for whiteness appeared to affirm a movement away from black womanhood, and of course, that image of the woman we did not want to become—our mother" (43). White femininity threatens the integrity of the black family from a location alternately inside and out. The relation of the two Watkins sisters thus both reiterates and complicates that of the Willis sisters. In hooks, the metonymic linkage of the sisters is verbal rather than visual; instead of being seated next to each other on the couch, the sisters are collapsed linguistically into a first-person pronoun that functions as a shifter that points toward both at once. Like Willis, although more emphatically, hooks seems to want to, but doesn't, extrude the

I. Plates

Plate I. From Larry Sultan, *Pictures from Home* (New York, Harry N. Abrams, 1992).

Plate 2. From Larry Sultan, *Pictures from Home* (New York, Harry N. Abrams, 1992).

Plate 3. From Larry Sultan, *Pictures from Home* (New York, Harry N. Abrams, 1992).

Plate 4. From Larry Sultan, *Pictures from Home* (New York, Harry N. Abrams, 1992).

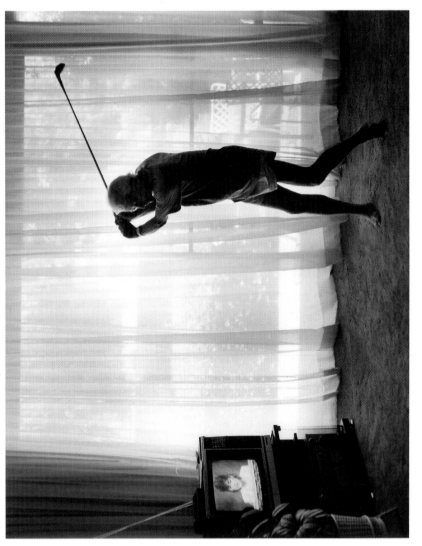

Plate 5. From Larry Sultan, *Pictures from Home* (New York, Harry N. Abrams, 1992).

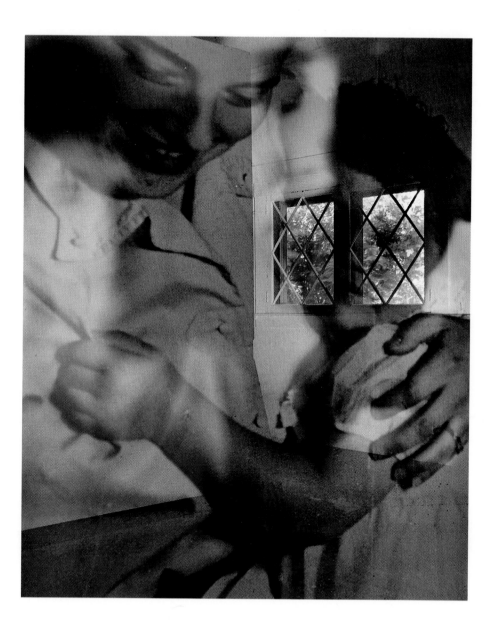

Plate 6. Lorie Novak, *Eye Window*. Color photograph, 36 x 30". © Lorie Novak/Swanstock 1987.

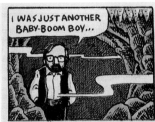
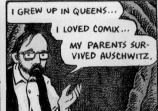
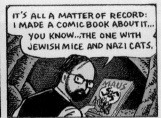
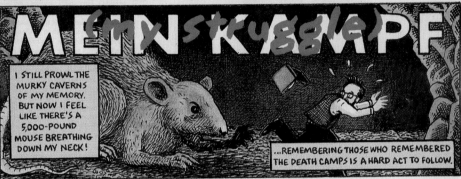
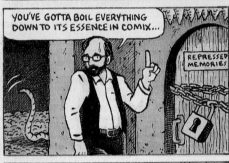
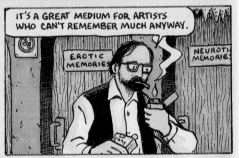
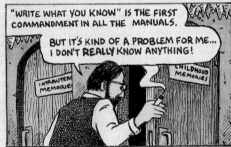
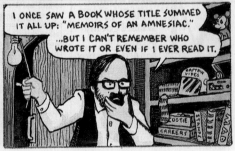

Plate 7. © Art Spiegelman.

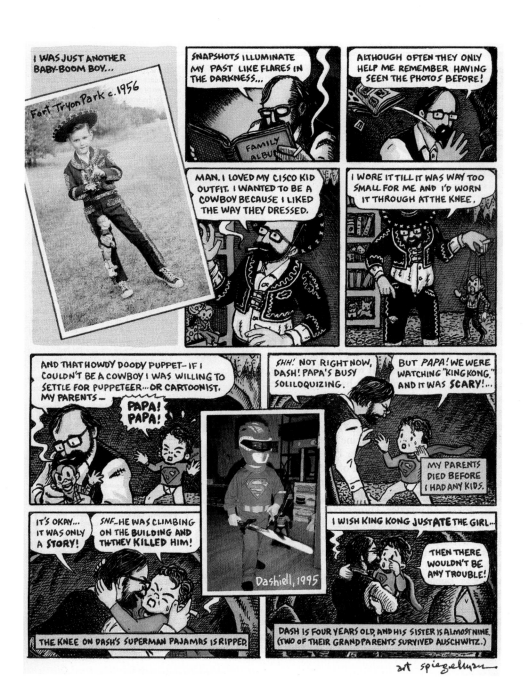

Plate 8. © Art Spiegelman.

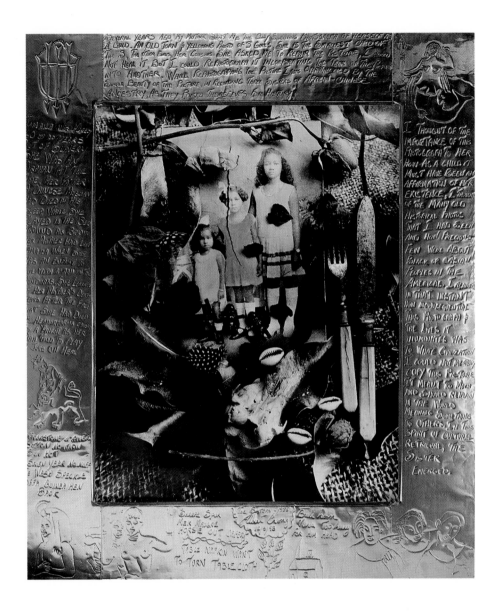

Plate 9. Albert Chong, *The Sisters*, 1986.

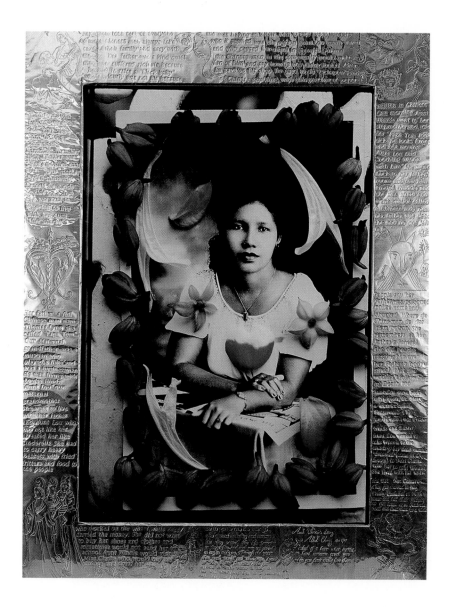

Plate 10. Albert Chong, *Aunt Winnie's Story*, 1997.

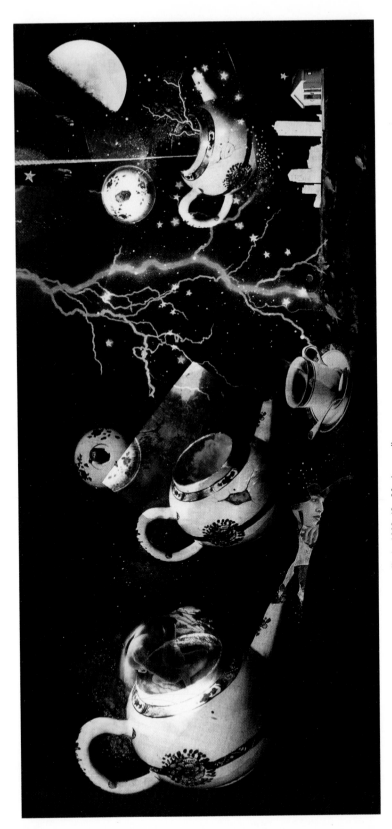

Plate 11. Joanne Leonard, *Letting Her Go with Difficulty*, 1993, 48 × 20, photo collage.

sister who constitutes a site of vulnerability to white femininity. Instead of effacing her, hooks installs her in an inextricable and indelible textual relation to herself as a distasteful but seemingly essential point of departure for this meditation on the slippery relationships among family, race, and photography.

3

The year after "In Our Glory" appeared in *Picturing Us*, hooks reprinted her essay in her own collection, *Art on My Mind: Visual Politics*. Hooks also included in this volume "Talking Art with Carrie Mae Weems," in which "In Our Glory" functions as a springboard to a discussion of Weems's 1990 phototext, *Untitled* (Kitchen Table Series):

> I just wrote a piece for Deborah Willis's new collection of essays on photography, *Picturing Us: African American Identity in Photography*. One of the things that I wrote about was how photography has been so central to African-Americans . . . You know, when I look at the *Kitchen Table* series what immediately surfaces is a visceral connection with a heterosexual convergence of pleasure and danger, of power and desire. Yes, the individuals are black, but the issues raised are about sexuality in general, the politics of desire—intimacy and domination.[17]

Hooks's comments trace a course from racial to sexual politics, from the importance of photography to black life to the importance of addressing the representation of that life's multiple (here, specifically erotic) dimensions; but the conjunction of "In Our Glory" and the Kitchen Table Series also traces a historical trajectory that enables us to shift our gaze to the end of the twentieth century.[18]

The Kitchen Table Series is composed of twenty silver print images, each 27¼ by 27¼ inches, and thirteen panels of 11-by-11 inch text that together, but not in synch with one another, tell the story of the creation and dissolution of an erotic bond between a woman and a man. Despite its own absolutely invariant frame and camera location—all twenty images represent the identical domestic setting from a fixed position at the far end of a kitchen table—this insistently reiterated space functions less as a figure of inviolable autonomy than as a theatrical arena into which characters enter and exit, performing and reforming family roles. The series carries to a performative extreme the conventions of family photography; characters, for example, are identified not by personal name but by generic identity: man, woman, child, friends. But instead of the canonical family occasions—the births, weddings, graduations, and holidays for which hooks and her siblings were so relentlessly lined up—Weems gives us ordinary, noncelebratory moments granted the ceremonial stature of

posed family photographs through the carefully sculptured postures, minimalist setting, and iconographic use of domestic props. Through this overtly fabricated representation of everyday life, Weems defamiliarizes familiality.

Although we are back in a kitchen, then—indeed, we are in Weems's own kitchen, carefully denuded of specificity to approximate a studio—we are in a highly stylized realm that requires no paternal mediation. We have shifted from the childhood kitchen, in which the daughter is subjected to the maternal hand, to a room, and an artistry, of one's own. Weems has devised her own representational veil, derived in part, she points out in her conversation with hooks, from her revision of a photographic zone system that is "based on white skin" (92). Claiming the authority of the paternal gaze, the mature black female subject is now on both sides of camera: both the photographer and the woman in the kitchen, played by Weems herself, who is present in all twenty frames (and the only character who is), often looking directly at the camera. As both subject and object of the gaze, Weems fulfills her commitment to remedying the gaps in Laura Mulvey's classic account of the male gaze by "creating a space in which black women are looking back."[19] Through this mirroring relation with the camera, Weems transforms domestic space into a landscape of female interiority.

It is the male companion, lover rather than father, whose tenancy in this space is now precarious. Although he makes his entry in the opening photograph, the man vanishes at the end of the first of the visual text's four photo "chapters."[20] His version of the story has more authority in the verbal text, a medley of song lyrics and popular phrases that narrate the doomed course of the sexual relationship in a quasi-parodic vernacular discourse composed,

2. Carrie Mae Weems, *Untitled* (Man and mirror), 1990. Courtesy of the artist and P.P.O.W., N.Y.

3. Carrie Mae Weems, *Mirror, Mirror*, 1987–88. Courtesy of the artist and P.P.O.W., N.Y.

LOOKING INTO THE MIRROR, THE BLACK WOMAN ASKED, 'MIRROR, MIRROR ON THE WALL, WHO'S THE FINEST OF THEM ALL?' THE MIRROR SAYS, "SNOW WHITE, YOU BLACK BITCH, AND DON'T YOU FORGET IT!!!"

after the completion of the photographs, to open their female-centered perspective to a variety of voices that could serve as a citation of masculine as well as feminine experience.[21] Split between a male-dominated verbal text and a female-dominated visual text, the mixed media of the Kitchen Table Series thematize some of the fault lines in the composition of the common ground called family. Within the visual text itself, Weems uses tropes of vision and voice to examine the differently gendered routes through which racism puts pressure on the private space of home.

For the woman, these pressures are introduced intertextually through the relation between the opening photograph, *Untitled* (Man and Mirror), which shows the woman gazing over her mirror, tilted towards her on the kitchen table, directly at the camera, and a precursor image, *Mirror, Mirror* (1987–88), which sets the terms for this insistence on self-reflection (illus. 2 and 3). In *Mirror, Mirror* the white baby-doll makes a powerful reentry in her fairy-tale epitome as Snow White, the distillation of pure white femininity aggressively counterposed by the voice of the mirror to the "black bitch" who dares to pose the famous question of the Queen: "Mirror, Mirror on the wall." The ideology of white daughterhood that in the fairy tale trumps (step)motherhood is here turned against the black female subject despite her attempt to inflect the question to her own advantage by translating *fairest* into *finest*. Yet her very address to the mirror betrays her internalization of the fairy-tale ideology; what she sees reflected back is not her own face, but the white maternal superego,

the wicked racist stepmother/Queen who denies and displaces her in an African-American revision of the mirror stage as a scene of ego deformation.

The mirror is thus an index and agent of racism's invasiveness: hence the need to reclaim it in the Kitchen Table Series. But before returning to the Kitchen Table Series, we need to dwell a little longer with the earlier photograph to understand how the 1950s ideology of white baby-doll femininity has been reworked by the feminism of the late 1980s. For as even my brief description suggests, the positions with which *Mirror, Mirror* plays are not monolithically or stably racialized. The face in the mirror is not that of Snow White herself, who is significantly unrepresented here, but that of the aging Queen, who has been transposed from her position in the original fairy tale—from the anxious, threatened asker of the question to its answerer; she has moved from one side of the mirror to the other to become the representative of the patriarchal voice that had previously disinherited her. The excess of anger in that voice— the three exclamation points punctuating the "You black bitch," an almost physical rebuke that administers a slap to the black woman's averted face— may derive from her own dislocation by the figure of Snow White, with whose name she now allies herself as a defense against the pain of losing her own claim to the status of the "fairest of them all." Indeed, perhaps, this claim was never secure, for the whiteness the mirror proclaims is represented as a matter of costuming and props rather than as biology. The Queen impersonates whiteness rather than embodying it: she performs it through her layers of gauzy clothing, which seem almost a form of drag, and the star that, held conspicuously in her hand, somewhat precariously signals her authority to be the judge, but not the incarnation, of female beauty. In passing through the looking glass, the Queen may herself be passing, and the visibly African-American woman occupies the position that she vacates. As the two women circulate through these subject positions, we realize that they are less diametrically opposed than at first they seem to be; both have been displaced by, and therefore seek to appropriate, that empty signifier "Snow White," whose name inscribes an ideology of pure white femininity that ostensibly resides in, but cannot be represented by, any female flesh.

The possibility of some alliance across a strongly marked racial boundary, of some recognition of shared dispossession by the norms of snow-white femininity, is reinforced by Weems's play with the photographic frame. The strong border of the mirror (especially in conjunction with the title of the photograph) seems initially to function as a surrogate photographic frame. This frame within a frame, however, does not coincide with it perfectly, but instead is held by the African-American woman slightly above the bottom of the photograph so that we see the other woman's arm and sleeve beneath the bottom of the frame: the photograph calls attention to the presence of a woman posed on the other side of the mirror frame. Despite the photograph's title, this is not, in fact, a mirror in which the black woman sees herself effaced, but rather

a transparent piece of glass, a window through which these women could potentially gaze directly at each other. Since the face of the woman on the glass's other side betrays none of the wrath of the mirror's words, it is even possible that she is not the mirror's mouthpiece, but instead invites the disbelieving woman toward whom she extends the silver star to resist the mirror's ugly address and accept the badge that would proclaim her finest of them all.[22]

By asking more questions than it answers, a standard feature of Weems's photographs, *Mirror, Mirror* sets the stage for the questions posed by the Kitchen Table Series. Here, the mirror is a figure of a successfully reclaimed black female interiority. The viewer's exclusion in *Untitled* (Man and mirror) from the intimacy of the woman's gaze in her mirror, tilted such that all we see reflected is the kitchen table's luminous but unrevealing surface, reinforces, as Marianne Hirsch has argued, the achievement of a resistant privacy.[23] This achievement may be what enables at least a fleeting realization of the earlier photograph's intimated alliance: the presence of a white female friend at the kitchen table in the second of the three tryptichs that track the shift from an unraveling heterosexual relationship to alternative constructions of familiality. As the title of the series' opening photograph suggests, the mirror is now the site of a new conjunction. The thoughtful, slightly troubled expression on the woman's face registers the presence of a different intruder who here stands behind her, the shadowy man whose entry interrupts the privacy of her self-reflection. The question on her face is whether the interiority restored and signaled by the mirror can incorporate sexual rather than racial difference, whether the affirmation of black womanhood can survive the introduction of heterosexuality, or whether the attractively enigmatic male, once installed within the home, will simply reinstate the patriarchal family in which the available visages of woman are the domesticated mother (the first Queen who dies and disappears from the story after giving birth to Snow White and who may be reborn in a different form in hooks's "image of the woman we did not want to become") or her alter ego, the aging, raging Queen.[24] Even in this reclaimed African-American feminist space, the variants of white patriarchal femininity that the Snow White characters have come to typify can enter through the back door, which is exactly where they do—perhaps. Wearing a dark jacket and tie, his turned-down face entirely shielded by the dark circle of his hat, which inverts the circles of the mirror and the lamp that together illuminate the female subject to herself, the man who has entered from behind ambiguously introduces both possibility and lack. In fact, he may not even introduce them, for like its precursor, the photograph subverts the boundaries it delineates. Although the man's jacket and hat imply that he has just walked through the now-closed door on the back wall, a second glass has been placed before an empty seat at the table. Has the woman desired and anticipated his arrival, or has he already been there (the glass is empty and the bottle of Scotch half-full) and just risen from his seat to embrace her from behind? Is

he an outsider or an insider, and does he introduce or fill an empty space in what the mirror proposes as a full interior?

The plot unfolds in the next image, *Untitled* (Man smoking), in which the man has taken off his hat and coat and settled into his seat, and the woman has exchanged her nightgown for a sexy, low-cut dress. The couple plays a game of cards: a traditional trope of erotic war and play (and the suit we see is hearts). They regard one another warily, appraising intentions and moves. The larger bottle of Scotch on the table, a full pint instead of half, suggests that the man has been incorporated into the household economy, and yet the bottle is still half-empty, or half-full, registering perhaps the persistence of both ways of regarding his contribution. A bowl of peanuts supplements the drinks, launching the representation both of erotic play as food, and of an imbalance in the rules of the game, since only the man appears to eat: the empty peanut shells are only by his glass. Similarly, only the man is represented smoking, and the smoke-tinged air is one tangible sign of how his presence has altered the domestic atmosphere. More dramatically, however, the previously empty wall is now covered with images, of which the centerpiece is an enlarged photograph of Malcolm X facing outward toward the man. Mirroring now transpires between men; sandwiched between the man and the photograph of Malcolm X that he has imported into her space, the woman is installed within the homosocial economy of black nationalism. By mediating the male relationship, her gaze directed toward the man instead of the camera, she becomes the instrument of their mirroring: the potential bearer of children that write paternity into the figure of the black male (the text tells us that the man wanted children, the woman didn't), and thus the bearer of the image of male potency. As personified by Malcolm X, the ideology of cultural nationalism, which constructs the home as a privileged site of cultural reproduction and autonomy, mirrors the gender arrangements of the outside culture from which it seeks to differentiate itself.[25]

But the romance does not remain confined by that ideological frame. In the next scene, *Untitled* (Eating lobster), the photograph of Malcolm X has been replaced by a birdcage and a still life of flowers that import into the domestic interior some of the sensuous natural imagery evoked by the verbal text. The game of cards is over, and the bowl of peanuts has yielded to that most luxurious of eating pleasures, lobster, which nevertheless continues to require cracking through a resistant shell. More disturbingly, it is still only the man who eats; the woman's lobster remains untouched on her plate, its claws still enclosed by white bands; and the two beers and nearly empty glass of wine by the man's plate contrast with the seemingly untouched glass by hers. Nevertheless, the gesture of tenderness with which, leaning toward the man, the woman reaches out and cups the side of his head with her right hand, which until now had been poised circumspectly by her mouth, and the trust implied by her closed eyes, which had previously been focused warily on him, signal a

physical intimacy that, however asymmetrical and potentially risky, is far more intense than the visual standoff of the preceding scene. In this erotic culmination of the series, music displaces mirroring—he plays the harmonica, she sings—and the characters (who have traded places) seem transported beyond their domestic roles; in the context of desire, cultural specificity is articulated under the sign of the blues, not that of Malcolm X.[26] But the photograph leaves open the question of whether desire can be translated into the frame of domesticity; maybe this is why figures of enclosure—the woman's bracelet and hoop earings, which echo the shape of the birdcage stand, the dark rectangular frame of the painting—are conspicuous precisely in the image in which domestic frame expands.

The erotic culmination of the relationship is also its termination, as we discover in the next scene—the tryptich *Untitled* (Man reading newspaper). Gone are the wine, lobster, painting, and bird; we are in the sparse setting of daily life, a bare table with two water glasses, and a man reading a newspaper, his hand against his cheek replacing the caress of the woman, who moves around the table, seemingly awaiting some sign of recognition as the man methodically peruses the pages from beginning to end. In a final pose that recalls the opening photograph, the man sits reading at the far end of the table and the woman, dressed in black, her face obscured, embraces him from behind. But for the man, the mirror is the newspaper, a textual rather than visual interface between internal and external worlds. Is he poring over the news or the want ads (the text tells us he is unemployed), and how does he see himself reflected in the shapes of social desire and pathology these pages body forth? This is the last frame in which we see the man, who vanishes abruptly from the visual (although not the verbal) text at this point, as if pulled out into the public world that breaks, via the newspaper, into the domestic frame. Is his immersion in the paper a symptom or a cause of his domestic disaffection? Although most readily legible as a symptom, it functions perhaps more compellingly as a cause. The negative reflection presented by the paper that occupies the place of the mirror is, I believe, a masculine counterpart to the face of the racist Queen: a counterpart that (in Weems's gendered division of psychic and social labor) cannot be purged within the private sphere, which it seems actually to evacuate of meaning. There is thus a fundamental incompatibility: the racist Queen in the mirror (the internalization, that is, of racism) induces for the woman a process of self-reflection which may or may not leave space for heterosexuality; racist images of black men in the daily social text exert a centrifugal rather than centripetal pull, not introversion to the private sphere, but a search for rectification in the social field.

The next photograph, and a connected one not ultimately included in the Kitchen Table Series but part of its inception, elaborate this incompatibility. In *Untitled* (Woman and phone), the man has gone, the other chairs and place settings have vanished from the table, and the woman sits alone, curled up in

a position that imitates the telephone, which signals the man's absence and occupies his place. Like the telephone, she awaits the call that will enable her to open up. In this trajectory from mirror to telephone, an instrument which by definition points outside the visual frame, she has lost the self-sufficiency it will be the rest of the series' project to reconstitute. It cannot be restored through the telephone, which, able to return the man only as voice, as absence, also implicates her in the voices that summon him contradictorily. These voices are thematized in the companion photograph, made at the same time, *Untitled* (Jim, if you choose), which is set at the same kitchen table (although it is now turned horizontally), with the same overhead lamp and props, and the same male model.[27] The telephone is here as well, but now it is off the hook and balanced by a tape recorder toward which "Jim" inclines his head tentatively, and somewhat longingly. Positioned between a white telephone and a black tape recorder, this contemporary rendition of Jim Crow (given how infrequently Weems uses names, not just in this series, but pervasively, the choice of "Jim" here cannot be insignificant) must choose which racialized interpellation he will heed. Through which medium is the message—"Jim, if you choose to accept, the mission is to land on your own two feet"—transmitted, and how does the medium become the message? The white phone is off the hook; Jim has seemingly put it down to listen to a more authentic black voice that encourages him to resist the solicitations of whiteness, to accept instead the mission of affirming his autonomy. But from what remote, authoritative locus does this mechanically reproduced and unanswerable voice of racial authenticity emanate, and why does it imitate the idiom of white TV? Could it be that Jim is being interpellated through the white telephone to embrace the heroics of white masculinity, and turns to the black tape recorder to check this invitation's credibility? In the *Untitled* (Woman and phone) photograph, to complicate the picture further, the white phone belongs to the woman. Could she, in the context of summoning him back, be explaining her commitment to affirming his masculinity? Or is the voice on the black tape recorder warning Jim that if he returns to that relationship, his mission is to stand up for himself, as if the call of the feminine, conflated in the Kitchen Table Series with the feminist, were, like the white instrument through which it is relayed, intrinsically emasculating? The dizzyingly reversible interpretive possibilities—made palpable, perhaps, in the cloud of smoke surrounding Jim's head—are what make his mission impossible.[28] He cannot land on his own two feet because he does not own them, split as they are between black and white locations that are both differentiated from and riddled by each other. There is no black interiority here untraversed by whiteness, which may be why Jim wears a white shirt beneath his black jacket, while the dark wine bottle is turned to display a white label. The dance exacted from Jim Crow in postmodernity is across racial boundaries that are not fixed in, but rather constantly remap, social

space. Hence the impossibility of resting within any one location: torn in half, pulled in contrary directions, Jim, the prototype for the man in the Kitchen Table Series, is perpetually on call, solicited by voices—via newspaper or telephone—that propel him out of the domestic frame.

"Jim" offers a masculine counterpart to *Mirror, Mirror*: together, they contextualize the gendered boundary tropes at work in the Kitchen Table Series. The mirror and the newspaper/telephone, associated with the woman and man, respectively, mark the vulnerability of any African-American interior to a racist exterior; but they pull ultimately in opposite directions—the visual toward redefining, the verbal toward disrupting, the space of family. The mirror returns after the man's departure from the Kitchen Table Series, and after the tryptich on the women friends. Entitled *Untitled* (Woman and daughter) (significantly not "Mother and daughter"), and abruptly introducing the child born years ago, this photograph opens a new visual "chapter" of the series by reinvoking the opening scene and reworking *Mirror, Mirror*'s rendition of Snow White's mother-daughter narrative, redressing the fatal rivalry in the mirror by endowing each woman with a mirror of her own (illus. 4). The daughter now imitates, rather than competes with, the mother's gaze in the mirror, and the poignancy of the image derives in part from this double mirroring: between as well as by the two women. This mirroring revises as well the fairy tale's other, idealized female relation represented not by the wicked stepmother, but by the devoted biological mother who dies as soon as Snow White is born: the mother whose only function is to reproduce her daughter, who effaces herself except as a reflecting surface in an exaggerated version of normative maternity, who is indispensable to the daughter's subjectivity but lacks any need to see, or be seen, herself. As the mother we may crave as daughters, and as the woman that we do not want to become, she is in both guises invisible. Weems's maternal figure, by contrast, becomes the object of her daughter's gaze by being the subject of her own, a position enabled by the imperative of erasing the racist stepmother's reflection. The mother becomes newly visible —to herself and to her viewers—from a cultural location that mandates maternal self-reflection rather than self-effacement. In this radically revised reproduction of mothering, what is transmitted across female generations are not fluid ego boundaries and relational identities but autonomy, interiority, and healthy narcissism. By mirroring her mother, the daughter learns how to mirror herself.

Or so I would like to think, for there is also a painful disconnection in the image, a lack of relationality suggested in part by the conspicuous presence of the empty third chair, which marks not only the place of the absent father who might intercept this female narcissism *à deux*, but also the empty space between the women. We can only speculate how it feels to the daughter to see herself reflected in the mirror rather than in her mother's face, to experience

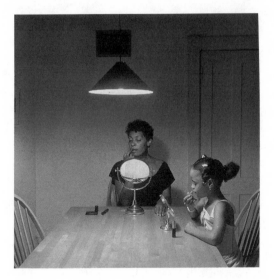

4. Carrie Mae Weems, *Untitled* (Woman and daughter), 1990. Courtesy of the artist and P.P.O.W., N.Y.

in reverse the shift that Winnicott initiated from the Lacanian mirror stage to the maternal mirror, and thus perhaps to inhabit the domain of ego alienation rather than integration. The rest of the series depicting mother and daughter is quite severe; play—that Winnicottian figure of creativity—occurs only in a game of cards with friends, as the mother looks on somewhat pensively and distantly.[29] We can't be sure of the daughter's response, for she drops out of the final sequence of images. What we do see there, in recurrent scenes of eroti-cized solitude, which are, I think, the most erotic scenes in the series, is a highly visible female/maternal subjectivity.

The Kitchen Table Series resolves the problem of maternal visibility by representing a woman who, in effacing the image of the raging racist step-mother Queen, also effaces the image of the self-effacing woman that we do not want to become. In the final photographs, we see a self-possessed and beautiful black woman whom we know (because of the sequences of images) to be also a mother. The Kitchen Table Series reverses the normative se-quence in which an autonomous and sexually powerful woman becomes a mother at the cost of her autonomy and sexuality. But these images of sexual-ized subjectivity occur only in the man's absence, and seem to depend on re-solving his position on the boundary in the direction of his departure. The final photograph, *Untitled* (Woman playing solitaire), recuperates for the woman alone the tropes from the highpoint of the sexual narrative: the paint-ing of flowers, the birdcage, and the game of cards, transformed now into a game of solitaire. Food has also returned—a box of chocolates, love food, whose empty papers suggest that she has actually been eating, that she feeds herself (only, perhaps) in the absence of the man. It is hard to avoid the im-pression of a progressive teleology.

4

In 1996, forty-one years after the publication of *The Sweet Flypaper of Life*, a new collaborative volume on the black family appeared. Coauthored by Michael H. Cottman (text) and Deborah Willis (photographs), *The Family of Black America* offers a survey of African-American family photography across the twentieth century. The variety and scope of the visual text are thus a necessary corrective to my few close readings, while the persistence of certain preoccupations in the verbal text clarifies both new directions for and resistances to the breaks with tradition enacted by the Kitchen Table Series.

Produced to commemorate the first anniversary of the Million Man March, *The Family of Black America* maintains a defensive posture about black paternity. Titled "One Million Men Committed to Black Families," Cottman's opening exposition tries both to validate the homosocial family of African-American men at the march ("brothers of the soul," "family in spirit") and to embed it within the biological families to which the million men returned, ostensibly renewed.[30] Cottman's text both manifests and tries to assuage anxiety about black men's status as heads of families; photography is therefore enlisted in ways that are now familiar to affirm black men's visible and vital presence in the family. By the 1990s, however, the potential critics of this project are feminist as well as racist, and the collaboration with Willis seems designed at least in part to forstall one line of critique. The photographs represent a broad spectrum of family groupings, including exclusively female groups of sisters, mothers, grandmothers, and daughters. The text that punctuates the visual display, however, calls our attention to the book's central categories and purpose with titles such as "Big Brother," "Our Fathers, Our Sons," "Saving Our Black Boys," and "From Inmate to Mentor"; no textual exhortation accompanies the photographs of African-American women.

Willis's contribution to this project is writ large and clear in the selection of photographs, a significant number of which are by women, including several by Carrie Mae Weems (although these are drawn primarily from the earlier, more traditional *Family Pictures and Stories*, the only selection from the Kitchen Table Series being the somewhat anomalous *Untitled* (Woman with children). Most striking for my purposes, however, are the ways that Willis's self-representation in the text both develops her earlier narrative and complements the volume's central theme. Willis's biographical note reprises (with some updating) her story of formation in *Picturing Us*. But the accompanying family photograph that forty years later displaces the sisters and their dolls now fulfills, by paying tribute to, the father's legacy. "My sister Leslie, me, my mother, and my sister Yvonne in front of 'Daddy's Ties,' a quilt in tribute to my late father" (1995) arrays the four female members of the Willis family on both sides of the commemorative quilt that Deborah Willis has created from

5. My sister Leslie, me, my mother, and my sister Yvonne in front of "Daddy's Ties," a quilt in tribute to my late father. Photograph by Robert Gore, 1995. Courtesy of Bob Gore Productions.

her father's ties (illus. 5). These are truly the ties that bind: a family genealogy that joins the women through lines descending from the father, whose status as head of family is rendered in and as his absence by the empty space above the ties, where his face would be. At the center of this family photograph is a father-daughter legacy that honors both members and diminishes neither, that affords no purchase to ideologies of white femininity, that serves to affiliate African-American women, smiling radiantly.

The photograph that Willis chooses here to illustrate her professional autobiography wrests the father-daughter relation from the pressures of cultural mimicry, and tweaks toward the daughter the father-son inheritance that the text of *The Family of Black America* celebrates. Yet for all its redemptive poignancy, the image doesn't challenge the father's central place in African-American family photography. The absence from this volume of more radical revisionings of the family—whether the unravelling effected by the Kitchen Table Series or the exploration of gay or nonbiological families taking place in more narrative visual forms, such as film—bespeaks the ongoing pressures of convention levied on the single, representative photograph of "the" African-American family.[31] How to circumvent these pressures is a question this volume

poses for African-American photography in the twenty-first century; finding answers may require seeking new ways to decenter, without dishonoring, the father.

Notes

I dedicate this essay to the memory of my father, Reuben Abel (1911–1997).

1. In *Putting Myself in the Picture: A Political, Personal and Photographic Autobiography* (Seattle: Real Comet Press, 1988), Jo Spence offers a trenchant critique of the ways that "visual representation privileges the nuclear family by naturalizing, romanticizing, and idealizing family relations above all others" (136). See also the essays collected in Jo Spence and Patricia Holland, eds. *Family Snaps: The Meanings of Domestic Photography* (London: Virago, 1991). The richest and most nuanced account of family photography is Marianne Hirsch's *Family Frames: Photography, Narrative and Postmemory* (Cambridge: Harvard University Press, 1997).

2. "Viewing the Remains," Deborah E. McDowell's brilliant contribution to this volume provides a succinct and powerful analysis of white culture's pathologization of the black family from the E. Franklin Frazier and the Moynihan reports through contemporary photojournalistic practices. McDowell's essay, which I read only after completing my own, greatly amplifies in other directions some of the questions I raise here about race, representation, and the family. For a related critique of some of the visual conventions that derive from and reproduce this pathologization, see Paul A. Rogers, "Hard Core Poverty," in *Picturing Us: African American Identity in Photography*, ed. Deborah Willis (New York: The New Press, 1994), 159–68. For a classic essay on social constructions of the black family, see Angela Y. Davis (with Fania Davis), "Slaying the Dream: The Black Family and the Crisis of Capitalism," in her *Women, Culture, and Politics* (New York: Random House, 1984), 73–90. In "Discourses of Family in Black Documentary Film," a paper delivered at the University of California at Berkeley, November 12, 1997, Valerie Smith offered both a concise historical overview of the ways the black family has been constructed as deficient, and a trenchant analysis of the costs of reactive nationalist discourses on the black family's stability and sanctity.

3. It would be hard to overestimate the brilliance and influence of DeCarava, who is, according to one of his early admirers, "the spiritual father of all black photography," and whose work provides "the most thorough and profound record we have of black life over the last two decades" (A. D. Coleman, *Light Readings: A Photography Critic's Writings 1968–1978* [New York: Oxford University Press, 1979], 22). DeCarava's influence is by no means limited to the domestic photographs included in *The Sweet Flypaper of Life*, but their highly successful publication in book form (in contrast to the thwarted project for the publication of DeCarava's jazz photographs in a second book to be titled

"The Sound I Saw") gave them much wider early visibility than the uncollected photographs of urban landscapes and jazz performances. According to A. D. Coleman, "the impact of *The Sweet Flypaper of Life* can be felt, attitudinally and conceptually, in the work of almost all black photographers, so that virtually every show by a young black photographer is a form of homage to DeCarava" (108). Peter Galassi assesses their influence in these terms: "Photography had never seen such pictures—pictures at once so unsentimental, so sensual, so intimate, and so tender. DeCarava had set out to fill a gaping hole in the world's image of Harlem: its image of itself. In succeeding, he captured the most delicate qualities of domestic life, black or white" ("Introduction," *Roy DeCarava: A Retrospective*, ed. Peter Galassi [New York: The Museum of Modern Art, 1996], 20). For the details of DeCarava's collaboration with Langston Hughes, who wrote the text for *Sweet Flypaper*, and the publication history of the book, see Galassi's "Introduction" and Sherry Turner DeCarava's essay, "Pages from a Notebook," in the same volume. According to Sherry Turner DeCarava, "No one had photographed black people in this manner or even as a subject worthy of art . . . There were no barriers between the photographer and the subject, no sense that the photographer was even there" (51–52). In a recent lecture at the San Francisco Museum of Modern Art, Roy DeCarava described the flood of cards he received, shortly after the publication of *Sweet Flypaper*, which testified that: "this could be my family. I feel that I know these people." ("An Afternoon with Roy DeCarava and Sherry Turner DeCarava," Jan. 24, 1998).

4. An incisive account of extended kinship networks and flexible child-rearing arrangements among African-American families is provided by Patricia Hill Collins, "The Meaning of Motherhood in Black Culture and Black Mother-Daughter Relationships," in *Double Stitch: Black Women Write About Mothers and Daughters*, eds. Patricia Bell-Scott, Beverly Guy-Sheftall, Jacqueline Jones Royster, Janet Sims-Wood, Miriam DeCosta-Willis, and Lucie Fultz (Boston: Beacon, 1991), 42–60. The photographs in *The Sweet Flypaper of Life* are especially good examples of the porous boundaries between outside and inside, community and kin. Represented in a range of relationships across generational and kinship lines, individuals are shown in small and shifting connections rather than in static and self-contained family scenes.

5. By focusing on the delegitimated father-daughter pair, I am weaving together the insights of Hortense J. Spillers's essay, "Mama's Baby, Papa's Maybe: An American Grammar Book," *diacritics* 17, no. 2 (Summer 1987): 65–81 with Spillers's subsequent claim that "African American culture is open, by definition, . . . situated in the crossroads of conflicting motivations so entangled that it is not always easy to designate what is 'black' and 'white' here." ("'All the Things You Could Be by Now, if Sigmund Freud's Wife Was Your Mother': Psychoanalysis and Race," in *Female Subjects in Black and White: Race, Psychoanalysis, Feminism*, eds. Elizabeth Abel, Barbara Christian, and Helene Moglen [Berkeley and Los Angeles: University of California Press, 1997], 139.) The case for matrilineage is most eloquently made by Alice Walker in such essays as "In Search of Our Mothers' Gardens," the title essay of the collection by that name, ed. Alice Walker (New York: Harcourt Brace Jovanovich, 1983), 231–43, and in her construction of Zora Neale Hurston as a literary mother for African-American women writers; see Hurston, *I Love Myself When I am Laughing . . . And Then Again When I Am Looking Mean and Impressive: A Zora Neale Hurston Reader*, ed. Alice Walker (New York: The Feminist Press, 1979).

6. bell hooks, "In Our Glory: Photography and Black Life," in *Picturing Us: African American Identity in Photography*, ed. Deborah Willis (New York: The New Press, 1994), 50. See also hooks's discussion with Carrie Mae Weems about white viewers in "Talking Art with Carrie Mae Weems," in bell hooks, *Art on My Mind: Visual Politics* (New York: The New Press, 1995), 74–93.

7. Quoted in Sidney Doniger, Sandra Matthews, and Gillian Brown, "Personal Perspectives on the Evolution of American Black Photography: A Talk with Carrie Mae Weems," *Obscura* (Los Angeles Center for Photographic Studies) 2, no. 4 (Winter 1982): 11.

8. Deborah Willis, "Introduction: Picturing Us," in *Picturing Us: African American Identity in Photography*, ed. Deborah Willis (New York: The New Press, 1994), 3–4. Subsequent citations will be placed in parentheses in the text.

9. For some of Willis's thoughts on the recent emergence of an African-American female perspective in photography, see her book, *Lorna Simpson* (San Francisco: The Friends of Photography, 1992).

10. For a similar rendition of the cultural paradoxes embedded in the rituals of the hot comb in the kitchen, see the chapter entitled "In the Kitchen" in Henry Louis Gates, Jr., *Colored People* (New York: Vintage, 1995), 40–49. Although straightening hair is by no means limited to women, as Gates's memoir reminds us, it consistently transpires via the female culture of the kitchen. Kobena Mercer's essay "Black Hair/Style Politics," *New Formations* 3 (Winter 1987): 33–54, remains a classic statement of the contradictory implications of straightened hair.

11. For an account of the Clarks' conclusions about the dolls tests, and the controversial role these conclusions played in the famous *Brown v. Board of Education* case, see Kenneth B. Clark, *Prejudice and Your Child* (Boston: Beacon, 1955; rpt. 1963). In her essay in this volume, Willis provides another layer of biographical meaning to the doll she prefers. The choice of a brown-skinned doll forms one of the many links between Willis and hooks, who recounts in her memoir, *Bone Black: Memories of Girlhood* (New York: Henry Holt, 1996), that she, the family's "problem child," was the only one of six daughters who repudiated the more available, less expensive, ostensibly more desirable white dolls in favor of a "brown doll, one that would look like me" (24).

12. For an analysis of the ways that commodity culture promotes racial homogeneity by producing black and white versions of the identical doll, see Susan Willis, "I Shop Therefore I Am: Is There a Place for Afro-American Culture in Commodity Culture?" in *Changing Our Own Words: Essays on Criticism, Theory, and Writing by Black Women*, ed. Cheryl A. Wall (New Brunswick, N.J.: Rutgers University Press, 1989), 173–95.

13. The preface concludes with a return to hooks's account of her response to a photograph of Billie Holiday; hooks is also the first person Willis names in her dedication of *Picturing Us* to the individuals who inspired her "to look at images in a critical way." Several intertextual resonances suggest that the two critics were in conversation throughout the composition of both texts. For example, Willis's self-description as a curator and "keeper of images," a phrase she puts in quotes directly after a citation from hooks, echoes hooks's description in "In Our Glory" of her grandmother, the cultural curator of her childhood, as a "keeper of walls" (50).

14. In *Bone Black: Memories of Girlhood*, hooks offers a fuller account of the reasons she would not want to become her mother, who neither understands nor encourages her

daughter's creative or political sensibilities, who reveres conventional domesticity, and who remains loyal to an abusive husband. The memoir also elaborates on the crucial role of her mother's mother in providing an alternative genealogy based on vision, imagination, and spirituality. At the same time, however, the more extended form of the memoir allows for greater ambivalence and complexity. In the memoir, hooks both acknowledges the sustaining force of her mother's love and recounts a troubling incident in which the idealized grandmother, who "does not read or write," resists the family's purchase of glasses for the nearsighted young hooks; here, it seems, it is the parents who see the child's need for a larger perspective (58; 37–38).

15. For VanDerZee's photographs of the dead, see James VanDerZee, Camille Billops, and Owen Dodson, *The Harlem Book of the Dead: Photographs by James VanDerZee* (Dobbs Ferry, N.Y.: Morgan and Morgan, 1978). For one example of the literary influence of VanDerZee's mortuary images, see Toni Morrison, *Jazz* (New York: Knopf, 1992), especially pages 11–13. Near the end of her essay, hooks cites this passage from *Jazz* as an example of the way that photographs "were and remain a mediation between the living and the dead" (52). See also the essays by McDowell and Willis in this volume for a fuller account of African-American photography's memorializing functions.

16. Hooks doesn't reproduce any of these photographs in her essay, but perhaps their structure and intent can be gleaned from a *Family portrait* by VanDerZee that shows five daughters (one fewer than in hooks's family) and one son aligned by size between the bookends of their parents (see page 160 of Deborah Willis-Braithwaite, *VanDerZee, Photographer: 1886–1983* [New York: Harry N. Abrams, Inc., in association with the National Portrait Gallery, Smithsonian Institution, 1993]). *Bone Black* makes clear the extent to which hooks felt like an "exile" within her family, and how painful and false it must therefore have been to be decked out and defined as a member of this family.

17. Bell hooks, "Talking Art with Carrie Mae Weems," 78.

18. I am choosing to focus on the Kitchen Table Series, which is only problematically characterized as family photography, precisely because of its contrast to the work of Willis and hooks. In many ways, Weems's earlier *Family Pictures and Stories* (1978–84)—which was inspired by DeCarava and designed as a refutation of the Moynihan Report's pathologization of the black family, and which traces through family photographs and audiotaped narratives the history of both her parents' families from their southern roots in Memphis and Clarksdale in the 1950s to the present—is much closer in spirit to the work of Willis and hooks; as a result, however, it doesn't expand our historical and theoretical scope to the same degree. On *Family Pictures and Stories*, see Andrea Kirsh, "Carrie Mae Weems: Issues in Black, White and Color," in *Carrie Mae Weems*, ed. Andrea Kirsh and Susan Fisher Sterling (Washington, D.C.: The National Museum of Women in the Arts, 1993), 11–12; and Saidiya V. Hartman, "Roots and Romance," *Camerawork* 20, no. 2 (Fall/Winter 1993): 34–36.

19. "[W]hen I was constructing the *Kitchen Table Series*, Laura Mulvey's article 'Visual and Other Pleasures' came out, and everybody and their mama was using it, talking about the politics of the gaze, and I kept thinking of the gaps in her text, the way in which she had considered black female subjects . . . All the pieces in the *Kitchen Table Series* highlight 'the gaze'" ("Talking Art with Carrie Mae Weems," 84–85). For hooks's own analysis of black female spectatorship, see "The Oppositional Gaze," in *Black Looks: Race and Representation* (Boston: South End Press, 1992), 115–131. In her con-

versation with Weems, hooks describes this piece, which was also triggered by Mulvey's work, as the theoretical counterpart to the *Kitchen Table Series*.

20. I am following Susan Fisher Sterling's structure in "Signifying: Photographs and Texts in the Work of Carrie Mae Weems," in *Carrie Mae Weems*. Sterling persuasively identifies four photo chapters: the first about the love relationship, the second about the woman's search for consolation after it ends, the third about the woman's relationship with her daughter, and the fourth about the woman's experience of solitude.

21. According to Sterling, on the basis of her discussions with Weems, the *Kitchen Table Series* began with the man's experience, rendered as a never-used set of images of the man looking in from the outside. After defining the visual text in terms of the woman's experience, Weems tried to articulate the man's point of view through her assemblage of voices in the written text. See especially Sterling's footnote 39, page 36.

22. I am indebted to Mieke Bal for raising this last possibility at the Dartmouth conference on "Family Pictures/Shapes of Memory"; for other readings of *Mirror, Mirror*, see bell hooks, "Talking Art with Carrie Mae Weems," 84, and Susan Gubar, *Racechanges: White Skin, Black Face in American Culture* (New York: Oxford University Press, 1997), 15–16.

23. See Hirsch, *Family Frames*, 141–50, for the most thoughtful and detailed reading of the *Kitchen Table Series*.

24. These visages have of course become familiar through Sandra M. Gilbert and Susan Gubar's reading of this archetypal fairy tale in *The Madwoman in the Attic: The Woman Writer and the Nineteenth-Century Literary Imagination* (New Haven: Yale University Press, 1979), 36–44. Having initiated Gilbert and Gubar's monumental study, the Snow White story also concludes it: in "The Further Adventures of Snow White: Feminism, Modernism, and the Family Plot," the final chapter of the final volume of *No Man's Land: The Place of the Woman Writer in the Twentieth Century* (New Haven: Yale University Press, 1994), Gilbert and Gubar analyze how the story's transformations can serve as a template for women's narrative fortunes.

25. On the specular relations between cultural nationalism and dominant cultural ideologies, see Wahneema Lubiano, *Like Being Mugged by a Metaphor: 'Deep Cover' and Other Fictions of Black American Life* (Durham: Duke University Press, 1997), especially the essay "Don't Talk With Your Eyes Closed: Caught in the Hollywood Gun Sights," which also appeared in *Borders, Boundaries, and Frames: Cultural Criticism and Cultural Studies* [Essays from the English Institute], ed. Mae Henderson (New York: Routledge, 1995), 185–201.

26. In response to bell hooks's comment in "Talking Art with Carrie Mae Weems" that "The *Kitchen Table Series* often makes me think of the blues," Weems explains: "I'm very interested in ideas about blues and jazz, that expressive musical culture. That's where I function . . . So in doing the *Kitchen Table* piece, it was always about how you construct it. How do you make a blues piece? What does that look like?" (88–89).

27. Susan Fisher Sterling claims in "Signifying" that these two photographs, which first appeared in Weems's 1990 book THEN WHAT? *Photographs and Folklore*, "stand out from the rest and are crucial to the beginning of the artist's next major photo-narrative. 'Jim' is the prototype for the man, whose social mission is impossible, while the disconsolate woman in *Untitled* (Woman and phone) is Weem's protagonist" (25). The first version of *Untitled* (Jim, if you choose), was a 15¼-by-15¼-inch silver print made in 1988.

Now in the collection at Williams College Museum of Art, it was originally made as part of the *American Icons* series (1988–89). It appears that another version, 14½ by 14½, was made in 1990 for THEN WHAT? using the same model who appears concurrently in the *Kitchen Table Series*.

28. bell hooks also ponders the implications of Jim's impossible mission in "Talking Art with Carrie Mae Weems," "Representing the Black Male Body" (also in *Art on My Mind*), and in "Doing It For Daddy" (in *Constructing Masculinity*, ed. Maurice Berger, Brian Wallis, and Simon Watson [New York: Routledge, 1995], 98–106).

29. In "Mirror-role of Mother and Family in Child Development," D. W. Winnicott contrasts Lacan's interpretation of the alienating features of the mirror stage explored in "The Mirror Stage as Formative of the Function of the I" with his own understanding of the integrative function of the mother's face in the child's development. In "Playing: A Theoretical Statement" and "Playing: Creative Activity and the Search for the Self," Winnicott theorizes childhood play as the origins of creativity. See these and other essays collected in D. W. Winnicott, *Playing and Reality* (Middlesex, England: Penguin, 1974).

30. Michael H. Cottman and Deborah Willis, *The Family of Black America* (New York: Crown, 1996), 10. The text is a good example of the ways in which cultural nationalism interweaves the homosocial with the heterosexual and mirrors dominant social formations.

31. Valerie Smith analyzes some of these films in her lecture on "Discourses of Family in Black Documentary Film." For an account of some alternative affiliational families, see Kath Weston, *Families We Choose: Lesbians, Gays, Kinship* (New York: Columbia University Press, 1991, rev. 1997).

Viewing the Remains:
A Polemic on Death, Spectacle, and the [Black] Family

Deborah E. McDowell

Black death has never before elicited so much attention. The . . .
publicity given to the slaughter becomes, itself, one more aspect of
an unforgivable violation.
> —James Baldwin, *The Evidence of Things Not Seen*

The dead are the objective figure of an exchange among the living.
> —Michel de Certeau, *The Writing of History*

Bulletins of black male death have commanded 1990s headlines: "To Be
Young, Male and Black: Worsening Problems Confront the Nation's 'Species
in Danger.'" "Young Black Men Much More Likely to be Murdered." "Death
at an Early Age." "Black Men in District Have Second Shortest Life Expec-
tancy." Grim statistics trailed the headlines: "Young black men were almost 14
times more likely to be murdered during 1992 than the nation's general popula-
tion," according to a report released by the U.S. Justice Department's Bureau
of Statistics in December 1994. Black males, between the ages of twelve and
twenty-four, the report continued, were "victims of homicide at a rate of 114.9
per 100,000 that year, compared with 8.5 murder victims per 100,000 of the
general U.S. population." And among males between the ages of sixteen and
twenty-four, the report concluded, "blacks were 1.5 times more likely than
whites to be victims of all types of violent crime."[1] Such statistics are the stan-
dard fare of the morning papers and the evening news, business as usual.
William Raspberry put it well in an editorial that rehearsed mortality rates in
the Washington, D.C., metropolitan area for January 1990 alone. "The overall

homicide count . . . was 51, one short of the record set a year ago. Stay tuned for the latest in sports."[2] It has almost come to that. Indeed, running tallies of shootings and killings in the city's streets do seem to mimic the innocuousness of sports scores, stock market reports, or year-to-date precipitation. Ironically they constitute, at best, a perverse form of death as victory; at worst, a form of counting that underscores how little black bodies "count," how little they matter, just how worthless they finally are.

These headlines and statistics have found their visual counterparts in yet another staple of contemporary journalism: post-mortems, photographs of black male homicide victims, featured regularly in major metropolitan newspapers and on the front covers of popular magazines.[3] At first glance, these pictures seem to humanize, to give face to the deadening abstractness of anonymous headlines and statistics, and more important, to excite public sympathy and moral outrage, to spark some communal response. As one reporter put it, the press tries to capture these stories "with the vague hope [that they] will somehow make a difference, that in the great scheme of things, [they] play [their] little part and it will spur other people to do their little parts."[4] But as the reporter concedes, "It isn't working." The coverage isn't doing its intended job. What, then, is its function? What do these pictures make us see?

At the most obvious level, they provide just one example of what the white press makes routinely evident: U.S. culture apprehends black Americans, especially black American men, largely through the ubiquitous artifacts and metaphors of photographic technology. Whether, as in these post-mortems, they are exploited to represent violence, "inner-city" decay, family "breakdown," and epidemic loss of life; or elsewhere, to represent athletic/sexual prowess or to sell fast food, soft drinks, or the latest high-top shoes, black men's bodies are ubiquitous, over-exposed. Clustering at either end of two kindred poles: sex at one and death at the other—EROS/THANATOS, the metonymic fantasy (the body as penis) and the victim ideal (the corpse)—their bodies have historically made good spectacle, have become seared in the nation's optical unconscious.

Recent academic work on masculinity has focused increasing attention on the black male body as spectacle[5] in a variety of contexts and, drawing on early film criticism, has tended to equate looking with "consumerism, corruption, deception, an ethical failure."[6] As Barbara Stafford and others have observed, such judgments tend too often and too easily to treat "spectacle," "spectatorship," and the "gaze" as static concepts and "to ignore the variability of optical sensations in different times, places, and individual beholders"(6). She argues rightly that "looking" need not be, *ipso facto*, evil, nor viewers reduced to detached voyeurs.

On a campaign to promote what she terms "visual literacy," by which she means a nuanced understanding of pictures as pictures, Stafford calls first and

most basically for learning to read images in context, for distinguishing between the protocols required to read images as opposed to written texts. And yet, the very concept of "visual literacy" effectively marries the image and the word; indeed makes the image dependent on the word.[7]

Interestingly, in a book that ranges over a vast domain of visual images, Stafford omits any discussion of the world of journalism, which would certainly put her thesis supremely to the test. Dependent on pictures to tell their stories and on stories to "tell" their pictures, newspapers, in particular, illustrate the inextricable connection between words and images. Not only do they use visual images as written texts, but they are fully parasitic on them. Nowhere is this tendency more brutally apparent than in these contemporary post-mortems, which illustrate the difficult, if not impossible, task of severing one from the other, of eradicating photography's associations with voyeurism and of dissolving the asymmetrical relations between the viewer and the viewed, the spectator and the spectacle, the consumer and the consumed.

These post-mortems circulate specifically within a journalistic economy linked to the dissecting and quantifying obsessions of social science, linked especially to its historically racialized obsessions with separating the "normative" from the "deviant." These categories construct two extremes of humanity: the embodied black males and their survivors and the faceless, disembodied reporters who objectify them for the consumption of the reading public.[8]

I. Picturing the [Black] Family

These contemporary post-mortems revive a genre of memorial photography that enjoyed mass appeal throughout the nineteenth and early twentieth centuries. Objects in the extensive paraphernalia of the mourning process, these pictures, then and now, represent the doubling of death, literalizing photography's symbolic associations with death. Despite our now common advertising hype about the timeless Kodak moment that keeps alive the rituals of domestic life and the celebrations of rites of passage, photography (which some have termed "thanatography") is an elegiac art. Susan Sontag describes it as an "inventory of mortality," and Roland Barthes, as that which is "*without future* (this is its pathos, its melancholy)." The photograph, he continues, "produces Death while trying to preserve life"; its age is "also the age . . . which denies ripening."[9]

At the height of their production in the mid-nineteenth century, post-mortems dealt explicitly with ripening denied, for, due to high infant mortality rates in the general population, children were the predominant subjects of these photographs.[10] When James VanDerZee began to take post-mortems of blacks

1. Daguerreotype of father and mother with dead child, c. 1850–1860s. Photographer unknown. Courtesy Strong Museum, Rochester, N.Y.

in 1920s Harlem, children were also his most frequent subjects, due again to the preponderance of black infant mortality at the time.[11] Images featuring dead children with their surviving parents were quite common, a photographic practice that doubled their social function (illus. 1 and 2). More than memorials to the dead, such images became staples in the image archive of middle-class families. Displayed on walls and in albums, along with other pictures, these photographs, which gathered together the living and the dead, preserved when possible the cultural ideal of the nuclear, conjugal family as corporate entity, as autonomous unit, together and whole.[12]

Now, as we near the end of this millennium, post-mortems have migrated from the walls of the family parlor and the pages of photo albums to the front pages of newspapers and mass-circulation magazines. In this public context, the images lose their specificity and their original function as private memorials to the dead, becoming, in the process, "family pictures" of a different kind. Let me first confront the obvious difference evoked by the "Black Family," a term historically cast as the negative obverse of the cultural norm: the imaginary "White Family." The gap between the two grows wider as younger and younger male victims increasingly become the subjects of these latter-day post-mortems, the very young men who symbolically represent the black family's future as a "legitimate" institution. That so-called "legitimacy" is secured, of course,

2. Daguerreotype of mother with dead child, c. 1840s–1860s. Photographer unknown. Courtesy Strong Museum, Rochester, N.Y.

by the presence of the father, a figure always presumed absent from the black family unit. In the place where he should be is the mother and not just any mother, but a single mother. As Martha Fineman has observed,

> The very label "single mother" separates some practices of motherhood from the institution of "Mother" by reference to the mother's marital status. As constructed and defined in this culture, mother is modified by her relationship (formal and legal) to the father . . . No one speaks of a "married mother"; the primary connection of husband and wife is assumed in the unadorned designation of "mother." It is only the deviant form of motherhood that needs qualification and, by implication, justification.[13]

In the following images of urban homicide, the black mother becomes the central figure in a tableau of death that ultimately marginalizes all other survivors. Indeed, one of the most striking compositional staples of these postmortems is the image of the mother looking down on or seated just to the side of the coffin that holds her son. His death is made all the more horrible for coming at the hands of another young black male, who, in the name of law and order, must subsequently suffer his own entombment in a prison cell. This

pose, which shrinks the larger network of familial relations to one, calls to mind that ancient, proto-sacral dyad that is mother and son. In this gendering of mourning, the mother is cast as the *mater dolorosa* (the mother full of grief), who, notes Julia Kristeva, "knows no masculine body save that of her dead son, and her only pathos . . . is her shedding tears over a corpse."[14]

We might read this image as a secularized pietà, albeit a mocking pietà, for this son is not the sacrificial image of redemption but in redemption's need. In other words, despite the traces of sacred iconography in these secular pietàs, the figures here are not emblems of the Holy Family. This is the "other" family that threatens the presumed stability and security of the norm—that modern nuclear unit with the father at its head. Of course, that pious construct—the nuclear family—has long been unstable and in flux, but the most powerful visions of its failure and collapse in the past few years have been colored black. The black male corpse can thus be seen as a flashpoint in a larger cultural debate about family values.[15]

Even though these pictures have all been taken within the context of funerals, the verbal texts that underwrite them veer far away from eulogy and remembrance. Indeed, the dead are accorded only passing mention as the narratives work to establish the structural links between violence, criminality, and the deviant family unit.

"The Mourning After: One Mother's Struggle to Survive her Son's Slaying," appearing in the *Washington Post* and, punning on black mothers' making their sons the locus of their desires, promises a story on this mother and son. That focus is obscured by the story's larger concerns with crime. Although the mothers of these stories are generally written *about*, Joyce Collette is granted a rare opportunity to speak, to address not only the pain of losing her son but also the larger issues of black urban homicide. The tendency of the press, she observes, is to see the victims as criminals or, at best, "victims who had asked for trouble." She condemns the police for wanting to know if Andwele "did drugs . . . if he had a juvenile record," and concludes, "if the media portray young men at all sympathetically . . . it is simply as victims [and] crime always has something to do with it. They are never seen as ordinary kids . . . endearing boys learning to be men."[16]

Similarly, in "Double Slaying Expands a Mother's Grief Twofold," appearing just a few days later in the *Washington Post*, an expected narrative of grief yields to a narrative of criminality, in which police upstage the grieving family members altogether. The story's sensational opening line: "Semiautomatic gunfire exploded last week in a dimly lit stairwell in Southeast Washington and changed Pauline Jones's life forever. In two short bursts of fire her two sons were dead."[17]

After identifying the sons by name and the Southeast apartment building where they met their fates, the reporter rushes to inform the reader that the suspect has been apprehended and law and order restored: "As mourners re-

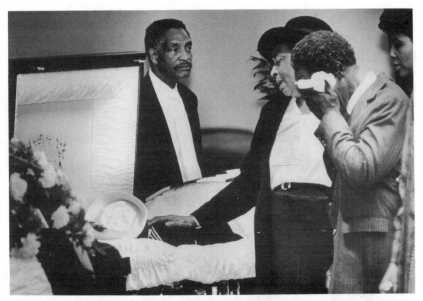

3. "Double Slaying Expands a Mother's Grief Twofold." Photo by James A. Parcell. © 1992, *The Washington Post*. Reprinted with permission.

membered the brothers, D.C. police homicide detectives arrested Rayfield Wilson Jr., 29, of the 6100 block of Walton Avenue, Camp Springs. . . . D.C. Superior Court records show Wilson was imprisoned in 1984 for second-degree murder while armed and carrying a deadly weapon. Authorities said he served seven years in prison and was released late last year."[18]

To illustrate the story, the *Washington Post* selects the photograph of the one son buried in military uniform (illus. 3). Significantly, his Navy cap obscures his face; indeed the cap dominates his shrunken figure, dwarfed as it is by the open lid of the coffin and the relatives who stand beside. The camera angle, both here and in the shot of Andwele Jackson (illus. 4), functions, whether intentionally or not, to dwarf the corpse, enlarging the image of the mother. And, although Jackson's mother, Joyce Collette, is described as weighing just under 100 pounds, the image of her, across from the post-mortem with her son is dominating and imposing. At both visual and verbal levels, the next image enlarges the mother's figure, while eclipsing the father's.

The fact that fathers are members of these grieving family units gets buried in the body of texts dominated, at least visually, by the mother's image. Though present, the father's face is cropped and he is almost crowded out of the visual frame (illus. 5). While it could certainly be argued that this effacement is necessitated by the layout of the page, I would suggest that we see beyond the frame, beyond the inches and corners of journalistic design. Here, visual image collaborates with verbal text to marginalize the father and shore up a

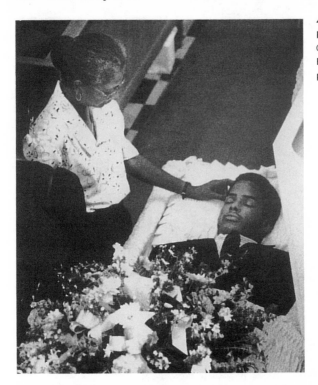

4. "The Mourning After."
Photo by Heather Stone.
© 1992, The Washington
Post. Reprinted with
permission.

deeply held and patently resilient myth about black family. So powerful is this myth that, even when fathers are present, they are subtly and symbolically "absented" or rendered "half-men," partial figures.

As the victims of urban homicide become younger and younger, the rhetoric of familialism becomes correspondingly more insistent. The death of a child contravenes the powerful Western image of childhood innocence, an image that does not extend to black children who are "born guilty," who are criminals-in-the-making. Nowhere is this more apparent than in the much-publicized death of Robert Sandifer or "Yummy," as he was called in the popular press. You will recall that he was the eleven-year-old gang member killed in Chicago one month after he allegedly killed Shavon Dean, a fourteen-year-old girl.[19]

Several newspapers and magazines detailed the story, but none as extensively as the *Time* cover story of September 19, 1994, headlined "The Short, Violent Life of Robert 'Yummy' Sandifer." Readers familiar with the fiction of Ernest Hemingway can hear echoes of his short story, "The Short Happy Life of Francis Macomber." Hemingway's story of an African safari is evoked throughout the six-page feature that attempts to explain the "short, violent" life of Robert Sandifer. Indeed, Chicago's South Side is figured as nothing if

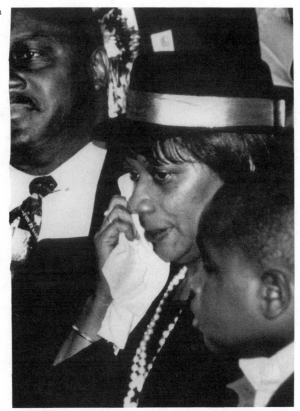

not a jungle, the proverbial Dark Continent, in which a child like Yummy is likened to a "trapped animal," alternately "hunter" and "prey." This image of Chicago, or at least Yummy's working-class neighborhood of Roseland, as jungle, contrasts sharply and ironically with the image silkscreened on a tee-shirt worn by Yummy's grandmother (illus. 6). Emblazoned across her midriff is CHICAGO in bold black type, and in the backdrop, the glorious façade of the city, the shoreline of Lake Michigan, the central business district of "The Loop," complete with skyscraper office buildings and luxury hotels. On the facing page, Yummy's mother stands with two of her children in front of a ramshackle dwelling, its porch piled with discarded household objects, its yard littered with debris. The relations of the politics and economy of "The Loop" to Yummy's Roseland should figure centrally in any larger narrative woven of the boy's demise, but in this story it figures almost not at all. While the reporters do suggest that Robert was a child failed by the courts, the cops, and the probation officers who tracked his short life and criminal career, they assign the greatest responsibility to the utter breakdown of his family: the absent father, in jail on drugs and weapon's charges; the mother, the

6. "He called her Mama: At her home in Roseland the day after the funeral, Janie Fields, Yummy's grandmother, stares at a photograph of herself." Steve Liss/*Time* magazine. © 1994 Time Inc. Reprinted with permission.

"third of 10 children from four fathers—[who] never knew her own" (57). Starting at age fifteen, Yummy's mother began to have eight children in steady succession. When a court psychiatrist declared her an unfit and abusive mother, unlikely "ever to be able to adequately meet her own needs, let alone . . . the needs of her growing family," Yummy and his siblings were placed in their grandmother's care. As the story points out, however, the grandmother's parenting skills are equally in doubt. Diagnosing her as having a "rather severe borderline personality disorder," the report of the court psychiatrist goes on to describe her as "a *controlling, domineering, castrating* woman" (emphasis added).

Here, the clinical language of diagnosis strongly evokes the ever-resilient myth of black matriarchy. At least since E. Franklin Frazier's *The Negro Family in the United States* (1939), from which Senator Moynihan took his controversial thesis, "black matriarchy" has taken the blame for everything from academic failure to teenage pregnancies to drug addiction to criminal recidivism—and now, if only through insinuation, to these epidemic rates of homicide.

In the absence of a functioning family unit, the gang becomes its substitute, ironically "protecting" Yummy at the same time that it increased the threat against his life.[20] While the cover features a wallet-sized mug shot of "Robert," picturing him at once as innocent and menacing, the post-mortem at the center of the story seems to signal unambiguously that he is more boy than

man (illus. 7). Dominated by the iconography of childhood, the image features a teddy bear lying beside him in the coffin. Young children surrounding the coffin to view the remains stretch out their hands to touch his face in a gesture of benediction. A teenage girl stands at the head of the group, near the frame's upper edge. On one side of her is the face of a toddler held aloft to view the dead boy; on the other, a figure cropped out of the picture, except for a hand, which clutches a baby bottle, its nipple pointing toward the young girl's face. This unstaged tableau of death could not have been more perfectly arranged for ideological effect. The picture's point of origin is the young girl's face, frozen in lateral relation to the toddler and baby bottle—a mother-in-the-making, a scene, judging from the previous stories, prefiguring a deadly future sequence of events.

There are no parents here. This is a society of abandoned children, the picture seems to state, a situation traducing the very idea of civilized society. Even those children who have miraculously, if only momentarily, escaped death's clutches, exist in families in which the roles are switched, in which children become caretakers of their parents. Yummy's twelve-year-old friend, Kenyatta James, makes the point in the story's closing image. As he leaves the reporter, he "place[s] both hands in his pants pocket for comfort before returning to his house to take care of his mother." In ending with this image illustrating the ambiguous status of the black urban child, the story comes to rest on the paradoxes that have structured it from the beginning. It positions Yummy, Kenyatta, and, by extension, the surviving children of Roseland in that ambiguous

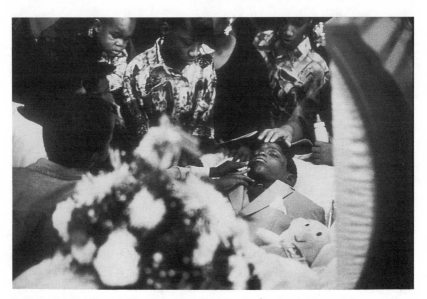

7. Yummy Sandifer. Steve Liss/*Time* magazine. © 1994 Time Inc. Reprinted with permission.

and mutually contradictory zone separating the world of children from the world of adults.

Although focused on children in eighteenth-century Paris, Arlette Farge's insights into the plural status of childhood in that context might be worth pondering for this one. "It is impossible to fix these children in a definite role," she argues, "because they contained within themselves that diversity of role and function which allowed them to exist simultaneously as both child and adult." A signal component of that diversity, she continues, was the "adult" role that "children" played in the economic transactions of their society. "They all knew the price of life, the difficulty and uncertainty of their parents' work and the rules of ethical change and reward and they played their part in that life both as child and as adult."[21]

It could be argued that "Yummy" Sandifer fell into the lap of an underground drug economy that claims and exploits many like himself who are recruited by local gangs in particular to run drugs for "cash bonuses." George Knox, identified in the story as a gang researcher, speculates that Yummy was probably going for such a bonus when he shot and killed Shavon Dean and precipitated the chain of events that led to his own inevitable demise.

In covering Robert Sandifer's story, *Time* magazine makes dramatic—even sensational—use of a child's dead body presumably to sound an alarm, but here this alarm is not followed by a rescue team, unless it be the timeworn, shopworn, "stable family," with "mother's milk" and nurturance. But instead of nurturance, the mothers of Chicago's South Side feed their children a different nutriment, a form of violence, exposing them to the terrifying face of death. The children are urged to touch the stitches on the dead boy's face, the place "where the bullets fired in the back of his head had torn through" (55). Explaining to the reporter this desperate measure of frightening her nine-year-old son, the mother notes: "maybe then he wouldn't be lying there himself one of these days" (55). Yummy's corpse thus serves an admonitory or cautionary function, serves as a shocking reminder to those not yet claimed by death that they too are vulnerable, that their dead bodies might be next in line.

Indeed, in its coverage of the story, the *New York Times* makes this point with dramatic force. It ran a post-mortem taken by a photographer of *Agence France* that featured a young boy who looks to be about Robert's age. There was an uncanny resemblance between Robert's face and that of a young boy standing at the head of the frame, a resemblance stressed further by their shared ceremonial attire: suit coat and tie. As both mirror opposites and mirror images, they did, in fact, suggest that the boy now living could shortly become the boy now dead.

The mother's assumption that haunting the children with the fear of death will help prevent their own deaths is as dubious as the efforts of some police departments to do the same. It is highly ironic that this assumption aligns the mothers with the desperate, specious measures of the law. The notion that

exposing young urban boys to death and violence will warn them away from it is the backbone of programs sponsored by various metropolitan police departments. In one Washington, D.C., program, run by Lieutenant Winslow McGill, the lieutenant visits the area schools and youth centers to show slides of fresh post-mortems of gang members, drug dealers, and others on the wrong side of the law. The presentation's shocking finale is a coffin rolled in, holding the waxed body of a thirteen-year-old drug dealer.[22]

That exposure to the aftermath of violence is a questionable strategy of prevention is made all too clear by the fact that one mother had taken Robert Sandifer, along with twelve other kids, to the local Chicago police station to see a film on crime the week before he died. The further irony of such "preventive" strategies is that the police are themselves the perpetrators of violence against urban youth in ever increasing numbers.[23] This fact put Mayor Rudolph Giuliani in a vexing position when he eulogized Nicolas Heyward, a thirteen-year-old shot by a police officer in a public housing complex two weeks after Yummy Sandifer's death. Responding to reports of gunfire, the officer came upon the youth who was "toting a toy gun while playing cops and robbers with friends" (yet another reminder of the conveniently ambiguous status of the black male youth).

The publicity that surrounded Nicolas Heyward's death can be read, at one level, as a matter of "good" public relations or a form of well-choreographed damage control; political fence-mending. Throughout his eulogy, Giuliani exploits the rhetoric of "family," although here he seeks not to indict the family but to embrace it. Addressing the slain youth's parents, he speaks first as a father of a son, then widens his appeal outward to include the metropolitan family: "All New Yorkers share your pain. Grieve with you. But it is particularly parents who understand some of what you are suffering." Then urging the congregation to "pray [to] God to find a way to love each other more," he closes the eulogy on a compensatory note invoking the interconnectedness of all human beings: "I share with you the *unifying* belief that the early solace of this loss, if there is any, is the recognition that *all of us* are children of the same God."

Though doubtless meant to forge a sympathetic identification with these parents in their grief, Giuliani's appeals to the poetics and motifs of Christian eschatology are weak consolation. Further, they risk absorbing the family's private suffering and loss into that of the general, public sphere, a risk recuperating the particularity of death and violence in black urban America into a timeless, sacred text from which all traces of this mortifying contemporary crisis have been erased. In other words, Giuliani's appeals to the transcendent language of *unity*, to the "common denominators" of the "human condition," mask the *differences*, the hard and persistent facts of police brutality, poverty, joblessness, and the signs of sweeping disenfranchisement that *divide* the "Universal Family.[24] Here, it must be reiterated that the unifying context of all these stories is the funeral, a ritual which has long marked the social place and status of the dead.[25]

Such matters are typically framed off from the media's accounts of black death. What remains inside the frame speaks to nothing more profoundly than blacks' absolute exclusion—real and symbolic—from the human family, from the social body. Indeed, one could argue that it is precisely the media's *exclusive* attention to black death that casts that social exclusion in such sharp relief. We might all die, but we do not all die under the same conditions. Jay Ruby does not exaggerate when he observes that news coverage of death is "confined to the publicly powerful and to poverty-stricken minorities—everyone else is invisible."[26]

Joanne Byrd, former *Washington Post* ombudsman, lends Ruby's observation added reinforcement. In her editorial "Not a Family Photo" Byrd registers and supports numerous outraged readers of *The Washington Post* who objected to seeing the photograph of a white man fatally wounded in front of the CIA Building on January 25, 1993. The readers argued that "The family should not have to see news photos of someone killed in an accident or a crime."[27] Byrd goes on to say,

> I am moved to write about this now because of the outpouring of public reaction to Tuesday's photo. Another day, we will wrestle with why *Post* readers responded this past week in such numbers and anger when they haven't done so about other pictures in the last half-year. But the principle of protecting the family remains, whether anyone calls.

In explaining the editorial decision to print the photograph, Executive Director Leonard Downie, Jr., noted that the in-house editors decided to publish it because they "thought it difficult to recognize the body in the car." He went on to say, "our policy is not to make a habit of showing recognizable dead people in the newspaper." The post-mortems of blacks clearly contravene, but only if we agree on the meaning and uses of "recognizable."[28]

It would be unfair to ignore the context of these remarks and to collapse two separate categories of "showing" or "viewing" the dead. While one could argue that the director, the editors, and the outraged reading public simply objected to printing the photograph of a victim caught in the instant moment of death's horrible surprise, the moment before the mortician's cosmetic reform, this does not fully satisfy, for without the news caption, the reader would not recognize the figure as dead. There was nothing objectively offensive about the image. More important, the director's statement raises all the more questions about the habitual publications of the corpses of young black men. Heightening the horror of their display is the fact that apparently nobody remembers *seeing* them.[29] And even if they are seen, *these* post-mortems do not invite protest. Perhaps they don't strike readers as "gruesome" because the press has accustomed them to viewing the face of black death. Indeed, in contemporary public media and discourse, death is synonymous with blackness and constitutes the absolute limit of "difference."

II. Imaging Death

> Today it is not normal to be dead . . . To be dead is an unthinkable
> anomaly; nothing else is as offensive as this. Death is a delinquency,
> and an incurable deviancy.
> —Jean Baudrillard, *Symbolic Exchange and Death*

As images supposedly used to "open our eyes" to the face of black death, to ig-
nite a national discussion about the urgency of "saving" the lives of young
black men, these post-mortems would seem instead to habituate the public to
the inevitable reality of their deaths, rendering them "natural" and "unnatural"
all at once. "Unnatural" because of current life expectancy rates, defied daily
in the bold black headlines. "Unnatural" because youth occupies a crucial
place in the American narrative of upward mobility and opportunity, a narra-
tive in which youthful prospects for a better future are often taken as one
index of national progress. "Natural" because the moment of death appears to
be the "goal" of life.[30]

The repeated emphasis on the brevity of black male life, by comparison to
the "norm," establishes the veritable racialized and absolute division separat-
ing "life" from "death." Indeed the black male corpse can be said to mark the
boundary separating the dead "other" from those defined as "living beings."
Even those who survive beyond their teenage years still face disparate life
prospects. According to a report recently released by the Harvard School of
Public Health and the Federal Centers for Disease Control and Prevention in
Atlanta, for black males in Washington, D.C., the 1990 life expectancy of 57.9
years is second in the country only to Oglala Sioux of the Pine Ridge Reserva-
tion who live an average of 56.5 years.

An implicit form of social Darwinism resurfaces in the media and works to
create this sense of hopeless and helpless fatality. Repeated in these images
and the narratives that accompany them is a powerfully resilient notion, which
has long circulated in social scientific circles, that this species is under threat
of extinction, its "fitness" to survive constantly "endangered."[31]

Although published in the 1950s, James Baldwin's observations in "Many
Thousands Gone" retain their relevance for contemporary times:

> The Negro in America is a *social* and not a personal or human problem;
> to think of him is to think of statistics, slums, rapes, injustices, remote
> violence; is to be confronted with an endless cataloguing of losses,
> gains, skirmishes; it is to feel virtuous, outraged, helpless, as though
> this continuing status among us were somehow analogous to disease—
> cancer, perhaps, or tuberculosis—which must be checked, even though
> it can't be cured.[32]

It is useful to compare this phenomenon to what Jeff Nunokawa has observed about gay men with AIDS. He argues that a benign form of homophobia explains widespread acquiescence to the catastrophic effects of the disease, according to the belief, fostered by the dominant media, that "gay people [are] . . . 'deathbed victims,'" who are "subject to extinction." He goes on to say that, perceived exclusively as a gay disease, despite massive evidence to the contrary, AIDS "means death, because [it] has made the most recent chapter in our culture's history of the gay male, a history, which, from its beginnings, has read like a book of funerals."[33] Taken together, these post-mortems read likewise like a book or photo album of funerals, converting the dead and their survivors into the stuff of spectacle, exposing, in the process, the social cleavages that spectacle expresses and the social status quo it secures.

It is well known and widely conceded that black death has made good spectacle for audiences who have relished it historically in every form from fatal floggings to public lynchings. And while it would, of course, be flagrantly irresponsible to compare these contemporary post-mortems to the charred and mangled corpses of lynching victims, I would suggest that the use and display of these images in the public media does indeed allude to that history. Its bulging archive includes several unforgettable and horrifying images: from Emmett Till's bludgeoned and disfigured face to the countless, nameless abject bodies hanging from the branches of popular trees. Although these latter-day post-mortems have been aestheticized, submitted to the cosmetic fabrications that hide the killing wound from sight, they are no less haunted by that history that has long imposed on the black male that extreme, hypercorporeality that, in Robyn Weigman's view, "defined his distance from the privileged ranks of citizenry and disembodied abstraction." Weigman continues, "lynching figures its victims as the culturally-abject monstrosities of excess whose limp and hanging bodies function as the specular assurance that the racial threat has not simply been averted, but rendered incapable of return."[34] In fact, only this or that *particular* body is rendered incapable of return, for the threat of another one, just alike, is always there, and the media depends upon this circulation to shore up racialist structures and to keep racist fears alive.

That these are mainly murders "in the family," brother against brother, if you will, helps to construct two separate viewing spheres: the "public" and the "private." The "general public," that other disembodied (and white?) abstraction, is effectively guiltless and absolved of all responsibility to intervene. This is "family," or "private" business, as it were. But the press has already invaded the much-vaunted "privacy" of the family in publicizing these images. Indeed the press can be seen to suggest that the "rights of privacy" do not belong to the dead and to those survivors who are, for all practical purposes, already "dead" themselves. Dead in that sense that they have been historically deprived of their judicial person and their rightful place within the legal framework of the United States.[35] Although they are seldom pictured in contexts outside the

funeral scene of grief, it is important to note that survivors of black male hom-
icide victims are claiming their right to "picture" or represent this crisis. They
understand that neither these deaths nor any initiative to arrest them can be
easily assimilated into the pious logic of "family values" and its violent simplifi-
cations, which obscure the role that class and power asymmetrics play in the
rise of black youth mortality. Continuing a tradition begun by Mamie Till
Bradley, the mother of Emmett Till, they have seized the political stage, refus-
ing to be relegated to roles as passive mourners. You will recall that Bradley,
barely preventing her son's hasty burial in Mississippi, politicized his death
and funeral by opening his casket for all the world to behold his battered and
disfigured body. Unlike the corpses in the post-mortems we have viewed, Till's
body was not and could not be beautified, nor could the broader political con-
text surrounding his murder be ignored.

Like Mamie Bradley, the mothers of these dead sons have attempted to
intervene in this tragedy and, to borrow from Douglass Crimp, to live the con-
junction of "mourning and militancy."[36] Some, such as Cynthia Harris, have
devoted their time to antidrug activities and have played central roles in Drug
Control Policy centers of various metropolitan areas. Others have held public
demonstrations and rallies at the U.S. Capitol to urge members of Congress
not to repeal the 1994 ban on assault weapons.[37] The rare press coverage given
their efforts to combine grief with political responsibility offers a glimpse of al-
ternative uses of photography during this crisis. In one photograph (illus. 8), a

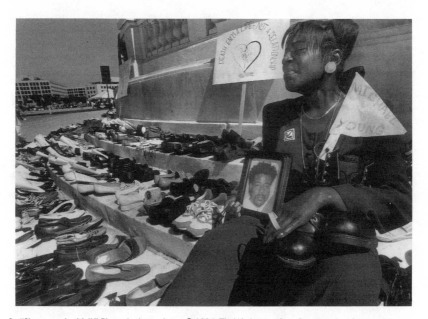

8. "Shoes on the Mall." Photo by Juana Arias. © 1994, *The Washington Post*. Reprinted with permission.

lone mother, her face contorted in grief, holds a framed photograph of her son, his boots slung over her shoulder. She stands at the capitol reflecting pool beside rows and rows of shoes belonging to 38,000 other victims of gun violence. Their survivors gathered in Washington for a silent march against gun violence that featured testimony from dozens of demonstrators, most of them mothers. Following the march, they paid visits to their Congressional representatives, either thanking them for their support or urging them to change their votes.[38] In still other photographs, the mothers reclaim the images of their sons, bearing their likenesses on their bodies. In one, a photograph of the son is printed on a T-shirt above the caption "Always in My Heart"; in another, an image in a circular frame pinned to a T-shirt reads "Survivors Against Violence Everywhere," and in another, a mother holds a poster on which is printed a gallery of photographs of the son within an ensemble of family pictures. These likenesses of the dead, taken from scenes of life, have become icons in the mourning rituals and political activities of the black working class.[39] They are retrieving memorial photography from its literal associations with the dead. These survivors live to tell a different story, to exhibit a different set of images suggesting a symbology in conflict with the uses to which the media typically puts its published post-mortems. Although they fail to control the terms of the debate, these survivors reject the role of passive mourners scripted by the media.[40] Bearing the dead that they have borne, they represent families that choose to exhibit the body not as still life, but as living still in memory.

III

Since 1990, when post-mortems began to appear with stunning regularity in metropolitan newspapers and mass-circulation magazines, reports have emerged that homicides are declining, albeit in negligible proportions. Although the tide of violence has not been stemmed enough to justify complacency, the media coverage is receding, its gaze has been averted or has shifted to the death of cities, especially Washington, D.C., whose decaying infrastructure, declining schools, and ineffectual government are daily anatomized. Blacks loom large as well in this accounting, although their presence is marked most especially by accounts of birth statistics, out-of-wedlock births, which begin anew the cycle of family degeneration. These are the mothers we have already seen: those shown time and again to be ill-equipped to save the lives of their children, who are always already marked for death.

When George Eastman introduced the Kodak in 1888, the blizzard of amateur photographs that resulted became known as snapshots, a word borrowed from hunters' jargon. According to Lorraine Monk, "when a hunter fired a gun from the hip, without taking careful aim, it was described as a snap shot.

Photographers referred to the process of taking pictures as shooting, and they would take pride in a good day's shoot the way country gentlemen would boast about the number of birds brought down in an afternoon."[41] At the risk of over-working the metaphor, let me suggest that the editorial decisions of many met-ropolitan newspapers and magazines amount to both "shooting from the hip" and taking careful ideological aim at the victims and agents of violence. The media's reproduction of these contemporary post-mortems and snapshots of grieving survivors constitutes its own form of violence, which heightens readers' fears of violence and reinforces long-existing racial and class divisions and antagonisms in the larger society. Even if used more benignly to illustrate the most unshakable (if naïve) assumptions of traditional documentary—that it will evoke compassion, or inspire social responsibility—they fail to do the job. As Susan Sontag argues, "the aestheticizing tendency of photography is such that, even when the medium is meant to convey distress, it all too often ends up neutralizing it."[42] In other words, these images can be and are easily left behind, the force and weight of their repetition producing, at best, "help-less outrage"; at worst, the awful sense that the only thing that can be done in the face of this wanton loss of life and wasted youth is to save the life that is your own.

Notes

1. "Young Black Men Much More Likely to be Murdered," *Washington Post*, Dec. 9, 1994. When I began this work, homicide was consistently reported as the leading cause of death of young black males under thirty. As of this writing, AIDS is the leading cause of death of young black men under thirty. While high rates of black male mortality rela-tive to their numbers in the population sound a necessary alarm, it should not be for-gotten that black female mortality rates from AIDS are also escalating.

2. William Raspberry, "Black on Black Violence: Jackson's Answer," *Washington Post*, Feb. 2, 1990.

3. While several metropolitan newspapers have featured post-mortems on their pages—*Los Angeles Times, Boston Globe, New York Times, Chicago Tribune*,—I have chosen to focus primarily on the *Washington Post*, whose treatment of this issue is fairly representative. As Roland Barthes reminds us, the name of any paper constitutes a knowledge that can powerfully inflect the reading of any image and text. The same photograph can change its meaning and significance depending on the name of the paper and the power it wields in the public sphere. The relationship of the *Washington Post* to the predominantly black city of Washington, D.C., has long been fraught, and the black citizens of Washington have repeatedly struggled with the *Post* precisely over

matters of black representation. For a discussion of a particularly controversial episode, see Jill Nelson's account of the controversy that surrounded the inaugural issue of the *Washington Post Magazine*. The cover line of the magazine read "Murder, Drugs, and the Rap Star"; the cover photo was the face of a young black man, a "dangerous-looking Negro, complete with animal-like flared nostrils." The companion story supported stereotypes of "young black men as inherently dangerous and of rap music as fomenting racist insurrection." *Volunteer Slavery: My Authentic Negro Experience* (Chicago: The Noble Press, 1993), 53, 55.

4. Cindy Loose, "How Many More Ways Can This Story Be Told?" *Washington Post*, Oct. 3, 1993.

5. For a discussion of black bodies as American spectacle, see Elizabeth Alexander's suggestive essay, " 'Can You Be Black and Look at This?': Reading the Rodney King Video(s)" in *Black Male: Representations of Masculinity in Contemporary American Art*, ed. Thelma Golden (New York: Harry Abrams, 1994), 91–110. See also Kobena Mercer, "Looking for Trouble," *Transition* 51 (1991): 184–97, and John Edgar Wideman, "The Killing of Black Boys," *Essence*, November 1997, 124–26, 184–87, 188–89. For general discussions of the spectacle, see Guy Debord, *Society of the Spectacle* (New York: Zone Books, 1994), and Susan Stewart, *On Longing: Narrative of the Miniature, the Gigantic, the Souvenir, the Collection* (Durham, N.C.: Duke University Press, 1993).

6. Here I draw on Barbara Stafford's *Good Looking: Essays on the Virtue of Images* (Cambridge, Mass.: MIT Press, 1997), 5. Subsequent references to this text will be indicated in parentheses above.

7. In an interview with Jan Swearingen, Walter Ong makes this very point. Literacy is so imperious, he argues (a point that Stafford has freely granted), that "we are likely to view any information processing [including visual imagery] in terms of literacy, by analogy with reading and writing." See Jan Swearingen, "On Photographic 'Literacy': An Interview with Walter J. Ong," *Exposure* 23 (Winter 1985): 20.

8. Here I borrow from W. J. T. Mitchell's nuanced understanding of "the public" as a fictional ideal, supposedly all-inclusive. But, as he well notes, the "public" can be "constituted only by the rigorous exclusion of certain groups," typically those without power or property. See "The Violence of Public Art: *Do The Right Thing*," in *Art and the Public Sphere*, ed. W. J. T. Mitchell (Chicago: University of Chicago Press, 1990).

9. Susan Sontag, *On Photography* (New York: Doubleday, 1977), 70. Roland Barthes, *Camera Lucida: Reflections on Photography*, trans. Richard Howard (New York: Hill and Wang, 1981), 90, 92, 94.

10. For a discussion see Richard Rudisill, *Mirror Image: The Influence of the Daguerreotype on American Society* (Albuquerque: University of New Mexico Press, 1971). See also Phoebe Lloyd, "Posthumous Mourning Portraiture" in *A Time to Mourn: Expressions of Grief in Nineteenth Century America*, ed. Martha Pike and Janice Armstrong (New York: Museums at Stonybrook, 1980); Jay Ruby, "Post-Mortem Portraiture in America," *History of Photography* 8 (July–September 1984): 201–222; and the photographic plates in *The Daguerreotypes of Southworth and Hawes*, ed. Robert A. Sobieszek and Odette M. Appel (New York: Dover Publications, 1976).

11. See Kelley Miller, "The City Negro," in his *Race Adjustment* (New York: The Neale Publishing Company, 1909). Miller attributed the "excess of the colored death rate over that of the whites" to "the great preponderance of infant mortality." Antici-

pating an analysis that we will continue to see, Miller attributes such high rates of mortality to the "carelessness, ignorance, and neglect on the part of Negro mothers" (126).

12. See Stanley B. Burns, M.D., ed., *Sleeping Beauty: Memorial Photography in America* (Altadena, Calif.: Twelvetrees Press, 1990); Jay Ruby, *Secure the Shadow: Death and Photography in America* (Cambridge, Mass.: MIT Press, 1995); Lindsay Smith, "The Politics of Focus: Feminism and Photography Theory" in *New Feminist Discourses*, ed. Isobel Armstrong (New York: Routledge, 1992). As Susan Sontag and others have observed, photography, in general, became a "rite of family life in the industrializing countries of Europe and America," just as the very institution of the family start[ed] undergoing radical surgery. As the claustrophobic unit, the nuclear family, was being carved out of a much larger family aggregate, photography came along to memorialize, to restate symbolically, the imperiled continuity and vanishing extendedness of family life" (*On Photography*, 8–9). See also Philippe Aries, "Pictures of the Family" in *Centuries of Childhood: A Social History of Family Life*, trans. Robert Baldick (New York: Vintage, 1962), 339–64.

13. Martha L. Fineman, "Images of Mothers in Poverty Discourses," *Duke Law Journal* (April 1991): 285–86. Fineman continues that single mothers are represented as "dangerous and even deadly, not only to their children, but to society as a whole" (291). She is obviously right to conclude that "the representation of single motherhood as pathological is inextricably linked to patriarchal ideology" (289). See also Dorothy Roberts, *Killing the Black Body: Race, Reproduction, and the Meaning of Liberty* (New York: Pantheon, 1997).

14. Julia Kristeva, "Stabat Mater," in *The Kristeva Reader*, ed. Toril Moi (New York: Columbia University Press, 1986), 175. Note that their relationship substitutes for and subsumes all others, including those erotic. The title of one article, "The Mourning After," announces such erotics right up front. And in another story, a mother attending a funeral, who understands this intimate orbit that is mothers and sons, empathizes with Pauline Jones, whose "arms are empty now." Jones is, then, both mother and lover. Beyond associations with a sacred text, figurations of this dyad of mother and son work subtly to reinforce ideologies of masculinity that thread their way through much of contemporary mass culture, never more strikingly than in the films of contemporary black men, in all of which a mother is either ineffectual or, symbolically speaking, a lethal weapon. John Singleton's *Boyz in the Hood*, Spike Lee's *Jungle Fever*, and Steve Anderson's *South Central* are just three examples.

15. The body of literature on the "pathology" of the "black family" is too vast to enumerate. Among the most controversial treatments are E. Franklin Frazier's *The Negro Family in the United States* (Chicago: University of Chicago Press, 1939) and Daniel P. Moynihan's *The Negro Family: The Case for National Action* (Washington, D.C.: Department of Labor, Office of Planning and Policy Research, 1965). Their ideas about the relation between female-headed families and the "antisocial" black underclass have found their way into journalistic narratives and into television documentaries. For example of the latter, see Bill Moyers's "The Vanishing Black Family: Crisis in Black America," which aired on PBS in 1986.

16. Tracy Thompson, "The Mourning After: One Mother's Struggle to Survive Her Son's Slaying," *Washington Post*, Dec. 14, 1992.

17. Avis Thomas-Lester, "Double Slaying Expands a Mother's Grief Twofold," *Washington Post*, Dec. 18, 1992.

18. News reports of many of these funerals have noted the presence of police officers, both uniformed and undercover. For just one example, see Courtland Milloy, "Mourners Say Goodbye to 'Stinkaman'—and Leonard," *Washington Post*, Sept. 19, 1991.

19. Stories about urban homicide have focused disproportionately on young men, who are indeed killed in greater numbers. But that fact should not eclipse the equally important fact that girls have been casualties of this crisis. See "Outpouring of Grief for Slain Sisters," *Washington Post*, March 29, 1991.

20. The reporters Julie Grace and John Steele note the irony that Yummy died "thinking he'd found a family," although his "odds of reaching the age of 12 [had already] dropped sharply when he fell in with the local Black Disciples gang." "Murder in Miniature," *Time* 144 (Sept. 19, 1994), 54–59.

21. Arlette Farge, "Concerning Parents and Children," in *Fragile Lives: Violence, Power, and Solidarity in Eighteenth-Century Paris* (Cambridge; Harvard University Press, 1993), 65. See also Arlette Farge and Jacques Revel, *The Vanishing Children of Paris: Rumor and Politics Before the French Revolution* (Cambridge: Harvard University Press, 1991).

22. See Michael Janofsky, "Officer's Parade of Death Rivet's Capital's Youth," *New York Times,* Dec. 11, 1994. Similar programs are run by funeral directors, such as the one by Paul Robinson from Gary, Indiana, who shows thirteen- and fourteen-year-old youths photographs of victims of violent homicides. At the end of the presentations, he conducts a mock funeral, asking the students to form a single file to the casket and then stare into a 12-inch-square mirror. "This could be you," he warns them. See "Funeral Director Uses Casket and Photos to Warn Kids," *Jet*, March 7, 1994, 23.

23. Although the highly publicized Rodney King beating in Los Angeles focused the nation's attention on police brutality in that city, the New York City Police Department has been repeatedly associated with incidents of police brutality against immigrants and minority groups. Most recently, the case of the Haitian immigrant Abner Louima, allegedly beaten and sodomized with a toilet plunger by two New York police officers has brought the problem to the surface. See a series of stories in the *New York Times*, August 17, 1997.

24. Of course, eulogies typically avoid controversy and tend to exploit the ancient theme of death as the great equalizer, but such echoes jar in the case of Nicolas Heyward, only one of many young black men who die in numbers greater than their presence in the general population. One of the most famous eulogies, Lincoln's Gettysburg Address, is an example of this pattern. As Garry Wills notes, Lincoln "eschews all local emphasis. His speech hovers far above the carnage. He lifts the battle to a level of abstraction that purges it of grosser matter . . . the nightmare realities have been etherealized in the crucible of his language." Gary Wills, *Lincoln at Gettysburg: The Words that Made America* (New York: Simon and Schuster, 1992), 37. Of course, there are such exceptions as Fannie Lee Chaney's eulogy for her son, James Chaney, murdered along with Andrew Goodman and Michael Schwerner during the "Freedom" summer of 1964. See Phyllis Theroux, ed., *The Book of Eulogies* (New York: Scribner, 1997), 149–50.

25. See Thomas Laqueur's "Bodies, Death, and Pauper Funerals," *Representations* 1 (February 1983):109–31.

26. Jay Ruby, *Secure the Shadow: Death and Photography in America* (Cambridge, Mass.: MIT Press, 1995), 84–85.

27. Not included here, the photograph reveals nothing that would mark the man as

dead. It features him, half in shadow, slumped over the steering wheel of his car. Without the caption that identifies him as one of the randomly slain, the reader would have no way to determine definitively the meaning of the photograph, and yet readers of the *Washington Post* registered enough complaints to warrant an explanation from Joanne Byrd, the newspaper's ombudsman.

28. Again, I must be careful not to misappropriate the victim in order to score an easy point, but the public's response to seeing a photograph of his dead body suggests much more about the all-too-visible invisibility of the black corpse in the media.

29. This situation calls to mind John Berger's incisive comment that, while recording what has been seen, the photograph "always and by its nature refers to what is not seen." See John Berger, "Understanding a Photograph," in *Reading American Photographs: Images and History*, ed. Alan Trachtenberg (New York: Hill and Wang, 1989), 293. And the invisibility encoded in the photograph simply registers the paradoxical semiotic symbol that is the corpse. Although it confronts us and reminds us of subjectivity," the corpse, as Vivian Sobchack puts it, "is not perceived as a subject." Rather, "it is simply an object which is an index of a subject who was." (Vivian Sobchack, "Inscribing Ethical Space: Ten Propositions on Death, Representation, and Documentary," *Quarterly Review of Film Studies* 9 [Fall 1984]: 286.)

30. More tragic still than these early deaths is the fact that black youth have ritualized plans for their own funerals. See "Black Youths Tell How Gangs and Guns Have Them Planning Their Own Funerals," *Jet*, Jan. 31, 1994, 26–28.

31. Black Americans have themselves liberally exploited this rhetoric of endangerment. See Jewell Taylor Gibbs, ed., *Young, Black, and Male in America: An Endangered Species* (Westport, Conn.: Auburn House Publishing, 1988), but this note has long been sounded in white America. Choosing randomly, we could point to Ralph Waldo Emerson's repeated references in his 1840s journals to blacks' susceptibility to extinction. "It is plain that so inferior a race must perish shortly," that blacks are destined to "serve and be sold and terminated," because of their "weakness." And late in the century, Frederick Hoffman, statistician to the Prudential Insurance Company of America, discussed various reports of the "waste of life among these people [blacks]," which left "unchecked, must lead eventually to extermination" in *Race Traits and Tendencies of the American Negro* (New York: Macmillan, 1896), a book teeming with the results of various research pointing to the statistical obsession with black morbidity, mortality, and overall "abnormality."

32. James Baldwin, "Many Thousands Gone," in his *Notes of a Native Son* (New York: Bantam, 1955), 18–19.

33. Jeff Nunakawa, "'All the Sad Young Men': AIDS and the Work of Mourning," *The Yale Journal of Criticism* 4 (1991): 2. See also Douglas Crimp, "Portraits of People with AIDS," in *Discourses of Sexuality from Aristotle to AIDS*, ed. Domna Stanton (Ann Arbor: University of Michigan Press, 1992), 362–88.

34. Robyn Weigman, "The Anatomy of Lynching," in her *American Anatomies: Theorizing Race and Gender* (Durham, N.C.: Duke University Press, 1997), 81. See also Trudier Harris, *Exorcising Blackness: Historical and Literary Lynching and Burning Rituals* (Bloomington: Indiana University Press, 1984). As Elaine Scarry has noted, "to be intensely embodied is the equivalent of being unrepresented and . . . is always the condition of those without power" (*The Body in Pain: The Making and Unmaking of the World* [New York: Oxford University Press, 1985], 207.)

35. For a discussion of these ideas, see Orlando Patterson's *Slavery and Social Death* (Cambridge: Harvard University Press, 1982) and Hannah Arendt's "Social Science Techniques and the Study of Concentration Camps," in *Arendt: Essays in Understanding 1930–1954: Uncollected and Published Works*, ed. Jerome Kohn (New York: Harcourt Brace, 1994), 232–47.

36. See "Mourning and Militancy," in which Crimp discusses the internal opposition of activism and mourning in his account of gay men's response to the devastating losses of the AIDS epidemic. Against those who would see mourning as militancy's shadow side, Crimp argues, "for many of us, mourning *becomes* militancy." "Mourning and Militancy," *October* 51 (Winter 1989): 9. That mourning, or certainly the public rituals surrounding it, have undoubted political force and value was evidenced by the swelling crowds of mourners in Soweto where funerals became huge mass meetings and the only type of public gathering for blacks that the apartheid government did not ban. See Nadine Gordimer, "Letter from Johannesburg, 1976," in *The Essential Gesture: Writing, Politics and Places* (New York: Alfred A. Knopf, 1988), 35. I think also of SO-SADD—Save Our Sons and Daughters—started by mothers in Detroit. All these cases speak to what Diamanda Galas terms "mourning as incitement," not at all mourning in the pacifistic sense. See *Angry Women* (San Francisco, Calif.: Re/Search Publications, 1991), 11–14. See also Keith Harrison, "Channeling Grief into Activism: Sons' Slayings Spur Women's Crusade," *Washington Post*, Feb. 10, 1990.

37. This antigovernment protest calls to mind the grieving mothers of the Plaza de Mayo, featured in *Las Madres de la Plaza de Mayo*, a documentary by Susana Munoz and Lourdes Portillo about a group of mothers who marched on La Casada Rosada in Buenos Aires, Argentina, to protest their "disappeared" children. And, most important, for this context, we could name the black mothers who have been catapulted into roles of public activism by the deaths of their children.

38. See "Shoes Are Placed on Mall in Protest of Gun Violence," *Washington Post*, September 1994.

39. In communities across the urban United States, African-Americans and Latinos are establishing their own rituals in the face of these tragedies. In Chicago, neighbors have gathered on the first Sunday of every month since 1993 to mourn the many youth killed on Chicago's South Side. Unfurling three large canvas panels, they take turns reading the names of all those who have been lost to urban violence. In James Chapman's "grief piece," "Our Young Black Men Are Dying and Nobody Seems to Care . . . ," the company asks the audience members to come up to the stage and write in a notebook the names of all their friends, associates, and relatives who have died violent deaths. In some communities, family hire local self-styled artists to paint memorials to the dead on walls of urban buildings. For a discussion of this memorial wall art, see my "R.I.P.; Memorial Wall Art: A Peaceful Disturbance," *Radical America*, August 1996. Perhaps the most prominent of all these rituals can be found in the lyrics of hip-hop in which death is everpresent. Some of the most chart-topping albums have been requiems. The violent death of Tupac Shakur and Notorious B.I.G. (Christopher Wallace) six months later, mirrored, for many, the seeming romanticization of death in such albums, especially in Wallace's debut production, "Ready to Die," and his posthumous 1997 album "Life After Death . . . Til Death Do Us Part."

40. Although this essay has focused on the ways in which the photographs contribute to a gendering of mourning, let me suggest that this emotional division of labor also

takes on inflections and semantics of class and race. Taking our lead from Robert Park's famous chestnut of romantic racialism: the Negro is the "lady of the races," we could begin to suggest that, in a culture ambivalent about death and grief, the collective work of cultural mourning is displaced onto poor blacks, especially poor black women, who must speak death and express mourning so that others can preserve their "dignity." Robert E. Park, *Race and Culture: Essays in the Sociology of Contemporary Man* (Glencoe, Ill.: 1950), 280. This business of dividing the labor of mourning takes on an interesting national dimension as well, projecting violence away from U.S. national borders.

41. Lorraine Monk, ed., *Photographs That Changed the World* (New York: Doubleday, 1989), 12. In "Photographs of Agony," a chapter in his book *About Looking*, John Berger makes essentially the same point. "The image seized by the camera is doubly violent and both violences reinforce the same contrast: the contrast between the photographed moment and all others." See *About Looking* (New York: Vintage, 1991), 43.

42. Susan Sontag, *On Photography*, 109.

The Image as Memorial:
Personal Photographs in Cultural Memory

Marita Sturken

The personal photograph is an object of complex emotional and cultural meaning, an artifact used to conjure memory, nostalgia, and contemplation. The photograph of personal value is a talisman, in which the past is often perceived to reside so that it can be reexperienced. It evokes both memory and loss, both a trace of life and the prospect of death. Yet, while the photograph may be perceived as a container for memory, it is not inhabited by memory so much as it produces it; it is a mechanism through which the past can be constructed and situated within the present. Images have the capacity to create, interfere with, and trouble the memories we hold as individuals and as a culture. They lend shape to personal stories and truth claims, and function as technologies of memory, producing both memory and forgetting.

A photograph does not in itself state its status as personal or cultural. Yet, the photograph plays an important function in the relationship of personal memory, cultural memory, and history precisely because of the ways in which images can move from one realm to the next. If we regard personal memory as the memories that remain solely within personal and familial contexts, separate from a public sharing of memory, and history as a form of sanctioned narratives of the past, cultural memory can be seen as memory that is shared outside of formal historical discourse, yet is imbued with cultural meaning. As technologies of memory, photographs play a primary role in the traffic between personal memory, cultural memory, and history. When personal memories are shared and exchanged in contexts distinct from history making, they form a kind of collective memory, either as interventions into or resistance to official history. Cultural objects, photographs among them, often move from personal

memory to cultural memory to history and back. Hence, a historical photograph has the capacity to affect the personal memory of an historical survivor, and a personal image can often acquire cultural meaning or historical meaning. This is increasingly the case with the proliferation of personal images in the form of videotapes, where, for instance, the amateur image taken by George Holliday of the beating of Rodney King acquired historical meaning when it was shown on national television and became the catalyst for the Los Angeles uprising. At the same time, survivors of historical events often report that, after time, they cannot sort out what is personal memory, what is the memories of others, and what derived from the images of the news media and popular culture. Hence, the public image, often marked as historical, can change and produce personal memories as well. Indeed, rather than positing memory and history as oppositional, as they are often described, we should consider them to be entangled, each pulling forms from the other.

It can be argued that the most poignant of photographs are those that were created within personal or familial contexts yet have since acquired a cultural, legal, or historical status. These images seem innocent and unsuspecting in retrospect—the casual image of a place that will later be destroyed, the framing of a group of friends, one of whom will soon be dead, the hauntingly informal images of the soon-to-be victims of war. Unlike the official images of war victims that were created by the Nazis or the Cambodians who systematically catalogued the soon-to-be dead, the informal and personal images that acquire historical status speak to a moment captured by the photographic camera that is totally separate from the weight it will come to bear. These images thus present a compelling prior innocence to which they offer a partial and enticing kind of retrieval. At the same time, they can be hauntingly tragic in their evocation of loss.

In this paper, I would like specifically to examine several contexts in which personal and family photographs journey into realms of cultural memory and acquire new meanings: the photographs left at the Vietnam Veterans Memorial in Washington, D.C., the personal pictures sewn into the AIDS Memorial Quilt, and the images of missing children disseminated on supermarket flyers, grocery bags, and television detective shows. In these three contexts, the images function both to memorialize their subjects and to speak to imagined audiences, though often with divergent purposes. Each is a particular form of address that reveals aspects of trauma in late-twentieth-century American culture, the trauma of untimely death, in particular those who died young and tragic deaths, and the trauma of the lost child. In the case of the memorial and the quilt, images are primarily viewed as forms of memory, and in the case of the missing children, they are used as law enforcement forms of identification. Yet they all demonstrate the fluid capacity of the image to change cultural status and, more important, the malleability of the personal images that acquire cultural status. All are fraught with the weighted meaning of the family

in contemporary American culture. The images I will discuss here are deployed for a number of personal and public agendas—among others, to memorialize the dead, to speak for and against the participation of the United States in the Vietnam War, to celebrate gay identity, to support families who have lost someone to AIDS, to refuse to mourn, to act as identification in criminal investigations, and finally to ask viewers to participate in searching for missing children among their neighbors. These agendas address viewers in different roles—as mourners, citizens, family members, and concerned observers. Each testifies to the traffic across the boundaries between public and private realms.

The Vietnam Veterans Memorial and the Image as Monument

Late-twentieth-century American culture has witnessed an unprecedented interest in the building of memorials. At a time when critics of postmodernism have labeled it antihistorical, it seems in fact that postmodern culture is preoccupied with the question of memory, and national culture has produced an increasing number of memorials to war and to figures of the past. This process began with the construction of the Vietnam Veterans Memorial on the Mall in Washington, D.C., in 1982, which then prompted the building of the memorials to Korean War veterans, American women soldiers, the civil rights movement, President Franklin D. Roosevelt, and the veterans of World War II. This process of memorialization also extended to the ongoing creation of the AIDS Memorial Quilt, which was begun in San Francisco in 1987 and which is periodically exhibited in its entirety on the Washington Mall.

Why are we as a nation so preoccupied with memory on the eve of the millennium? American culture is constantly referred to as a culture of amnesia, a nation with little sense of history, a society that identifies with the future rather than the past. Yet the relentless memorializing of the 1980s and 1990s reveals the fundamental role that national memory plays in the politics of the present.

In the early 1980s, Roland Barthes wrote: "Earlier societies managed so that memory, the substitute for life, was eternal and that at least the thing which spoke Death should itself be immortal: this was the Monument. But by making the (mortal) Photograph in the general and somehow natural witness of 'what has been,' modern society has renounced the Monument."[1] Barthes argued that the photograph had superseded the monument and memorial. Like others, he saw the emergence of photography as signaling the end of the monument, replacing it with the image technologies of memory. Yet, how could Barthes have foreseen, from his perspective on modernism and the photograph, the excessive memorialization taking place in Euro-American culture today? It seems, rather, that the contemporary photograph has not replaced the monument so much as it is demanded in its presence.

This can be seen through the interaction of visitors at the Vietnam Veterans Memorial. Since it was built in 1982, the memorial has become a kind of national shrine. Unlike any other place on the Washington Mall or in the nation's capital, it invites a participatory interaction. As the most visited site in the nation's central tourist region, it has acquired a unique status as the place at which people feel they can speak to the nation in some form. The low, black walls of the memorial, sunken into the landscape, break the commemorative codes of the Mall; as such, they inspire contemplation and invite visitors to ritualistic forms of action. People may touch the engraved space of the names, make rubbings of names to take away with them, or leave objects at the base of the long black granite walls. These experiences of emotional engagement with the memorial have provided the material for innumerable coffee-table books of photographs in which the pain of a nation is enacted and rememorialized again.

Originally, when people began leaving letters, photographs, and objects at the memorial, the National Park Service classified them as "lost and found." Then, officials realized the artifacts had been left there intentionally and began to save them. There are now over forty thousand objects that have been left at the memorial, which are housed in a government archive and some of which are exhibited at the Smithsonian. These range from the expected (combat boots and military insignia) to the extraordinary (a Harley-Davidson motorcycle), to the evocative and poignant, objects long carried and finally let go, such as the wedding ring of a dead Vietnamese soldier, a pair of Vietnamese sandals, or a can of C-rations. More and more objects concerning contemporary controversies that are the focus of marches on Washington have also been left at the memorial. Hence, talismans regarding the Gulf War, the abortion debate, and the gay rights movement have been left there as a form of speech. However, a significant number of the artifacts left at the memorial are compellingly cryptic, ambiguous, and mysterious. It is clear that many of the stories behind these objects will not be told, because they were left at the memorial not to explain anything to its audience, but to speak directly to the dead.

Family and personal photographs proliferate among these objects, where they assert particular strands of memory. While many images of men at war have been left as tributes, there have also been many images that presumably represent the war dead in their youth, in times of prior innocence before they became first soldiers and then casualties. What inspires this kind of interaction at the memorial? The Vietnam Veterans Memorial is unique in its foregrounding of the loss of an individual in war. Its listing of names of those who died in the war, in chronological order of when they were killed, has produced a very rich and complex discourse of memory. The names, by virtue of their multiplicity, situate the memorial within the multiple strands of cultural memory. For many visitors, this has the effect of imagining the widening circle of pain and grief that extends out from each to family and friends, imagining in

effect the multitude of people who continue to be directly affected by the war. Despite the fact that the listing of names allows for a reclamation of codes of heroism and sacrifice in the nationalistic context of the Washington Mall, in its foregrounding of the individual over the collective the memorial is a powerful antiwar statement about the tragic and futile loss of so many lives.

The personal photographs at the memorial testify to the previous aliveness of the war dead. As images of states of prior innocence—the soldier as a child, the family gathering before the tragic loss of a family member, the now long-absent father hugging a child—these images demand an acknowledgment of the insanity of the priorities of war. Each seems to ask: How could this life, so simple and important in its ordinary experience of the everyday, have been worth sacrificing? How could a war—many would argue, in particular, this war—have warranted this price? Placed in the context of the memorial, these photographs condemn the act of war simply in the contrast between their ordinariness and their presence at a memorial to war dead. They personalize the names, give them flesh, faces, and family connections, and in so doing they speak to the incomprehensibility and irrationality of war.

The memorial is perceived by many of the families and friends of the war dead to be a kind of living memorial, where the dead are located and can be spoken to, hence where, by implication, they can hear and respond. This means that many of the photographs that have been left at the memorial chronicle the continuing lives of those who have been left behind. These images, of grandchildren and family rituals, allow the living to feel that the dead can witness the continuity of life and its rites of passage. In one, a frame that contains an image of a fetal sonogram, is accompanied by a note, which reads:

> Happy Father's Day, Dad! Here are the first two images of your first grandchild. I don't know if it's a boy or a girl. If the baby is a boy—he'll be named after you. Dad, this child will know you—Just how I have grown to know and love you, even though the last time I saw you I was only 4 months old. I love you daddy, your daughter Jeannette. (Sgt. Eddie E. Chervony, 55E 6)

The sonogram "photograph," which is now the requisite first image in the baby album, is presented here as a form of connection and witnessing, a means of speaking to the absent father.

The names on the memorial act as surrogates for the bodies of the Vietnam War dead, and visitors to the memorial often make rubbings of names to carry away with them. Yet the presence of the photographs, letters, and objects attest as well to the incompleteness of the names. It is as if the names present the individual so powerfully inscribed in death that they demand the presence of photographs to bring the dead alive. What is, after all, a name marked in stone but a name that is irrevocably inscribed within a narrative of remembrance?

What does it mean to read a name? On one hand, it signals the life of the individual in war, on the other hand, it is a shallow evocation of their presence. Judith Butler writes, "But do names really 'open' us to an intersubjective ground, or are they simply so many ruins which designate a history irrevocably lost? Do these names really signify for us the fullness of the lives that were lost, or are they so many tokens of what we cannot know, enigmas, inscrutable and silent?"[2] The need to bring photographs and objects to the Vietnam Veterans Memorial and to leave them for others to witness indicates the need to memorialize the dead with images, stories, details, and specifics, precisely because of the way in which the name provides only an empty shell of remembrance.

By nature of its placement within the nationalistic context of the Washington Mall, the Vietnam Veterans Memorial constructs a narrative that foregrounds the loss of 58,196 American lives over those of the three million Vietnamese who died in the war. Yet one of the most compelling photographs that was left at the memorial is an image that speaks not to the dead whose names are listed on the wall, but to a dead Vietcong soldier. It is a worn, hand-colored image of a Vietnamese man, dressed in a military uniform, with a young girl beside him, both seriously regarding the camera (illus. 1). The note that accompanies it reads:

> Dear Sir, For twenty-two years I have carried your picture in my wallet. I was only eighteen years old that day that we faced one another on that trail in Chu Lai, Vietnam. Why you didn't take my life I'll never know. You stared at me for so long, armed with your AK-47, and yet you did not fire. Forgive me for taking your life, I was reacting the way I was trained, to kill V.C. . . . So many times over the years I have stared at your picture and your daughter, I suspect. Each time my heart and guts burn with the pain of guilt. I have two daughters myself now . . . Above all else, I can now respect the importance that life held for you. I suppose that is why I am able to be here today . . . It is time for me to continue the life process and release my pain and guilt. Forgive me, Sir.[3]

As we read these lines, the photograph, with its crumpled image and faded color, evokes many narratives—the act of placing it within one's military uniform and carrying it into combat as a talisman of good luck, the scene in which it is taken from the dead man who carried it, the years it was kept and continued to haunt, the ways in which it most likely continues to haunt in its absence. The letter is deeply contradictory, both moving and troubling. I am moved by the evocation of guilt and helplessness in this note, yet disturbed by the impulse that resulted in its eventual arrival at the memorial. What does it mean to take a photograph from the dead body of someone one has just killed? Is it an act of remorse or a further violation? The photograph pulls from another place and another life a set of enigmatic and ultimately unknowable stories, each

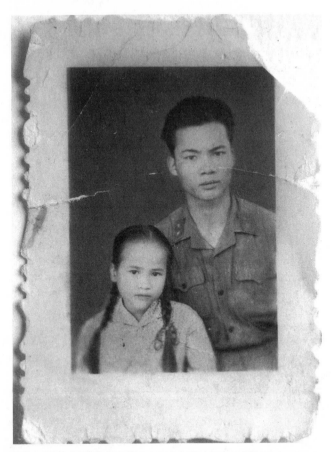

1. Photograph left at the Vietnam Veterans Memorial. Photo: Claudio Vasquez–Turner Publishing, Inc. Courtesy Vietnam Veterans Memorial Collection, Museum Resource Center, National Park Service/National Capital Region.

charged with loss. Where is that little girl now, did she survive the war or is she also memorialized here? Why did her father hesitate?

Above all, the photograph contains a startling view into a moment of prior innocence—how could they have known in that moment not only the fate of the father but the eventual trajectory of the image itself: that it would be carried for many years by the father's murderer, left at a memorial in Washington, D.C., that commemorates not the Vietnamese but the American dead, held in an archive by the United States government, and photographed for a coffee-table book of that collection, purchased by middle-class Americans? Indeed, its trajectory continues. In the summer of 1997, Richard Luttrell, the veteran who left the photograph at the memorial, contacted the embassy and received a letter from the dead man's son, who had identified his father in the photo-

graph with the help of relatives. At the time that I write this, he is planning to travel to Vietnam to return the photograph to the family.[4]

These unanswered questions occur in the movement of photographs across the boundaries of personal and cultural memory. The photographs at the memorial change status several times, from personal and family images, often placed in family albums, to images that are meant to be shared by the audience at the memorial. Often, as is the case with this image, this means an attempt to bear witness to one's pain and a need to ask forgiveness at a site where the dead are perceived to be present (even the dead who are not named on the wall). Once placed at the memorial, these photographs acquire the status of cultural objects and shift from personal to cultural memory. When they are subsequently placed in the archive, they acquire the status of historical artifacts. Those that are exhibited in the Smithsonian are also described as artistic artifacts and assigned authorship, where possible, by curators and writers. Awarded authorship and secured within a historical archive, where they are treated as precious objects and held only by gloved hands, these photographs and objects are pulled from cultural memory, a realm in which they are meant to be shared and to participate in the memories of others, and reinscribed in official narratives. Yet the majority of the objects and images that have been left at the memorial are either unexplained or, like these images, powerfully evocative of untold stories. Many are compelling in their anonymity and ambiguity. Their refusal to tell all their stories and their impulse to speak directly to the dead, rather than to the memorial's audience, continues to work in tension with the narratives of history.

The AIDS Quilt: Reclaiming the Bodies of the Dead

Like the Vietnam Veterans Memorial, the AIDS Memorial Quilt memorializes by naming the dead and presenting their images. The quilt, which now consists of more than forty thousand panels, each three by six feet, is a collectively produced, grass-roots project in which lovers, friends, families, and concerned strangers make panels in tribute to those who have died of AIDS (illus. 2). Quilt panels have been created from an enormous variety of materials, ranging from cloth, clothing, stuffed animals, cowboy boots, wedding rings, letters, and feather boas to photographs and cremation ashes. In their attempts to symbolically evoke aspects of the lives of the dead, many makers of quilt panels resort to highly literal forms: a scrub tunic for a doctor, scissors for a hairdresser, or a crib cover for an infant. Other panels are anticommemorative in their gestures, deploying humor, anger, and an aesthetics of antimourning. Because quilt panels allow for a hyperindividualization of the dead and because the aesthetics of the quilt is often vibrant and irreverent, it is often perceived as a testimony not to death but to lives lived.

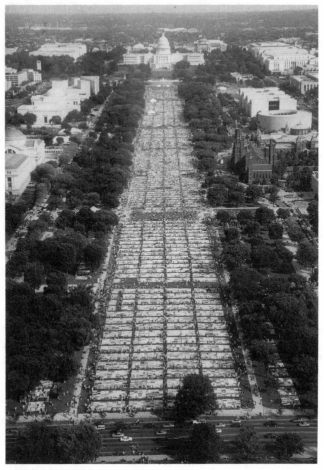

2. The AIDS Quilt, Washington, D.C., October 1996. Photo: Paul Margolies. ©
NAMES Project Foundation.

Like the memorial, the quilt memorializes primarily through naming the
dead, yet this naming is individualized through the testimony, objects, and
photographs embedded within the quilt. In many ways, the quilt presents a
conversation with the dead, in which questions are asked, testimony provided,
and entreaties presented, all with the implication that the dead are located
within the quilt and can witness and listen from there. The voices of the quilt
speak to an imagined audience, often perceived as either the community of
people affected by AIDS or as a naïve and uninformed audience that needs to
be educated as to the value of the lives lost (illus. 3).

 Personal photographs take many forms in the quilt. They are often sewn
into panels or screened onto cloth. This sometimes gives panels the quality of

3. The AIDS Quilt, Washington, D.C., October 1996. Photo: Winifred Cambrecht. © NAMES Project Foundation.

fabric photo albums, which depict the absent person in many different places and states of being. Photographs are clearly perceived in the quilt to offer not only the trace of the dead person as alive but also concrete testimony to his or her existence. They are a primary means by which the quilt provides evidence of the human loss of the AIDS epidemic. Because the quilt responds to the fear that the AIDS dead will be forgotten, their lives less valued and their loss less mourned than that of other dead, quilt panels often testify simply to the fact that these people existed—they lived, loved, and felt pain; their lives were tragically cut short. Personal photographs affirm this existence.

To evoke lives lived, the quilt often attempts to render present the bodies of the dead. Each panel corresponds approximately to the size of a body or coffin, and many quilt panels conjure the absent bodies of the dead through a variety of likenesses—as outlines of the frame of someone's body or empty articles of clothing that echo the body that once filled them. Here, photographs are used almost exclusively to establish the dead as youthful, healthy, and alive. The representation of bodies in the quilt must be seen in the context of the discourse on bodies of the AIDS epidemic itself. One of the distinguishing features of AIDS is the aging effect of the opportunistic infections that ultimately cause death. These diseases waste away once-strong bodies to skeletal frames, making those in the advanced stages of AIDS appear to be decades older than they are. Theirs have been, in particular in the beginning of the epidemic, bodies that were coded as contaminating and untouchable. Through the fabric and tactile quality of the quilt itself, these bodies are retrieved as warm, touchable, loving, and erotic. In photographs, the dead are presented as vigorous and healthy, bodies that emanate sexuality and energy. These images seek to restore these bodies to their pre-AIDS status and retrieve some of their dignity.

These are images that convey, like the images left at the memorial, a profound sense of prior innocence. In a panel for Bill Bell, who died in 1984, a series of casual photographs frame a swatch of Japanese fabric. Here, smiling while costumed at a party, eating dinner, sitting in Golden Gate Park, he conveys a sense of the profoundly irretrievable everydayness of his life. His friend Paul Harman's panel frames a series of casual snapshots with elaborate fabric and two cats guarding the image of the Golden Gate Bridge. Many quilt panels evoke this sense of a tragically produced photo album, its images chosen in an attempt to convey the facets of a life now gone. These images function as icons, along with the symbols of places visited and professions pursued, of the pleasure of life before the presence of death. In this context, the casual aspects of their snapshot qualities convey a terrible sadness.

The photographs in AIDS quilt panels testify to previous states of being, to lives lived before AIDS entered the gay community and the lives of the AIDS dead. Many are highly nostalgic images, which defiantly reclaim the exuberant hedonism of the 1970s gay community before AIDS devastated it and irrevocably changed its status. These photographs of young, healthy men thus inevitably became political statements that refuse to apologize, regret, or moralize. They achieve a kind of poignancy through their lack of awareness of what will come, representing a time when the onslaught of AIDS was unimaginable.

Photographs in the quilt not only retrieve a time of prior innocence but also reaffirm connections to those who are still living. Many of the most moving quilt panels have been made by families and contain within them family photographs. Removed from the context of a family album, these images acquire political status in the quilt. While it can be implicated in many of the divisions between the communities affected by AIDS, the AIDS quilt has succeeded in fostering new communities across lines of sexuality, race, and class. Many stories surround the quilt of strangers meeting and coming together to mourn the dead and celebrate their lives. The numerous stories of alienation, rejection, and discrimination, of lovers excluded by families or names removed from panels, are balanced by moving stories of the construction of an AIDS-affected community unified in loss. They speak directly to the stereotype of young gay men as inevitably estranged from their families and the popular refusal to acknowledge the kinds of extended families that are constructed within the gay community. The discourse of gays as existing outside of the notion of family in the context of AIDS has been so extreme that the term *family* has often been equated with being HIV-negative. This was most evident in 1986 with the passage of a bill that legalized the creation of designated-donor pools that would allow families to donate blood within the family to prevent transmission of HIV, implying that families are inherently HIV-negative and those who are HIV-positive remain outside family structures.[5]

This larger context renders the presence of family photographs within the quilt a politically charged statement about the capacity of families to love and

care for the sick and dying, to work against homophobia, and to participate in the work of gay and lesbian communities. Like the teddy bears that proliferate in the quilt (and at the memorial), family photographs of the dead also suggest not only how young many of them were (there are many children memorialized in the quilt, however most of the dead represented in it were young men when they died), but also a desire to revisit a time when they were unmarked by tragedy, as they now inevitably are.

The mix of simplicity and complexity of many quilt panels attests to the difficulty of summarizing and representing a life. Indeed, the presence of photographs both at the memorial and in the quilt testifies to the fact that the names are not enough. The names act as surrogates for the bodies of the dead, yet they remain incomplete. The photographs within the memorial and the quilt are attempts to fill these empty names with individual significance. Yet these memorials also demonstrate the inability of the photograph to conjure the dead: while these images attempt to make the dead present, they testify to the profound incommensurability between the dead and the living. Ultimately, it is contestable whether these images can conjure in any sense the presence of the dead. Photographs have been used since their invention to signify a trace of the absent one, yet their complex relationship to contemporary memorials might, indeed, suggest that this capacity is profoundly limited. Perhaps we need to consider the ways in which the desire to build so many memorials in the late twentieth century constitutes a recognition of the incompleteness of the image (the same image that Barthes believed signaled the end of the monument) to provide rituals of remembrance and make present those who are absent.

Images of Mortality: Photographs of Missing Children

Images that move through the realms of personal memory, cultural memory, and history cross the porous boundaries between the private and public arenas. When the images left at the Vietnam Veterans Memorial or incorporated into the AIDS Memorial Quilt acquire cultural and historical status, they function as public memorials for the dead. These photographs have been transferred from personal to cultural memory with the aim of speaking to a larger audience about the impact and resonances of a life. But what of the photograph that unintentionally acquires cultural status? I would like to turn finally to the meaning of the images of missing children, which have proliferated in American culture in the 1980s and 1990s. These personal photographs, like those of the memorial and the quilt, have acquired specific cultural meanings. Unlike those images, they are awarded legal and investigative status. Yet, because of their status as photographs, they also function, despite their intended role, as image memorials.

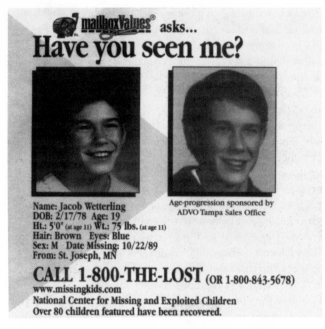

4. Direct mail flyer with "age progression" photograph of a missing child.

Photographs of missing children greet us throughout our daily lives, in advertising flyers, on grocery bags and milk cartons, on the Internet, and on investigative television shows (illus. 4). They ask us to register the face of the missing child in order to scan the faces around us and offer identification. They ask us, "Have You Seen Me?" and demand that we respond by looking at them.[6] The context in which these images are produced indicates as much about American culture in the 1990s as the AIDS Memorial Quilt evokes of the 1980s and the Vietnam Veterans Memorial of the 1960s and 1970s. The contemporary concern about the numbers of missing children is part of a larger context in which discourses of popular culture, fears about the state of childhood, and accusations of sexual abuse have produced a collective hysteria about the abuse of children and the experience of childhood.[7] It is worth noting, for instance, that many of children whose images are circulated as missing children have either run away from home or have been "abducted" by one of their parents in a custody battle.[8] This is an enormous topic, which I will not attempt to address here, but I would like to examine the ways in which the cultural status of these family photographs can have unintended effects.

Photographs have long been analyzed as objects of death. In its freezing of time in an instant, and its capacity to carry the image of the dead forward in time, the photograph renders a mortality to its subject. A photograph represents the what-has-been, awarding to its subject the quality of being of the

past—once a photograph is taken, its moment is situated in the past, unlike the video image, for instance, which can operate in the present. This quality allows the photograph to function as a means of retrieval from the past, but it also gives the photograph an aura of death. Its stillness produces a sense of finality, and allows the photograph to be, in Eduardo Cadava's words, "the uncanny tomb of our memory."[9]

The photographs of missing children are highly self-conscious in their status as the what-has-been. Because we understand that these are photographs of children, people whose appearances can change dramatically in a relatively short period of time, these images often entreat us to note immediately the date on which the child was reported missing, and to look again at the photograph to gauge its pastness. After all, we know that it represents a child who no longer looks like this. These images are often computer-enhanced for "age progression" in attempts to update the children's images for better identification. Who is this child who is asking us if we have seen him or her, a virtual child who may or may not resemble the real child who may or may not be out there somewhere? This computer enhancement gives these images the quality of time slipping quickly away, rapidly erasing the original face and morphing it into another, older, perhaps more awkward visage.

This use of the "age-progressed" photograph, which falls into the realm of the more low-tech police sketch in terms of witnessing, has taken on the kind of narrative of wonder once reserved for the photograph itself. The traditional wonder at what the photograph can represent of the absent is replaced by the "gee whiz" response to the capacity of technology to predict the aging process of child to teenager. This can be, under examination, profoundly unnerving. I recently received an image flyer of Jacob Wetterling, who has been missing since 1989. In his photograph, the eleven-year-old Jacob smiles innocently for the camera. In the age-progressed image ("sponsored by the ADVO Tampa Sales office") he has morphed into a teenager, yet with the exact same smile. The image is uncannily convincing, yet, like many digital images, disturbing in its lack of referent. Is Jacob alive? Does he look like this?

Both the computer-enhanced images and the photographs that demand our gaze register a poignant and desperate grasp of the past, one that appears to be quickly slipping away. Like the photographs at the memorial and in the quilt, these are images coded with prior innocence, terribly ordinary pictures of childhood faces, smiling at the camera. In the context of a querying milk carton, they intend to shock and provoke us. The ordinariness of the image asks, how could such a seemingly average child be gone? Where is this child? We are not meant to look beyond the question to the potential problems of the narrative, although those images that feature the parent who is with the child disrupt this poignancy dramatically.

The photographs of missing children speak directly to us as citizens. They ask us to engage with them not as personal images, snapshots of the past, but

rather as participants in an investigation. Citizenship is defined through these images as the active surveillance of one's neighbors, always on the lookout for suspicious groupings of individuals and potential missing children under cover. These images speak a belief in the capacity of the casual family photograph to function as a form of identification and evidence in a search. They state that the child is retrievable through the photograph and that the photograph can aid in the reclamation of the family. Hence, the family image is deployed to make the country feel safe in the knowledge that the highly disruptive narrative of the missing child can be contained through technology— specifically the technologies of photography and digital computer enhancement. I do not mean to say that the stories of children who have been kidnapped are not deeply tragic and troubling. But the photograph of the missing child who is a runaway or with an angry parent also entreats us to respond with uncritical outrage. The photograph that prompts its viewer to feel anger about a missing child yet safe about the means to recover that child cannot accommodate the narrative of the child who left the family by choice or design, and who may actually be better off away from it.

The narrative of technological comfort is sharply evident in the photographs that form a part of the success stories of missing children searches. The National Center for Missing & Exploited Children (NCMEC) runs an online database and website in which the complex technological status of these images becomes evident.[10] The website and database are allied with television shows such as *Unsolved Mysteries* and *America's Most Wanted* and the ADVO direct mail and supermarket campaigns in a complex web of nonprofit, commercial, and government interests. In one of NCMEC's online success stories, the recovery of three children, Hans, Heather, and Laurel Holmgren, is declared as the "direct result" of the age-progressed image of Heather, which was seen by a neighbor. However, other parts of the story begin to seep into the narrative, since it is revealed that the "abductor" who was arrested "within 45 minutes" was her "abductor father," whose photograph was also distributed. The story of this "abduction" is entirely unclear and unrevealed—who was searching for these children and why is their father now a criminal? Allowed to remain intact in this narrative of success, however, is the notion of allied technologies of surveillance which can be used to offer the public a sense of safety and security.

These photographs of missing children, whether enhanced or not, often can have effects other than their intended role as identifiers. Because of the phenomenological relationship of photographs to the what-has-been, these images often convey a sense of finality and irretrievability, not queries of hope and investigative optimism but image memorials. These children who ask us to search for them look, in fact, already gone, marked by the mortality of the image. They appear arrested in a previous time, unable to grow older. They

offer moments of prior innocence that proclaim the end of that innocence. The computer enhancement only makes the problem worse, creating instead virtual images of the child who never was—by implication, the child who never will be. If this child is unreachable (by contemporary standards this means unphotographable) then his or her replacement with a morphed image signals only a kind of technological death knell. Hence, contrary to their intent to incite the reader to recognize and identify them nearby, these images seem to suggest the hopelessness of the search, the child as already lost. This unintended effect can also circle back again to the discourse of the threat to childhood that produces the anxiety about the missing child in the first place. If the child is already missing and irretrievable, then forces must be mustered to find him or her, indeed to retrieve childhood itself in a nostalgic state.

If these images signify a lost past and, hence, a kind of memorial, what kind of memorial is this? The images of missing children reach us through a variety of commodified contexts—flyers with coupons, grocery bags, milk cartons, television. Indeed, we see them almost exclusively in the context of commerce. They share cultural meaning with the increased number of electronic memorials—website tributes and memorial pages, for instance. In what ways do they ask us to shift from the mode of the consumer to the consumer-citizen to the citizen-investigator to the witness to memory?

The Public/Private Image

These family and personal images demonstrate the paradoxical cultural role of the photograph—both a testimony to the lives of those who are absent and an object that in itself renders mortality. Their proliferation in cultural arenas speaks not only of the technological development that has allowed for greater access to the production of public images, but also to an erosion of the realm of the private. Once released into public arenas, these images can operate as free-floating signifiers, open to diverse meanings and available to many different political agendas. They retain the status of personal, but their shifting meanings are evidence not only of the malleability of the image but also the fraught role played by the family as a signifier in contemporary politics. As snapshots, they are replete with the public meanings of the personal lives they depict.

Indeed, the capacity of these images to carry their poignancy into realms of cultural meaning indicates the ways in which the notion of a private realm separate from the public has always been a fallacy. For the so-called private moments that they depict are, of course, already coded with social meanings about youth, childhood, marriage, family, and the ideologies of American culture.

The photographs that move from personal and familial contexts into public arenas, from family photograph albums to public memorials such as the

Vietnam Veterans Memorial and the AIDS Memorial Quilt, from picture frames set on bureaus to missing children mailers and milk cartons, function as forms of speech in the face of cultural traumas. These photographs are offered up as testimony, hopeful evidence to the humanity once embodied by their subjects, proclamations of prior innocence, and often desperate cries for those who are absent, missing, or dead. They speak to a national public in ways that ask it to be both empathetic and vigilant. As they are pulled from personal memory into cultural memory and public discourse, they symbolize many of the hopes, fears, and desires that circulate through concepts of the family and the nation. In their ordinariness, they demand an attention to the small details and casual meanings of daily life. They are restless images, changing meaning and moving onward, asking us to pay attention to the stories, both declarative and secretive, that they tell.

Notes

1. Roland Barthes, *Camera Lucida: Reflections on Photography*, trans. Richard Howard (New York and Wang, 1981), 93.

2. Judith Butler, "Review Essay: Spirit in Ashes," *History and Theory* 27, no. 1 (1988): 69.

3. This photograph and letter are included in Thomas Allen, *Offerings at the Wall: Artifacts from the Vietnam Veterans Memorial Collection* (Atlanta: Turner Publishing, 1995), 52–53. People who have left mementos at the memorial can contact the archive at NPS/MRCE, Box 435, Glenn Dale, MD 20769.

4. Identification of the picture was also aided by the fact that it has the name and place of the photographic studio on the back. There has been some controversy generated in Vietnam around the image. After Luttrell announced his intention to return the photo, an article published in Vietnam stated that it was a case of misidentification. The young girl in the picture remains unidentified. Associated Press, "Letter Ends Anguish of Vet's Vietnam 'Kill,'" *Newark Star-Ledger*, Aug. 19, 1997, and telephone interview with Richard Luttrell by author, Oct. 8, 1997.

5. See Jan Grover, "AIDS: Keywords," in *AIDS: Cultural Activism/Cultural Analysis*, ed. Douglas Crimp (Cambridge, Mass.: MIT Press, 1988), 23.

6. Marilyn Ivy analyzes the paradoxical aspects of this speaking position on the advertising flyers, which read "ADVO Asks . . . Have You Seen Me?" in which ADVO the company speaks to the recipient, but the child asks the question. See Marilyn Ivy, "Have You Seen Me? Recovering the Inner Child in Late Twentieth-Century America," *Social Text* 37 (Winter 1993): 227–52.

7. I have written more extensively about contemporary concerns about recovered

memories of child abuse in "The Remembering of Forgetting: Recovered Memory Syndrome as Cultural Memory," *Social Text* (Spring 1999). See also Anne Higonnet's essay in this volume.

8. See Ivy, 231.

9. Eduardo Cadava, "Words of Light: Theses on the Photography of History," *Diacritics* (Fall/Winter 1992): 92.

10. See http://www.missingkids.com.

A Meeting of Two Queens
An Exercise in Memory Work

Annette Kuhn

To mark the Coronation of the Queen, my mother made a special frock for me; and on Coronation Day my father took a photograph of me wearing it.

In her dress of white muslin, trimmed with red-white-and-blue ribbon and accessorized with matching hair ribbons, ankle socks, and Coronation handkerchief and brooch—and with a fraction of an inch of petticoat visible below the hem—the little girl is not posing for a casual "family snapshot," or even for a formal family photograph of the sort that predated home snapshooting. Like the portrait of the soldier in uniform or the sports team photograph, this is a piece of ceremonial portraiture in which ceremonial dress of one sort or another signifies that the moment being celebrated by a photograph subsumes the individualities of the individuals in the picture to larger communities, to attachments that both include and go beyond the lives of the picture's subjects. Ceremonial portraiture, then, binds the personal to the public, the individual to community and history. But how do these processes work from the inside, from the standpoint of the subject, whose memory of the occasion will certainly be singular, and may well also be tangential to the photograph's ceremonial ambition?

Today, as I imagine myself at that moment, inside that dress, my body feels constrained, my chest tight. I can scarcely breathe. The clothes are uncom-

Reprinted, with permission, from *Family Secrets: Acts of Memory and Imagination*, © Verso Editions, 1995.

fortable, restricting. The belt squeezes, the collar chokes. The top half of my body feels cramped and immobile. I hate the dress, in any case: it is fussy and overdecorated. There is too much red-white-and-blue, and I dislike especially the excessiveness of the brooch and the precariousness of the handkerchief. I did not ask for, nor do I want, these clothes. The business of curling my hair has been painful: I have slept all night with it tied up in rags. And now it is frizzy, the bows are pulling, and my head hurts. I have already shown my aversion to the whole business by being uncompliant and irritable while being dressed: with the consequence that my body has been subjected to a good deal of poking, prodding, and pushing. No wonder the child looks like a stuffed dummy.

Associated with this photograph is an indistinct but intense memory of sickness. Around the time it was taken, I was ill with bronchial pneumonia and spent what seemed to me a very long time away from home, first in hospital and then at a convalescent institution a long way away, where I received no visitors and some unaccustomedly rough treatment at the hands of the nuns who ran the home (they called me "unhealthy child"). Oddly, given the urgency with which both the illness (it felt, feels, like a turning point) and the unhealthy child that I was force themselves into my memory, I find it impossible to be certain whether the photograph was taken before or after my (as I saw it) banishment. But there is always this memory-feeling attaching to it: I have not been well; this is perhaps the occasion of my return to full health; I am to understand that no further allowance will be made for unsociable behavior on my part.

But the precise sequence of events matters less, perhaps, than their content: the memory of being ill, and the nature of the ailment. For the physical sensations I associate with the dress and the photograph—the tightness in the chest, the inability to breathe—are, of course, exactly the symptoms of a bronchial condition. What is more, these sensations, these symptoms, mirror the sickness my father, as I remember it, had always suffered: chronic bronchitis, later to develop into emphysema. I recall no time when drawing breath was not an effort for him. His struggle to breathe repeats itself in the content of my own childhood illness, which then haunts my response to this photograph. Even today, at moments of stress, these symptoms return to my body.

Already, at the age of seven, I knew how little girls were supposed to feel about new frocks and being dressed up; about how they are supposed to respond to being put in front of a camera, Daddy's camera. It is equally clear that, even if rather half-heartedly and shamefacedly, I was refusing to wear it, almost literally. The attention was undesired: it felt overwhelming, an immoderate demand. So many gazes, so much scrutiny. Who or what did they—my mother, my father, the camera lens—want to see when they looked at me? It would be too easy, I think, to say that what they wanted was a pretty little girl who willingly made herself the adored object of her parents' gaze, and derived pleasure from being looked at, from pleasing them. No, the messages I was receiving about femininity were far less straightforward than that. Perhaps the grownups did not really know themselves—or perhaps they had differing ideas about—what they were looking for in me.

And yet the making of the dress and the care devoted to my appearance on this occasion suggest that what was consciously intended was a gift. The dress, the preoccupation with the child's appearance, the elaborate mise-en-scene and composition of the photograph: all are displays, earnests—of what? Anthropologists say that because it expresses the expectation that acceptance commits the recipient to be what the giver wants, the rendering of gifts is in part an act of aggression. My mother's gift to me was, I believe, directed more

at the neglected little girl that she had been than to a daughter whom she might have regarded as a person in her own right. The dress felt—*feels*—tight, constraining. Surely, with its high waist and narrowly cut shoulders, it is too small, too young a style for a seven-year-old? (It was in fact cut from the pattern of the dress I had worn two years earlier as a bridesmaid at my brother's wedding.) At seven, I was outgrowing being my mother's baby, the little girl she had lost in herself but found in me. Letting go, perhaps, was proving difficult.

There is something about this photograph that reminds me of those formal portraits of themselves in full uniform that tens, hundreds, of thousands of ordinary soldiers fighting in World War I commissioned to give their loved ones: not only as mementos of their lives—and so often of their deaths—but also as records of service to their country. I remember, too, that my mother's father left home to go to that same war when she, my mother, was only seven years old, my own age at the time the Coronation photograph was taken. I recall, too, that she always spoke with a longing clouded with bitterness about this man, absent for so much of her childhood, who never gave her the attention or the love she wanted from him. The particularity of this lack, this longing, surfaces in my mother's fondness for uniforms of all kinds, however lowly: an attraction in which desire and identification are blended in equal parts.

My mother's investment in my appearance; her gift to me of this would-be uniform, a Coronation dress; her desire to commemorate a special day, a day of national significance, with a ceremonial costume and a photograph of her daughter wearing it: all these things are compressed into the layer upon layer of meaning in this image. An excess of meaning, in fact, just as the many-layered costume itself (a veritable palimpsest of haberdashery—ribbons, handkerchief, petticoats) is immoderate in its protestation of loyalty. It is all too much. The desire, the wanting, the expectation—all of that lies behind the attention to, the gaze at, this overfed and undernourished little girl, who surely knows she cannot possibly satisfy such intense need, meet such extreme expectations. And so she refuses the gift, disappointing and angering the mother she loves. The costume, despite all the effort, is not quite flawless: its underside betrays itself. The slip is showing.

In this story, the refusal of a gift can also be seen as an act of separation, a declaration on the child's part that she is neither her mother nor her mother's "inner child." And yet it is not so simple, for the rejection is equivocal and shot through with guilt, ambivalence, even with a sense of loss. But if the child's defiance is equivocal, she finds herself unable to adopt the less overtly defiant (and more acceptable) strategy of putting on a mask, acting and pleasing like a good little girl whilst maintaining an inward distance from the action. No, she is too involved. Her sullen refusal to cooperate is a mask of another sort, a cover for contradictory desires. She wants to grow up and be accepted for what she is; but knows that in doing so she risks losing what she prizes above all— her mother's love. If only that love were unconditional, but it is not: it depends

upon the child's continuing to mirror the mother's desire, the mother's desire to be the loved and lovable little girl she herself never was and still yearns to be. This is the dilemma facing the awkward child in the photograph, and she is overcome by feelings she cannot name, but which find inchoate expression in her body—in the "wrong" demeanour, in feeling suffocated.

To this story there is no happy ending, at least in the short term: disappointment is a foregone conclusion. Even if the child accepts the projection and carries on being her mother's baby, in so doing she takes into herself the lack that gave rise to the projection in the first place. She feels incomplete, unable to name her own desires, incapable of following a path that feels her own. She cannot grow up.

Such investments are at work in this as in all my mother's work on my appearance; but in this story there is something else at stake as well. For the dress in the photograph has been made as commemoration of a ritual which, being an occasion for national celebration, goes beyond the dynamics of the mother-daughter dyad. On this day, by virtue of the nation's participation in the Coronation, the ordinary, the everyday, will become imbued with the extraordinary, the special. Everyone will be touched by the aura of the event. My dress and the photograph are a tiny part of a grand ceremony of affirmation, of commitment to a larger identity: a sense of national belonging.

I remember little about the Coronation of June 2, 1953; but those few memories are extraordinarily vivid: the decoration of houses in our street with flags and pictures of the Queen; the street party with gifts of ice lollies and Coronation cups-and-saucers to all the children; the Queen of Tonga; watching the live broadcast of the Coronation with relatives, friends, and neighbors on our television set, the first in the street; the mayor giving out silver Cornation spoons at school morning assembly.

Popular memory accounts are marked by the ways in which they bring together the lives of the "ordinary" people who are its subjects and its producers with events on a grander, more public, scale.[1] Formally speaking, popular memory typically involves the rememberer, the subject, placing herself—what she did or where she was at the time of the big event—at the center of the scene; as it were grounding the remembered event in her everyday world, domesticating it. For example, I recall the setting and the circumstances in which I watched the Coronation on television far more vividly than what I saw on the screen; glancingly recollect the feeling of being among several hundred schoolchildren at morning assembly on the day the mayor paid his gift-bearing visit; have a fairly strong memory-image of the Coronation decorations in my own street; and can all too readily relive my feelings as I wore the frock that

was in its own way part of the decorations. The fragmentary, anecdotal quality of my recollections is characteristic, as well: popular memory—indeed most memory accounts—unfolds less as a fully rounded narrative or drama than as a disjointed flashback, vignette, or sketch.

Pointing as it does—in its characteristically local, rooted, immediate, way—to larger, more public histories, popular memory also speaks volumes about the culture and the society in which it is produced and circulated and to which it always alludes. In the case of the Coronation, my own memories—and indeed popular memory in general—of the event invoke key concerns of a particular moment in Britain's postwar history: the promise of a new, more affluent and egalitarian society; the question of the role of history and tradition in the new order; a reassessment of the idea of Britain as a nation and of the meaning of Britishness. Among these concerns, a desire to preserve valued national traditions in a new, more open, social order assumes paramount significance.

Comprised as it is of stories people tell each other about the past, *their* past, popular memory is a shared story, a story visible in the creation in people's talk about the Coronation at the time of the event. It seems that television figured prominently in the innumerable conversations in which people retold each other what they had seen of the ceremony. Of especially compelling interest was one of the Queen's guests at the Coronation ceremony, Salote,

2. Queen Salote of Tonga. "The tallest queen in the world (6' 3" in height) . . . repeatedly waved and smiled to the crowds, completely ignoring the heavy rain which was falling." *Illustrated London News*, June 13, 1953. Courtesy Tony Stone Images, a Getty Images company.

Queen of Tonga[2] (illus. 2). But why does the ruler of a Polynesian island few in Britain had even heard of before the Coronation have such a stellar role in popular memory of the event? And why does she figure in the way she does? Three stories about Salote were repeatedly retold around the time of the Coronation, and still circulate. First, the simple observation, or the assumption, that she was immensely popular ("Linger longer, Queen of Tonga/Linger longer, do," she was urged). Second, that Salote alone braved the heavy rain that fell on the Coronation procession to wave to the crowds from an open carriage. Third, a joke:

Q: Who is the little man sitting in the carriage with Queen Salote?
A: Her lunch.

Of a large contingent of Commonwealth heads of state invited to Britain to attend the Coronation, Salote was singled out for unique attention and adulation. "The tallest queen in the world" is represented as a larger-than-life figure in other ways, too, for it seems that she dwarfs, and is even capable of devouring, her carriage companion. Generosity and permission-giving are the hallmarks of the persona of Salote, who becomes a sort of mistress of the revels. And yet she also possesses considerable dignity, figuring in the popular imagination very much as a powerful matriarch.

As the reigning monarch of Tonga for thirty-five years and, aside from Elizabeth, the only queen in the Commonwealth, Salote is ideally cast in a piece of theater featuring a symbolic meeting of two queens. The ampleness, bonhomie, maturity of experience, and dark complexion of the one supply the perfect foil to the youth, inexperience, solemnity, diminutiveness, and whiteness of the other. Salote is what Elizabeth, at twenty-seven, is not—or not yet. She is in a sense also what Elizabeth will one day become: a female sovereign of ripe years and in possession of considerable matriarchal authority. Photographs of Salote suggest a certain resemblance in bearing to the older Queen Victoria (the younger of the two queens was more explicitly—and less convincingly—likened with the first Queen Elizabeth). Alongside Salote, the Elizabeth of 1953 emerges with singular force as a figure for youth and energy and for the lofty ideals behind the quest for national renewal. But as queen of the people's revels, Salote brings things down to earth a little, bridging the gap between high and low, easing the intermingling of sacred and profane, seriousness and laughter, in "vulgar" celebrations of the Coronation.

The web of fantasy surrounding the persona of the Queen of Tonga must account in some measure for the apparently genuine affection in which she was held by the British people. And yet there is surely more to it than this. What, for example, are we to make of the fact that this persona has about it more than a shade of the monstrous, devouring mother? Salote's island domain is still, in 1953, a tiny blob of pink on the world map, and Salote herself in some ways re-

3. Coronation of Queen Elizabeth II. Photo: Horton, *The Times*. © Times Newspapers Ltd.

calls Victoria, the sovereign matriarch who presided over the British Empire at its zenith. Does Salote not stand for the presence at the Coronation of a formerly mighty but now crumbling Empire? If Salote is associated with an erstwhile imperial age, Elizabeth stands for a certain postimperial order. The Empire's benign successor, the Commonwealth of Nations, is constructed very much as a *family*, a family of nations. As head of this family, Elizabeth in 1953 is regarded as a sort of apprentice *materfamilias*, the dutiful and caring young mother of a family whose junior members will in due time grow up and make their own way in the world, keeping up family ties, and whose senior members will stem any unruly behavior on the youngsters' part.

The family motif at the heart of the idea of the Commonwealth thoroughly imbues representations and memories of the Coronation, such that Coronation and Commonwealth are inextricably linked in the popular imagination. This is clearest, perhaps, in the idea of Royal Family itself. Like any other family, the Royal Family is at once real—with its own quota of shadows, secrets, and black sheep—and a repository of innumerable fantasies fuelled by desire for unconditional love, intimacy, closeness, and security. As the mother of two young children, the Queen readily serves as a figure of popular identification; and yet as sovereign she stands at many removes from the lives of ordinary citizens. But the royalness of this particular family—the specific combination of similarity to and difference from the rest of us—writes these fantasies peculiarly large. In the Royal Family, the family is imagined in its most idealized form (illus. 3).

While serving as mirror and model for ordinary families, the Royal Family also epitomizes and celebrates not only the ties that bind together all people who belong to one nation, but also the ties between nations: the nation *as*

family; the family *of* nations. In this topos, in which she figures most promi-
nently as a mother figure, the sovereign's femaleness is all-important. Salote,
older queen and benevolent matriarch of another island nation, but junior
member of the family of nations, reinforces what Elizabeth, the younger but in
the end the more powerful woman, represents for the British nation and the
Commonwealth. The family/nation/Commonwealth nexus also connects with
the Coronation's historical meanings, in the suggestion that the promised bet-
ter future will be carried forward with a respect for cherished traditions. As
part of Britain's past, the Empire is to be neither forgotten nor jettisoned, but
will transform itself into an internally harmonious and mutually supportive
family of nations.

The Coronation service in Westminster Abbey was attended by ruling fig-
ures from all over the Commonwealth; and the Coronation procession in-
cluded thousands of members of Commonwealth police and armed forces, all
of whom received considerable attention in media coverage of the event. Such
a gathering was never again to take place in Britain; the Coronation was a
swansong, perhaps the very day the sun set at last on the British Empire. In
her dignified and reassuring matronliness, Queen Salote bridges the old Em-
pire and the new Commonwealth, easing the passage into decline, making it
acceptable, even perhaps noble.

In these imaginings of monarchy and family, nation and Empire, Salote and
Elizabeth are indivisible, two sides of a single coin in a currency that still re-
tains its value in the "mother" country. Not only does the *idea* of the mother
carry considerable force here, but the matriarchal power of flesh-and-blood
women reigns supreme as well. The queen, birth mother of her own children
and ruler of the mother country, is mother also to the nation as family and the
family of nations.

And yet there is a darker underside to these homely imaginings. The "Royal
Family Album" photograph is completely dominated by women, royal males
being relegated to the edges of the frame and the back of the group. Is there
not a hint of excess in this frank representation of the dominance of matriarchs
within a preeminently powerful family? And, like the powerful mother of
archetype, the high-profile Salote has a terrible aspect that is more than merely
hinted at in the suggestion of cannibalism in the endlessly repeated joke. Does
this suggestion of savagery, a murky side to an otherwise reassuring presence,
not warn of cracks in the harmonious relations within the nation as family and
the family of nations? After all, Salote, the dark queen, stands for those parts of
the Empire that would soon be dubbed the "new" Commonwealth, a euphe-
mistic reference to the Commonwealth's nonwhite member countries.

For while the Commonwealth's ruling elites—black, brown, and white—
were making their brief visit "home" as the Queen's invited guests at her Coro-

nation, the Empire—in the form of hundreds of thousands of economic migrants from the new Commonwealth—was making a less temporary return to the shores of the mother country. Having launched themselves on the migrant's eternal quest for better lives for themselves and their children, these humbler Commonwealth citizens would, unlike the Queen of Tonga, decidedly linger longer.

Organized as a multicultural and multiracial event, the Coronation provided the occasion for an affirmation of kinship between the people of Britain and the people of the Commonwealth. But this was a kinship dependent upon geographical separation. As the solitary suggestion of racial difference in British popular memory of the Coronation, Salote emerges in the sharpest relief, standing not only for the qualified kinship of outward relations between Commonwealth and mother country, but also for the repression of racial difference that is required in order to sustain those ties. In 1953, the genuinely warm welcome extended to Salote notwithstanding, to be British was still to inhabit that default racial identity: white.[3]

All this suggests that the idea of the British—and perhaps of any other—nation as a family is necessarily founded on repressions. The Empire's unheralded return to Britain, erasing the lines of distinction between the nation as family and the family of nations, was eventually to force some of these into the open.

* * *

What does all this have to do with a photograph of a little girl in white, a little girl wearing a dress made specially for the Coronation? Both scenes—the larger one of popular memory of the Coronation and its social and cultural significance; the smaller one of my own memories, the Coronation frock, and the photograph—are packed with layer upon layer of cultural and psychical meaning. Both also involve family dramas of one sort or another. And in the way of such dramas, both scenes express the desire, the power, we invest in the idea of the family as a safe haven, while exposing the very impossibility of that ideal.

"The country and the Commonwealth last Tuesday were not far from the Kingdom of Heaven," the Archbishop of Canterbury is reported to have declared soon after Coronation Day. Hyberbole it might be, but this statement does express something of the spirit of the Coronation voiced in contemporary accounts, and resurfacing in popular memory. What comes across most strongly in these is both a sense of community and an almost transcendent aspiration to communion.

Notwithstanding, the communal and communitarian quality of representations and memories of the Coronation is founded on a certain idea of the family and of the place of the mother, or maternal power, within the family. But closer scrutiny of these representations and memories—a look at what is not

shown, not remembered, and also at the deeper meanings, the shadow sides, of what *is* shown and remembered—brings to light some family secrets.

In the smaller story, the little girl's frock and its commemoration in a photograph can be read both as a statement of attachment—to a community, a nation—through participation in a ritual; and also as visible expression of an Oedipal drama that is both personal and collective. The ritual meaning of her costume was no doubt largely lost on a young Annette wholly preoccupied by her loathing of the outfit and her discomfort about wearing it. But this in no way detracts from the broader symbolic and cultural meaning of a child dressed up and put on display in this manner.

The sense that life surely ought to be better, at least once in a while, for ordinary working people translates itself in the special circumstances of the Coronation into a desire for belonging, for attachment to larger ties: community, nation, Empire. However, as an expression of a mother's yearning for something better, something she had never had, the Coronation dress writes small these imagined communities, coloring them with the hues of a particular psyche and a personal history. The corollary of this must be the flipside of every Oedipal drama: projection, hostility, and disillusion ensue as reality inevitably falls short of the ideal. The loyalty, the wish to belong, claimed in the outward display of a ceremonial dress and a photograph of it are riven with disenchantment: a daughter disappoints, an Empire crumbles.

This, perhaps, is the point of connection between a mother-daughter drama and a national occasion. If these stories about Coronation day, the dress, and the photograph underline the impossibility of the family as an ideal, they also point up the difficulty of an imagined community of nationhood that takes the family as its model. While it might be possible, even necessary, to understand—indeed to live and try and hold on to—the utopian desire that fuels these ideals, is it not incumbent on us to direct it into a quest for attachments that do not rest on repressions?

NOTES

1. For a discussion of popular memory, see Popular Memory Group, '"Popular Memory: Theory, Politics, Method," in Centre for Contemporary Cultural Studies, *Making Histories: Studies in History-Writing and Politics* (London: Hutchinson, 1982), 205–52.

2. Philip Ziegler, "Coronation, 1953," in *Crown and People* (New York: Alfred A. Knopf, 1978), 97–126. Salote is discussed on page 122.

3. On early representations—especially photographs—of migrants to Britain from the West Indies and elsewhere, see Stuart Hall, "Reconstruction Work: Images of Post-War Black Settlement," in *Family Snaps: The Meanings of Domestic Photography*, ed. Jo Spence and Patricia Holland (London: Virago, 1991), 152–64. For an enlightening discussion, from the standpoint of the formerly colonized, of the psychological and structural impact of colonialism on the *colonizing* nation, see Ashis Nandy, *The Intimate Enemy: Loss and Recovery of Self Under Colonialism* (Delhi: Oxford University Press, 1983), 29–48.

The Album and the Crossing

LEO SPITZER

As a very young child, I am told that my grandfather Leopold died on the ship when he, my grandmother Lina, and my parents were on the way from Austria to Bolivia. I am shown photos of the ship, the Italian passenger liner Virgilio, and am impressed by its bright white color, its large funnel spewing smoke, and its two masts. I am also shown pictures of my parents and other passengers. My mother has a big belly in the photographs, and my parents explain jokingly that I am "in there"—a stowaway on the voyage. I eventually learn that the Virgilio, in this July 1939 voyage, is transporting hundreds of refugees from Nazi Germany, Austria, Czechoslovakia, and the civil war in Spain to South America. I am also told that the Virgilio's captain wanted to bury my grandfather at sea. This would have been a violation of orthodox Jewish law mandating the interment of a body in the ground. My grandmother and father objected—less, I find out, from any religious reservation on their part than from some elemental unwillingness to have his final resting place be an unmarked spot in the ocean. But it was only after a more per-suasive fellow passenger interceded on their behalf that the captain changed his mind, agreeing to convey the corpse to the ship's next port of call, the Venezuelan harbor La Guaira. There, my grandfather's body was taken from the ship, dressed in a shroud, and buried in earth in the Jewish cemetery in Caracas.

1. The Album

The album containing the photos of "the crossing," as many of the refugees and members of my family referred to their month-long sea voyage of emigration

208

1. The *Virgilio*, June-July 1939.

from Central Europe to South America, has long been an object of fascination for me. Although German or Austrian in origin, it was acquired by my parents in Bolivia shortly after their arrival—a small, well-crafted, rectangular binder volume with textured grey and tan cloth-wrapped covers, dark brown photo pages, and fine-quality translucent tissue separators imprinted with spider-web designs. Held together by a braided cord with tassel ends, the album must certainly have been quite elegant and appealing when it was new, and still looks "modern" and feels good to the touch despite its age and wear, continuing to invite examination and perusal. Like a beautifully bound book, its external aesthetic qualities have drawn me back to it again and again over the years. But the real power of its attraction for me has always come from the eight pages of photographs of "the crossing" at the beginning of the album—photos that helped to satisfy some of my early curiosity about my parents' *Virgilio* sea journey and their move to Bolivia; photos that I also associated with the death of grandfather Leopold, the grandfather for whom I was named but whom I had never met.

No doubt, for the viewer unfamiliar with our family history, the photographs devoted to the emigration in this album would be difficult to decode. Unlike other albums that had belonged to my parents, this one does not include my father's or mother's written subheadings to describe the contents of photos or to identify people portrayed. It contains photographs of what was identified for me as the port of Marseilles, the first stop of the *Virgilio* after its departure from Genoa, where most of the Austrian and German refugees had started their sea journey. Only the indistinct outline of a man wearing a flat-topped, stiff-visored cap typical of French policemen suggests the identity of this harbor. It also in-

2. Rose pregnant, aboard the *Virgilio*, July 1939.

cludes a group of fascinating pictures of heavily bomb- and shell-damaged buildings and equipment in the port of Barcelona, where the ship stopped next to pick up émigrés in the aftermath of the Spanish civil war. It then displays a series of photographs taken in Cristóbal, on the Caribbean side of the Panama canal, where passengers were permitted to disembark for a short period of sight-seeing. My mother, smiling, dressed in what appear to be loose-fitting, lightweight, pedal-pushers, is in one of these photos, posing in a park. She is standing with some fellow passengers—a comely couple in their early twenties and a young boy—and with my grandmother Lina, who wears a tannish dress with a white-bordered collar, dark stockings and shoes, and who is shown carrying a large black purse and squinting into the bright sun located somewhere above and behind the photographer. Two other photos, of the five in the album recalling this particular stopover, show young Afro-Panamanian girls in white dresses—their inclusion perhaps indicative of how unusual an encounter with children of African descent must have been in my parents' lives up to that moment. Photographs of locks of the Panama canal, of the port of Buenaventura in Colombia (which again focus on black subjects on the dock below the ship), as well as of numerous people posing on the deck of the *Virgilio*, make up the remainder of pictures from this voyage. Most of the latter are of fellow Central European refugees and their children (although one is of an elegantly dressed Asian man with his young son)—posed photos rather than snapshots, generally showing ship's passengers on deck, with smiles on their faces and in a seemingly relaxed frame of mind. Some of these pictures include either my mother or grandmother (or both) in the pose; a number of them do not.

3. Five album photos from the *Virgilio* crossing.

It never occurred to me while my parents were still alive, however, to ask them for an explanation or clarification of what I eventually came to view as puzzling omissions and curious incongruities in this album of their emigration. The displayed collection contains no photos of Genoa itself, for instance, or of their departure from that city, nor of various other ports of call normally visited by passenger ships belonging to the fleet of the "Italia" Line.[1] Did this reflect some restrictions on photography that may have existed in Genoa and other "sensitive" harbors during the increasingly tense months preceding the out-break of war in Europe? The Italian military, after all, had invaded and occupied Albania only two months earlier, and a close political and military alliance with Germany had been forged in May of 1939. Or were the omissions inadvertent—due to my parents' personal worries and distractions at the time? Or do they perhaps reflect conscious selection by them, both in choice of subject and the construction of their album? Why are there no photos of Arica, where my parents, grandmother, and the bulk of refugees disembarked to travel overland, by train, to Bolivia? And no photos of the train journey? Had they run out of film by the time they reached Chile? Or did the omissions merely point to conservation on their part—to my parents' decision to employ their box camera judiciously so as not to use up all of their film, a scarce and, for them no doubt, expensive resource?

Why, moreover, is there no photograph of Grandfather Leopold in this album? He died as the *Virgilio* was approaching the Caribbean, somewhere at high sea between Trinidad and La Guaira, almost three weeks after he, Grandmother Lina, and my mother and father had departed from Italy. Had he been ill this entire time, lying in his berth or in the ship's infirmary, in no condition or mood to be photographed? He was seventy-three years old when he died. But in photos in another family album, taken of him and my grandmother in Vienna not long before their emigration to South America, he can be seen smiling, dressed in a three-piece suit, and he seems to reflect the demeanor of an urbane elderly gentleman. He does not look ill, and certainly not like a person long suffering from a debilitating or incurable disease, near death. In this album of "the crossing," he is an invisible presence for me—a mysterious phantasm that begs for explanation.

Had I not known about my grandfather's death on the *Virgilio*, or about the escalating Nazi intimidation and persecution that constituted the background for the emigration of my family and the other Central European refugees on this voyage, my "reading" of these photos might have led me to draw conclusions about their historical and psychological content that differed considerably from what they "actually" reflected. A "naïve" viewer, encountering this album and its pictures without any background information, might be curious about the bombed-harbor photos and the pictures showing the canal locks and machinery. He or she might also puzzle about the identity of the people in the *Virgilio* photographs, and, while probably able to conclude from their dress

and surroundings that they were not First Class passengers on a luxury voyage, would not necessarily discern that they were refugees on a voyage of displacement and escape—on a flight from oppression.

For a long time now, however, I qualified as neither an innocent nor naïve examiner of these photographs. I have looked at the album on numerous occasions over the years in the presence of people depicted within it. Since early childhood, I have also been a listener to emigration accounts that have certainly helped me to contextualize some of its contents and to clarify many of its representations. And I have always been privileged as a viewer in an even more special sense. I could view the family photos in our album of "the crossing" with an "affiliative look"; I could understand these images as an insider, as a member of the family, and I could adapt them into what I came to consider our familial narrative.[2]

But, it was perhaps *because* I had this special relation to many of the photographs in this album that the incongruities between what I came to see as the outward appearances of my parents and grandmother, and my expectations of what I should have been seeing, took on such enormous importance for me. Knowing that my family, within a relatively short period of time, had undergone a series of traumatic experiences—their loss of homeland and familiar surroundings, the death of my grandfather, the threat of his burial at sea—I scrutinized the photos, searching my father's, mother's, and grandmother's faces, their dress, their postures, their apparent involvement and interaction with each other and with their fellow passengers. I was determined to gain a deeper insight into their feelings and state of mind at the time. Yet what I saw I found bewildering.

I had expected their "look" in these photographs to provide me with some indication of the emotional sadness of their mourning—of the intense grief and sorrow that my grandmother and father especially, my grandfather's closest kin, must have felt after his death and funeral. While my family's circumstances as refugee emigrants aboard a ship would no doubt have mitigated many of the observances that Jewish practice required of a deceased man's wife and son, I had at least wanted to find some visual expression, even if only symbolic, of lamentation on their part.[3] But I was surprised that no physical indications of their status as mourners—no sorrowful stances or hurt looks, no black clothing or armbands—were apparent to me within these photos. Indeed, given the background and the circumstances in which these photographs were taken, the very matter-of-factness and casualness reflected in many of them was not only puzzling but also jarring. How was I to read my grandmother and parents' facial expressions and body language—their smiles, and their seemingly relaxed attitude and bearing—in photos taken on the ship and in Cristóbal only a few days after my grandfather's death and burial? How could I understand this apparent incongruity between the visible and the historical?

4. Rose, Lina, and friends in Panama stop-over on the crossing.

It is, of course, possible that Leopold had been so seriously ill when he boarded the ship, and in such great pain, that my family viewed his death as a release from his extreme suffering. This perception would perhaps have allowed them to console each other more readily, to cheer up more quickly, and to present a relatively placid and unstrained image of themselves in the photographs. Their feelings of loss and bereavement, moreover, might also have been counterbalanced by the more general sense of relief that they undoubtedly shared with many of their fellow refugees on the *Virgilio*, and with others who had managed to flee from Nazi persecution. On their journey toward a potential new haven—after maneuvering through prejudicial and bureaucratic obstacles to acquire visas and secure tickets for departure—they would, after all, have been able to take some comfort, breathe more freely, and engage life with some hope of renewal. As Arthur Propp remarked in his journal not long after he embarked on a ship taking him to Arica: "All is forgotten—Nazis as well as forced departure. This is the beginning of becoming human again" ("Und alles ist vergessen . . . Nazis und Austreibung. Es is der Beginn der Widermenschwerdung").[4]

But while relief, and the exhilarating prospect of "becoming human again," may indeed explain the seemingly untroubled facial expressions and outward appearances displayed in these photos of the refugee voyage, there is another possibility to be considered. These images—posed, despite their apparent informality—also conform to conventions of family and tourist photography. As "tourist photos," they fall within a long tradition of souvenir representation, reflecting efforts to recall and display a journey's highlights photographically for viewers, and to attest to a "being present," to a "having-been-there."[5] In Susan

Sontag's words, as tourist photos, they provide "a way of certifying experience" while actually limiting it "to a search for the photogenic."[6] At the same time, within the conventions of the family photograph, these photos also reflect the frequently displayed presentation of family harmony, equanimity, and the camera-induced-"say cheese"-smile. Little room was left within these conventional boundaries and expectations of familial and touristic photography to fit the darker and more complex reality of their experience.

Indeed, it was only when I decided to "restore" the album, by detaching a number of the pictures from their pages in order to clean and refasten them with newer bonding, that the limitations of these photographic representations and the incompleteness of my speculations became shockingly clear to me. On the back of each of the photographs, in my father's handwriting, I found his brief explication of the photo's content and setting. The identities of fellow passengers, whose names I had forgotten or never known, were thus suddenly revealed to me: Mr. and Mrs. Rubenstein, with whom my parents seem to have become good friends on the voyage, and who appear in a number of pictures; Mr. and Mrs. Reiss with their young son, Peterle; the Kesslers and their teen-age daughter with blonde, braided hair; Miss Jedinger, leaning on a railing, standing with my pregnant mother and my grandmother; the dapper José Miro, who had fought in the twenty-seventh Division of the Karl Marx Brigade in the Spanish civil war; Mr. Lau Hong and his son, two Malay Chinese emigrants sailing to Callao. I was also able to confirm or correct the location of all of the

5. My father, posing on the deck of the *Virgilio*.

sights and ports depicted in the album (some of which I had misidentified over the years), as well as of the Third Class deck areas that served as shipboard social spaces for the emigrants during the voyage. Most dramatically of all, however, my father's commentaries expose the intense feelings of grief and sadness that he associated with his voyage on the *Virgilio*, which the photos in the album certainly do not make apparent. They reveal his profound sorrow about the death of his father, and the pain of his forced rupture from the world in which he had been raised and reached adulthood. "Our bad-luck ship 'Virgilio,'" he wrote on the back of one of the pictures, "that accursed transport where our unforgettable father died." "Flying Dutchman aboard a ship of sadness," he declared on another. "Fore deck of the confounded *Virgilio*," he inscribed on a third, "far from homeland [*Heimat*], somewhere at sea."

Inadvertently, I had thus discovered the obverse, hidden, side of the smiling faces and relaxed demeanors in the photographs—desolate and unhappy representations of self and voyage, which, if nothing else, supported my initial expectations about the appropriate responses to the traumatic events my grandmother and parents had experienced. Within my father's handwritten inscriptions and comments, his profoundly touching lamentations of mourning for parent and origins stood out, unambiguously explicit. And, on a more general level, my discovery of these notations also brought home to me how complex the character—and how knotted the meanings—of the refugee experience encapsulated in the words "the crossing" really had been for all of its participants.

2. "We had all become refugees . . ."

"There were Jewish emigrants in First and Second Class—people who must have stashed some money to pay for the tickets," Julius Wolfinger remembered about his "crossing"—not on the *Virgilio*, but on the "Italia" flagship *Augustus*, in December 1939, a few months after my parents' departure.[7] "But most of the life that was going on was in Third Class," he emphasized, "much of it on deck, in the open."

> There were over a thousand of us: Austrians, and Germans, and Czech refugees, and there were some who had come out of Dachau and Buchenwald. I really felt then that even though we came from different places and from different backgrounds, we had one big thing in common on the ship. We really were in the same boat! We had all become homeless.
>
> People played games, cards, chess. Lots of conversation. Stories about how everybody got out. Arguments sometimes. Boredom sometimes. We younger ones flirted and entertained ourselves. We laughed,

but there was also sadness and tension in the air. It came from leaving
Europe and the relatives who stayed behind. I couldn't help thinking:
what was going to happen?

I was 17 years old when I left and emigrated to South America. I
clearly remember one day standing by the railings of the ship looking
out at nothing but the ocean. I felt sad about leaving, and angry about
having to leave, and a little lonely, and also a little unsure about what I
was going to find in Bolivia. What was it going to be like? How would I
make out there? But I was young, and also felt like this was an adven-
ture. And I started talking to a man and woman standing near me who
were also going to Bolivia, and who also began to tell me their stories
and to talk about their worries and mixed-up feelings. And at some
point, when we were talking about this, one of us said: "Maybe that's
what it feels like to be a refugee." And we had a good laugh.[8]

From the vantage point of a moment in the 1990s in which the word "refu-
gee" appears almost on a daily basis in news accounts, and is the reality of exis-
tence for millions of people in so many parts of Africa, Central America, the
Middle East, South East Asia, and Europe, it may seem surprising that Julius
Wolfinger and his shipboard companions in 1939 struggled to define and *name*
what they, and no doubt many others, were experiencing and feeling during
their passage from a world of persecution to a world as yet unreal. Quite pos-
sibly, of course, Julius Wolfinger misremembered the *exact* words spoken on
the *Augustus* a half century earlier when he recalled that moment, and inad-
vertently substituted a term of more recent vintage for one in usage at the time
he left Europe. The designation "refugee" (*Flüchtling*) was not commonly
used for self-identification by Central European emigrants in the late 1930s,
and an awareness of a collective and shared common experience of "refugee-
hood" (as opposed to a shared sense of persecution) does not seem to have
been widely developed among them as yet either. "Emigrants" (*Auswanderer* or
Emigranten) was the term they applied to themselves, and by which they were
grouped together, defined, and generally known by others at the time.[9]

"Emigrants":
I always thought that the term they used for us was wrong.
After all, it refers to willing departees. But we
Did not depart of our own free will
Choosing a different country. And did not move
To a land in order to settle there, possibly forever.
Instead we fled. We are the driven out, the banished.
And the land that took us in is not to be a home but an exile.
 Bertold Brecht[10]

But, exactly remembered or not, it was precisely a "refugee identity," and sense of "refugeehood," that the "the crossing" seems to have catalyzed and helped to construct among the emigrants—an identity and awareness of condition which were to be reflected psychologically and socially in a variety of ways in the ensuing months and years. The emigrants' long ocean journey in the close company of others who were also dispossessed and excluded, and their collective experience of a passage "in-between"—between continents and between existences—brought to surface the complex constellation of emotions and responses which Julius recalled so vividly in his account of his voyage, and which he so aptly and concisely identified in the phrase, "that's what it feels like to be a refugee."

In thinking about Julius's narrative in relation to the many other personal recollections and descriptions of "the crossing" that I have heard or read, my belated discovery of my father's comments concealed on the underside of photos in our family album has given me an instructive lesson. It led me to realize that the complicated and seemingly contradictory feelings and emotions that were revealed in the album when I expanded my inquiry from the apparent to the hidden were emblematic of the collective responses of Central European emigrants during this era—that, indeed, the "refugee identity" and general sense of "refugehood" that emerged on the emigrant voyages were Janus-like in character as well, defined by ambivalence and by reactions that were not always visibly or verbally expressed, or immediately perceptible. In Julius Wolfinger's narrative, in my father's notes, and in the accounts of other émigrés, "what it feels like to be a refugee" seems to have emerged and gained definition in relation to two poles: to that of a known Europe—an origin and homeland, culturally familiar, forcibly abandoned, left behind, seemingly lost—and to a new land of refuge—alien, unknown, other. Feelings of relief and thankfulness such as those expressed by Arthur Propp—of having gotten out alive, if not intact—existed inside of the very same people who were suffering the intense pain of separation from relatives and friends, the traumatic loss of home and possessions, and who had been forced to break their connection with place, with social and cultural milieu, with life-work and profession. Having been denied the possibility of belonging to the Central European world of their origin and upbringing, emigrants on "the crossing" now found themselves in a liminal space: occasionally disoriented, nervous, lonely, yet also in midst of an incipient community of people who were "in the same boat." Memories of past times, and feelings of both joy and hurt, coexisted within many of these individuals, engendering moments of nostalgia and yearning, but also of lightheartedness and gladness: tears as well as smiles.

At the same time, the exhilaration that they sometimes showed—brought on by the possibilities and challenges of renewal, and by the pleasures of imagining a new, and perhaps better, life in another land—had its counterpart in their expressions of anxieties about the future. The place to which they were

emigrating was vague and unformed in their minds. It was offering them respite, a potential haven, a different—they hoped friendlier—social and political environment. Yet they were also uneasy about its strangeness and about their own chances within it. "What was it going to be like? How would I make out there?" Julius had worried about Bolivia, while immediately reassuring himself on the *Augustus* that things would work out well—that he was young and engaged on "an adventure." Within the multifaceted "refugee identity" that was emerging, optimism frequently alternated with disquietude.

From the accounts and recollections of the émigrés, moreover, it is also apparent that their refugee identity contained an additional, and perhaps central, characteristic. In broad psychological terms, this feature echoed that very intense emotional response revealed in my father's notations on the backs of our album's photographs: his sorrow concerning my grandfather's death, and his mournful lament about his own forced separation from people and places to which he had a lifelong connection. Feelings of mourning like his, I realized, were deeply imbedded within the refugee identity in general—dynamic feelings of pain, suffering, and loss that surfaced occasionally, submerged again, and changed in intensity over time, but which affected *all* refugees personally and profoundly for years to come. Indeed, the universality of these feelings—not only within these refugees but within all emigrants and exiles—has been described by the psychoanalysts León Grinberg and Rebeca Grinberg on the basis of their extensive clinical work with voluntary and involuntary emigrant groups. Metaphorically and psychologically, "the one who leaves dies," they write, "and so does the one who stays behind. The feelings of mourning with which each side responds to the separation may be compared to those one has at the death of a loved one. The unconscious association between leaving and dying [is] extremely intense."[11]

But it is important to stress that the complex emotions and expressions that characterized and defined "refugeehood" and the "refugee identity" were embedded within lives and human interactions that, on the surface, appeared to be routine and normal. Refugees conversed, argued, gossiped, laughed, played games, read, flirted, listened to music, sang songs, took photos, touched and considered each other, and their surroundings. They continued, in other words, to pass through many of the hours of the days and nights of their lives engaged in activities that were *ordinary* in character, which were not *obviously* marked by the traumatic experience of displacement and flight. And their engagement in the "ordinary," of course, was usually their salve for survival—their "distraction" in the present, the immediate, and the normal, which would eventually enable many of them to work through and come to terms with the vicissitudes, losses, and pain of the refugee experience.

NOTES

A longer version of this essay appears in my book *Hotel Bolivia: The Culture of Memory in a Refuge from Nazism* (New York: Hill and Wang, 1998).

1. The Italia Line was formed in January 1931 by the consolidation of the Cosulich, Lloyd Sabaudo, and Navigazione Generale Italiana Lines. See Eugene W. Smith, *Passenger Ships of the World: Past and Present* (Boston: George H. Dean, 1963), 716.

2. For a critical discussion of the concept of the "affiliative look" and of the "familial narrative," see Marianne Hirsch, *Family Frames: Photography, Narrative and Postmemory* (Cambridge: Harvard University Press, 1997).

3. For a concise but extremely thorough and informative discussion of Jewish mourning practices, see [A. Ro] in *Encyclopedia Judaica*, vol. 12 (Jerusalem: Macmillan, 1972), 485–93.

4. Arthur Propp, "[Auto]Biography to the End of the Stay in Sucre," *Propp Memoirs*, typescript at the Leo Baeck Institute, New York, 131.

5. Roland Barthes, *Camera Lucida: Reflections on Photography*, trans. Richard Howard (New York: Hill and Wang, 1981), 80–81.

6. Susan Sontag, *On Photography* (New York: Anchor, 1989), 9.

7. Because of the heavy passenger bookings in the aftermath of the outbreak of war to Bolivia and to those few countries on the western coast of South America still accepting refugees, the larger *Augustus* was taken out of its North Atlantic service and rescheduled for Central American and Latin American sailing in December 1939. See "Circulaire, Paris 10 Nov. 1939," HIAS-HICEM Archive at YIVO, Series II, France I, File #390.

8. Julius Wolfinger, transcript of telephone conversation, July 1, 1990, and video interview in New York, July 2, 1990.

9. Numerous contemporary documents, letters, and so on in archival and private collections substantiate this. In English the term "refugee," referring to "one who, owing to religious persecution or political troubles, seeks refuge in a foreign country," was originally applied to the French Huguenots who came to England after the revocation of the Edict of Nantes in 1658. It came to be applied to displaced people in general—to people driven from home by war or the fear of attack or persecution—and was used descriptively by British officials and writers in the Boer War, World War I, and in the course of the late 1930s and World War II. See "refugee" in *Oxford English Dictionary*.

10. Quoted in Christian Kloyber, "Man gab ihnen den Namen 'Emigranten'," in *Wien* 1938 (Vienna: Historisches Museum der Stadt Wien, 1988), 299. My translation of: "Immer fand ich den Namen falsch, den man uns gab: / Emigranten. / Das heisst doch Auswanderer. Aber wir / Wanderten doch nicht aus, nach freiem Entschluss / Wählend ein anderes Land. Wanderten wir doch auch nicht / Ein in ein Land, dort zu bleiben, womöglich für immer. / Sondern wir flohen. Vertriebene sind wir, Verbannte. / Und kein Heim, ein Exil soll das Land sein, das uns aufnahm."

11. León Grinberg and Rebeca Grinberg, *Psychoanalytic Perspectives on Migration and Exile* (New Haven: Yale University Press, 1989), 67.

III. Resisting Images

 All in the Family:
Familiarity and Estrangement According
to Marcel Proust

MIEKE BAL

Introduction

Marcel Proust's modernist masterpiece, *Remembrance of Things Past*, is a showcase of the male gay literary canon. I think feminist and lesbian theory should espouse this book, too. *Remembrance* is much less about the past, or temporal otherness and the desperate attempts to grasp it, as it is about elusiveness in the present, about contemporary otherness and the desperate attempts to grasp *it*. Through the exploration of alterity the novel elaborates a semiotics of desire that can be characterized as gay, but more specifically, lesbian. In this essay I will demonstrate that this long novel's subject, the narrator, Marcel, is engaged in a search that is simultaneously philosophical, poetic, and libidinal, and whose object is "love," understood as the perfect match or total matching of two bodies rubbing against one another, an experience that is not based on penetration, but instead takes a fantasy about lesbian love as an ideal. The philosophical model for this experience is an epistemology of photography; the poetic model is an aesthetic of glimmering surfaces and the limitations of exteriority; the libidinal model is lesbian love.

The subject of both search and fulfilment, however, remains a (homosexual) man. Hence, the claim that the fantasy model I will describe *is* lesbian would be both absurd and wrongheaded. What makes it relevant for lesbian cultural politics, however, is not the model as such but the elevation of lesbianism to a primal model, compared to which other sexual, epistemic, and poetic models are derivatives. With Djuna Barnes's *Nightwood* and the work of Gertrude Stein, *Remembrance* constitutes a canon of modernist fiction whose

radical sexual politics point to, and start up, a postmodern future.[1] For this proto-postmodern slant in the work, photography is the poetics: it is a visual poetics that operates by means of a photographic "eye" that probes the balance between familiarity and estrangement in the snapshot. Many of these snapshots balance on the edge of the familial: grandmother, father, lover, closeted object of desire, figures who are either within the family but must be cast out, or who are not, but must be drawn in.

Suffering from mainstream canonization, *Remembrance* has been overwritten by admirative accounts that aim at "rendering," that is, paraphrasing, the philosophy of the text. As a consequence, the novel is usually read in terms of its "depth." Moreover, many critics have discussed Albertine, the narrator's longstanding love object, in terms of the author's homosexual relationship with his assistant, thus seeming to do justice to a gay impulse.[2] But not to a gay poetics. Where the biography points to homosexuality and the novel disguises it, the poetics might be said to be (falsely) straight. Needless to say that the epistemic model of "depth" inherently colludes with this straightening out of the text. Instead, I will claim that Albertine, far from being a gay man in disguise, stands as a model for the disguise of the gay man as a lesbian, and for the importance for the gay man to represent his homosexuality in this form.

Hence, we are better off without "deep" philosophy and thematics. Instead, I will focus on a structure that links the three areas—epistemology, poetics, desire—whose totally inextricable integration defines *Remembrance*'s uniqueness. This structure is the relation between subject and object of the act of looking, often referred to as "the gaze." Here, the gaze is neither the look alone—held by the subject—nor the Lacanian gaze *stricto sensu* of the ideologically determined visual order which "looks back" at the subject, thus framing what the latter is able to see; the gaze is inflected and thickened by the familial. The Proustian gaze here described probes and questions the limits of what the gaze in the latter sense permits the look to see. The work thus offers a discussion with, not a wholesale endorsement of, something like a Lacanian theory of the gaze.[3] The look embedded in familiarity and affective routine is confronted with a look of estrangement which opens up, instead of closing off, a potentially different look, which is offered as an alternative visual domain. Henceforward I will call this look the (Proustian) *gaze*, to emphasize its double status.

In accordance with—but by no means reducible to—the historical time in which the book was written, the Proustian gaze operates as a privileged device for the closeted representation of homosexual desire.[4] The discussion must be limited to two forms in which the gaze functions to that effect. First, I will focus on the production of textual-visual imagery, most notably, snapshots, as tokens of a sensibility that announces postmodern theories of gender as "masquerade," theories that originate, notably, in feminist thought.[5] Next, I

will examine the status of the subject holder of the "discussing" gaze as an explorer, or ethnographer, whose trade is otherness. In this respect, Proust can be seen as a precursor of postcolonial thought, also of the feminist slant.[6] Together, these two forms provide a glimpse on the nature of lesbian desire as the most crucial meeting place of the three major areas of *Remembrance*'s search, in summary: a sensualist poetics as an epistemology.

To shape the mediation between visuality and language that any visual reading of a literary text requires, two terms are basic for my approach in this paper: flatness, or *platitude*, and figuration. The former indicates the level on which the world seen is articulated in the many passages where vision is at stake; it is the area of textual visuality. The text's insistence on the flat quality of the image becomes ambiguous when photography is at stake and the meaning "banality" accrues to the physical two-dimensionality. The latter indicates the way flatness is written, the way it is made generative of the novel as narrative, as literary text. The result of these figurations can be formulated as a series of visualizing effects, which abound in *Remembrance*. To give a few examples: The *still-life effect* occurs when the unbridgeable abyss between the remote view, which fixates and decolors the object and the close-up, which numbs the senses and sickens—two epistemological and aesthetic obsessions in Proust—is overcome through the mediation of Chardin's miraculous roving attentiveness. The *museum effect* occurs when the visible world that cannot be encompassed is represented as a juxtaposition of flat images, figured according to seventeenth-century Dutch genre painting. The juxtaposition enables the focalisor[7] to see different views without unifying them, and to integrate realistic description with a refusal of its major tool, linear perspective. The *magnifying-glass effect* results from attempts to negotiate discrepancies in attention. The *photographic effect* combines flattening, blowing up, isolating parts of the image, as when Marcel looks from a distance at the band of girls on the beach, and decides, as he phrases it in a proto-postmodern way, to "live his novel" with Albertine because she cycles out of the glossy image. The *snapshot effect* constitutes a subset of the photographic effect, and comes about when the representation takes the form of an album of multiple "takes," and moves in the direction of photographic seriality. This effect is central to my argument about lesbian desire in *Remembrance*.[8] And as I will later argue, these visual effects, in turn, defamiliarize the familiar and familial look we cast on the photographs that abound in our daily lives.

Desire and the Ontology of the Snapshot

Of course, Proust's work is literary, not visual in the material sense. As I have hinted, my analysis of vision in it is predicated upon a distinction between (material) medium and (semiotic) mode. The language of narrative can produce

vision. Where there is visuality, there is a viewer. The viewer within narrative may or may not be identifiable as the narrator. This subject of vision, the focalisor, is often used to stage the position of the outsider as photographer. That position is a condition for the production of the snapshot.

The focalisor's position is a position of the outsider, at the threshold of the diegetic world—which is, in *Remembrance*, essentially the familial. These passages refer to, or take their model from, particular kinds of photographs: snapshots, instantaneous arrests, random stills. They are narrative paradoxes: turning narrative into pictures, they subsequently turn a photo album back into a record of "life" while simultaneously emphasizing the immobility caused by the medium rather than by the object. This paradoxical character is necessary, I contend, to produce the specific epistemological mode of vision that I call, on the basis of the examples analyzed here, the closeted gaze.

There are great differences amongst Proust's visual effects. For our purpose it is important to notice the difference between, on the one hand, the museum effect, the juxtaposition of pictorially pretty images which entertain an obvious interdiscursive relation to a specific genre in painting—one based on voyeurism of domestic intimacy[9]—and, on the other, the snapshot effect of the emphatically random and vulgar kind.

Since for Proust, poetical, libidinal, and epistemological considerations are one and the same, the problems of representation he raises tend to be problems pertaining to the integration of these three domains. For example, the reflection on the changing nature of beings, *êtres de fuite*, articulates the issue of ontology—what *is* the other?—as one of epistemology—how can I know that? According to Brian McHale, this shift from epistemological to ontological uncertainty is crucially bound up with the shift from modernism to postmodernism.[10] Of course, Proust's work is a monument of modernism, and a postmodernist reading of it offends the delicate sensibilities of literary historians. In my reading of the novel, however, I draw it into the postmodern direction because it is there that its gay meanings escape from the closet while putting the closet to meaningful use. And it is precisely in the shift from epistemology to ontology that radical otherness becomes the ultimate object of desire, and that Marcel as the narrative subject of the novel, remaining a queer man, turns his desire into a lesbian one.[11]

The character who makes epistemology tumble into ontology is Albertine. The entire *roman d'Albertine* is a quest for knowledge about her, but this epistemological anxiety is constantly fed by glimpses of her ontological difference: she is unknowable because, as a woman and as a lesbian, she *is* doubly other. And the representation of this ontological otherness is carried out by way of snapshot effects: this object of obsessive jealousy is a fugitive being because all she leaves behind is snapshots.

The ontology of the snapshot consists of the denial of depth, of existence behind or beneath the glossy, random surface of the accessible visual present.

Albertine is the figuration of this ontology. She was selected as a love object the moment she visually detached herself from the photograph of the girls on the beach, taking off on her bicycle and thus riding off the picture, necessitating the change of photographic aesthetic from group portrait to snapshot.

Indeed, in *The Prisoner*, Albertine, who has lost her former, fixed quality of beach photo, consists only of a series of snapshots: ". . . a person, scattered in space and time, *is* no longer a woman but a series of events on which we can throw *no light*, a series of insoluble problems" (III 99–100; emphasis added).[12] The shift from epistemology ("no light") to ontology ("is no longer a woman") announces postmodernism, and the phrase "scattered in time and space" *(disséminé)* with its derridian overtones articulates that shift.[13] That "woman" as "other" falls prey to this lunacy of the snapshot is, of course, no coincidence. This dissolution in visual, flat seriality only aggravates as Marcel tries to counter it and "fix" Albertine by means of "light" thrown on her, and on paper. Thus she ends up *becoming* (ontology) the sheet on which the images (epistemology) of jealousy are going to be fixed (illus. 1): "For I possessed in my memory only a series of Albertines, separate from one another, incomplete, a collection of profiles or snapshots, and so my jealousy was restricted to a discontinuous expression, at once fugitive and fixed" (III 145–146). With the word "mémoire" keeping the issue also on the level of epistemology, ontological "fugitivity" is presented here as a perversion of the former. The final words here, "à la fois fugitive et fixée," define quite precisely the nature of the series of snapshots, and explain the specific use of this poetic in the novel. The importance of eroticism is crucial: the object of this fugitive fixing is the love object of whom the focalizing narrator is unable to fix the essence, which for him is represented by her sexual orientation.

This is a philosophy of looking as fixing that is quite different from the standard theory of the gaze as control, which sometimes comes close to a paranoid iconophobia.[14] Most readings of Lacan's theory of the gaze emphasize the confining aspect of it, although it seems obvious that the symbolic underpinnings of the visual imaginary also enable social intercourse through semiotic exchange. It is this more cheerful, even, saving aspect of the gaze that Proust explores in other passages than this.

There are three first cousins of approximately the same age in my family; one is my own daughter, the other two the daughters of two of my sisters. They are quite close, meet frequently but most often in pairs, and the triangle is not without its occasional fits of jealousy when the one seems fonder of the other than of the third. The youngest one, Lies, is becoming an excellent photographer, already getting commissions here and there. The strip of contacts reproduced as illustration 2 is, I surmise, her attempt to "fix"—to know and thereby to be able to participate in—her cousin Eva's identity (illus. 2).

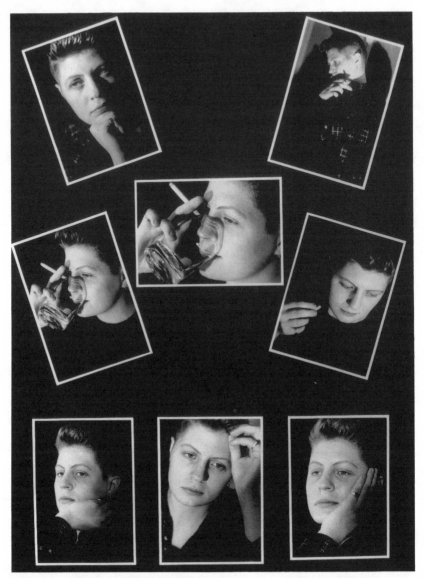

1. Series of posed portraits, 1994. Carla de Groot.

For me, as the doting aunt of both photographer and sitter, I see Albertine floating in and out of the subject's grasp. Close up, more distant, looking at the camera or closing her eyes, Eva cannot be fixed. The series, more than the individual snaps, inscribes the failure to know, which liberates Eva to be within herself. The last image of the series makes her utterly unavailable, but the others are more ambiguous. Tantalizingly almost giving herself over to scrutiny in

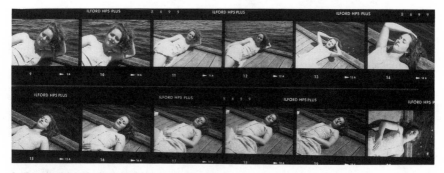

2. Contact sheet of snapshots, 1997. Photos: Lies ter Beek.

the first and second frames, she recedes afterward one way or the other—by distance or by closing her eyes.

The pose in the last few frames adds to the symbolic ambiguity of her spatial framing between land and water, and the ambiguity of her age between adolescent and adult, increasingly unclear as the series progresses, a hint of sexual ambiguity which remains with her when, in the last frame, she turns away from her cousin's searching camera, a fugitive from all attempts to fix her. A hint of a smile is more visible when the distance increases, disappears when she comes closer. The smile is utterly unreadable: is it pleasurable, mocking, communicative, erotic, or solitary? As if to express her refusal to disclose her secret, she does not open her mouth in any of the frames.

In conjunction with Proust's desperate attempt to grasp Albertine, Lies's attempt to enclose Eva in a familiarity that would fix her recalled to my mind a series of photographs of my own daughter, Nanna, made a few years prior to Eva's contact sheet (see illus. 1). Here, the photographer is not part of the family but of the social group, a closely knit lesbian community in Nanna's home town. Suddenly I saw why I had cherished these photos, put them in my Nanna album, but never really grown fond of them. They were not "of Nanna," not of the Nanna my own familial, motherly gaze surrounds with the fixing routine of affection. In none of the photos does the sitter look at the camera. I wondered if Carla, the photographer, in addition to her ambition to be a professional photographer, also had the ambition to probe Nanna's identity—and failed. Like Albertine, Nanna refused to be fixed.

All this is either arbitrary, an unforseeable effect of light and time, or artificial, a pose willed by the sitter. In the case of illustration 2, none of it corresponds to the "facts" of Eva's sense of self, nor of Lies's declared intention. Anticipating the second part of my analysis of illustration 3 below, the third party of the triangle is the familial gaze with which I scrutinize these photographs, surrounding them with both the routine of affection and the album of Albertine that Proust inscribed in my visual memory.

But Albertine, ironed out ontologically, does not benefit from this at all. If

looking is a form of killing, as horror films about voyeurism suggest,[15] looking away is what kills Albertine. The minute she turns from an *être de fuite* into a real fugitive, running away from the obsessive attempts to flatten and fix her, to make her "part of the family," and escaping the desperately seeking gaze, she is killed off by redundancy, a state the author with his genius for cultural anticipation, represents, in a superbly proto-postmodern play, by her literal death.[16]

But proto-postmodernism is "proto-" precisely because it feeds off modernism. The ontology of the snapshot needs, and is predicated upon, the epistemology that founds it. During Albertine's presence at his side, the narrator composes an album, in the vain hope of fixing the inaccessible other. But the photograph's flatness has yet another feature, and that one hinders the very attempt that makes the narrator cultivate it: it encourages deceit, role playing, masks; what is fixed is, precisely, the exterior, the appearance, which only hides more effectively the being which, in the case of Albertine, does not exist outside of the (family) album. If the serial picture taking helps the subject to an epistemological trick, the fixing of image on paper bears on the object as well, and hence, the endeavor cannot but fail:

> And before she pulled herself together and spoke to me, there was an instant during which Albertine did not move, smiled into the empty air, with the same air of feigned spontaneity and secret pleasure as if she were posing for somebody to take her photograph, or even seeking to assume before the camera a more dashing pose . . . (III 146)

Dashing: definitely, this is how Nanna holding a glass or cigaret escaped Carla's probing camera in illustration 1. The ontology is grafted upon the epistemology because what is at stake is not, or not primarily, the fugitive being herself. The series of snapshots functions to reveal not the other's essence but the relationship between subject and other. That is why it matters that this is a narrative text, and thus, needs to be considered in that way. The relationship between the subject of perception, interpretation, desire, and knowledge, on the one hand, and, on the other hand, the object whose sole function is to elude grasp, is transient, tenuous, changing, and ultimately, elusive.

Thus taken seriously as a specific photographic poetics, the series of snapshots poses, and proposes to acknowledge, the limit of epistemic modesty when the object is another human being. In other words, it partakes of a methodological exploration of ethnography in which the other's being cannot be assessed without knowledge, yet knowledge infringes upon being. This, I contend, is the essence of the family as both affective haven and prison, of the familial as a denial of otherness. Albertine is the embodiment of this problem, and therefore, it is crucial that she be gay, a woman, and literally fugitive. Neither the subject of this novel nor, of course, its author is lesbian, but the

3. Studio portrait of a young woman (my mother), 1936. Photographer unknown.

search, the desire, and the epistemology are modeled upon a fantasy—not the reality—of lesbianism as the counterpart of the familial.[17]

"Glamour"—the studio portrait—is inherently in tension with the familial snapshot; not because it grasps the essence of the subject better—it does not—but because it peels away any pretension to know. Illustration 3 shows a young girl in the 1930s. She is twenty-one years old. Her beauty is glamorous, but, although "real," it is rhetorically emphasized and conveyed by the aesthetics of the studio portrait. The soft sheen is in the right spots: forehead, nose, cheeks, delicate neck, wave of the hair. The twinkle in the eyes rhymes with the tiny spot of light in their corners. "Beauty" is enlivened to solicit desire by the features which define the young woman as eligible, such as the smile, which gives and holds back to underline the shyness of youth within the maturity of the woman who can pose. Clearly, this girl is marriageable: ready to be taken out of her own family, of which there is no trace, into a foreign one, based on this glimmering rhetoric of the portrait.

Proust's narrator refuses to fall for such rhetoric. Whenever the "studio portrait" informs his descriptive poetics, the subject is familial: the grandmother. The familial, which encompasses the incest taboo, does not allow unmitigated desire. Albertine, then, represents one side of the novel's ambitious exploration

of love, which gives the biblical euphemism of "knowing" other people a decid-
edly new turn. The symmetrical counterpart of Albertine-as-other is the self-
same object of desire, turned subject by narrative structure.[18] At the other side
of the novel's experiments with photography, in particular, the exploration of
the epistemology of the snapshot, stands the narrator's best friend and friend of
the family, his ego model, closeted homosexual and closeted love object, Robert
de Saint-Loup. Through this figure, the familial *becomes* the closet.

Robert's ontological status is like hers: surface over depth, albeit a surface
characterized not by photographic fixation but by fugitive mobility. The differ-
ence shifts the poetics of the snapshot just enough to turn into a poetics of se-
riality: of the contact sheet à la Muybridge. Visions of him yield not a picture
album but a contact sheet of rapidly taken photos of movement.

Photography in its specific guise of the serial snapshot provides the narrator
with a uniquely suitable and efficient mode of representing this important
character; of revealing the secrets he is invested with while keeping them.
Saint-Loup is the most "photographic" character of *Remembrance*. He is the
most photogenic one, of a luminous beauty, hence, he is the ideal object of
"studio portrait" photography with artistic ambitions. He is also the "official"
family photographer: he is the one who takes the famous photograph of the
dying grandmother, who wished to leave her grandson a visual memory of her.
Among a great number of narrative and poetic functions, that "photo session"
narratively enables the revelation of Robert's homosexuality, as gossip has it
that developing the photo in the darkroom was a pretext for him to make love
to the lift-boy in the Balbec hotel. But, most importantly, he is constantly
being "photographed" in his movement. One such photo session constitutes
the *mise en abyme* of the poetics and politics of the snapshot in *Remembrance*.

Robert is a Muybridge character (illus. 4). Like the nineteenth-century
photographer Eadweard Muybridge, Proust explores through this figure the
possibility of fixing movement. If his movement could only be fixed, allowing
the desiring gaze to pin him down, the final frame of Muybridge's series could
become visible. The attempt to fix movement *qua* movement is, of course, as
old as visual representation. But in *Remembrance* this complex narrative-
pictorial trick is endowed with heavy philosophical, poetic, and libidinal in-
vestment, so as to come to signify the unbearable lightness of being.

Clearly, the issue at stake in this Muybridge work points in a different di-
rection than does the contact sheet of Eva. Speed characterizes this Proustian
character, speed is the sign of him, as it is the sign that signals the difference
between writing as snapshot and cinematic writing. This character of speed is
a fugitive being, but, as I said, not in the same way as Albertine. The differ-
ence between them is, of course, gendered. But in a complex way, in this gen-
dered homosexual universe, the classical opposition between (male) subject
and (female) object, which is such a defining feature of the history of Western
art, doesn't turn out the way one would expect.

4. Eadwaerd Muybridge, *Wrestlers*, 1887. Photographed by Td B. Coll. Ernst van Alphen, Amsterdam.

Albertine is more radically other; Robert more radically in movement. She is characterized by a certain passivity, an adaptation to the narrator's wishes so systematic that she entirely loses her consistency. Lacking autonomy as a character, paper doll at the service of the narrative, she does exactly as she is told. The resulting snapshots reveal only the more painfully the impossibility, in principle, to "fix" her. This inaccessibility of Albertine is *represented as*, not a representation of, lesbianism. In Proust there is no lesbian gaze, no "lesbian as visionary," yet lesbianism is the most important, essential site of desire.

Robert, in contrast, escapes fixing in a different way, more actively, and even more thoroughly visually. As of the beginning of their acquaintance, the narrator has characterized Robert by quickness of movement, as a trait that will pursue a character all through the novel, as his or her determining, identifying sign.[19] This trait, however, develops into much more than the initial label or arrow, index of identity. It is filled with narrative meaning, psychological characterization, physical feature, and, for the narrator, support onto which he can build his plot. These fillings are slowly stored inside the black areas between Muybridge's frames.

Primal Scenes: Against the Familial Gaze

Two scenes stand as exemplary of the way Proust probes the nature of the gaze between affective routine—the familial gaze—and estrangement—the gaze in and out of the closet. Both scenes represent a power struggle with familial authorities: Marcel's grandmother, and Mlle Vinteuil's father. Authority, as often in *Remembrance*, is defined by an excess of affection; it is fundamentally based on a feminized fantasy of the familial that rubs against the Oedipal model.

As if to emphasize the distance from the Oedipal model, Marcel's paradigmatic love object is not *maman* but his grandmother. In order that her grandson may have a beautiful image of her to keep after her death, which she

knows to be imminent, the grandmother asks Robert de Saint-Loup to take a photograph of her. Marcel, who does not know that his grandmother is dying, is extremely irritated by what he perceives as her coquetry. This irritation provokes him meanly to extinguish the expression of joy from the old woman's face that she would have liked to have preserved for him (I 844). They engage in a blind struggle for the power over the image. They are struggling in the present both for the power to determine what the image will be, its future, and the power to control the brief click that immortalizes that which will nonetheless slip away, the past. Marcel's cruelty wins out, and whereas she will soon pass away, he lives to regret his victory.

The photograph in question reappears often in the novel, whether it be as the object itself or as a memory of the event that produced it. In each instance it changes meaning. It is also the object of choice around which the intrigue that opposes Marcel to his doubles will be developed; these doubles, whose misleading identities Marcel discovers during his "ethnographic" enterprise, that voyage of discovery that he makes without leaving home. This discovery has the effect of advancing his self-discovery. In the episode of the grandmother's photograph, Saint-Loup, the photographer, will in retrospect be described as being "a stranger to himself" once the narrator discovers that he used this opportunity to touch up the hotel lift-boy in the darkroom, which becomes by means of this revelation a "camera lucida" (III 699). The focalisor is semantically fleshed out by what it sees as object or other; grandmother's photograph is also indirectly a photograph of Robert.

True to his understanding of the ambivalence of the familial, the narrator reflects often on his impulse to spoil all pleasure and happiness, which he reveals on this occasion. His reflection begins during the involuntary recollection that overcomes him on the first evening of his second stay in Balbec. He considers the photographic session as part of a more general tendency that gives him cause to believe that he killed his grandmother:

> I . . . had striven with such insensate frenzy to expunge from it even the smallest pleasures, as on the day when Saint-Loup had taken my grandmother's photograph and I, unable to conceal from her what I thought of the ridiculous childishness of the coquetry with which she posed for him, with her wide-brimmed hat, in a flattering half-light, had allowed myself to mutter a few impatient, wounding words, which, I had sensed from a contraction of her features, had struck home; it was I whose heart they were rending, now that the consolation of countless kisses was forever impossible. (III 786)

Words that struck home. Since Barthes, one might say that words have taken precedence over the photograph, but I contend that this precedence is itself "photographic." The very mission of the photograph is to strike home: "A

photograph's *punctum* is that accident which pricks me (but also bruises me, is poignant to me)"—thus Barthes elaborates his concept of the punctum before the discovery of the photograph from the Winter Garden.[20]

The reflection continues by cruelly opposing the failure of the photograph to capture a nonexistent truth. Despite Françoise's remark, "Poor Madame, it's the very image of her, down to the beauty spot on her cheek," this visual detail is not capable of bridging the gap between the part and the whole (II 803). This incapacity has significant consequences: the photographic "it's the very image of her" fails to establish the link between the subject and the object of the vision that is the only means of saving the subject in its envelop of familiality. The stakes are high, for as Barthes writes: "if he cannot . . . supply the transparent soul its bright shadow, the subject dies forever" (169). Proust's narrator is well aware of this: "We had not been created solely for one another; she was a stranger to me. This stranger was before my eyes as I looked at the photograph taken of her by Saint-Loup" (II 803).

The defamilializing effect of photography is based on an awareness that is only today becoming fully understood: that there is an irreducible divorce between the subject who looks, the object that is "fixed," and the operator who clicks the shutter. Between the three positions of this visual or love triangle, there is the movement of the merry-go-round that hides an emptiness in the center. This is the problem that the photograph poses. Unable to immobilize, it is just as slippery as the object it is supposed to fix. And in its slipperiness, it acts, it strikes home, without the subject's being able to control it.

The pain he caused—it will remain the flat, present, superficial remembrance, which is all he has; there is no depth. Pain is the only sign that offers access to a past familiality. I cannot look at the photograph of the young woman in illustration 3, studio portrait as it may be, without seeing the pain in the eyes. The eyes do not twinkle, I now see; the spots of light are superposed from the unfamilial outside onto the eyes that cannot smile along with the mouth as soon as the sadness pierces through the glimmering surface. The woman is not holding back; on the contrary, she would like to give more so as to be able to escape the family of which she is still a prisoner. I remember her sadness, although this photograph precedes my knowledge of it. What I remember also is how I fell for the glamour because this was the mother I could admire, love, and desire (to be); but never quite. She had a beautiful smile, but I have no memory of ever seeing the glamour without the sadness. Or was it my own sadness? Within the familial, there is no gaze that does not stick onto its object in an inevitable merging. This is what Proust's narrator knew, and it was the motor of his search.

The grandmother's photograph will continue to obsess Marcel. But during all this time, the photograph has had a rival in the form of another photograph, taken when Marcel returns to Paris and unexpectedly visits his grandmother who, for a brief instant, is not aware of his presence in the room. This other

photograph will set in motion the photographic figuration in the narrative discourse of *Remembrance*, the one that probes the familial gaze as nurturing and stifling, the defamiliarizing gaze as frightening and liberating. It operates as the shifter from the visual represented to a visuality that represents. This is an important passage: it reviews in detail the significant aspects of the family photograph in Proust, defining it as the place where affectivity and cognition, epistemology and aesthetics, the subject and the object, are inextricably commingled. It is also the passage that "theorizes" how narrative can espouse visuality, how words can show. Thus we see that the raw material of this novel consists of an interweaving of the external, "true," and objectifiable image with the mental image.

It is in this passage that we discover the phantom that will haunt the narrator throughout the work, constituting the metaphorical counterpart to the first photograph, the essence of which it describes better: the nonreciprocal gaze. Entering the room without announcing his presence, the narrator writes, "I was there, or rather I was not yet there since she was not aware of my presence, and . . . she was absorbed in thoughts which she never allowed to be seen by me" (II 141). Here we have an example of heteropathic identification—identification based on going outside of the self, as opposed to idiopathic or "cannibalistic" identification, which absorbs and "naturalizes" the other. Heteropathic identification is associated with a risk of alienation, but enables the subject to identify beyond the normative models prescribed by the cultural screen, and is thereby socially productive.[21] This identification never stops appealing to the narrator, even while it exposes him to obvious risks. This appeal makes *Remembrance* relevant for feminist and postcolonial thought.

This passage is made all the "thicker" by the fact that it presents another aspect of the narrator's tendency toward voyeurism. The voyeur is constantly in danger, since alienation robs him of his self when he is not interacting with the other. This danger determines the extent to which the voyeur must "flatten" himself in visual identification onto his object, finding himself unable to avoid participation in the spectacle. The contemplation of the spectacle afforded by the other is a photographic act, both existential and formative. The phantom of the grandmother, which reveals her illness, is, thus, also the phantom of Marcel, who is devoid of all substance when he sees without being seen or known to be there. For a brief instant, he wavers between the disembodied retinal gaze of linear perspective that affords colonizing mastery and the heteropathic identification that takes him out of himself with body and soul to "become" other. The *specter*—both spectacle and phantom—that leads Barthes to define photography in terms of lost time, in other words, in terms of death, is exactly what the subject inevitably is himself:

Of myself—thanks to that privilege which does not last but which gives one, during the brief moment of return, the faculty of being suddenly

the spectator of one's own absence—there was present only the wit-
ness, the observer, in travelling coat and hat, the stranger who does not
belong to the house, the photographer who has called to take a photo-
graph of places which one will never see again. The process that auto-
matically occurred in my eyes when I caught sight of my grandmother
was indeed a photograph. (II 141)

The passage continues in the longest and most sustained reflection on photog-
raphy in the entire work. Here photography is defined as the threshold
between familiarity and estrangement. It is seen as an art, or an "automatic
process," that cuts and slices, transforming life and the past. Describing one-
self in the third person amounts to describing the uncanniness, but also the
excitement of discovery that results from the heteropathic identification.

The photograph that makes the photographer a stranger to himself differs
from the one that is described implicitly as its negative. The word "automatic"
reappears and it is said to be "some cruel trick." The passage gradually devel-
ops a more hostile, if not violent, language, leading at the end of this worrying
amplification to the description of the mental photograph that will always be
with the narrator: "I saw, sitting on the sofa, beneath the lamp, red-faced,
heavy and vulgar, sick, vacant, letting her slightly crazed eyes wander over a
book, a dejected old woman whom I did not know" (II 143). The "truth" of
photography is this stranger, this unknowable person, cut off from the familial,
affective gaze by photography.

The material photograph of the grandmother is combined with the mental
photograph, both of which are dispersed throughout the work. An eye for an
eye: the eye that is veiled by habit, tenderness, the continual affective adjust-
ments that we make to our field of vision, is opposed to that other eye, which is
mercilessly "to one side," that is to say, the lens of the camera. It is the art, not
of mimesis, nor of direct indexical contact, but of deviation.[22]

Ethnography as Voyeurism

If the photographic scenes around the grandmother generate the visual "phi-
losophy" of the gaze between the familial and the need to escape it, and of the
gaze between voyeurism and heteropathic identification, the lesbian scene
generates the model toward which the alternative optic aspires. As is well
known, the long novel is punctuated by a series of scenes of voyeurism, em-
phasizing by means of that rhythmic return of that "primal scene," the crucial
importance of this particular visual libidinal epistemology. It is less well
known that the series consists of four, not three, cases, and that two of these
are lesbian, the other two queer scenes. The lesbian scenes precede the queer
ones, and set the epistemological conditions for the other two; I contend that

they also determine the libidinal and poetic conditions for the queer scenes, which in turn define the narrator's identity and sense of self. In this sense, they are just as "primal" as the one discussed in the previous section.

The series begins with the spying on an infantile "sadistic" scene between Mlle Vinteuil and her female lover, typically centered on a photograph; passes through the vision, in an oblique mirror, of Albertine and Andrée dancing with their breasts clinging against one another; then, there is the literalization of the closet at the Hôtel de Guermantes when Marcel accidentally spies on the homosexual encounter between Charlus and Jupien; and the series ends on the "adult" sadomasochistic scene during the war.

These four scenes together form a series of "ethnographic" experiences whose primary project is epistemological; they reveal "the other" to the watching subject, who presents his act of looking as a voyage of discovery. But in a profoundly biblical association, the attempt to *know* the *other*, the very core of ethnography, is libidinal as much as it is poetic, and defines the subject as someone, to recycle the biblical phrase, "who has known another man." Like the light that is fixed on paper in photography, knowledge as "seeing the light" enables writing but only if the "fixing," the identification of subject and object in a perfect matching, also happens.

The first scene occurs early on, when Marcel is still a child dreaming of unexpected encounters with girls, and when the writing skirts an overt description of masturbation linked to ethnography as well as to framing.[23] This scene generates all later figurations of the photographic gaze in its most important variety as the poetics of the snapshot, as distinct from those derived from the grandmother's "familial studio portrait." Here, the initial device for defamiliarization is an insistent fictionality. The scene begins with a fairy-tale set-up, with the young hero falling asleep, the magic mirror in the shape of the pond. Like Alice, Marcel changes when he traverses the mirror. The vision or object of voyeurism, Mlle Vinteuil appears as if magically; but the magic is of a libidinal nature defined by the masturbatory fantasy that precedes. The "technical" framing, however, is modeled upon voyeurism:

> The window was partly open; the lamp was lighted; I could watch her
> every movement without her being able to see me; but if I had moved
> away I would have made a rustling sound among the bushes, she would
> have heard me, and she might have thought that I had been hiding
> there in order to spy upon her. (I 174)

Of course, spying upon her is exactly what he is about to do. The focalisor's gaze zooms in: if Mlle Vinteuil is represented as if on a photograph, within this picture another picture becomes the figure of this libidinal epistemology: "At the far end of Mlle Vinteuil's sitting-room, on the mantelpiece, stood a small photograph of her father . . ." (I 175). It is the profanation of that photo by Mlle Vinteuil

and her lesbian lover that constitutes the object of voyeurism. But the father does not figure here as the Oedipal authority to be killed. He is already dead, like the grandmother, and like her he needs to be kept at bay, cut off from an excess of familial love, the affective routine that precludes vision yet is its precondition.

This primal scene will later become the point of reference for the narrator's idea of sadism as well as the motor of his obsessive jealousy. According to this logic, jealousy will be a painful visual pleasure. Mlle Vinteuil's lover formulates this unwittingly when she says, not knowing they are being watched: "And what if they are [watching]? All the better that they should see us" (I 161).[24]

Inasmuch as the narrator affirms himself the profound influence of this vision on the rest of his life, this scene sets the stage for Marcel's self-discovery through the other. In other words, for the integration of ethnography and identification, his heteropathic identification, which, in turn, enables him to become (like) a lesbian.

The second scene of voyeuristic ethnography is often referred to as the "danse contre seins," the "dance against breasts," at the casino at Incarville. Again, the effect of the scene is postponed, as it takes Marcel several weeks to fully digest the implications of the sight. Again, the scene is set up in an emphatically implausible way, an antirealism that emphasizes its "philosophical" importance. He had declined the invitation of the "gang of girls" to join them at the casino, but due to an accident, he later wanders into the casino with Doctor Cottard: the young apprentice and the older scientist. It is of crucial importance that he be accompanied by another man, and that this man be an expert. The girls comment that there are no men available to dance with, and begin to dance together; Marcel watches them in a mirror, and obliquely.

As I mentioned earlier, Marcel selects Albertine to "live his novel" with, because of the way she is situated in the flat image of the band of girls. The fact that she is part of that band, hence, that she has a girl's life to which he has no access, is just as important as the opposite fact, namely, that she cycles out of the image, detaching herself from that collectivity. Just as in the scenes on the beach, where Marcel the outsider "photographs" the band of girls whose bonding within a world of their own both arouses and distresses him, here the girls are presented as living rigorously outside the world of men. On the other hand, the talk between the two men, typical men's talk about women, produces a strong sense of homosocial bonding between the older and the younger man. This bonding shapes the event; it establishes the social distance that, superposed upon the visual distance, enables the classical evaluating discourse of power that betokens male dominance. But it is precisely through that discourse that things turn sour.

Cottard, the medical expert, is visually handicapped; he has forgotten his glasses. "Are they pretty at least? I can't make out their features," he says, establishing the blindness necessary for his expertise. "'There now, look,' he went on, pointing to Albertine and Andrée who were waltzing slowly, tightly clasped

together, 'I've left my glasses behind and I can't see very well, but they are cer-
tainly having an orgasm.'[25] It's not sufficiently known that women have it
through their breasts. And theirs, *as you see, are touching completely*'" (II 823–4;
emphasis added).

The doctor's epistemological competence is opposed to his visual incompe-
tence: he cannot see the women's exterior features, but he nevertheless claims
that he can know the interior of their bodies. But that knowledge of their inter-
ior is even more exterior-based than a superficial judgment on their looks
would be; hence the insistence on the doctor's visual incapacity. "Certainly"
functions as an epistemic shifter. "It's not sufficiently known" introduces the
medical cliché for whose utterance the doctor's presence was required in the
first place. But, on a different level, the one where the visual prothesis is lack-
ing, "It's not sufficiently known" implies the verdict that generates jealousy. In
jealousy one never knows enough.

Whether the medical knowledge is actually true or false doesn't matter;
what matters is its definition as *general* and as *exterior*. The master ethnogra-
pher, the one who "knows," doesn't *see* properly, hence, he can judge only from
the outside. But without the doctor Marcel would not have seen anything at
all. On the one hand, medical discourse as the "discourse of the Other"; on the
other, the failure of vision, which necessitates indirect language as the basis of
a knowledge that can only be insufficient. The scene installs the failure-to-
know, which establishes the challenge that Marcel's voyeurism of discovery at-
tempts to overcome.

Ethnography's project is a doubly impossible knowledge: the interior
knowledge of the other, and specific, interpretive understanding through gen-
eral theoretical knowledge. In *Remembrance* this aporia takes the shape of the
conflict between distant and close-up views.

The consequences of this incident are extreme. Established in a voyeuristic
position, the two men are able to construct *together* a knowledge sufficient to
lock the ethnographic object up. The scene generates *The Prisoner*, the long
novel in which Albertine is effectively held captive by Marcel's obsessive jeal-
ousy, generated by the failure-to-know. It matters that the failure is the prod-
uct of the homosocial collaboration between the two men who constitute the
women as others. And whereas the two later scenes of voyeurism have male
homosexuality as their object, the two earlier ones continue their effect, like a
"slow poison," as Marcel says it, to determine the failure to know, the *manque-
à-savoir*, which results from visual aporia.

The Narration of Relation

What can we learn from Proust about the familial gaze? Flipping through my
family albums after reading Proust with photography, I yearned to understand

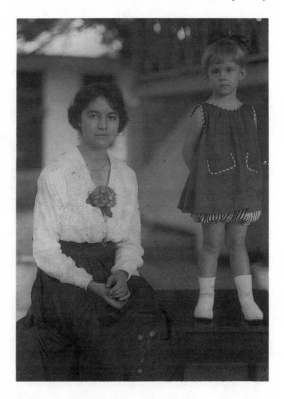

my mother. Among the photos that constructed the narrative of her life, illustrations 5 and 6 became paradigmatic for the sadness that so often pours out from under the poses of merry play or familial togetherness—rarely in the same picture. In illustration 5, my mother as a child poses with her mother. The latter, beautiful as she is, repulses me. There is no relation between the adult and the child. However hard I try, I do not see anything of the ambivalences of the familial in the picture. All I can see is the one side of it: the authority that looms over the child like a shadow of a power that can break. The grandmother I never knew refuses to allow familial affection to be inscribed in the photo. Her little daughter is irremediably alone. No sustenance is offered. Here begins the sadness that marks the glamorous studio portrait, as in illustration 3.

In illustration 6 the little girl smiles. The face of the nanny, called *babu* by the Malay-speaking child, is traversed by an incipient smile. She is beautiful, too, and beautifully dressed in ornate indigenous dress. Thanks to the smaller child, the picture comes closer to a snapshot than the other one. The child's face is lively, caught in play, her foot blurred by movement, her busy body turned in profile whereas her face seems drawn to the camera behind which the photographer hides under a black cloth. The woman holds her, safely protected from falling off the chair.

6. Photo of my mother in colonial
"India" with her *babu*, 1917.

But although the child seems better off with the hired substitute mother, her nanny, the woman is no mother. As the space between the child and the woman's body indicates, the embrace is a gesture of expertise, not of love; not of "family" but of subordination, a woman doing her job, and doing it well. Her smile does not burst open as, one imagines, it would within her own family, after work; it is one of resignation, not pleasure. Her body is stiff, as her knees and feet suggest. Most poignant is the other arm, free of the child but not of servitude and estrangement. The curve of the arm describes tension. The hand, a fist clutching the chair's arm, demonstrates more than the unfamiliarity with the photo session. It denotes unfamiliality, unbelonging, unrelatedness to the mother-child dynamic. Counterpoint to the merry child interrupted in play, the ornately-dressed "Indian"[26] woman is estranged from the gaze browsing through the family album, searching the past for a mother in the present. Although the scene is set in her country and culture, she sits there as irredeemably other, in a chair that, carved by her tradition, belongs to the masters, with a child she is kind to, but whom she can treat only as one who will be taken away at the masters' volition. For me, these two pictures embody the familial as Proust has represented it: not as a domain but as an edge, a threshold, and a stormy sky of ambivalence.

The photographic passages of *Remembrance* have taught me about photography. They uniquely represent neither the subject nor the object of the gaze, but the process that produces the relation between the two, a process that is dynamic and changing—hence, narrative is needed—as well as conducive to a resulting knowledge/pleasure best described as *matching* (although the French word *collage* suits even better). The paradigm set up by the first two scenes links visuality and lesbianism together as a model for the homosexual scenes.

It is now possible to understand the connection between visual narration and lesbian desire that I have been hinting at throughout this analysis. Much more elaborate in its preparatory stages than the previous scenes of voyeurism, this last one definitely questions the subject of the gaze: his attempt to "cover" the object will be virtually successful here, so that the act of looking, taking the inhabitants of the closet out in the open, will lock the looker himself in. The rubbing flesh of the lesbian scene at the casino, where Albertine and Andrée dance together in a closeness that feeds Marcel's jealousy while sharpening his desire, remains the model that cannot be emulated, for as much as he regrets it, Marcel is not "really" a lesbian. But the final scene of voyeurism comes as close as he will ever manage to come.

The nature of the gaze involved, and the function of the serial snapshot to represent that gaze, deserves closer attention in this respect. I contend that the novel's most basic exploration is this erotico-epistemological experiment: the serial snapshot, producing a contact sheet that allows the inside of the closet to become a knowable spectacle conveyed by a closeted gaze, accessible only to whoever is able and willing to handle such knowledge. In the tradition of the metaphor of the camera obscura, instrument, after all, of inverted vision, of ideological distortion, and of exteriorization,[27] the closet occupies the same paradoxical position of allowing vision without having anything "inside" to show. This image of the closet as darkroom suits the text perfectly: behind the surface of photographic light-writing there is neither depth, as Albertine's case demonstrates, nor inside, as Robert's does.

But with Albertine and Robert at the center of desire in *Remembrance*, how can I claim that the desire this novel puts forward is lesbian rather than queer? This question needs to be addressed by connecting the motions of desire to the "platitude" of the imagery. The flattened breasts of the two dancing lesbians echo the numerous passages where Marcel evokes the ultimate pleasure of lovemaking with Albertine in terms of lying against her, skin on skin. Nowhere in this long and love-obsessed text is penetration mentioned.

No passage provides a clearer insight in the fundamental literary, epistemological and libidinal lesbianism of this novel, as that where, much earlier on in the novel, Marcel is about to kiss Albertine for the first time. He reflects on the drawbacks of the human organs for sensual pleasure. The description of

that kiss constitutes a showpiece of modernist writing, as the subject's itinerary to the object, Albertine's cheek, is the occasion for a multiplied series of sense perceptions. But the reflection that precedes it is a showpiece for the work's ideals in the domains it addresses. In it, the narrator discusses the impossible ideal of "knowledge through the lips" ("une connaissance par les lèvres"). Let me therefore wind up by quoting that strange passage:

> I believed that there was such a thing as knowledge acquired by the lips; . . . man, a creature obviously less rudimentary than the sea-urchin or even the whale, nevertheless lacks a certain number of essential organs, and notably possesses none that will serve for kissing. For this absent organ he substitutes his lips, and thereby arrives perhaps at a slightly more satisfying result than if he were reduced to caressing the beloved with a horny tusk. But a pair of lips, designed to convey to the palate the taste of whatever whets their appetite, must be content, without understanding their mistake or admitting their disappointment, with roaming over the surface and with coming to a halt at the barrier of the impenetrable but irresistible cheek. (II 377–78)

It is not surprising that the ultimate pleasure is epistemological in nature. The self-irony in the absurd, farcical comparison with a sea-urchin and the whale, hardly conceals the serious investment: the two animal species he discards here each stand for one of the two realms of vision, the small and the big, the close-up and the distant views, which obstruct the narrator's visual epistemology all along because of the irreducible gap between them. The "horny tusk" combines the hardness of the urchin's thorns with the greatness of the whale. But the tusk resembles most of all that instrument of penetration that men use for their incomplete and disappointing pleasure that pushes them to seek fulfilment in other forms—in flat, rubbing flesh. The tusk represents those aspects of that instrument that are totally negative in terms of the narrator's quest: hard, insensitive, blind, big, and hurting. If only the skin would not be a barrier, the "roaming" kiss could do.

There are not eyes that can see in close-up beyond the skin. But the interior pleasure that doctor Cottard "sees" within the bodies of the two dancing girls, brought about by their flattened breasts, constitutes the perfect image of the ideal the narrator pursues all along. When, in the final scene of voyeurism, Charlus tries to overcome the drawbacks of the "tusk" by being flattened by beatings, the skin is no longer a barrier. But the only way to understand this bizarre masochism beyond the vulgarity of the event in the plot, and to link it to the larger and more radical pursuit of this long novel, is to see it as the closest emulation to those two pairs of breasts. The superficiality of the snapshot, then, is the unexpected representation beyond the confines of the familial, of a homosexual practice seen by an anxious outsider whose keenest desire is in-sight.

Notes

I thank the members of my family for their collaboration in providing the photographs included in this essay and allowing me to expose (on) them.

Some of the ideas in this essay were published under the title "Bird Watching: Visuality and Lesbian Desire in Marcel Proust's *A la recherche du temps perdu*," in *Thamyris* 2, no. 1 (1995): 45–66. Some (other) of the ideas are developed in my book on the subject, Mieke Bal, *The Mottled Screen: Reading Proust Visually* (Stanford: Stanford University Press, 1997).

1. My approach is best understood as comparable—although not identical—to Ernst van Alphen's analysis of *Nightwood* as a "poetics" for the paintings of Francis Bacon: *Francis Bacon and the Loss of Self* (London: Reaktion Books, 1922); Cambridge, Mass.: Harvard University Press, 1922), 119–42.

2. See J. E. Rivers, *Proust and the Art of Love: The Aesthetics of Sexuality in the Life, Times, and Art of Marcel Proust* (New York: Columbia University Press, 1980), for a typical account.

3. My main interlocutor, here, is Kaja Silverman, especially her *The Threshold of the Visible World* (New York: Routledge, 1996). I consider her the most Lacanian *and* the most feminist of the Lacanian feminists I know. See my review of her most recent book: "Looking at Love: An Ethics of Vision," *Diacritics* 27, no. 1 (1997): 59–72.

4. Norman Bryson usefully examines the historical implications of the view I am putting forward here, in "Introduction: Looking and Intersubjectivity," in *Looking In: The Art of Viewing*, ed. Norman Bryson and Mieke Bal (New York: Amsterdam Art International, in press).

5. Judith Butler develops this idea in depth in *Gender Trouble* (New York: Routledge, 1990) and effectively responds to misunderstandings later in *Bodies That Matter* (New York: Routledge, 1993), especially in the Introduction.

6. For this aspect I consider myself in line with Gayatri Chakravorty Spivak, *In Other Worlds: Essays in Cultural Politics* (New York: Methuen, 1987) and *Outside in the Teaching Machine* (New York: Routledge, 1993).

7. The term "focalisor" refers to the subject of vision, also called "point of view," within the narrative. For all narratological concepts, see my *Narratology: Introduction to the Theory of Narrative*, rev. ed. (Toronto: the University of Toronto Press, 1997).

8. These effects are analyzed in detail in my book *The Mottled Screen*.

9. See Norman Bryson, *Looking at the Overlooked: Four Essays on Still-Life* (Cambridge, Mass.: Harvard University Press, 1989), specifically the picture on the book's cover. For the gender aspects of this domesticity and its relation to class and age, see Nanette Salomon's fine analysis of seventeenth-century prints, "Domesticating the Peasant Father: The Confluent Ideologies of Gender, Class, and Age in the Prints of Adriaen van Ostade," in *Images of Women in Seventeenth-Century Dutch Art: Domesticity and the Representation of the Peasant*, ed. Patricia Phagan (Athens, Ga., Georgia Museum of Art 1996), 41–70.

10. Brian McHale, *Postmodernist Fiction* (London and New York: Methuen, 1987).

11. A similar approach to lesbian desire as a principle of figuration, albeit a different one, is developed by Ernst van Alphen for Djuna Barnes's *Nightwood*. *Over de verwoording van verwording. Zellfverlies in "Nightwood" van Djuna Barnes* (Amsterdam: Perdu, 1990). For a shortened version of this analysis in English, see van Alphen, *Francis Bacon*, 119–42).

12. Marcel Proust, *Remembrance of Things Past*, trans. C. K. Scott-Moncrieff and Terence Kilmartin (London: Penguin Books, 1981).

13. Derrida, "Différance," most accessible in *Writing and Difference* (Chicago: University of Chicago Press, 1980). For a feminist critique of the concept of dissemination, see my *Reading Rembrandt: Beyond the Word-Image Opposition* (New York: Cambridge University Press, 1991), 19–23; and "Light in Painting: Dis-seminating Art History," in *Deconstruction and the Visual Arts: Art, Media, Architecture*, ed. Peter Brunette and David Wills (New York: Cambridge University Press, 1994), 49–64.

14. See Martin Jay's seminal account of iconophobia in contemporary thought, *Downcast Eyes: The Denigration of Vision in Twentieth-Century French Thought* (Cambridge, Mass.: Harvard University Press, 1993). Also Norman Bryson, "The Gaze in the Expanded Field," in *Vision and Visuality*, ed. Hal Foster (San Francisco: The Dia Art Foundation, 1988), 87–114.

15. Parveen Adams, *The Emptiness of the Image* (London: Routledge, 1995).

16. Thus, the earlier decision to "live" his novel with her is here coming to a symmetrical closure when she is killed off "in reality" but resurrected in a posthumously received letter, and later in a misread telegram. This is one argument why it is necessary to interpret Proust's way as, at least, proto-postmodern. Either that, or he qualifies as a misogynistic, sadistic monster, a view that few of his readers will want to endorse, although some of his fanatically realist readers do. See for example, Rosine Georgin, *Contre Proust* (Paris: Cistre/Essais, 1991).

17. A different but still compatible view of lesbianism as a model for looking is Diana Fuss, "Fashion and the Homospectatorial Look," *Critical Inquiry* 18 (Summer 1992); 713–37.

18. *The Mottled Screen*, 214–37.

19. See the chapter on characterization in my *Narratology* (79–92); also, Shlomith Rimmon-Kenan, *Narrative Fiction: Contemporary Poetics* (London: Methuen, 1981).

20. Roland Barthes, *Camera Lucida: Reflections on Photography*, trans. Richard Howard (New York, Hill and Wang, 1981), 27, 49.

21. These two forms of identification have been extensively theorized by Kaja Silverman, in *Male Subjectivity at the Margin* (New York: Routledge, 1992) and in *The Threshold*.

22. This is an allusion to Rosalind Krauss's seminal study on the subject, *Le photographique. Pour une théorie des écarts* (Paris: Macula, 1990).

23. The passage begins with an allusion to the masturbation scene in the "cabinet sentant l'iris":

> appealing to it as to the sole confidant of my earliest desires when, at the top of our house in Combray, in the little room that smelt of orris-root, I could see nothing but its tower framed in the half-open window as, with the heroic misgivings of a traveller setting out on a voyage of exploration or of a desperate wretch hesitating on the verge of self-destruction, faint with emotion, I explored, across the bounds of my own experience, an untrodden

path which for all I knew was deadly—until the moment when a natural trail like that of a snail smeared the leaves of the flowering currant that drooped around me. (I 172)

The French is more precise in its allusions to the masturbation fantasy and its connection to writing (trace de colimaçon"; I 158).

24. The translation is here, as in many other places, censoring away the explicit sexuality. The French has: "Quand même on nous verrait, ce n'en est que meilleur," meaning "it [the love-making] would only get better because of it."

25. I have modified the translation here, which is decisively censoring: "Elles sont au comble de la jouissance" can only refer to an actual orgasm, whereas the translation "they are . . . keenly aroused" is clearly minimalizing the sexuality while making the narrative more realistic than the text warrants.

26. Before the liberation of Indonesia from Holland in an extremely bloody war, the Dutch called the country: "Indië" and the people "Indiërs," a terminology indistinguishable from the one referring to India and its inhabitants. Future Indonesia was to the Dutch what India was to the British. And the Orient, in the Dutch imagination, was just the Orient, remote and mysterious, as well as ready for the taking.

27. See W. J. T. Mitchell, *Iconology: Image, Text, Ideology* (Chicago: University of Chicago Press, 1985), especially the last chapter; and, for the aspect of exteriorization, Svetlana Alpers, *The Art of Describing: Dutch Art in the Seventeenth Century* (Chicago: University of Chicago Press, 1985).

Seeing Sentiment:
Photography, Race, and the Innocent Eye

LAURA WEXLER

"Our white sisters / radical friends / love to own pictures of us /
sitting at a factory machine / wielding a machete / in our bright
bandanas / holding brown yellow black red children / reading books
from literacy campaigns / holding machine guns / bayonets / bombs /
knives / Our white sisters / radical friends / should think again."
—Jo Carrillo, *And When You Leave, Take Your Pictures With You*

1

In *Camera Lucida*, Roland Barthes distinguishes between two fields of atten-
tion to photographs. First, and always, there is a *studium*:

> Thousands of photographs consist of this field, and in these photo-
> graphs I can, of course, take a kind of general interest, one that is even
> stirred sometimes, but in regard to them my emotion requires the ra-
> tional intermediary of an ethical and political culture. What I feel about
> these photographs derives from an *average* affect, almost from a certain
> training. I did not know a French word which might account for this
> kind of human interest, but I believe this word exists in Latin: it is *stu-
> dium*, which doesn't mean, at least not immediately, 'study,' but applica-
> tion to a thing, taste for someone, a kind of general, enthusiastic com-
> mitment, of course, but without special acuity. It is by *studium* that I
> am interested in so many photographs, whether I receive them as politi-
> cal testimony or enjoy them as good historical scenes: for it is culturally

(this connotation is present in *studium*) that I participate in the figures, the faces, the gestures, the settings, the actions.

Second, there may also be a *punctum*. Of the *punctum*, Barthes writes:

> The second element will break (or punctuate) the *studium*. This time it is not I who seek it out (as I invest the field of the *studium* with my sovereign consciousness), it is this element which rises from the scene, shoots out of it like an arrow, and pierces me. A Latin word exists to designate this wound, this prick, this mark made by a pointed instrument: the word suits me all the better in that it also refers to the notion of punctuation, and because the photographs I am speaking of are in effect punctuated, sometimes even speckled with these sensitive points: precisely, these marks, these wounds are so many *points*. This second element which will disturb the *studium*, I shall therefore call *punctum*: for *punctum* is also: sting, speck, cut, little hole—and also a cast of the dice. A photograph's *punctum* is that accident which pricks me (but also bruises me, is poignant to me).[1]

In this essay I attempt to read a punctum in one white family's sentimental photograph of an African-American "nursemaid" and a white child. I do so not because this particular image is unique, for it is not, but because it has often been reproduced without being attended to critically. In my view, historical contextualization of this photograph opens (or reopens) a kind of wound—a punctum, to use Roland Barthes's exquisite term—that offers the opportunity for a subjugated history to be spoken. In the contexts in which it has been reproduced so far, this photograph of the "nursemaid and her charge" has played the part of the studium. The Barthean punctum cuts a hole in this "general enthusiastic commitment" of vision.

One caveat: I write in the belief that close, attentive readings of historical photographs can restore resonance and context to historical knowledge that may have been hidden or repressed; but what I offer is my own reading solely. It is not meant to speak over or foreclose other meanings. Perspectives on photographs, as on history, differ from individual to individual and from social location to social location. One alternative reading of the "nursemaid and her charge" that has been suggested to me, for instance, poses the "nursemaid" as a day laborer for the white family, and not at all disturbed by her situation or by the scene of photography. Certainly she herself has no real voice. She has been silenced by the deracinated manner in which her image has been preserved and reproduced, her actual thoughts and emotions unavailable to the viewer. It is, therefore, theoretically possible to support such an alternative reading.

However, my own research into the archives of the Cook family, for whom she worked, leaves me skeptical about the validity of that reading. I take my

cues from the general social context surrounding the photographer and his subject. What I am interested in recovering is not some pure and transparent version of the young woman's inner life, which would be both impossible and presumptuous to attempt, but the character of the historical setting within which her image as *sign*—stripped of her voice—was circulated. Each standpoint—and surely my own, as a white, upper-middle-class woman who is a university professor—contains ignorance and blindness as well as knowledge. I hope that in drawing attention to the photograph and insisting on reading its context, naming the political functions that I see to be at work in the image, I add to the power and knowledge that this image makes available, and that I do not at the same time objectify its subject or misname history from my own partial perspective in ways that might invite additional reification.[2]

2

The Greeks had a word, *ekphrasis*, that we don't have, which designated an art that we, also, don't have: the virtuoso skill of putting words to images. Writing recently in the *New York Times*, John Updike reported his joy on discovering this word, for it named what had long been an insistent, but faintly embarrassing, passion of his, and made it seem legitimate. Similarly Bryan Wolf recently came out in *The Yale Journal of Criticism* as a "closet ekphrastic . . . [hurling] caution and nicety of distinction to the winds . . . and [arguing] both for the rhetoricity of all art and the ideological work performed by all rhetoric."[3] However, estatic ekphrastics hardly ever turn to photographs. For instance, not one of the readings legitimated by Greek paternity in Updike's recent book of essays on art, *Just Looking*, is of a photograph, even though Updike devotes the entire lead essay to the Museum of Modern Art in "What MoMA Done Tole Me," and the MoMA he remembers haunting for an unforgettable twenty months between August of 1955 and April of 1957 housed at that time what was arguably one of the most important collections and display spaces of photographs in the country.[4]

Serge Guilbaut and Christopher Phillips have both demonstrated that, through its cooperation with the government and its curatorship of the photography collection at that time, MoMA turned itself into one of the country's most productive bastions of cold war ideological politics.[5] Perhaps it is too much to have expected John Updike to have noticed any of this in particular, even though he was there during the very months that "The Family of Man" exhibition was installed in MoMA and was drawing enormous crowds of visitors, subsequently to "travel in Europe, Asia, Latin America, thereafter to travel globally for two years." "The Family of Man," organized by Edward Steichen, was an anthology of images edited to show the universality of daily human life all over the world, which purportedly revolves around utterly dehistoricized,

utterly naturalized experiential categories, such as "birth," "death," "work," "knowledge," and "play." Supported by quotations from "primitive" proverbs or verses from the Bible, the message of this spectacle sent by the American government all over the world was that we are all one family. But Updike's neglect of these photographs and attention to the more prestigious realm of "high art" painting suggests more than a personal lapse. It represents a decided critical tendency that is not Updike's alone; and it suggests the need of inventing another term, photographic *anekphrasis*, to be coined from its opposite. Anekphrasis would describe an active and selective refusal to read photography— its graphic labor, its social spaces—even while one is busy textualizing and contextualizing all other kinds of cultural documents.[6]

Photographic anekphrasis is not innocuous. The comparative neglect of critical attention to the raced, classed, and gendered productions of the photographic image is a form of cultural resistance. It represses the antidemocratic potential of photography. The dynamic meanings of cultural forms produced and marketed since the mid-nineteenth century simply cannot be fully adduced without concurrent attention to the way that those cultural forms have used photography to naturalize and enforce their message. One might even go so far as to say that anekphrasis itself is an institutionalized form of racism and sexism, in so far as photography has always been deeply involved in constituting the discourse of the same. In the analysis that follows, I am attempting to address one instance of this refusal. I want to try to join an unread photographic moment with the discourse of nineteenth-century sentimentality because by and large, with quite serious results, cultural theory has so far refused to attend to it.

Cultural theory is not guilty of anekphresis overall. Indeed, feminism has sustained a major critical engagement with the photographic image. No one has ever attributed more social power to the photographic image than the antipornography movement. Crucial questions about the commodification of representations of women's bodies in advertising; the cultural enforcement of women's positioning *as* representation, *as* image; and the reconstruction of a basis for female spectatorship that moves out from under the dominion of the "male gaze" have had their most serious considerations within feminist analysis of photography and film. Yet even within this significant enlargement of the critical gaze, feminist interpretation has often made it seem as if issues of sexuality can be separated analytically from those of race and class.[7] While the feminist movement has been brilliantly effective in forcing discussion of the domination and objectification of women by men, it has been relatively silent about the internal dynamics of objectification within its own ranks, woman over woman, and about the ways in which women themselves have gained and lost from the racial and class power differentials among men. Second wave feminism allowed the image of the middle class white woman to circulate as the signifier of the category "woman." But gender distribution is not the same

thing as race distinction. The notion that they are parallel inequalities, and that an analysis of the sexism of photographic practice will automatically yield a model for thinking about race as a category of difference is one of feminism's anekphrases. So that, although feminism sees photographs, the question has become, frankly, just what is it that feminism sees.

Sentimentality was a theory of gender. It held that differences among the domestic lives of peoples were natural, rather than historical, differences, and that a new education in domesticity was necessary both for white males and nondominant peoples. That is in good part why twentieth-century white feminist criticism has been able to retrieve so successfully the sentimental writings of the "Other American Renaissance."[8] *Both* forms of cultural critique—white domestic ideology in the nineteenth century, and white feminist theory in the twentieth—largely bracket questions of race and class in an imperializing, single-minded insistence on the critical specificity of gender. However, sentimentality left another record of these operations, in photographs, through which it is possible to see around the edges of its masquerade as nature. Photography was part of the master narrative that created and cemented cultural and political inequalities of race and class. I hope that seeing sentiment in photographic images can be one way of encouraging our society to see itself.

3

A young woman sits for the camera in a good striped dress with a white collar (illus. 1).[9] A small, simple broach is successfully pinned exactly at the central meeting place of the two starched white points of the collar that rise up slightly from the surface of her dress. Formally, with its quiet precision, its broad simplification of background space, its tonal balance, its graphic playfulness, and its flat, tight framing of the figure, this image has the look of the long tradition of plain style American portraiture that unites the primitive folk art practices of the early itinerant portraitists like Ammi Phillips and Erastus Salisbury Field with the vernacular masterpieces of the J. S. Plumbe and Southworth and Hawes daguerreotypes. Iconographically, this image also relates to a long symbolic tradition, that of the Madonna and Child, a tribute to the highest achievement that womanhood can attain in Christian culture, and a paean to the actual woman who occupies that mythical role. "Craftsmen of Western art have revealed better than anyone else the artist's debt to the maternal body and/or motherhood's entry into symbolic existence," writes feminist critic Julia Kristeva in "Motherhood According to Bellin":

> Not only is a considerable portion of pictorial art devoted to motherhood, but within this representation itself, from Byzantine iconography to Renaissance humanism and the worship of the body that it initiates,

1. Cook Collection, Valentine Museum, Richmond, Virginia.

two attitudes toward the maternal body emerge, prefiguring two destinies within the very economy of Western representation . . . Worship of the figurable . . . or integration of the image accomplished in its truthlikeness within the luminous serenity of the unrepresentable.[10]

Like this photograph, the painted Madonna is often rendered in vivid detail, and like this photograph also, the attentive "truthlikeness" to the materiality of the figure in the depiction often blends into some other unidentifiable expression that is "unrepresentable," or disengaged. Painted Madonnas are usually holding the baby Jesus but looking away. In this averted gaze, Kristeva notes, "the maternal body slips away from the discursive hold," to "become the last refuge of the sacred."[11]

It used to be only artists' models or wealthy, aristocratic women who could see themselves painted in this role, but the discovery of photography in the nineteenth century allowed millions of ordinary mothers to have images made in that virginal and compelling guise (illus. 2). On the strength of its formal and symbolic characteristics alone this photograph should take its place in the procession of American religiously influenced art. And like the Catholic paintings of the Madonna that Protestant Harriet Beecher Stowe urged her readers to hang upon the walls of their homes, to signal the sisterhood of spirit and the communal reservoir of art that nurtured faith no matter of what denomination,

2. Courtesy of the Society for the Preservation of New England Antiquities.

formally considered, this photograph would uphold the canons of domestic sentiment.

However, "a nursemaid and her charge," as this photograph is entitled in *We Are Your Sisters*, edited by Dorothy Sterling, or "former slave with white child," as it is captioned in *Labor of Love, Labor of Sorrow*, by Jacqueline Jones, is not an image of the vaunted female icon of Christian humanism, nor is it an example of popular folk art; merely to repeat such a formal or an iconographic analysis would be deeply misleading. In fact, this image ironizes both the self-absorption of Kristeva's depiction of Western religious painting and the unexamined populism of the vernacular approach to the photographic image. For this image was made in Virginia, circa 1865, by a skilled white studio photographer named George Cook, of his own family's "nursemaid," for his own family's consumption. Cook was a northerner who settled in the South just before the Civil War. He is widely known for his pictures of military officers on both the Union and the Confederate sides of the war. But he continued to photograph after the war, maintaining a thriving studio business in Richmond. According to Norman Yetman, the one historian who has written even briefly about the conditions under which the picture was made, the young woman depicted is almost certainly a slave or only recently freed. Since the baby on her lap appears white and she is black, most viewers would assume that it is not her baby at all, but another woman's child. And, in fact, the baby is Heustis Cook, the son of the photographer, who himself grew up to be a photographer

like his father, but specializing in making pictures of former slaves. "Heustis Cook," notes Yetman, "was one of the first of the 'field' photographers who packed his buggy with cameras, glass plates, plate holders, colodion, silver nitrate, plus his tent or 'darkroom' and all his developing supplies and took photography to the back roads." The father and son's collection of pictures of the former slave population of Virginia, South Carolina, North Carolina, and Washington, D.C., is now in the Valentine Museum in Richmond, Virginia. A substantial portfolio of their images was reproduced in *Voices from Slavery*, edited by Norman Yetman, in 1970.[12]

This Madonna is therefore a weirdly skewed rendition of the Christian story. The young woman, like Mary, holds a baby who is virtually, even perhaps literally, her master. As his more than maternal servant, she, like Mary, is tending to a child who, like Christ, will make a living record of the future, a future in and of which she, herself, will not be able to speak. But this baby is not the baby that God the Father gave her to bear. That baby, if it exists, is elsewhere. Despite her youth and beauty, this woman cannot be simply another mother who commemorates the ecstatic moment of typological juncture, the swelling pride of womanhood fulfilled, since as a slave or former slave she has been at the same time human chattel and, to adopt Orlando Patterson's pungent figure, a social corpse. Motherhood may be what the genre marks as woman's great accomplishment, but sitting for the camera *as* the white woman sat, in the pose that the white woman held, holding, in fact, the white woman's baby, within the iconographical space and actual society that claimed for white women an exclusive right to occupancy, the slave or servant brings into existence not her own family's precious keepsake, but a monument of doubleness and double entendre. Rather than bonding figure to type, the photograph displays instead the innumerable barriers and memories in the way of that apotheosis. The "unrepresentable" that Kristeva invokes is not some abstract sacred principle, but the materiality of the figure of a young black woman.

In the earliest years of its existence, photography was laminated to sentimental functions along with domestic novels, domestic advice manuals, educational reform propaganda, and abolitionist agitation. While the middle-class home became the port of entry for sentimental fictions of all sorts, the hall table and the parlor were accumulating photographs at an impressive rate. Like domestic novels, the resulting accumulation of images helped to make, not merely to mirror, the home. Photography was another mode of domestic self-representation. It worked by staging affect, or imaging relation—literally *seeing sentiment* as a way of organizing family life. "Our cabin measured 16 × 20 feet in the clear," wrote one white settler in Montana,

The logs were chinked and painted with clay. The floor was of earth, beaten hard and smooth—a box cupboard held our stock of dishes and cooking materials. Beside it stood the churn. The flour barrel was

converted into a center-table whereon reposed the family Bible and photograph album with their white lace covers.[13]

Or, as Nathaniel Hawthorne observed in his notebooks, when Sophia rearranged the parlor and put a table with books and pictures at its center, the new house in Lennox became a home.

The valorization of the visual image of the middle-class white woman as the signifier of the category "woman" that makes other social relations invisible took shape in the early nineteenth century. Sentimental ideologies of womanhood explicitly turned to images to mark the social divisions advanced by the middle class and to make them seem rooted in something actual. Photography, invented in 1839, was an even better technique than drawing or painting for making images of "nature," and photography was therefore conscripted for the sentimental cause.[14] The idea was that if you could take pictures of something, it must exist. To the middle-class nineteenth-century viewer, a photograph was a "mirror" of nature; not only that but unlike other mirrors it had a "memory," too. Photography inscribed, therefore, a very powerful image of the "real."

But what this idea disguised is the fact that photographs have meaning only as elements of a set. Photographic meaning is a system of relations that are established not *in* but *between* images. In the words of Patricia Holland, Jo Spence, and Simon Watney, photography is ideological in that it is a "set of relations established between signs, between images—a way of narrating experience in such a way that specific social interests and inequalities are thought about, discussed and perpetuated."[15] Or, in the formulation of Griselda Pollock, to interpret images of women, it is necessary to develop "a notion of woman as a signifier in an ideological discourse in which one can identify the meanings that are attached to woman in different images and how the meanings are constructed in relation to other signifiers in that discourse."[16] Nineteenth-century bourgeois domestic photography, then, became as productive and constitutive a force as it did because it related images of women to one another and to other cultural practices through a hierarchizing narrative of social signs. Photographic sentiment helped to create the hierarchies that, ostensibly, it merely recorded.

In the sheer accumulation of these photographic images, the simple weight of the fact that now there were so many of them when before 1839 there had been none, there is another significance. Far from exhausting demand, photography in the early years provoked a seemingly limitless appetite. If, as critics have argued, sentimental fiction fed the hunger for middle-class self-transformation through the institution of a depth psychology of self-monitoring, self-possession, and self-control, sentimental readers were also evidently famished for corresponding views of the visible surface of their lives. Critics have suggested that these images were personal fetishes, bulwarks against nineteenth-century anxieties about separation and early

death, and no doubt that is true. But looked at in the aggregate, this cannot have been their only function. As codifications of class and identity, these ubiquitous reflections of private life in private homes must also have demarcated the edges of social visibility and invisibility for a group of people who, not yet secure, repeatedly invoked the materiality of appearances to justify their claim to dominance and their every incursion into the private space of others.[17] Anxious *for* separation, for a visible difference in display and deportment that could squelch any challenge to the distinctive privileges they claimed, middle-class people must have found in the very numbers of domestic photographs that filled their homes an assurance that real family life was coincident with the kind of families the photographs showed.

I would like to suggest that people outside the magic circle of nineteenth-century domesticity—for instance, slaves, Native Americans, Mexicans, later the Eastern European immigrants, the Filipinos, and the Chinese—pose an interesting problem of exclusion in relation to such uses of photography. I would like to suggest also that it is a problem that can be illuminated by examining the relation of these Others to the regime of sentiment, taken as an aggressive, rather than merely a private, social practice. In this view, the culture of sentiment aimed not only to establish itself as the gatekeeper of social existence, but also to denigrate all other people whose style or conditions of domesticity did not conform to the sentimental model. Since the sentimental home was the model home, it followed that anyone else's home was in need of reform. And since the sentimental image was the model image, it followed that any other photograph was an image of lack. The partitioning off of a domestic space for photographic display in the home accompanied a categorization of difference between those who did and those who did not own a "home" to decorate with their own images. Photography, even more than the written word, was a state-of-the-art technique for making this distinction.

It was not that other people were actually *unseen*. Slaves, servants, the poor, the infirm, the socially dispossessed were evident in virtually every domestic landscape, and in one way or another their presence affected virtually every middle-class household. Morever, as Philip Fisher has shown, the gathering force of sentiment as a social ideal was driving home the idea that it was necessary to have a more inclusive philanthropy that included precisely these people.[18] The problem was really managerial, an orchestration of the gaze. If the function of middle-class domestic photographs was, as I have been suggesting, to precipitate a seemingly natural mirror image of the sentimental home out of the household, the economic unit, it would follow that the household, although it visibly and palpably sustained the home, as well as heterogeneous images, would need to be rendered functionally invisible. The ideal of "domestic individualism," as Gillian Brown has called it, at least in this respect, extended even to the image of the domestic unit itself.[19] Such a unit could not appear in photographs as the heterogeneous and corporate product that it actually was.

In the aggregate, historical photographs indicate that families addressed this editorial problem in a variety of ways. One was obvious, and easy. In a family portrait made in the studio of a professional photographer, the household could compose itself *as* composed only of those members that it wished to portray. Slaves, servants, renegade sons, unsightly or unstable dependents were all easily excised. They simply needn't be included in the trip to the studio. And, in fact, by far the greatest number of family studio portraits have this appearance. Although there were alternative practices, and there are numerous contradictory collections, the weight of the archive of mid-nineteenth-century middle-class family portraits is not only overwhelmingly white, like the mid-nineteenth-century middle-class family, but affectively harmonious, and physically eugenic.[20] Looking at many of the images of the family in mainstream historical collections, one would hardly know that other people were around. When an itinerant photographer came to a family's residence, however, as sometimes happened in the early years, the act of composing the family's public image would need to be more explicit. For at least some families, it appears to have been more difficult under these circumstances to manage so closely a properly narrow approach to its own social construction. There are numerous photographs that show servants, for instance, on the edges of the family group, on the lawn, or under the trees. They are standing in the background, but they are clearly visible. The servants are not being depicted in these photographs as family members, but sentiment is being extended toward them as well.

In the Cook family collection, such a photograph exists. The family has arranged itself on the front porch and steps of its country house, expressing its sense of the pleasures of leisure by holding a set of croquet mallets conspicuously in the front row. At the side of the house, almost out of sight around the corner but nevertheless clearly visible as an "outsider within," is the figure of a black man (illus. 3).[21] Whether the interpersonal as well as the ego boundaries were more or less permeable in such a structure would be a matter for debate, but the existence of such images points to at least some ambiguity about where and how to draw the line.

Occasionally, however, a family like the Cooks might choose to make or to purchase individual portraits of their slaves or servants to add to their own accounts or memorabilia. The majority of sentimental domestic images of slaves that I know of come from situations like this. Maybe it was a kind of conspicuous consumption. In any case, with slaves, one need not always worry about drawing the line, since usually the line would be drawn by color. In this particular instance, George Cook was a photographer and could do as he wished, which made the acquisition of such a picture easy. In point of fact, the Cooks—both father and son—were very interested in making photographs of former slaves, and after the Civil War they made a great many images of black life in and around Virginia. These, too, are framed chiefly as sentimental, hu-

3. Cook Collection, Valentine Museum, Richmond, Virginia.

manistic images within the representational codes of the nineteenth-century bourgeois portrait. By and large, the sentimentality in all the Cooks's postslavery images appears on the surface to be well intentioned towards black people and, aside from some egregious counterexamples, such as the figure of a banjo player (illus. 4), they are, at least apparently, generous toward the personalities and human worth of their sitters.[22] The majority of the photographs clearly present themselves as representing the former slaves to be people of dignity, with few or no visible debilitating marks of slavery. In the Cooks's images, in fact, the former slaves appear as bona fide members of the universal "Family of Man." Such images could easily have had a place in Steichen's exhibition.

It is not within the scope of this essay to explore the extent to which this impression of an absence of wounding mystifies the historical relation between the photographic gaze of the Cooks and the former slave population upon whom they trained it. However, I can here at least sketch certain of its ominous associations by referring briefly to the contemporaneous poetry of Benjamin Batchelder Valentine, a close family friend of the Cooks, in whose Richmond mansion, now a museum, the Cook family archive is located. In his book *Ole Marster and Other Verses*, published posthumously in 1921, Valentine makes a sustained apology for slavery and the social order it supported. Here, for instance, are the opening two and closing two stanzas of his poem "The Race Question," a poem about the problem of black employment during and after Reconstruction, which is written, as is most of his poetry, in a black dialect voice:

4. Cook Collection, Valentine Museum, Richmond, Virginia.

When I wuz young de color'd folks
 Wuz 'low'd ter lay de bricks;
Dey climbed de scaffolds, toted hods,
 An' made de mortar mix.

Dey'd handle hammers, saws an' planes,
 An' any tools dey'd choose—
It wan' no folks 'cep' niggers den
 Whar use' ter half-sole shoes.

. .

I 'lows we' settin' up de tree—
 De nigger's on er boom—
But I wan' know whar 'bouts is I
 Gwine git some elbow room.

Er-stydy'n' bout one question, Suh,
 Nigh bu'sts my brain 'jints loose,
"Is niggers now er-cotchin' holt,
 Er is day off de roos'?"[23]

Valentine is arguing that free labor—the northern system—has been an economic disaster for southern "niggers" because it brought about competition for which they were essentially unsuited.

In the opinion of Mary Newton Stanard, who wrote the introduction to *Ole Marster and Other Verses*, "southern negroes brought up by 'Ole Marster' and 'Ole Mistis,' and even descendants of these dear, dark folk who inherited their character, manners, speech and devotion to 'we all's white folks' are rapidly becoming mere tradition, and with them is passing from the American scene something vital, something precious."[24] But Valentine, she writes, who was one of the "white people who were associated with them in a relation unique then and impossible now, whom they loved and served and who loved and served them," was one of the few who "possessed a supreme gift for interpreting them so that through his work they will live always." Stanard knew of this "gift" from her own experience, for Valentine used to give performances in which he impersonated the "faithful colored folk" in dialect verse in his "old and storied Richmond mansion, whose rooms were filled with books and treasures of artistic and sentimental value." To attend a performance of these poems, remembered Stanard, was "an unforgettable experience":

> Under the quaint humor which bubbled on their surface flowed a deep
> current whose echo could be heard in his mellow, lilting voice, for all its
> contagious chuckles, and which could be glimpsed in his expressive eyes
> for all their merry twinkling—showing that with fine imagination, with
> sympathy amounting to genius, he felt at once the picturesque traits of
> his subjects which shallower interpreters are prone to caricature and
> their mental and spiritual processes. Whether or not the philosophy
> which was a marked characteristic of these simple souls was an original
> development or was imbibed from their "white folks" and passed on in in-
> tensified form to their "white folks'" children, is impossible to say, but as
> seen in the work of "Ben Valentine" it is as typical of the interpreter as of
> the interpreted. Each portrait in the gallery which his negro verse com-
> prises is sketched with unerring touch from some point of vantage pecu-
> liar to itself, and the whole thus presents, as nearly complete as could be
> within the bounds so circumscribed, a visualization of a vanishing race.[25]

Thus, the poems published in *Ole Marster and Other Verses* are evidently the texts of the performance pieces that Valentine used to present. It is likely that the Cook family attended "Ben Valentine's" performances in Richmond. Certainly they would have known of them. And probably, part of the interest that the father and son sustained in "taking photography to the back roads" was to present a parallel in photography to the kind of "visualization of a vanishing race" that their friend was producing in dramatic verse. As Valentine's poem "The Race Question" establishes, the purpose of this effort to visualize was to turn back the clock; to force Reconstruction to deconstruct; to argue that slavery was not only harmless, but was also better for the "simple souls" than the freedom that followed.

I would hold, in fact, that this trajectory is why the Cook photographs bear no visible relation to the hardly distant violence of slavery, but allude only to the dignity of their subjects. Such innocent images were much more useful than images of harm would have been for the white supremacist movement that surged throughout Richmond, and all over the South of the Reconstruction era and after, to argue that slavery *did* no violence. But the photograph that George Cook made of the nursemaid punctures this reverie.[26] It is distinct from the rest of the "portrait gallery" because of the intimate nature of its cross-racial subject. The baby, like the domesticity, is his.

The contradiction that the photograph of "a nursemaid and her charge" poses, for critical consideration of a structure of sentimentality like that of the Cooks, is that such a use of photography *within* the private zone of the family runs afoul of a basic sentimental principle. It was clearly articulated by Stowe, Warner, Gilman, and others, that the images of women to be accumulated for the domestic circle—women whose physical presence, by being photographed, would be rendered permanently and intimately familiar to the family—should be images of women of sensibility in its white, middle-class incarnation. The domestic image is a kind of alternative religious testament for the white, middle-class household, and photographs, like paintings, are a way of instructing children. "Pictures hung against the wall, and statuary lodged safely on brackets speak constantly to childish eyes, but are out of reach of childish fingers" wrote Harriet Beecher Stowe,

> They are not like china and crystal, liable to be used and abused by servants; they do not wear out; they are not consumed by moths. The beauty once there is always there; though the mother be ill and in her chamber, she has no fears that she shall find it wrecked and shattered. And this style of beauty, inexpensive as it is, is a means of cultivation. No child is ever stimulated to draw or to read by an Axminster carpet or a carved center-table; but a room surrounded with photographs and pictures and fine casts suggests a thousand inquiries, stimulates the little eye and hand.[27]

The people in such photographs do not have to be kin. As the mid-nineteenth-century cult of collecting celebrity images in cabinet photographs demonstrates, they could be strangers, as long as they were an uplifting influence. Middle-class sensibility was the possession and mark of the moral being of such a person. Images like these, as Stowe put it, were all extensions of the moral function of the middle-class mother.

But a photograph such as this of a servant or a slave could destabilize the comforting economy of this vision, just as it could destabilize the relation of figure to type in the Madonna. Certainly very few of them were made for domestic uses. Photographing the "nursemaid" does not threaten the hegemony

of sentiment, but it can "raise a thousand inquiries," questions that one might not want the child to ask. Unlike the white mother, the black "nursemaid" does not come to possess an inward sensibility by the recreation of her image in the sentimental vein. Despite spending time and money on the photograph, despite accumulating her image in the mode of a member of the family, the Cook family was not displaying the "nursemaid" as a woman, a mother, a person. It was her job to "enhance by contrast," as Harryette Mullen has put it, the maternal power of her mistress.[28]

In the one instance that I have located of a photographic portrait that Cook made of his wife, the ideological framing and mise-en-scène of the figure does contrast with the portrait of the "nursemaid" (illus. 5). Much about the portrait of Mrs. Cook is similar to that of the "nursemaid." She is dressed in a style similar to that of her slave or servant, with a brooch similarly pinned at the meeting place of the two halves of the white collar of her dress. The two young women seem to be about the same age. But unlike the "nursemaid," Mrs. Cook as an individual is the sole focus of the camera, and she wears as if by simple right a wreath of flowers in her hair, a symbol of freshness and natural innocence that was not provided to the "nursemaid." The "nursemaid," by contrast, wears a uniform. The portrait of Mrs. Cook seems, at least to me, to bear the mark of patriarchal protection, in attempting to cast her in an ethereal light. The camera concentrates on the luminosity of her eyes, on the gentle smile that plays

about her lips, and on the way the braid in her hair picks up light like a halo. The figure is different from the family figures on the porch, of whom Mrs. Cook was possibly one, in that its scale and tight focus magnify the impression they give also of a delicate individuality and distinction. It is also different from the figure of the "nursemaid" in that the image of the slave or servant does not offer supplementary signifiers that register her as innocent and fragile womanhood, thus placing her within the bounds of southern patriarchal male protection.

In another of Valentine's poems, entitled "Mammy's Charge,"[29] the figure of the nursemaid is counterposed to that of the mother in such a way that every considerable virtue the nursemaid evinces is literally "outshone" by the fact that the mother has died, gone to heaven, and become a star. In this poem, the little girl's mother has died and a grieving "Mammy" has been given the assignment of keeping the child occupied during the day of the funeral. "Mammy" holds her up before the window, and eventually the child falls asleep in her arms:

> My heart is mos' broke, Judy, an' my haid is achin' bad,
> Dis is de sor'ful's evenin', honey, dat I is ever had.
> Dey knowed I love dat dear sweet chile, an' now her Mummer's daid
> Dey could trus' her ole black mammy fer ter treat her good, dey said.
>
> So dey lef' me in de nu's'ry fer ter keep de chile up dyar,
> But I still culd heah de service, an' de preacher read de pra'r;
> De chile too kotch de singin', an' de tears I had ter hide,
> When, in play she kep' on 'peatin', "O Lord, wid me abide."
>
> When de fune'al it wuz over, an' de hearse wuz driv' away
> I try might'ly fer ter 'muse her, an' ter keep her dyar at play,
> But she 'sist on askin' questions like, "What is my Farver gone?
> I wants ter see my Mummer; will she stay 'way frum me long?"
>
> I cyar' her ter de winder, an' she look' out in de street,
> 'Tel she got so tired waitin' dat she went right fas' asleep;
> But I set dyar in de twilight an' I hel' de little dear,
> 'Tel de street wuz on'y darkness, an' de stars bein' ter 'pear.
>
> Den one star come out, Judy, whar I never sees befo',
> An' I look at it so studdy dat de tears wuz 'bleege ter flow;
> Den I tu'n an' see my darlin', in her sleep, begin ter smile;
> An de new star seem' a-shinin' right down upon de chile."[30]

Despite the tender warmth, care, and sympathy in "Mammy's" gaze, it is clear that benediction comes only from the mother, who is, not coincidentally, "up above." If my comparisons of the two women's photographs are apt, this sort of

enhancement by contrast should also illuminate Cook's portrait of "Mammy's Charge." It was evidently her part in the family to represent the best of earthly care, while her mistress allegorized eternal love, which trumped that earthly care. Note that this is a not unfamiliar role for white women, who, in sentimental structures, show their truest strength when dead.

But photographing the nursemaid threatens to alter the balance of power between these "facts" of sentiment and hidden others. It threatens to give her a social currency that, as an outsider inside the home, she should not have, and also to expose the social conditions under which her labor is naturalized in that home. Therefore, it seems apparent that although the Cooks have allowed the photograph to pass the outward signs of feminine sensibility over her figure—the baby, the Madonna-like pose, the domestic reference, indeed almost all of the chief technologies of gender—they used them as a caul, rather than as signs of human relation. And for the young woman portrayed within this extension of domestic representation, being rendered with visible sentiment just makes her social personhood more invisible than ever. The portrait is, in Hortense Spiller's words, a "violent jamming, two things enforced together in the same instance, a merciless, unchosen result of the coupling of one into an alien culture that yet withholds its patronym."[31] As a nursemaid, she might really teach the baby; but as an image, she must have less meaning than a piece of furniture.

This reification is apparent in the subsequent history of the Cook family photograph. Putting her in their photograph seems to have been almost like hiding her in plain sight. The Cooks themselves could not have bothered to read the complicated body language and facial expression of the nursemaid in the photograph in their midst; or reading it, they could not have lent it even the remotest capacity to signify. Otherwise the photograph, coded as a sentimental family memento of her faithful devotion, must have acquired a more problematic meaning than its history as a cherished keepsake of the family would allow. Arguably, it is as much an image of the violation of her social personhood as are the more infamous Zealey daguerreotypes of Delia, Renty, and Jack; and it is as eloquent a record of the social relations that grew out of slavery.[32] The photograph of the teenaged, barebreasted Delia was given by a South Carolina slaveholder to Professor Louis Aggassiz of Harvard University to help him to "study anatomical details of 'the African race'" in order to "prove" his theory that blacks were a distinct species, separately created. Harryette Mullen writes of Delia,

> History preserves only the picture of her body, photographed as a "scientific" exhibit. Prefiguring the critique of bourgeois power/knowledge monopolized by privileged white males, represented by private tutors who serve the slaveholding elite in Williams' *Dessa Rose*, Morrison's *Beloved*, and Johnson's *Oxherding Tales*, are the historical encounters of

slave women with white men of science: Dr. James Norcum ("Dr Flint" in Jacobs's narrative), who instructed his slave that she had been "made for his use"; Dr. Strain, who desired visual proof of Sojourner Truth's sex, viewing the self-empowered blackwoman as a freak; and Professor Louis Agassiz, who conceived a project in which the illusory immediacy of the subjugated image would provide seemingly irrefutable proof of African inferiority through a photographic display of black bodies, a project in which racial and sexual differences were to be read as perceptible evidence of inferiority.[33]

For Mullen, Agassiz's "coercive recording of her bare-breasted image leaves her silent, underscoring Delia's materiality as 'property,' and 'exhibit,' as 'scientific evidence,' a unit of data within a master discourse controlled by white men, bent on denying her subjectivity . . . But what is most at stake . . . for me is that something of Delia [in the expression of her eyes] escapes or at least challenges the subjugating gaze that holds her body captive."[34]

Similarly, what is at stake for me, in the photograph of the "nursemaid and her charge" is that there seems to be something in her body language that "escapes or at least challenges the subjugating gaze that holds her body captive." The compelling visual pattern of the striped dress is uncannily like a subliminal message to the viewer to "read between the lines." If the white cloth at the bottom of the frame, which a viewer easily could have processed at first as a single, vague entity, were earlier interpreted entirely as the infant's dress, it will now resolve itself assertively into two distinct shapes—the apron that designates a servant/slave as well as the clothing of the child. The cloth across the young woman's left shoulder, something any mother or nanny might use in a multitude of ways to protect and shelter and swaddle the baby and herself, comes to appear as much a curtain separating the two as it does the implement of any ritual of care or bonding. As one looks more closely, it becomes apparent that the cloth covers unnaturally and entirely her left arm and hand; in fact, it has been arranged or flung upon her much as if she were a chair or some other piece of upholstery, so as to set off the baby's head against a dark solid surface that corrects for the photographically busy background of the eloquent striped dress. Evidently it was important that the baby's individuality come through sharply in this portrait; and for this purpose, the woman is merely the setting, the not-quite-perfect background that needed to be improved. But her body language suggests that she comprehends this expediency and that she resents it, for she makes no effort to hold or cradle the baby, but merely suffers him to be balanced upright and exhibited to the camera as he waves his arm in the crook of her exaggeratedly extended elbow.[35]

I think that there is an additional layer of meaning encoded in this image of the "nursemaid and her charge" that I have not been able to establish on any

historical grounds. Nevertheless, it seems appropriate to say that nursemaids nurse babies, that in order to nurse a baby one must have recently borne a baby oneself, and that therefore the visible presence of Heustis Cook in the image may erase the presence of the "nursemaid's" own baby, who remains invisible. What the social relationships were that surrounded *that* baby, if it existed, are impossible to tell.[36]

The Cooks weren't the only ones who refused to read this photograph. Although the "nursemaid and her charge" has three times recently been reprinted in widely read books on African-American history, including two feminist books—in Norman Yetman's *Voices from Slavery*; in Dorothy Sterling's *We Are Your Sisters*, and in Jacqueline Jones's *Labor of Love, Labor of Sorrow*—it has never yet drawn a critical glance beyond Norman Yetman's general assessment that the "nursemaid's" image, like all the images in the Cook collection, is "sensitive . . . honest . . . [and] forthright," and that "a quality exists in each of them that marks them as an interesting composition and a work of art in their own right."[37] Furthermore, each time it has been reprinted, the photograph has been rendered outside of the context of its production. What does this continuing anekphrasis tell us about the allegiances of our critical institutions, which have, since slavery, continued to govern the interpretation of the photographic gaze? Does seeing nineteenth-century middle-class "sentiment," that critical turn that has been so vitally important for the establishment of a feminist standpoint in literary criticism, actually function as a mechanism of displacement, ensuring that other sentiments will not be seen?

It is commonly alleged that photography was a democratic medium, one that made portraits available "to the millions." Yet, as Jeanne Moutoussamy-Ashe has pointed out, "if indeed photography was a 'democratic art,' then it was so only to the extent that those who used the process were free to express themselves. If slaves were allowed to be creative, they were only to be creative in their menial labors, such as carpentry and basketry work for their slave owners."[38] The ability to express themselves was severely restricted in the most basic of ways. Although Deborah Willis, former Curator of photographs and prints for the New York Public Library's Schomburg Center for Research in Black Culture, and now at the Smithsonian Institution, has ascertained that several hundred African-American photographers were working throughout the United States from 1840 to 1940, most of them were free men and women. Scholars generally agree on prices of an individual studio portrait of top quality that would have placed them beyond the personal resources of almost any mid-century Southern slave. It is fair to say that slaves did not generally make their own photographs or have studio photographs made of themselves, unless it was at the behest and with the money of their masters. This meant that virtually any slave's photograph could be used to serve the discourse of the masters,

and that the slave's self-expression in photography would be in the mode of subversion, like the self-expression of the "nursemaid."

This is not democracy. Against the sheer weight of the accumulated valor-ization of images of the white family, and against the fact that the white family was virtually the only context in which the "nursemaid" would have a portrait made, the requirement that visible subversion be coded inside of sentiment made it functionally invisible. Nor could self-knowledge and self-assurance be gained from the photographic image as it was gained by the whites, because considering how it was made, the image could not be trusted. In fact, slave owners even used photographs of the slave family to try to increase their psychological domination. Moutoussamy-Ashe reports a rare correspondence between Louisa Piquet, born a slave, and her slave mother, Elizabeth Ram-sey.[39] The story is told in full by Louisa Piquet herself, in the slave narrative she dictated to the Reverend Mr. Mattison of the A.M.E. Church.[40] Elizabeth Ramsey and her daughter Louisa had been separated since Louisa was four-teen, and in this correspondence they are sending photographic portraits to one another. They communicated with the permission of their masters, through letters actually written by others.[41]

Evidently, even these rare photographic tokens of the sentiment of slaves—precisely because they *were* tokens of sentiment—were made into vehicles for the master's allegations that the family life that he provided in slavery for Eliz-abeth Ramsey was superior to the condition of free black people. Therefore, although Louisa Piquet has finally obtained photographs of her mother and brother, she cannot learn of their true condition from looking at the images. Like wartime propaganda, these images are thoroughly suspect. The pull on the heartstrings, the longing they provoke for mother and home, those senti-mental staples, are used here with the calculating malevolence of a man who wishes receipt of the photographs to destroy even the small sense of security that they dangle. Louisa's experience of photography is not separable from the social system in which it was embedded. For her, the camera is no "spirit of fact," no "unimpeachable witness."

4

In 1864, writing in his popular manual *The Camera and the Pencil*, Marcus Au-relius Root observed of photography the usual things, that:

> By heliography, our loved ones, dead or distant; our friends and acquain-tances, however far removed, are retained within daily and hourly vision. To what extent domestic and social affections and sentiments are con-served and perpetrated by these "shadows" of the loved and valued origi-

nals, every one may judge. The cheapness of these pictures brings them within reach, substantially, of all.

In this competitious and selfish world of ours, whatever tends to vivify and strengthen the social feelings should be hailed as a benediction. With these literal transcriptions of features and forms, once dear to us, ever at hand, we are scarcely more likely to forget, or grow cold to their originals, than we should in their presence. How can we exaggerate the value of an art which produces effects like these?[42]

This was the sentimental axiom.

But Oliver Wendell Holmes was much closer to the mark, although perhaps inadvertently, when, celebrating the discovery of photography, he called photographs "the social currency, the sentimental 'green-backs' of civilization."[43] In a social order that was structured by fundamental racial and sexual inequality, and increasingly maintained by the cynical or self-deluded manipulation of affect, the exchange of photographs that helped to cement the regime of sentiment—and with it the triadic system of kinship, conquest, and incorporation that it sponsored—could became the very triage point of human status. Like the currency of money, or the currency of freedom, it is the conditions for the circulation of one's image, and not the image itself—as we learned again just recently with the televiewing of Anita Hill—that will cast individuals either onto the shore of social protection through representation, or into the void.

Photography has always been a constitutive force, not merely reflecting but actively determining the social spaces in which we live our lives. The narratives we make about photography, relating image to image, and to other cultural forms, have helped to shape our current violent predicaments of race, class, and gender. Were she writing it now, Gisele Freund's pioneering work on *Photography and Society* would need to be recast: photography *is* society; they are not distinct. As a social institution, American photography commemorates a popular struggle to envision—and the struggle to be visible in—a modus vivendi for American lives. The right to see and be seen, in one's own way and under one's own terms, has been the point of contention.

But, impressive as is this capacity to envision lives, American photography has also had a capacity to destroy them. Photography has always been an enforcer, with the power to make certain things invisible just as surely as it has made other things visible. It behooves us now to learn just how this differentiating function of photography has proceeded, so as to loosen its grip on the continuing production of democratic signs and cultures. We must seek out the cognitive appropriation of the Real. The moral positivist's "mirror with a memory," in the nineteenth century, must become the historian's "memory with a mirror," in the twentieth.

"The reading of a photograph is always historical," wrote Roland Barthes. "It depends on the reader's 'knowledge,' just as if this were a matter of a real language, intelligible only if one has learned its signs."[44] "To articulate the past historically," wrote Walter Benjamin, "does not mean to recognize it 'the way it really was.' It means to seize hold of a memory as it flashes up at a moment of danger. Every image of the past that is not recognized by the present as one of its concerns threatens to disappear irretrievably."[45] But what do they mean by history?

For Barthes, a historical reading calls upon a fund of knowledge about the past. In looking at a photograph, Barthes is interested in reading signs of the way things were. He is a linguist, a translator. He translates the meaning of the image from knowing of its past. But for Benjamin, all knowledge is in the present, about the present. The only reason that Benjamin wants to remember the way things were is to help in a present emergency. Benjamin's term, to "articulate" is a pun. To "articulate the past historically" is to speak about history, but it is also to mesh the past and the present into the future, as the wheels of one gear articulate with the next. To "articulate the past historically" is to aid in the birth of the new.

If we have learned in recent years from Barthes and from feminism to do close analysis of photographs, we must learn from Benjamin what for. Surely, it is not the record of the past as it is simply illustrated in photographs, an inert collage of the way things were, a past that accepts the fiction of being over, that is the most important thing about our reading of photographs. Nor is it the past that photography has brought to bear on and in itself, as in the history of the medium.

Instead, the photographic past that ought now to be among our most urgent concerns is the remembrance that photography has helped to shape our current violent predicaments of race, class, gender. "We would argue," write Patricia Holland, Jo Spence, and Simon Watney, that:

> what is often described as racial difference, as a gulf between black and white similar to that between male and female, is better described as a construction of "otherness." Photography has played an important role in identifying people who are not like "us," who become the bearers of all those qualities which "we" find unfamiliar and unacceptable—from the violent and disorderly to the exotic and the quaint. This is the tradition of the representation of "inferior" groups which has evolved within the history of colonialism and imperialism, and which feeds and sustains contemporary racism. A politics of anti-racism takes on these issues within the social structure and within the realm of representation.[46]

In other words, since the middle of the nineteenth century, the kind of sentimentality that is the seeing-sentiment has served as one of imperialism's many and least innocent eyes.

Notes

Another version of this essay appeared in *Female Subjects in Black and White: Race, Psychoanalysis, Feminism,* ed. Elizabeth Abel, Barbara Christian, Helene Moglen (Berkeley: University of California Press, 1997).

1. Roland Barthes, *Camera Lucida: Reflections on Photography,* trans. Richard Howard (New York: Hill and Wang, 1981), 26–27.

2. My philosophical position here is informed by Donna Haraway's discussion of partial perspectives in "Situated Knowledges: The Science Question in Feminism and the Privilege of Partial Perspective," *Feminist Studies* 14, no. 3 (1988): 575–99; by the analysis of standpoint theory in Sandra Harding, *The Science Question in Feminism* (Ithaca: Cornell University Press, 1986), and Sandra Harding, *Whose Science? Whose Knowledge:* (Ithaca: Cornell University Press, 1991); by Michel Foucault's discussion of "subjugated knowledges" in *Power/Knowledge: Selected Interviews and Other Writings,* ed. Colin Gordon, trans. Colin Gordon, Leo Marshall, Jon Mepham, Kate Soper (New York: Pantheon Books, 1972); and by Patricia Hill Collins in *Black Feminist Thought: Knowledge, Consciousness, and the Politics of Empowerment* (Boston: Unwin Hyman, 1990).

3. Bryan Wolf, "Confessions of a Closet Ekphrastic," *Yale Journal of Criticism* 3, no. 2 (Spring 1990): 185.

4. John Updike, *Just Looking: Essays on Art* (New York: Knopf, 1989).

5. See Serge Guilbaut, *How New York Stole the Idea of Modern Art: Abstract Expression, Freedom, and the Cold War* (Chicago: University of Chicago Press, 1983); and Christopher Phillips, "The Judgement Seat of Photography," in *The Contest of Meaning: Critical Histories of Photography,* ed. Richard Bolton (Cambridge: MIT Press, 1989), 14–47. See also Edward Steichen, *The Family of Man* (New York: The Museum of Modern Art, 1955), and Roland Barthes's classic deconstruction of it, "The Great Family of Man," in *Mythologies* (Paris: Editions du Seuil, 1957), 100–102.

6. Alan Trachtenberg has been the chief and most persuasive advocate for the necessity and the difficulty of reading photographs. In his most recent book, *Reading American Photographs: Images as History, Mathew Brady to Walker Evans* (New York: Hill and Wang, 1989), Trachtenberg argues a social constructionist position for photographs as documents of American cultural history: "Just as the meaning of the past is the prerogative of the present to invent and choose, the meaning of an image does not come intact and whole. Indeed, what empowers an image to represent history is not just what it shows but the struggle for meaning we undergo before it, a struggle analogous to the historian's effort to shape an intelligible and usable past" (xvii). The politically nuanced attention that Trachtenberg is advocating as "reading" should not be confused with formalism.

7. An excellent discussion of the pitfalls of a merely additive conceptualization of oppression may be found in Elizabeth Spelman, "Theories of Race and Gender: The Erasure of Black Women," *Quest* 5, no. 4 (1982): 36–62. See also Spelman, *Inessential Woman: Problems of Exclusion in Feminist Thought* (Boston: Beacon, 1988).

8. Jane Tompkins's *Sensational Designs: The Cultural Work of American Fiction, 1790–1860* (New York: Oxford University Press, 1985) is the outstanding example of this critical thrust.

9. The photographs I am analyzing in this essay may be found in the George Cook Collection of the Valentine Museum in Richmond, Virginia. The "nursemaid and her charge" has often been reprinted, but there are hundreds of unpublished images of George and Heustis Cook extant in this archive. I want to take this opportunity to thank the staff of the Valentine Museum for its help and cooperation, and especially Barbara Batson, John Fachman and Teresa Roane for their generous responses to my requests.

10. Julia Kristeva, "Motherhood According to Bellini," in *Desire in Language*, trans. Leon S. Roudiez (New York: Columbia University Press, 1980), 243.

11. Ibid., 241, 247.

12. Norman Yetman, *Voices from Slavery* (New York: Holt, Rinehart and Winston, 1970), n.p.

13. From *Covered Wagon Days*, n.d., in Robert Taft, *Photography and The American Scene* (New York: Dover, 1964), 138.

14. The *locus classicus*, and still one of the best discussions of this process is Roland Barthes, "Myth Today," in *Mythologies*, 109–59.

15. Patricia Holland, Jo Spence, and Simon Watney, *Photography/Politics: Two* (London: Comedia Publishing Group, 1986), 2.

16. Griselda Pollock, "What's Wrong with 'Images of Women'?" *Screen Education*, no. 24 (1977): 25–33.

17. Richard Brodhead's discussion of the function of domestic fiction in the consolidation of the early nineteenth-century bourgeois family offers an illuminating, and substantially parallel, example of the "cultural work" (Jane Tompkins's term) accomplished by sentimental cultural products. See Richard Brodhead, "Sparing the Rod: Discipline and Fiction in Antebellum America," in *Representations* 21 (Winter 1988): 67–96.

18. Philip Fisher, *Hard Facts: Setting and Forming in the American Novel* (New York: Oxford University Press, 1985).

19. Gillian Brown, *Domestic Individualism: Imaging Self in Nineteenth-Century America* (Berkeley: University of California Press, 1990).

20. This statement should not be taken to imply that there were no black photographers or photographs of black families. Quite the contrary. As Angela Davis has written in *Women, Culture, Politics* (New York: Vintage Books, 1990):

> Many will find it astonishing that Black people became involved in photography shortly after the invention of the daguerreotype: Jules Lion, who became acquainted with this process in France, may well have introduced it to the city of New Orleans. But, then, how many prominent scientists, scholars, and artists have been banished from historical records for no other reason than their racial heritage, only to be revealed, shamefully late, as outstanding contributors in their fields? Jules Lion, Robert Duncanson and J. P. Ball ought not now to evoke new responses of surprise. Rather they should be celebrated as evidence of what knowledgeable persons should have strongly suspected all along. Yes, Black photographers were active during the very earliest stages of their medium's history. Granted, they were but a few, for slavery imposed a historical prohibition on virtually all forms of open aesthetic creation; only music, misunderstood as it was by the slaveocracy, was permitted to flourish. But what about the untapped artistic potential of those millions

of slaves? Do we dare imagine how many pioneering Black photographers there might have been had more favorable socioeconomic circumstances prevailed? (221)

Deborah Willis, Valencia Hollins Coar, and Jeanne Moutoussamy-Ashe have published the major works to date on the history of black photography in the nineteenth century, and a great deal more research is currently underway. See Deborah Willis, *Black Photographers 1840–1940: A Bio-Bibliography* (New York: Garland Publishing, 1985); Deborah Willis, *Early Black Photographers 1849–1940*, with the Schomburg Center for Research in Black Culture (New York: The New Press, 1992); Deborah Willis, *Picturing Us: African American Identity in Photography* (New York: The New Press, 1994); Valencia Hollins Coar, *A Century of Black Photographers 1840–1960* (Providence: Rhode Island School of Design, 1983); Jeanne Moutoussamy-Ashe, *Viewfinders: Black Women Photographers* (New York: Dodd, Mead & Company, 1986); and Willis's essay in this volume.

21. *Outsider-within* is the term Patricia Hill Collins uses to designate the social position of the black woman domestic worker in white families. I have here extended it to apply as well to the social position of the black man connected with the Cook family. See discussion in Patricia Hill Collins, *Black Feminist Thought*, 10–13.

22. For an excellent account of the complex implications of the banjo player portrait, see Eric Lott, "Love and Theft: The Racial Unconscious of Blackface Minstrelsy," in *Representations* 39 (Summer 1992): 23–50; and Eric Lott, *Love and Theft: Blackface Minstrelsy and the American Working Class* (New York: Oxford University Press, 1993).

23. Benjamin Batchelder Valentine, *Ole Marster and Other Verses* (Richmond, Va.: Whittet and Shepperson, 1921), 60–63.

24. Mary Newton Stanard, "Forward," in Valentine, *Ole Marster and Other Verses*, n.p.

25. Ibid.

26. I am using the term *puncture* here in accordance with Roland Barthes's account of the *punctum* in *Camera Lucida*. I differ from Barthes, however, in that the *punctum* he seeks is a purely private sensation, whereas my notion of the *punctum* includes as well the registration of ideological rupture, like puncturing a balloon in front of one's face that has kept one from seeing where one really is.

27. Harriet Beecher Stowe, *House and Home Papers* (Boston: Houghton Mifflin, 1896), quoted in Lynn Wardley, "Relic, Fetish, Femmage: The Aesthetics of Sentiment in the Work of Stowe," *The Yale Journal of Criticism* 5, no. 3 (Fall 1992): 80.

28. See Harryette Mullen, "'Indelicate Subjects: African American Women's Subjugated Subjectivity," in *Sub/Versions: Feminist Studies* (Santa Cruz: University of California Press, 1991).

29. Benjamin Batchelder Valentine, "Mammy's Charge," in *Ole Marster and Other Verses*, 56–57.

30. Ibid.

31. The source of the Spillers quotation is the paper she presented at the "Psychoanalysis in African-American Contexts: Feminist Reconfigurations" conference at Santa Cruz, October 1992. The paper was entitled "All the Things You Could Be By Now if Sigmund Freud's Wife Was Your Mother." When Spillers later published that essay, in *Female Subjects in Black and White: Race, Psychoanalysis, Feminism*, ed. Elizabeth Abel,

Barbara Christian, Helene Moglen (Berkeley: University of California Press, 1997), this language disappeared.

32. Alan Trachtenberg published several of these photographs in *Reading American Photographs*, along with an extensive discussion of them. Some are also published in Melissa Banta and Curtis M. Hinsley, *From Site to Sight: Anthropology, Photography, and the Power of Imagery* (Cambridge: Peabody Museum Press), 1986. They are also discussed in Jeanne Moutoussamy-Ashe, *Viewfinders*, 5.

33. Harryette Mullen, "Indelicate Subjects."

34. Ibid.

35. This reading accords with the assessment by Barbara Christian of the mammy figure in slave narratives that "unlike the white southern image of mammy, she is cunning, prone to poisoning her master, and not at all content with her lot." Barbara Christian, *Black Feminist Criticism, Perspectives on Black Women Writers* (New York: Pergamon, 1985), 5. See also Trudier Harris, *From Mammies to Militants* (Philadelphia: Temple University Press, 1982); and Patricia Hill Collins, "Mammies, Matriarchs, and Other Controlling Images," in *Black Feminist Thought*, 4–90. But I also want to add a cautionary note to the idea I am suggesting that resistance to the master discourse may be legible in the body language and discursive signs of the photograph. This is what I believe, but I believe it tentatively, or, as Jacques Derrida has put it, *sous rature*. As both Carla Kaplan and Franny Nudelman have recently argued, the assignation by a would-be "emancipatory reader" of a language of resistance to individuals who are placed in situations of domination and oppression is a complex wish, and such an assignation, when it is merely projection, may be a subtle form of "othering." See Carla Kaplan, "Narrative Contracts and Emancipatory Readers," *Yale Journal of Criticism* 6, no. 1 (Spring 1993): 93–119, and Franny Nudelman, "Harriet Jacobs and the Sentimental Politics of Female Suffering," ELH 59 (1992): 939–64. On the other hand, to refuse to read such a language is also to objectify. My exertion, in this essay, has been to contextualize the photograph historically in ways that I think make it possible to support a disruptive reading of the signs of both the domination and resistance that I see. However, my major "emancipatory" effort here is directed not toward the woman in the photograph, whom I do not know, nor toward the position of people she represents, which would be presumptuous, but toward a broader discussion of the social role of photography under conditions of social inequality and radical disempowerment, such as slavery, or immediate postslavery "reconstruction" life. This is a discussion that has been seriously distorted, I believe, by "sentiment."

36. Gabrielle Foreman first pointed out to me the possible link between a "nursemaid," nursing, and the invisible presence of a child of her own.

37. Norman Yetman, *Voices from Slavery*, n.p.

38. Jeanne Moutoussamy-Ashe, *Viewfinders*, 7.

39. Ibid., 6–7.

40. Rev. H. Mattison, A.M.E., *Louisa Piquet, the Octaroon: A Tale of Southern Slave Life* (1861), reprinted in *Collected Black Women's Narratives*, ed. Anthony Barthelemy (New York: Oxford University Press, 1988). For invaluable commentary on the Piquet narrative and an analysis of the response of Louisa to the "male gaze," see Gabrielle Foreman, "Who's Your Mama? Louisa Piquet and White 'Mulatta Genealogies'" (paper presented at the Nineteenth-Century American Women Writers in the Twenty-

First Century conference, Harriet Beecher Stowe Center and Trinity College, Hartford, Conn., June, 1996).

41. This correspondence is quoted in Jeanne Moutoussamy-Ashe, *Viewfinders*, 6–7, and in Mattison, *Louisa Piquet, the Octaroon*, 31, 34, 35. It is cited on pp. 115–16 in this volume.

42. Marcus Aurelius Root, *The Camera and the Pencil* (Pawlet, Vt.: Helios, 1971), 26–27.

43. Oliver Wendell Holmes, quoted in Robert Taft, *Photography and the American Scene*, 143.

44. Roland Barthes, *Image-Music-Text*, trans. Stephen Heath (New York: Hill and Wang, 1977), 28.

45. Walter Benjamin, "Theses on the Philosophy of History," in *Illuminations*, ed. Hannah Arendt (New York: Schocken Books, 1973), 255.

46. Patricia Holland, Jo Spence, and Simon Watney, *Photography/Politics: Two*, 7.

Black Bodies in Evidence:
Maternal Visibility in Renée Cox's
Family Portraits

Andrea Liss

The woman is pictured in a state of tenderness, solemnity, and service. She is graceful, stabilizing, foundational. Her name, however, remains unknown to us. "Slave" is the name they gave her. Labeling the photograph "slave and child" rather than "woman and child" places the woman in a subhuman category outside the normal interpersonal relations designated by "man, woman, and child." This woman's historical inscription of servitude survives in the photograph's contemporary caption. The young girl, too, swathed in all her white finery, goes unnamed. But "child" is an echo of the privilege, legitimacy, and sexuality this young girl would later carry. The slave holds the child. That's one way of putting it. The nurse-nanny carries her charge, this stilled young girl. Granting more mutual affection to this forced couple, we could call the photograph "mammy and child," as remarkable portraits such as this one are more commonly if not euphemistically named. Yet "mammy" gets closer to the maternal caress with which the woman encircles and protects the child. Her steady, graceful hands sway the girl into becoming the photograph's subject, while the mammy looks down and holds herself within the frame as its subjugated object. The girl's centrality is emphasized by the blinding whiteness and floating expansiveness of her dress, which contrasts sharply with the mammy's tight-fitting and grid-patterned garb that cloaks and imprisons her. The mammy's hands and face fade almost imperceptibly into the photographer's backdrop. Indeed, she is visible merely as background in this alienating domestic scene. The anonymous intimacy of this photographic set-up scorches us with the devastating proportions of its legacy[1] (illus. 1).

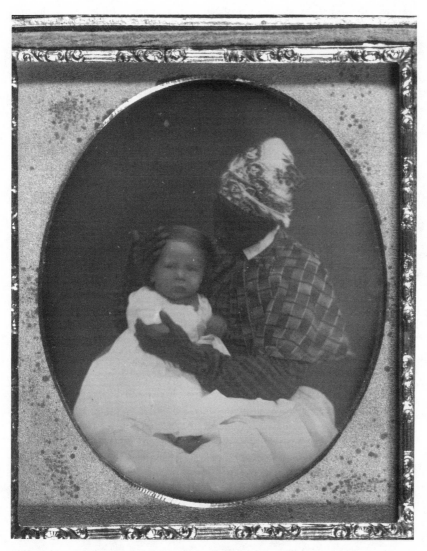

1. *Slave and Child*, 1848. Sixth-plate daguerrotype by R. G. Montgomery, Jackie Napolean Wilson Collection. Reprinted by the permission of Russell & Volkening as agents for the author. Photograph courtesy of the J. Paul Getty Museum.

I am drawn to mammy and child portraits in part because of how power-fully feelings of tenderness and care accrue around such photographs that are themselves enveloped in the most cruel fiction of domestic bliss. Born into her role as enforced surrogate mother of her owner's white children, the slave as mother represents the most severe form of oppression and servitude. If the fig-ure of the mother in Western patriarchal culture already stands in for extreme passivity and devalued love, the mammy is the doubled icon of sacrifice.[2]

Mammy and child double portraits are perhaps the most complex and dis-turbing images from the antebellum period precisely because the women are pictured in the material presence and repressed evidence of their bondage. The woman/slave and the child are photographed seemingly worlds apart from the male arena of commerce and violence that are absent in the portrait, yet which propel them nevertheless. The mammy was the woman entrusted with the care of her master's most precious commodities, his children. Thus, such portraits initially functioned to honor the children pictured, and to bolster their father's and mother's status as well as the horrific patriarchy of slavery. In most cases, mammies were not permitted a legitimate biological family of their own, since it was believed that they would not be able to perform their "domestic duties" in addition to their own maternal work. No wonder domes-ticity still rings with the echoes of slavery. More insidiously, beyond the mere economy of the master/slave relationship, the recognition that the woman had a family of her own would have been too revolutionary because it would have granted her human status. Thus her children, property in the slave owners' eyes, were as a rule wrenched from her and sold off like cattle.

We can only guess today that the tenderness given by these women to their owners' children was a complex and despairing blend of love and resistance. Their stories are largely silenced within the fetishized, locket-like daguerreo-types that contain their images.[3] It is impossible to look at these portraits with-out wondering what psychic strategies the women created to survive the vio-lence of their institutionalized lives and to summon the strength to maintain some form of autonomy over their owners' control. Toni Morrison's character Sethe in her novel *Beloved* comes to mind. Although she was not a mammy, Sethe was a slave who killed her own baby daughter in an act of infanticide both desperate and monumentally brave. It saved her daughter from the hor-rors of slavery that she herself endured.[4] Even though slavery is abolished today, the psychic knots that keep racism alive have yet to be severed. Let's re-member that in a wholly different contemporary infanticide case, Susan Smith conjured up a black "boogeyman" as her maternal alibi.

Indeed, with the specter of the willful, to-be-tamed black male behind every image of his domesticated female other, it hardly seems possible that these tranquil "family" scenes could remain contained within their diminutive frames. Collected by the plantation owners as cherished mementos cloaked in greed and delusions of superiority, these coy memories of things past are

plagued by posthumous questions. What kinds of tricky double meanings did such mammy and child portraits generate for the woman/slave and how did they resonate differently for the slave owner, his wife, and their child(ren) as they grew up? What sorts of perversions and substitutions did these startling images stand in for? If I allow myself a vulgar reading of the particular double portrait before us, these questions are underlined when we consider the dark concave shape traced out in the foreground by the girl's foot. Embedded as it is in the girl's fluffy finery, it also appears to be the shape of a vulva as it mimes the place where the black woman's genitals would be.

The complex cultural and psychic meanings of such double portraits beg the very existence of the family photograph, which is usually taken for granted. However when a people's family and cultural history is marked by violation, disruption, and erasure, no such recorded visual lineage or ownership of those memories can be assumed. Seemingly honorific family portraits taken before and during the Civil War bear out the familial tear in the legacy of African-American history. This tear is most severe in family portraits in which the mammy is pictured. Indeed, mammy and child portraits reveal the ideological fissures in traditional notions of sentimentality and domesticity, the very notions that have upheld the supposedly serene surface of family photographs. Few family portraits in the history of photography bear such potent witness to the travesties of domesticity, motherhood, and ownership.

Renée Cox's *Yo' Mama* (1993) mother-and-child portrait, part of the larger photographic series by this Jamaican-born and Scarsdale-raised artist, radically transforms the pictorial legacy of slavery and maternity (illus 2). Working against both the historical imprisonments of black women and the patriarchal clichés of mothers as self-enclosed and passive, Cox offers a complex representation that is at once bold and contemplative. Her black emblazoned body emerges from the Rembrandtesque darkness behind her, while she holds her infant son's lighter body in an ambivalent gesture that both offers him to the world and protects him. His dark hair merges with the blackness of infinity that envelopes him, as he stands out against his maternal bearer. The oscillation in Cox's hold on her son is reflected in the ambiguous relationship set up between her piercing expression and her frontal nude self-representation. Her gaze is focused down at the viewer; menacing, taunting, daunting. Yet, contradicting her bold projection of self, her expression seems reserved, almost sad. Cox's ambivalent expression challenges the viewer to survey her Superwoman nakedness, which merges androgynous sensuality with distinctly feminine signs of sexuality. The provocative black high heels she wears seem an organic part of her statuesque power. The viewer may need several encounters with this complex photograph to reconcile its dramatically unconventional and seemingly contradictory projections of woman as mother. This is hardly a traditional

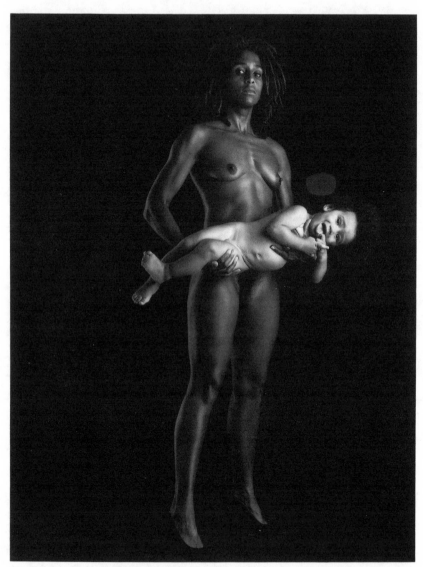

2. Renée Cox, *Yo' Mama*, silver gelatin print, 1993.

Madonna and Child image from the long repertoire of Western art and cultural history. This is a genre scene of a wholly different kind. Indeed, this double portrait is a heightened scene from contemporary everyday life in the process of birthing new images of mothers by choice, of black mothers breaching new possibilities for merging maternity, sexuality, and work.

The photograph is huge in stature, measuring in at over eight feet tall. Cox also elaborately framed her self- and family portrait, granting it the status of a precious and valued heirloom. Her control of the image, both within it as implacable presence and outside of it through the caress of embellishment on its frame, signals confidence in proper ownership and the trust in future generations that is implied in the passing down of an heirloom. By dramatically enlarging the scale of the traditional family portrait and wedding its physical power with its strategic adornment, Cox issues a call and response back to the small, jewel-like mammy and child daguerreotype portraits. Her contemporary portrait explodes the myth of domestic bliss embedded in the mismatched nineteenth-century "family" portraits and bestows black mothers with renewed value and respect. Cox's redefined family portrait is monumental not only in its scale, but in its historical proportions. In 1998, well over one hundred years since the abolition of slavery and four decades since the beginning of the civil rights movement, it is still no easy task to create images that work against mutual exclusivities and open up the conception of black women as sexual and as mothers on their own terms. Let alone to live these complexities without taboo. Through Cox's vigilance, *Yo' Mama* works against keeping the figure of the mother in her assigned place.

"You're what . . . !" was the response Cox received from many of her fellow students at the Whitney Museum of American Art Graduate Studies Program in New York City when she shared the news of her *second* pregnancy. Cox was the first woman in the program within a quarter of a century to become a mother. As if pregnancy were a disease in the art world, a disease that rots our all-too-female bodies and extracts energy from our wanna-be male creative minds. In a rare public forum confronting the taboo of motherhood in the art world, Susan Bee and Mira Schor posed a set of questions to a diverse group of women artists who are mothers. Among the startling responses they received, none was more disturbing than the following: "[T]he subject proved too painful for some artists who couldn't write responses. More than one artist wondered how we'd found out that she *had* a child, so separate had children been kept from art world life."[5] And, as artist Joan Snyder put it, "The bottom line is that you don't have to be a mother or a daughter to be discriminated against in the art world . . . you just have to be a woman."[6]

One wonders therefore whether, albeit unconsciously, restrictive perceptions of motherhood were not also working in tandem with racism in the responses to Cox's pregnancy announcement. As feminist legal scholar Patricia J. Williams puts it:

Most Americans still believe that blacks are having more than their fair share of babies, that blacks account for more welfare recipients . . . that women have babies on purpose, just to get welfare checks . . . Blacks, even black children, are treated at every level like an abomination against nature, a mistake in the scheme of things, a deviance denied in hyperdefensive, warring terms.[7]

Cox's *Yo' Mama* photographic response to such limited thinking and repressive stereotyping brings to mind former slave, mother of four (three of whom were sold off into slavery), and abolitionist Sojourner Truth's eloquent challenge. A gifted speaker with a powerful public presence, Truth was often heckled by her audiences who sometimes threw eggs and stones at her. Small children even taunted her, calling her "nigger witch." In one infamous case, using the excuse of her tall stature and deep voice, her audience tried to silence her by accusing her of being a man disguised as a woman. She riveted her audience by baring her breast, declaring, "It is not my shame but yours that I do this." Soon after, in 1852, in another case of protest against her, Truth was finally allowed to address a women's rights meeting in Akron, Ohio. Incorporating her previous audience's attempt to degrade her into a strategic defiance, this time Truth countered her taunters with the now-famous line, "Ain't I a woman?"[8]

Cox's *Yo' Mama, The Statue* (1993) (illus. 3), is another powerful contemporary reverberation of Truth's brilliant double-edged response to the censoring of her race and sexuality. In this case, Cox's sculpture and photographs were directed not toward an antagonistic stranger, but toward an intimate relation. During the advanced stages of her pregnancy, Cox's husband told her he was not attracted to her and declined interest in her sexual invitations.[9] For many women, this denial of our erotic pregnant selves by the men who made it happen is like spiritual rape. One private incident of punishment by refusal—the pregnant woman was acting out of place—signals the larger patriarchal repression of maternal erotics and desire. Cox took the personal into the public arena and responded to the censoring of her sensuality by making a white plaster cast from her own pregnant body, which she then incorporated into several double self-portraits. The one pictured here is especially arresting. It merges a stable, calm defiance directed outward with a tenderness that wraps around the self. Cox subtly leans the weight of her black pregnant body against the resolute white cast. The gesture seems to ask for protection, to shield her and her anticipated baby. Her own left hand rests on her pregnant body in a casual caress. As if to complete the other part of herself, the right arm of the white cast is raised with its hand resting self-assuredly at the hip. The effectiveness of Cox's interplay between autobiography and history, between private/public taboos and their filtered photographic representation, again strikes deep. This image recalls the words of

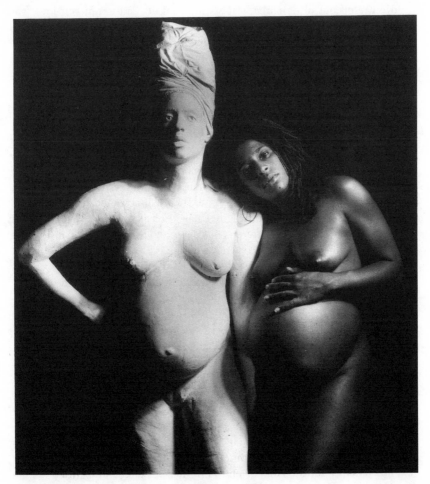

3. Renée Cox, *Yo' Mama and the Statue*, silver gelatin print, 1993.

Xuela, given voice by Jamaica Kincaid in her remarkable novel, *The Autobiography of My Mother* (1997): "My human form and odor were an opportunity to heap scorn on me. I responded in a fashion by now characteristic of me: whatever I was told to hate I loved and loved the most . . . I observed and beheld myself; the invisible current went out and it came back to me. I came to love myself out of defiance."[10] This unusual declaration of self-love was born out of the Carib woman's experience of being treated as an outcast in her own land and within her own family. The white cast of Cox's sculpture eerily alludes to the figure of her white French husband. It also resonates as Cox's own ghost image of herself. When the work is on exhibition, it is accompanied by an audiotape, from which the artist's voice is heard before one enters the installation where the sculpture stands. She intones, alternatingly sexy and outraged: "So baby do you want to fuck tonight?" and "Don't fuck with me."

Cox's provocative and ironic *Yo' Mama* family portraits, like Sojourner Truth's sensible acts of defiance before them, are directed against the mutual exclusivities that separate women's sexuality from motherhood, and in turn, maternal eroticism from power. Yet for all their self-assurance, strength, and dignity, Cox's self-portraits showing her naked black body with and without her son(s) still conjure up the trauma of slavery and the devastation it wrought on women's bodies and souls. Precisely through the contrast of her direct and eloquent self-presentation against the abyss of black women's histories, Cox's remarkable portraits bring into full evidence the denials slavery brought to bear on the black female body—denials that disallowed women their legitimate motherhood, rightful property, and self-owned sexuality. In their reigning poise, Cox's photographs sound an echo back to clothed maternal bodies of mammies in no position to show off the power of their maternal rights or sexuality. That was reserved for their owners' private pleasures, which went largely undocumented. As one art critic aptly put it, "*Yo' Mama* is an ironic dig at society's rending of the female parent into madonna and whore."[11] I would add that this rending is especially wounding for black mothers, who are always already further devalued and exoticized within the patriarchal paradox embedded in the fear of female/maternal bodies.

The woman pictured in the nineteenth-century *Slave and Child* portrait had no choice about the label given to her. Yet Cox deliberately titled her series *Yo' Mama* after a name her own son, at age five, called her. "That line comes from my life," says Cox. "My kid said that to me, and my kid comes from a loving, racially mixed home where blackness is appreciated . . . That disrespect is not coming from my house—it comes from society at large."[12]

Yo' Mama tautly addresses the phenomenon of derogatory naming from within as well as from without. Let's revisit the manner in which the mother holds her two-year-old son. Her pose is a highly unconventional mother and child depiction. Cox's son is neither merged vertically with the mother's body

nor engulfed by the maternal caress. Rather, he is pictured as emerging from the mother's sexuality, at once a part of her and distinct, almost distant. However, the mother's seemingly cool relationship to her child reveals another layer of intersubjectivities between them. Rather than posing Madonna-like with the child on the mother's breast, Cox reveals hers in a gesture that frees her son from becoming the target of frontal harm. Her body is bared so that he can remain, as his exuberant face attests, in a carefree and playful state of innocence. It is no wonder that Cox holds her infant son's lighter black body in a gesture that ambivalently offers him to the world and simultaneously protects him. Consider the traditional Madonna and Child representations, which embody the figure of Mary as an unequivocal safety zone for the holy child. The countless blissful faces of Mary peering out at us from beneficent landscapes over the centuries seem smugly to say, "What insurance do I need when I've got the Catholic Church behind me?" Cox's representation of the black mother stands up for herself and her sacred son. I hear Billie Holiday imploring, "God bless the child who's got his own."

Cox's hold on her son and her photographic projection of him into the world triggered a wide-ranging comment that likened him to a gun—and not just any gun, but an uzi. Certainly, as Audre Lorde wrote earlier, black women must raise their sons like warriors. But the embattled, militaristic interpretation of Yo' Mama, which was printed on a wall label at the Bad Girls exhibition in 1994 at the New Museum of Contemporary Art, turns the child into an aggressive object. Among the complex implications of this characterization, it denies any human relation between the mother and child. Indeed, likening the young boy's body to a lethal weapon is to load onto his innocent, pliant, as-yet-unformed being the larger cultural paranoia surrounding the adult male black body. Why not read this image, instead, on a more intimate and intersubjective level? In this way, one could see the mother's hold on her child as a representation of everyday maternal care inseparable from her concerns for her child in society—especially doubled for the mother of a black boy—composed of burden, fear, love, responsibility, and reward. Indeed, the way Cox holds her son in this resonant photograph implies the mother's uneasy bearing of a trophy, as it takes on lived meaning as an emblem of pride, a gift of love, an ode to success and survival.

As we know from her iconoclastic and pioneering work on the mother-child relation in Western culture, Post-Partum Document, begun in 1973,[13] feminist artist Mary Kelly also had a son. The son and the mother figure in her installation and book project indexically, that is, as signs, traces, and language that represent their interdependence as they navigate through and against the binds of psychoanalytic theory, in the end granting the mother an active writing and thinking position within the infant's developing social world. The schematic structure and nonmimetic mode of representation in Post-Partum Document was a brilliant strategic move on Kelly's part in the early 1970s, in

response to over-coded clichés of the passive, romanticized mother in Western culture. Her resistance against any static visual images of the mother or the child also powerfully underscores the dilemmas of representation. To avoid the mimetic image is at once a rejection of the past and an opening up to new possibilities. Such an approach thus understands visual representations as fictions of the possible, not as implacable givens.

So what sense can we make of the startling photograph of Mary Kelly seated with her son in her lap, the image that serves as the book's frontispiece and which is one of the few family portraits orchestrated by the mother in the repertoire of twentieth-century imagery? Her dark shirt (could it be crescent moons printed on it?!) highlights K's (her son, as she refers to him in *Post-Partum Document*) light-toned body and underwear. He stands out against her; his genitals are hardly contained. She bends over looking down, while he resolutely holds a speaker in his hand and looks out with a determined, anchored gaze. Reading this photograph too literally and wholly within the psychoanalytic trap that casts the boy as all-powerful, as I've just ironically done, begs the question whether this image is included in the project as Kelly's way of breaching the taboo of mimetic representation, even against her own grain. Or more dogmatically, the consequence of this reading would be to assert that this phallic image is present to remind us, before we move into the mother's new claims, that it is the boy who really reigns. Now let's be fair. It wasn't Kelly's fault that she had a boy. I wonder how differently we would read this photograph if a girl were couched in the mother's lap with that same steadfast gaze. Would anyone put the phallic rap on a girl? Would they dare? Cox's body, it seems to me, is the more phallic, if not warrior-like, in these signifying images of gender power dynamics. From Kelly's "phallic" son to Cox's boy as a gun, it seems mothers are damned if they do and damned if they don't.

The trouble, of course, is that mimetic representation rings so many cultural bells . . . or is it triggers? The body of Kelly's *Post-Partum Document* incorporates her son's psychic and physical development and the mother's relationship to these and her own transformations into a multilayered art exhibition and book format that refuses to depict recognizable and available visual bodies. In comparison, Cox's photographed body in full evidence is hardly a transparent, easily legible, or universalized body surface. Her photographic icons rely on the visibility of her naked body, but they are distanced from other publicized artistic exposures of the naked pregnant body, such as the emphatic symbolism of Judy Chicago's images from the *Birth Project* (1980), as well as from the coy photographic realism employed by Annie Leibovitz in the infamous portrait of Demi Moore from the August 1991 cover of *Vanity Fair*. The potent history of the representation of the female body in feminist art in the late twentieth century, especially in photography, is laden with unease and constant renegotiations between the physical body and the larger institutional bodies that constitute the very meanings of a woman's self-representation.[14]

Paramount in this history are strategies directed toward asserting that the female body will not be open for violation. Much cogent theoretical writing and photographic pratice during the 1970s and 1980s articulated the necessity for women to refuse the representation of their bodies as target sites for the patriarchal scopic gaze. These stances powerfully underscored the importance of rejecting easily exploitable depictions of women's bodies. However, such approaches in the 1990s leave little room for the possibility of employing the seemingly evident body as a means to create dialogues between stereotypes and the complexities of women's lived experiences. Thus, it seems to me that Kelly's *Post-Partum Document*—strategically cool and detached from any visual representation of motherhood (except for the fascinating frontispiece photograph)—and Cox's *Yo' Mama* photographs, with bodies in evidence, are not so distant from each other. Both reconfigured family portraits assert that the woman's body in evidence is not enough; her cultural traces and lived experiences must also be legible.

Two crucial differences in their representations of the maternal body, however, are that Cox's is black and naked. The cultural taboo against picturing motherhood in its lived realities is doubled by the historical censorship of black women, a censorship that is itself belied by the exposed and eroticized black body, what art historian Lisa Gail Collins astutely calls the "enforced overexposure of black women's bodies."[15] So for every image of the mammy as Madonna in proper dress and pose for the camera lurk more debased and equally public images of the woman slave made dirty and exhausted from working in the field, being exhibited on the auction block, or being raped by her owner. No contemporary image of a naked black woman, even if produced by the woman herself, goes unaccompanied by the shadow of violences from the recent past. Such devaluations cannot be easily erased by willing them away, although turning the violent gaze of others' hatred into images of self-respect and love is a fruitful if difficult approach. Veiling women's bodies to ward off disrespect and exploitation was a dominant strategy for white feminist artists in the last few decades, followed by more recent strategies that focus on picturing desire, visibility, and sensuality on our own terms. Yet these redefined visibilities represented through the foil of women's bodies take on more troubled and complex renegotiations as black women face the contradictions of their own liberated visions of themselves.

The visible, emphatic nakedness of Cox's body and her variously forceful, pensive, almost pleading facial expressions in the "seenness" of her *Yo' Mama* photographs make explicit the multiple dilemmas in this vulnerable visibility. Bell hooks also confronts this doubled trap of vulnerability and emancipation in making black seeing bodies visible. She writes:

> Living in white-supremacist culture, we mostly see images of black
> folks that reinforce and perpetuate the accepted, desired subjugation

and subordination of black bodies by white bodies. Resisting these im-
ages, some black folks learn early in life to divert our gaze, much in the
same way that we might shield a blow to the body. We shield our minds
and imaginations by changing positions, by blocking the path, by simply
turning away, by closing our eyes.[16]

Shielding and veiling black women's and men's bodies, minds and, souls is
a sensible survival strategy against others' attempts at dehumanizing them. In-
formed by contemporary feminist art strategies, the power of self-portraiture,
and above all, her own experiences of blackness and motherhood, Cox refuses
to turn her gaze away. Confronting others with her steadfast gaze against the
force of their desire to make her and her sons invisible will not will away their
hatred, but Cox's *Yo' Mama* photographs seem to say that this is the only
stance she can take. In her work to unearth and reform the racist foundations
of property law, Patricia J. Williams also imagines new ways for blacks to own
and envision themselves. Particularly in her powerful and poetic essay, "On
Being the Object of Property," interestingly under the subheading, "On being
visible," Williams writes about the dilemmas of being looked at derogatorily
and, like Cox, finds power and clarity in allowing herself to look out from
under the paralyzing gazes of others:

> My parents were always telling me to look up at the world; to look
> straight at people, particularly white people; not to let them stare me
> down; to hold my ground; to insist on the right to my presence, no mat-
> ter what. They told me that in this culture you have to look people in
> the eye because that's how you tell them you're their equal . . . What
> was hardest was not just that white people saw me . . . but that they
> looked through me, that they treated me as though I were transparent
> . . . By itself, seeing into me would be to see my substance, my anger,
> my vulnerability, and my wild raging despair— . . . To look is also to
> make myself vulnerable; yet not to look is to neutralize the part of my-
> self which is vulnerable. I look in order to see, and so I must. Without
> that directness of vision, I am afraid I will will my own blindness, disin-
> herit my own creativity, and sterilize my own perspective of its embat-
> tled, passionate insight.[17]

In harmony with hooks's concept of shielding and protection and
Williams's reflections on visibility, I see Cox's revolutionary family portraits of
bodies in evidence not as mere transparencies of vision but as incantatory
provocations for black women and mothers to let themselves be seen, and by
being seen, to look back and out.

Cox's *Yo' Mama* photographs thus disrupt the serene surface of family por-
traiture in order to reveal the multiple paradoxes between the seen and the

obscene. In one literal spewing of obscenities, Cox received the following "response" to the *Yo' Mama* photograph after it was exhibited at the deCompression Gallery and published in an alternative magazine in Tempe, Arizona. An unidentified male called the gallery, ranting "What's this nigger bitch doing in this magazine?"[18]

This idiotic racist rambling gives new meaning to the sorely misused phrase "in your face," often meant to obscure powerful visual depictions of cultural taboos that merit being faced. Cox's courageous and exquisite self-representations and family portraits challenge us to envision black female bodies as new terrain for expanding black maternal visibility, for giving evidence of the tremendous strength involved in vulnerability and caring.

The back-and-forth tension of this essay between historical inscriptions of violence and contemporary images of liberation is meant to underscore that the new body of possibilities Cox's photographs embrace also simultaneously traces decades of resistances. The reparations they seek for black women echo in June Jordan's remarkable poem, "Gettin Down to Get Over."[19] Like Cox's photographic incantations, it brings us into a journey of historical cruelty, cultural renegotiations, and psychic calls to face black mothers anew:

MOMMA MOMMA MOMMA
momma momma
mammy
nanny
granny
woman
mistress
sista

luv

blackgirl
slavegirl

gal

honeychile
sweetstuff
sugarsweetheart
baby
Baby Baby
MOMMA MOMMA
Black Momma

Black bitch
Black pussy
piecea tail
nice piecea ass

. .

the infant fingers gingerly
approach caress the
soft/Black/swollen/momma breast
and there
inside the mommasoft
life-spillin treasure chest
the heart
breaks

. .

teach me to survive my
momma
teach me how to hold a new life
momma
help me
turn the face of history
to your face.

Notes

1. I was first moved by this remarkable portrait at the exhibition "Hidden Witness: African Americans in Early Photography," at the J. Paul Getty Museum, February 28– June 18, 1995, guest curated by Jackie Napolean Wilson. This portrait is part of Wilson's unusual and large collection of photographs depicting African-Americans before, during, and shortly after the Civil War. Wilson's own grandfather was born a slave. For a discussion of this exhibition and Carrie Mae Weems's accompanying exhibition in response to it, see my critical review, "Facing History," *Afterimage* (Sept.–Oct. 1995): 21–22.

2. Cynthia Willett's book *Maternal Ethics and Other Slave Moralities* focuses on the conflations of sacrifice in the mother/slave binding. My thanks to Patty Mannix, who made me aware of Willett's important and original book, published by Routledge (New York and London, 1995), which brings together issues in contemporary psychoanalysis, philosophy, and ethics with child development research through discussions that range from "The Sensuality of the Good" to "Social Struggle" and through texts by Lévinas, Nietzsche, and Frederick Douglass, among them.

3. See Harriet Jacobs, *Incidents in the Life of a Slave Girl*, ed. Jan Fagan Yellin (Cambridge: Harvard University Press, 1991).

4. See Marianne Hirsch, "Maternity and Rememory: Toni Morrison's *Beloved*," in *Representations of Motherhood*, ed. Donna Bassin, Margaret Honey, and Meryle Mahrer Kaplan (New Haven: Yale University Press, 1994), 92–110.

5. "Forum on Motherhood, Art and Apple Pie," *M/E/A/N/I/N/G* 12 (Nov. 1992): 3.

6. Ibid., 37. Please see also my essay "The Body in Question: Rethinking Motherhood, Alterity and Desire," in *New Feminist Criticism: Art, Identity, Action*, ed. Joanna Freuh, Cassandra Langer, and Arlene Raven (New York: HarperCollins, 1994), 80–96, for a discussion that challenges notions of women's art and maternal work as devalued labor and offers, instead, a feminist ethics of motherhood that negotiates between engrained codes of maternity and embraces the lived complexities of chosen motherhood.

7. Patricia J. Williams, "In Search of Pharoah's Daughter," in *Out of the Garden: Women Writers on the Bible*, ed. Christina Büchman and Celina Spiegel (New York: Fawcett Columbine, 1994), 61, 66.

8. For more biographical information on Sojourner Truth, see William Jay Jacobs, *Great Lives, Human Rights* (New York: Charles Scribner's Sons, 1990), 107–16.

9. Conversation with Renée Cox, New York City, Feb. 12, 1997.

10. Jamaica Kincaid, *The Autobiography of My Mother* (New York: Plume/Penguin, 1997), 32, 56.

11. Sherry Chayat, "Powerful Photos Explore Racism," *Syracuse Herald American* Oct. 15, 1995.

12. Quoted by Kathleen Vanesian, "Black Like She," *New Times* Oct. 20–26, 1994, 63.

13. The installation was later formulated as a book, *Post-Partum Document* (London: Routledge & Kegan Paul, 1983).

14. Among the literature on this complex and in-flux subject, see the catalog to the exhibition *Sexual Politics: Judy Chicago's "Dinner Party" in Feminist Art History*, ed. Amelia Jones (Los Angeles: UCLA Armand Hammer Museum of Art and Cultural Center and University of California Press, 1996) which also looks in-depth at feminist art from the 1960s to the 1990s. See also Rebecca Schneider, *The Explicit Body in Performance* (New York: Routledge, 1997).

15. Collins exposed the problematics of representing the unclothed black female body, and lack of these images, in her paper, "Economies of the Flesh: (Re)Presenting the Black Female Body," presented at the session on African-American art organized by Phyllis Jackson at the College Art Association Conference in New York City, Feb. 14, 1997. For a specific study of black female nudity outside the frame of art, see Catherine Lutz and Jane Collins, *Reading National Geographic* (Chicago: University of Chicago Press, 1993). The dilemmas of black female representation are also taken up in terms of the particular problems of photographic representation by artist Lorraine O'Grady in relation to her own self-portraits. See her essay, "Olympia's Maid: Reclaiming Black Female Subjectivity," in *New Feminist Criticism*, 152–70. In another brilliant essay on the topic oriented more toward the often conflicting legacies of African-American photographic representations, and beginning with her own family album, Deborah Willis navigates a tricky course in her introduction to *Picturing Us: African American Identity in Photographs* (New York: The New Press, 1994), 65–70.

16. "Facing Difference: The Black Female Body," in *Art on My Mind: Visual Politics* (New York: The New Press, 1995), 94–100.

17. This essay was first published in *Signs: Journal of Women in Culture and Society* 14, no. 1 (Autumn 1988): 5–24.

18. Quoted in Vanesian, "Black Like She."

19. "Gettin Down to Get Over," in *Naming our Destiny* (New York: Thunder's Mouth Press, 1989). The poem was originally published in June Jordan, *New Days: Poems of Exile and Return* (New York: Emerson Hall, 1974). Copyright © 1989 by June Jordan, reprinted here with permission of the author.

Photography, Feminism, and the Good Enough Mother

JOANNE LEONARD

Its ambiguity—a photograph never says anything unequivocally, even when it most appears to be doing so—allows the family to escape with its secrets."
 —Janet Malcolm[1]

My photographs of my daughter have been generally the least likely of all of my work to stir controversy, in part because they often have produced scenes of childhood as a happy idyll and seem to reproduce the pages of my mother's illustrated copy of *A Child's Garden of Verses*.[2] But why this romantic portrayal in my own work? I have a twenty-two-year-old daughter whom I have raised entirely without partnering or support. Where in my photographs are the psychological, emotional, and economic complexities of the lives we've led, the tensions for me between my love for her and my ambition for myself as an artist? In this essay I explore the tension between the representation of the family as happy and idyllic and the difficulty of recording photographically alternate stories. After expanding on the many meanings and interpretations of one of my own photographs that appears to represent this idyll of childhood, I'll describe how photo collage has provided me a medium in which I can visually layer some of the contradictions and complexities of the life behind the photographs onto the photographs themselves.

A mother who makes *hundreds* of pictures of her child (as I have done) may simply be performing and exaggerating activities of maternal absorption and devotion. There is a popular notion that women's creativity is "natural," that

293

procreative and creative forces in women are part and parcel of the same womanly instinct. Then what could be more "natural and motherly" than the picture-taking mother that I have been? But a mother's act of paying close and frequent attention to her child through photography can be read many ways including (positively) as devoted and attentive ("imaginative integrity and creative fire") or (negatively) as horridly intrusive ("a maternal flame whose heat would destroy whatever it touches"[3]). In fact, these two poles reflect popular ideas of mothers with or without cameras and do not even begin to set out the range of possibilities. Today mothers with cameras will at times be seen as cold, objective, exploitative, or even abusive, when, more often than not, they have only photographed children doing things all children do but which are seldom recorded (including being messy, mean, naked, or sexually curious about their own bodies). On the other end of the scale, some of the same mother photographers, from a feminist vantage, will be seen as picturing motherhood from their own perspective, still, at times, a radical act—radical, but nearly as old as photography itself. Some of Kodak's earliest ads show a mother, camera in hand, photographing her children. One of Kodak's intentions was to convey that operating a camera was so simple that *even* women could do it ("You push the button, we do the rest," reads the ad campaign[4]). Kodak's featuring of women in these early ads may have been conceived only as a clever sales campaign, but the effect was to endorse, repeatedly and in public venues, mothers photographing their own perspective on the family.

For me, the tensions between the ideal, the idyllic, and the "real" continue to crop up everywhere I might turn my camera. I used to say (and I thought I was talking about my "feel" for good composition) that I was guided to click the shutter when things looked "right." But for many years now, I've been more interested in examining where these ideas of right- and wrong-looking things/ moments come from and in forcing upon myself recognition that the "right" looks come from more than the convergence of beautiful lighting and strong arrangements of shape and form. Looking at the images that have filled my head since childhood, that is the socially constructed images of the good life, good family and the good, or at least good enough mother,[5] allows me to learn more about how I happened to make the images I have, and to shed light on the power some of my photographs have held for others.

Few of my photographs have had the varied life and range of responses to it that this image has had (illus. 1). It appears in *Baby Baby Sweet Baby*[6]—". . . sixty photographs of babies being babies, toying and dallying with us . . . an irresistible, loving celebration of babydom, with all its joys, mysteries and pleasures" (dust jacket). It appears on greeting cards and calendars which carry the "Sweet Baby" theme into the realms of Hallmark and hallway. Yet it also was included in *New American Nudes*[7] as decidedly the youngest nude, and, in an exhibition *Imagined Children, Desired Images*.[8] It has thus been associated

1. Joanne Leonard, *Julia, One Week Old*, 1975, gelatin silver print, on 8 × 10 paper.

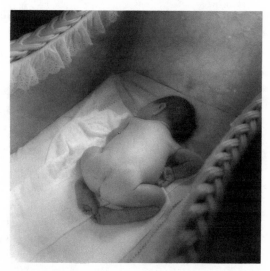

with such ideas as the nude in photography, the pleasures of looking, and the erotics of parenting. But, of course, first it was a family photograph, a mother's picture of her sleeping child, my picture of Julia, one week old.

When Julia was an infant, she slept through much of my picture-making attentions. But over the years she definitely became complicit in the making of her own image and thus, if the images matter, so does thinking about this enduring partnership between artist and model, between Julia and me, her mother/photographer. While I introduce here Julia's own remarks, I don't want to imply that I take them as the answer to my questions about the photograph, its impact, and its meaning. For one thing, try as we might, she and I could never rid ourselves of the power dynamics of our situation. Just as when she was little she may have sought to please me by posing for a photograph, and when she was older manipulate me by withholding a picture-taking moment I'd indicated I wanted, each of our responses are too intricately linked to the other dynamics of our lives to sort them all out into one coherent story and explanation. What her comments here may allow is reflection on just a few of the "realities" and contradictions about family life embedded in this image by me, as the maker of it, by Julia its subject, and by viewers, who have become the audience for the work.

Julia and I had been talking about writing a book together about the photographs I have taken of her. One idea was to give Julia a chance to answer the question she is so often asked, "How does it feel to be your mom's photo subject?" She picked out a number of photographs that were important, but for a time, that was as far as we got. More than a year later, about three-quarters of the way through her first term away from home in art school, Julia wrote about the photo of her, *Julia, One Week Old*, the first of the set we had selected:

This photo now when I look at it makes me think of how excited you must have been to have this little thing to look at finally after having it in your tummy for so long. To be able to show me off to all your friends "look at what I made." This photo has always felt so loving and warm as though you see this baby through eyes of someone who loves and knows this baby like a "view" as opposed to just a snapshot or a family photo. When I was younger this photo and other photos from this small green house made me wish I could remember more about the time we lived in San Francisco. Now I remember the answers you gave me to all my questions [when] I asked you [about things] like my yellow room with the long white shades, the fish . . . that I killed, Puli [the dog] rolling me over, the snails, eating too many strawberries on my birthday, playing under the yellow blanket in your bed in the living room. The list goes on. I feel that this and all other photos of me before I could remember help me remember being a baby. P.S. Mom I hope this helps start our book. Love, me, your kid, Julia. I miss you too.

—Julia Leonard

Clearly her first idea is to shift her own position from a self on view to a self standing beside me, behind the camera, joining me in looking at her. Though she shifts her location from viewed to viewer, and looks in now on me looking at her, she keeps a small child's voice perhaps as a way to retain her own position as she starts out thinking about "this little thing . . . in your tummy for so long." But now as an art school student herself, and as a young woman, she can also identify with my artistic practice, imagine herself as a mother, as well as see herself as the object of my pleasure, as both daughter and image. Astutely, she has noted some of the shifting ground on which I stood to look at her as both her mother and a photographer—"you see this baby through eyes of someone [the mother] who loves and knows this baby like a 'view' [photographer]."

Julia concludes that my photographs give her memories of things she was too young to remember. Her report of her own memories are for me exquisitely visual and tactile all at once—of things she saw and touched. She saw yellow light in her room—a dark back room turned sunny with paint. She squished her fish, but didn't mean to kill it. My bed was in the living room, just as she remembers it, and I remember the fun of hiding under the covers together.

Remembered, too, are the limitations this detail makes clear—that our little single parent family had only one bedroom, hers (hers, so I could shut the door for/on her at night and have the rest of the house to myself). When we moved from that nine hundred-square-foot house she was three, and we moved up in the world; I left my three part-time teaching positions and became a tenure-track professor; we moved away and we acquired our first house with a bedroom for each of us, near Detroit, a Northern city with its

history of racial tensions, a region soon to hit economic downturns as the U.S. auto industry declined. Each detail Julia remembers has a story, a history, that belongs to the social structures of economic class, race, and geographic location. Does the absence of these narrative and textual details make a photographic distillation of a moment into a lie, half truth, or fiction?

The subjects of race and class are not so much *in* this image as behind it. Other issues, such as those that arise from Julia's nudity and vulnerability, are closer to the surface. The viewer might ask why Julia had been put down to lie thus, without clothing or covers. She lay naked in this, her first week of life, not because of the heat of the day (it is not hot in the San Francisco Bay Area in April), nor simply for the delicious vision she made as she settled down to sleep so unfettered, but because, jaundiced at birth, she needed maximum exposure to the sunlight from her window. Jaundice untreated can cause cerebral palsy, even death. When I learned that some viewers had disliked the photograph, imagining it was a picture of a dead baby, I was surprised, disturbed. But how far from our thoughts is death at the time of birth? (All observers bring their own experiences. A viewer whose baby had died was one who saw death in my photo.) A sleeping baby is a lovely sight, but perhaps few other sights are such a powerful reminder to us of vulnerability and responsibility. New babies are often fragile and death threatens. How comforting it is every time a baby reawakens and reassures us a tiny heart is still going strong.

Part of the power of the image, it now seems to me, lies in its ambiguities, particularly the ambiguity created by my (the mother's) implied presence and absence from the picture, the way this is not only a photograph of an infant, but a *mother and child* image. One may feel the mother's presence and her looking is perhaps quite like touching, a look associated with intense pleasure. At the same time, the mother is not there (in the frame) to offer symbolic or actual protection of the child, to draw a curtain between her child and the intrusion of strangers as does Berthe Morisot's mother in her renowned painting of maternity, *The Cradle*.[9] Along with the pleasure in looking at my photograph of the soft, vulnerable form of a tiny baby girl may come a disturbing sense of transgression, objectification, or danger. Has the baby been made too vulnerable, since the mother has left her position next to the cradle, stepped out of the frame, and, in this case, behind the camera? Or is it the irresistibility that the baby's body invokes that has made some shrink back at the same time as feel drawn in? In a remarkable piece she wrote for the *New Yorker*, Noelle Oxenhandler discusses the connections between looking and touching and counterposes this irresistibility of babies with "the knowledge that we must resist, that we must respect their separateness from ourselves—a separateness made all the more poignant by their complete dependence."[10]

Anne Higonnet wrote revealingly how images of *mother and infant* pictures relate to issues of class. Writing about paintings in the late 1880s, she says,

No matter what the time, place or situation of the subject, critics stressed the transcendent qualities of the good mother. . . . Such pictures and language imagine a bliss shared by the child and the mother who identifies herself with her child in a time before loss, anxiety, discipline or hierarchy. Both nostalgic and utopian these maternal images attempt to substitute the memory of infantile pleasure for the problems of adult society. . . . mother-child relations exist in a world apart, disconnected from the rest of life. To grow up is to fall from grace and suffer the social destinies that follow expulsion from maternal paradise. . . . after separation from the mother, class identity that has been submerged in a classless maternity reasserts itself.[11]

If mother and infant images from art history are classless, they also largely depict whiteness without seeming to be about race. Though black and white, my image conveys a baby with white skin. Perhaps the viewer's or the baby's race (though it is not evident, Julia herself is not solely white; her father is Mexican) will influence the response to this photograph. Often I layer collage onto my images to suggest a variety of narratives to which my photo image is key. But clearly every photograph is itself a collage of meanings and associations for maker, subject, and viewer.

I, my mother, and my grandmother all kept pictures, notes, letters, and vital information about baby's growth in books that fit the genre of "baby books," scrapbooks devoted to baby. I made this piece, *Day Care Documents* (illus. 2), as part of the series *Not Losing Her Memory, Stories in Photographs, Words and Collage*, a set of collage/text works made over a period of five years and entailing an exploration of photographic meaning, female identity, family, and layered, autobiographical storytelling. With that series I began my efforts to layer on to photographs *explicit* indicators of contexts and social structures such as those that seemed merely *implicit* in *Julia, One Week Old*.

Day Care Documents includes photographs of (from top to bottom): myself at thirty-five with baby Julia; my grandmother, Ida (Peg), at nineteen with baby Marjorie; and my mother, Marjorie, at thirty-five with her twins, my sister Eleanor (Elly) and me. *Day Care Documents* includes replicas of baby book pages (starting at bottom left and going counterclockwise): Marjorie's typed "excerpt from letter to Aunt Minnie"; Ida's handwritten notes on the prescribed areas of pages from a commercially available "Baby Book";[12] and my own notes in a bound book I kept conscientiously only for a brief period of Julia's babyhood, and then became a place to stuff notes and other mementos from time to time.

In *Day Care Documents*, the upper left-hand corner holds a reproduction of a page from the book my grandmother kept. Her extreme self-consciousness is evident in her writing.

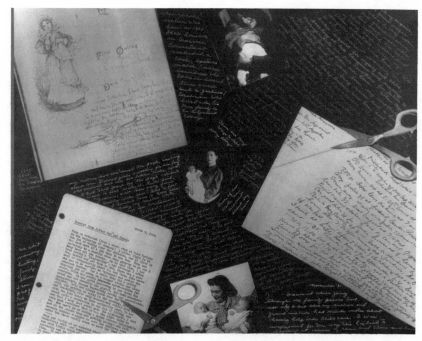

2. Joanne Leonard, *Day Care Documents*, 1991, 20 x 16, gelatin silver print with collage and white ink.

> Miss Mobbs and I took baby and sat on a bench with her. I at first tried to show my experience in caring for my children by holding her but baby objected strenuously showing her feelings by waking and crying at intervals and attracting a curious lot of eyes in our direction so I handed her gently into Miss Mobbs arms where she peacefully reposed, I holding an umbrella to shield her eyes all the while. After one hour, we returned.
> —Ida G. Battelle from *Day Care Documents*

In assembling this piece, I was initially drawn to certain visual connections. For example, the remarkable twinship of my own pose as I held Julia to the pose of the figure (a drawing) holding the baby in my grandmother's baby book page.[13] I assumed this drawing represented a mother. Later, however, I came to realize that this illustration is meant to show a hired nurse. Her role is signaled in codes easily understood in their time: the mobcap and apron of the servant class. In another photograph my grandmother sits holding her baby, stiff and awkward in her dark high-collared dress—a formal portrait of an upper-class woman, not (yet) a nurturing mother. She was only nineteen and greatly worried about her own capabilities. In writings elsewhere, my mother quotes her own mother's narration for this picture: "poor little thing, I used to feel so sorry for you . . . I didn't feel old enough to be a mother."[14] With some apparent relief,

my grandmother deferred to her professional surrogates, the hired nurse/nanny.

Conscious of eyes upon her when "baby" cried, she handed her infant back to Miss Mobbs, the nurse. She wrote of wanting to "show her experience in caring for her children" exaggerating (or imagining her future) as she wrote, since she was, as yet, the mother of only one child. Given her youth, her wealth, and her access to/dependence on full-time servants, it is not surprising that even in her own eyes she was playing a role to some extent, able and eager to give baby over to the care of Miss Mobbs if curious eyes did not seem approving, then describing her baby in repose as she stepped partially out of the mother role and into that of observer and umbrella holder.

I've come to think of myself, the photographer, as stepping into a long chain of mother observers—mothers who step outside the family circle to *look* and record. This distance of the observer interests me intensely: my female family set the stage for my photographer's habit of sitting outside the family circle, observing. In one of our family's oldest photographs, my deaf great-grandmother, Carrie, sits on the sidelines of the family, visibly separate (and happy! reading a book, presumably looking up occasionally, observing). She must often have been sidelined to this outsider position and become an "outside" observer because it was difficult as a deaf woman not to be often sidelined by members of the hearing world, even family. My grandmother, Ida, in her turn, separated herself from routine maternal care because her class position allowed (required?) it. She had nannies and servants to care for her children much of the day, but commissioned photographers to record her with her children in stylized portraits of maternity—one we have shows my grandmother reading an open book, her two children draped on her either side in positions so similar to the figures in a drawing for *Collier's Magazine* by Jessie Willcox Smith,[15] that it's hard to imagine the photographer did not set out deliberately to mimic this popular culture icon of ideal maternity. When I chose to be a photographer/ mother, I repeated my psychologist/mother's professional act of looking and recording. For *Day Care Documents* I reproduced the following passage from the baby book my mother kept about my twin sister, Elly, and me:

> March 9, 1943. Excerpt, from letter to Aunt Minnie. When we returned (from a week's stay at Palm Springs in the beginning of January) I pitched right in to the job of taking over the children, and at first it was much more of a job than it was fun. They can certainly be a handful when they gang up on me and they know all the tricks. Up to that time I had been mostly a "play-mother," and although I often fed, bathed and put them to bed, there was a good deal of irregularity about it, and Doris (the nurse who was to be married in February) was always the constant factor. Besides, Doris had always taken over the getting up early in the morning, dressing and breakfast with only occasional relief from me. With the late hours we have ordinarily kept, it has meant

quite a revolution in our way of living but now that I have just about made the adjustment, I feel very much convinced that it was the right thing to do. One can't go on having a nurse forever (especially not at the prices they are getting today) and with nursery school equipped for children even under two there really seems no need for the expense.

—Marjorie Rosenfeld Leonard from *Day Care Documents*

I had looked at our baby book hundreds of times as a child, but it was only as I selected a page for *Day Care Documents*, that I first focused on this page of my mother's writing and saw immediately her recorded conflict between the play and real work of mothering. (My mother "played" at being a mother while we "played" the role of a baby. As six-month-old twins, my sister and I were selected to "play" Marlene Dietrich's baby in a film—a Hollywood childhood has brought me particularly close to notions of the performative within images and ideas about family!) We'd been my mother's *play* when Doris cared for us; now we were *work*. I'd never fully realized how my mother's upper-class expectations and financial wherewithal had protected her/prevented her from getting up in the middle of the night with us for the demanding two and a half sleep-deprived years that most mothers experience. Sometimes she substituted something more like professional engagement for the hands-on mothering from which she was freed. She kept notes on our behavior and these often read like clinical notes. I remember feeling her distance, sometimes with hurt. Now I am troubled at times, wondering if I have hurt Julia with this same wavering mix of motherly and professional interest. In these clinical jottings my mother blurs the lines between professional observation and motherly record keeping. These lines were soon to be blurred in the popular imagination as well.

The "baby book" my mother kept for my sister Barbara four years later (1944) is full of charts, diagrams, and grids—not only height and weight but also eruption of teeth, eating habits, operations, and more. Unlike Elly's and my baby book, a common three-three ring binder cheerily covered in bright orange-and-white white patterned paper, the book for my younger sister, Barbara, provides its own pages and charts to fill in. It is called *Your Child Year by Year, A Development Record Guide from Birth to the 16th Year*.[16] Designed to be used not only by parents but by the child's teacher and doctor in future years, it declares on its cover, "In sharp contrast to the old fashioned sentimental Baby Book, this child development record is thoroughly modern, scientific and useful . . . It enables you to compare your child's mental, physical and character development with the 'average' child." Mothers had their jobs cut out. It was clearly going to be work, but useful work. (This was 1944 and many moms were being subtly socially engineered to return to the kitchen and nursery after being Rosie the Riveter during war time.) My mother, who had taken her psychology training in Germany, was staking out professional terrain within the realm of Küche and Kinder.

In the "baby book" I kept for Julia the entry reads in part :

> . . . up at 5:20 AM., back at 7 PM. Leave the house at 7 AM . . . drop Julia
> off at friend Sandra's, 5 min. away . . . I stay with Julia 15 minutes then
> take off, meet car pool at 7:40 at rapid transit station. Park my car and
> . . . back to Berkeley at 6:15 back to Sandra . . . home at 7 after nursing
> at Sandra's . . . At first it was hell, now (after 5 weeks) its working out
> o.k. . . .
>
> —Joanne Leonard from *Day Care Documents*

How would this text change the image of sleeping *Julia, One Week Old* if it
were somehow layered onto the space of it? Does it make the moment of sleep
and peace in the photo of Julia in her cradle false? How long does a moment
have to endure to be thought of as "truth" or "reality?" As I put this piece to-
gether, I was particularly emphasizing the downward economic turn my own
situation as single parent head of household signaled in our female family his-
tory. My daughter was only eleven months old when I wrote the account pic-
tured in *Day Care Documents*. For nearly two and a half years, my mother,
from my perspective, seems to have had comparatively light duty as a mother,
getting up only rarely in the middle of the night and doing very little of her own
children's "day care." (As a child-care professional and mother proud of her
skill with children, would she have been too self-conscious to admit more than
a little how hard it was when she did single-handedly take on the care for her
twin babies? My dad was definitely *not* a modern father, and participated little
if at all in routine child care.[17])

I find myself drawn to investigate the gestures (so often occurring, so little
discussed) of not looking, not seeing, and not recording that occur (as in my
own case, the relative absence of fathers) within acts of photography. Not re-
corded, of course, are all the moments before and after the moment of atten-
tion, the click of the shutter. In *Day Care Documents*, at the bottom, I in-
cluded a favorite picture of mine, my mother with two babies, her twins. In
this photo, my mother is both looking and not looking (since she can gaze on
only one baby at a time). But am I the one she is looking at or the one not
within her gaze? I have no idea. (Elly, my twin sister, and I cannot identify our-
selves with any certainty in pictures of our infant days.) What we look at, pay
attention to, photograph, enters memory. In words and pictures we save and
pass on our past and, as Carolyn Heilbrun wrote, "these narratives *become* the
past, the only part of our lives that is not submerged."[18]

I used the black space around the photographs and baby book pages of *Day
Care Documents* to comment on inclusions and omissions hinted at by the
scissors and the texts that run off the pages. In some of the spaces I "confess"
to having cut out the part of the letter from my mother where she wrote about
"the colored girl," her hired help. I was embarrassed and wanted to leave out

this story and my mother's old-fashioned term. Now I see the irony—that without this reference, I would have included no indication at all of the presence in my childhood of several African-American women, nor their lasting impact.[19]

Other significant omissions and excisions from photographic records occur with and without intention. For ten years before my own daughter was born I unfailingly delighted in taking photographs of Elly's children whenever the opportunity presented itself. Was it just a busier life or an interest and concentration on my own child, a decided preoccupation with collage and neglect of more direct camera records, or the fact that Barbara herself takes photographs, that has meant I've made very few photographs of Barbara's children? Or do her son's many surgeries, scars, and difference in appearance veer too markedly from my picture-book framework of images? In *The Creatures Time Forgot*, David Hevey writes of the absence of images of disability in *The Family of Man*, that post–World War II collection of photographs that made me long to become a photographer when I saw it in my early teens.[20] *The Family of Man* was aimed at healing, moving from world conflict to world family. And in this postwar family, communality, not differences, were to be stressed. No disability allowed. I have no doubt that somewhere in my brain and psyche are imprinted many self-censoring ideas of what can and can't be made into what Julia has called "views," and what Hollywood might portray as scene/screens of the happy family.

There is a certain circularity to *Day Care Documents*, almost a pinwheel effect. Text runs through, becomes interrupted, scissors call attention to themselves and their acts of disruption. The scissors are the foremost layer and they are the only items in the work that are in color, perhaps highlighting their connection to the present, and the tailoring of the story in my time, by my hand. Texts have been forced into corners and edges, photographs, though small, are central. Through these many visual devices, more so than through any expectation that the texts themselves would receive the detailed reading I'm providing here, I have tried to suggest the tensions between the various truths, memories, real lives (reel lives), performances, fictions, stories, inclusions, and excisions, the usual fare of family stories.

My collage strategies work to give a sense of narrative over time and some particulars of place, class, and race and of women's experience; at the same time they make somewhat explicit the fact that they are partial, snippets that is, of only a few of the stories which might be represented. *Julia, One Week Old* seems by comparison to be both far more open-ended and, oddly, more complete—open to both cheerful and fearful fantasies the viewer will layer on to it, it allows both remembering and forgetting.

In a volume devoted to notions of looking and of family, such as this one, what could be more appropriate than looking at the largely (even today) unpictured realm of women's reproductive life. Before my pregnancy with Julia, an

3. Joanne Leonard, *Miscarriage/Ms. Carnage,* from *Journal,* 1973, 11 x 17 collage with blood and pencil on paper.

earlier pregnancy ended in miscarriage. (This was early 1973—I had never seen Frieda Kahlo's work about her miscarriages. Today Kahlo's work is so widely published that it is hard to imagine its near total absence in the early 1970s.) I put blood on pages of a blank sketchbook during the first hours (the prelude to the miscarriage), and afterward returned to use the blood in collage works such as the ones called *Rupture* and *Miscarriage/Ms. Carnage* (illus. 3) which made up this visual journal. I was devastated by the miscarriage and the abrupt end to my expected motherhood. At the same time I entered an enormously productive time. In response to the experience of loss, I created thirty collages in as many days. I was certain somehow immediately of their importance and remember the resulting turmoil—such intense sadness and loss, mixed with a thrill of happiness about the new work; motherhood and artwork operating in opposite emotional realms, with my artwork really sustaining me and moving me forward.[21]

Another page is *Reproduction* (illus. 4), where a baby is being passed through the developing chemicals of a photo print tray, providing a visual pun

4. Joanne Leonard, *Reproduction*, from *Journal*, 1973, 11 x 17 collage and pencil on paper.

on the term "reproduction." The mother's body is absent from this "birth" image and work or labor is represented by the activity of the darkroom. Two hands are visible: one a mother's hand, holding the baby, the other a hand managing the prints as they are passed through the chemicals, but gloved, like a doctor, the medical manger of both successful births and the mishaps of miscarriage. The images throughout the *Journal of a Miscarriage* (1973) vacillate between suggestions of the clinical and the sexual in the experiences leading to birth. In *Reproduction*, the developing fluid (a poisonous medium in which one would never in fact bathe a baby) is deployed visually in the image as a possible stand-in for fluids of sexual union and birth. It is recently that I've become consciously interested in representing the tension between working mother and the work of mothering, but I see now I had previewed this duality in my collage of more than twenty years ago. I also foreshadowed Julia's comments which put her both in the position of the baby and as the simultaneous subject of my mothering and picturing. This is, ultimately, one of the most hopeful images in the *Journal of a Miscarriage*. My (and the viewer's) pleasure is divided between the idea of a resulting "picture" and the humorous metaphor of baby being "developed" through an alchemy of darkroom process and motherly attention. The magic and attraction for me of collage is exactly the double entendres it permits, allowing the maker and viewer to hold several sometimes irreconcilable ideas in mind at once.

This mural format collage (four feet long) suggests both the death of my mother and the emergence of my daughter into her own life, away from family. Pain, rupture, departure, and fracturing are all present. When I made *Letting Her Go With Difficulty*, I thought I had finished with the series about my mother, her memory loss, and her death, *Not Losing Her Memory: Stories in Photographs, Words and Collage*. In *Letting Her Go With Difficulty*, I believed I was making a piece about my daughter and the hard time for me that preceded and followed when she first moved out of our home (plate 11). But Elly and

[Plate 11.] Joanne Leonard, *Letting Her Go With Difficulty*, 1993, 48 x 20, photo collage, top, and detail. Also see the color plates section following page 134.

others took *Letting Her Go With Difficulty* to be about my mother's leaving, dying. I was hurt and angry and depressed. I wanted to depict hearts breaking, physical damage, and pain, but found I could not wreak havoc upon my images of Julia, myself, or even on generic female forms. I wanted to refer to women and damage without picturing bodies already so prevalent in news and advertisements. For a time every image that came to mind was either unbearable in its violence or as trite as the phrase "broken hearted." The teapot had been an old theme of mine. I'd used it, along with teacups, to suggest companionship

(two cups) and solitude or loneliness (the teapot or one cup on its own). When I began to picture the teapot breaking and mending in this tableau, the issue of who was leaving whom seemed unclear. My own struggles for self and identity within the roles of mother and artist were part of the imagery of struggle, damage, and repair. Anne Higonnet says of Morisot "She had to picture a self that was not a self, according to nineteenth-century individualism, but that was instead an identity at once independent and shared with her daughter."[22] I had stepped out of the frame in *Julia, One Week Old*, to take a view, a perspective, from a distance. Separation had been the issue from the beginning and I was continuing to explore separations in *Letting Her Go With Difficulty.*

If I hadn't held myself back on many occasions, I'd own dozens of teapots as I find them very compelling—permissibly pot bellied, or maybe pregnant, dear and female, cozy and domestic, with heat and fluid largely kept from view. They were exactly right for my purpose. I wanted the first rupture to be birth . . . the leave-taking that starts right off. After I had given birth, I'd actually missed the sense of being doubled, accompanied, and complete when I was pregnant—perhaps unconsciously I felt the childhood presence of my twin. I didn't feel "occupied" and overtaken as some women report. I actually had had to adjust to the fact that I was no longer full (and in that sense, fulfilled) when Julia was born. I struggled to find a way to have the teapot give birth, and for Julia (her portrait cut into the shape of a swimmer) to emerge and go forth. I struggled with the use of the photograph of an unborn fetus, so nearly co-opted as an anti-abortion image by the right-to-life movement. I risked that association, hoping to claim the image for my own purpose here.

I wanted the anger to have force, to be real, and to suggest its explosive nature. I used fiery images that came from photographs of volcanoes, most effective (fiery red) when reproduced in color. I suppose computer graphics would be the way to go even these few years later, but I made my altered images by painting directly on my gigantic print, making the pot look broken and then mended through the use of paint. There will never be enough anger and sadness in this piece to have it be equal to the moments that pushed me to make it. Anger and its difficulties in my family is something I wrote about (but not enough) when my sisters and I were each writing about the tensions surrounding caring for my mother when she was ill with Alzheimer's.

In *The Texture of Memory*, James Young asks the reader to consider if monuments (memorial sculptures) have as their chief function to provoke viewer recall and stem the tide of forgetting. Or, are they useful chiefly because people need places to leave their memories of the past in order to get on with life?[23] Photographs have similarly multiple and sometimes conflicting roles, though as scraps of everyday life they may seem more simple on the surface. In fact a photograph is so much a part of everyday life, so seemingly transparent in its

relationship to what was and what is remembered, that one might look at it, even at one that seems enormously compelling, and think it represents a simple, unified truth. It takes time and attention on the part of the viewer to remain with a seemingly undemanding record of an instant and delve into the contradictions it may contain. Perhaps even more so when the image is one that, as a record of family life, is both straightforward and a dense focus for both personal and social interpretations from within and outside the family. In photography I have veered between the photograph presented on its own terms, and the restructuring of photographic images through collage, a process that allows discovery of intersections between the idealized, the everyday, and the radical reenvisioning of women's worlds.

NOTES

1. Janet Malcolm, "The Family of Mann," review of *Immediate Family* by Sally Mann, *New York Review of Books*, Feb. 3, 1994, 8.

2. Robert Lewis Stevenson, *A Child's Garden of Verses*, illus. Jesse Willcox Smith (New York: Charles Scribner's Sons, 1905).

3. "'Une ardente flamme maternelle, où se mit, en entier, la créatrice,' wrote Mallarmé . . . As usual, Mallarmé's (untranslatable) syntax conveys more than one meaning. A linear translation implies that Morisot threw her entire creative self into an ardent maternal flame that could destroy whatever it touched. But Mallarmé also placed the syntactical juxtaposition of and analogy between 'en entier' ('in its entirety') and 'la créatrice' ('the creator') in equilibrium with 'the ardent maternal flame' he thereby equated Morisot's imaginative integrity with maternal fire." Anne Higonnet, *Berthe Morisot's Images of Women* (Cambridge and London: Harvard University Press, 1992), 208.

4. One example with this slogan shows mother photographing daughter and doll, while son stands on the sidelines, between them, hands on hips (supervising? regulating her gaze?). Richard Conniff, "When 'Fiends' Pressed the Button, There was Nowhere to Hide, The Snap Shot at 100, a Celebration of the 1st Century of the Kodak Camera," *Smithsonian* 19 (June 1988): 106–16.

5. The literature of the "good enough mother" (a term that originated with D. W. Winnicott) suggests impossible contradictions and feminist efforts to resolve them: good mothers should be selfless nurturers; bad mothers are selfless nurturers who merge dangerously with their children. Janet Doan and Devon Hodges, eds., *From Klein to Kristeva: Psychoanalytic Feminism and the Search for the "Good Enough Mother"* (Ann Arbor: University of Michigan Press, 1992), 3.

6. Bruce Velick, *Baby Baby Sweet Baby* (San Francisco: Pomegranate Press, 1992), 24.

7. Arno Rafael Minkkinen, ed., *New American Nudes, Recent Trends and Attitudes* (Dobbs Ferry, N.Y.: Morgan and Morgan, 1981), 63.

8. *Imagined Children, Desired Images*, Davis Art Museum, Wellesley College, Wellesley, Mass., 1995.

9. "We see the baby asleep behind a veil; to us she looks like a sketch . . . The mother shelters the baby from us by holding the cradle curtain gently in her hand" (Higonnet, *Berthe Morisot's Images of Women*, 120).

10. Noelle Oxenhandler, "The Eros of Parenthood: Not Touching Children Can Also Be a Crime," *New Yorker*, Feb. 19, 1996: 47–49.

11. Higonnet, *Berthe Morisot's Images of Women*, 214–15.

12. Ida Scott Taylor, *Baby's Book*, illus. Frances Brundage (London, Paris, and New York: Rafael Tuck and Sons, Ltd., c. 1905).

13. Ida Scott Taylor, *Baby's Book*.

14. From page 1 of *Her Mother Was Deaf,* an unpublished account Marjorie R. Leonard wrote of her own mother's life. I included this quote in *Conversations: My Mother and Her Mother*, from the series *Not Losing Her Memory: Stories in Photographs, Words and Collage*. This work was included in the exhibition *The Familial Gaze*, Hood Museum, Dartmouth College, Hanover, N.H., 1996.

15. Cover of *Collier's*, June 30, 1906. Reprinted in Edward D. Nudelman, *Jessie Willcox Smith, American Illustrator* (Gretna, La.: Pelican Publishing Co., 1990), color plate 3.

16. John E. Anderson and Florence L. Goodenough, *Your Child Year by Year, A Development Record and Guide from Birth to the 16th Year* (*The Parent's Magazine* and New York: W. W. Norton, 1942).

17. Another explanation for my father's infrequent appearances in our family photographs is that he took most of the photographs. Perhaps this division of labor in a family is common enough and some viewers might intuit it. However, my father's absence, Julia's father's absence, and absences generally have many explanations. So far in my own visual work, fathers have remained largely off stage. It is a fascinating challenge to consider how and even if it is possible to make visual and more explicit the absences and off-stage nuances of everyday life.

18. Carolyn Heilbrun, *Writing A Woman's Life* (New York: W. W. Norton and Co., 1988), 51.

19. Elsewhere in this volume, Laura Wexler's essay discusses a photograph of a black servant holding a white child. I thought I might comment on one relevant instance that comes to mind from my own family history. In a beautiful little book my younger sister, Barbara, still has, there are photographs clearly taken by a hired professional showing Barbara after a bath. Bessie is seen only as *the hands* supporting baby Barbara. Clearly it was Bessie and not my mother who had just bathed Barb. Though my mother likely was present when the pictures were taken, she did not step into the frame. We have many snapshots where Bessie is fully in the picture and some photographs I made of her when I visited her years later, but in this instance of formal and professional baby pictures commissioned by my parents, Bessie's presence and absence are both in evidence.

20. David Hevey, *The Creatures Time Forgot* (New York and London: Routledge, 1988), 55–56.

21. For almost twenty years the work was not reproduced. The work had its first publication in Ruth Behar's essay "The Body in the Woman, the Story in the Woman,"

illus. by Joanne Leonard, in *The Female Body*, ed. Larry Goldstein (Ann Arbor: University of Michigan Press, 1991), 268, 277, 306; and as my "Miscarriage/Ms Carnage and Other Stories: a Visual Essay," in *Discourses of Sexuality from Aristotle to AIDS*, ed. Domna Stanton (Ann Arbor: University of Michigan Press, 1992), 297–311.

22. Higonnet, *Berthe Morisot's Images of Women*, 204.

23. James E. Young, *The Texture of Memory: Holocaust Memorials and Meaning in Europe, Israel and America* (New Haven: Yale University Press, 1993).

Focusing on the Family:
Family Pictures and the Politics of the
Religious Right

ANN BURLEIN

For the religious right, family photography and the family album provide an ideal medium of representation for promoting the conservative politics of family values. My analysis in this paper concentrates on primary materials drawn from Focus on the Family, one of the most influential organizations in the burgeoning family values movement.

Focus on the Family deploys the family as a resisting image that appropriates popular protest for a conservative politics. This appropriation draws on the conventions of the family photo album as well as on the referential aspect of photography to represent the 1950s family not as an antiquarian past, but as an unchanging truth that exerts a powerful claim on people in the 1990s. Calling America to "focus on the family" disciplines people's affective investments. By aligning the private family with private business, the religious right eclipses the public from view, thereby depoliticizing both populist protest and the significance of difference.

Focus on the Family

Focus on the Family began in 1977 when child psychologist James Dobson left his joint positions at the University of Southern California School of Medicine and the Los Angeles Children's Hospital and started a weekly twenty-five-minute local radio program. Today this program is heard daily on over four thousand stations across the globe. The original radio program has spawned over sixty different media ministries, including multiple radio and video series

for children; book and magazine publishing; educational resources; a cultural studies program, which sponsors seminars and monitors youth culture (including multicultural and sex education curricula as well as popular media); the Institute for Family Studies, where college juniors earn credit for spending a semester at Focus on the Family; and a public policy division, which issues reports (on topics like the social dangers of homosexuality) and sponsors seminars across the nation to educate religious conservatives regarding how their beliefs can affect politics. Dobson was also influential in forming a national organization, the Family Research Council, to ensure "representation for the Christian perspective" in Washington.[1]

In keeping with this wide scope, Focus on the Family operates on an annual operating budget of over one hundred million dollars. The organization acquired a sufficient national profile to be recruited by the Colorado Springs Chamber of Commerce as part of a municipal plan to rebuild the local economy by bringing national nonprofits to the town. As the jewel in the crown of this program, Focus on the Family was offered a four-million-dollar grant from one of the premiere local charitable foundations; Focus on the Family used the grant to acquire a forty-seven-acre campus. When I visited this new campus in 1994, the staff were receiving an average of 3,000 to 4,000 phone calls and 8,600 letters each day.

Dobson has gradually translated his high profile in evangelical and fundamentalist subcultures into a more mainstream political presence. In 1980, he was appointed to President Carter's White House Commission on the Family after he announced on the air that he wanted to be appointed, and thousands of his listeners called the White House. Dobson has subsequently served in numerous advisory roles to presidents Reagan and Bush. During the 1996 Republican presidential primaries, all four candidates trekked to Colorado Springs to speak with Dobson, who (along with other religious right leaders) pressured the Republican Party to resist tilting toward "moderation" on issues like abortion.[2]

Focus on the Family represents itself as "dedicated to the preservation of the home." The organization executes this mission by elaborating a "comprehensive, rational and biblically based conception of the family."[3] According to Focus on the Family policy analyst Glenn Stanton, "at creation, God set certain laws into motion with intelligence and intention. This included a norm for family life."[4] Focus on the Family teaches that "the heart of God's plan for the family is a marriage of a man and a woman for life," each of whom embodies biologically differentiated gender roles.[5] Focus on the Family sees itself as defending this norm against a secular humanist conspiracy which emerged from 1960s social movements and gradually captured "most of the power centers of society." Ensconced in the halls of power, secular humanists institutionalized government support for programs such as Planned Parenthood, multicultural curricula, civil rights, teacher's unions, as well as church-state separation.

Dobson describes these diverse projects as part of a "well-thought-out and co-ordinated" conspiracy to eradicate all memory of America's Christian heritage by redefining cultural norms regarding the family, gender, and sexuality.[6]

While the organizational rallying cry is "Focus on the Family," the organization's primary purpose is evangelism. By "turning people's hearts toward home," Dobson hopes to turn their hearts toward Jesus Christ, "the creator of homes." As Focus on the Family explains in its 1995 promotional brochure:

> In a godless society where human hearts have become hardened to traditional Christian evangelism, Focus on the Family is developing new approaches to reaching a world that does not know the Savior. We've discovered that people who might never attend church or allow someone to witness to them will listen to what the Bible says about a meaningful home life. Thus, the connection between meeting the family's relational needs and addressing its spiritual emptiness is the key to helping us present the Gospel of Jesus Christ in homes across the country.[7]

This brochure acknowledges that talk about the family is also a strategy for Christianizing American culture.

The key to the success of this softer style of evangelism is Dobson's ability to represent Bible-based family values as an image of resistance. Dobson constructs the family as a place of identification and investment from which people are empowered to resist capitalist market logics. Dobson speaks clearly about the dangers of over-consumption, for example, warning that people can become slaves to the things they buy. He warns against becoming so consumed by work that there is little time for emotional or spiritual relationships. Reading Dobson, I am continually struck by his ability to articulate how contradictory postmodern life feels to those sufficiently privileged to live in its spaces: the sense of being overwhelmed by limitless choices coupled with a pervasive feeling of powerlessness and emptiness; the high affective stimulation combined with apathy, indifference, and boredom; the surplus of information but relative scarcity of meaning. In explicit contrast to market imperatives that interpellate people by urging "Achieve at all costs!" or "Thou shalt consume!", Dobson offers an alternative imperative for identity: focus on the family.

While Dobson offers the family as a site from which people can resist the relentless market solicitations to become a citizen consumer, he frames this populism within theories of secular humanist conspiracy. Such theories position populist protest within a series of binary oppositions that function like vectors of force to orient people toward the right. According to this conspiracy theory, social movements represent special interests rather than the common

good. In keeping with their concern for the public, such movements are funded by big government and are therefore represented as parasitic upon the people, who must take money away from their families to pay the taxes that foot the bills for these experimental social programs.

Framed in this way, the "private" functions as a switchpoint between two different dimensions: the private realm of heart and hearth, but also the realm of private business. While focusing on one's family can empower people to resist frustrating and frightening transitions, a politics of family values deepens popular apathy and alienation by cutting off people's connections with larger and more public communities in favor of confining their primary identifications within the private family. This focus makes collective public action disappear as a viable option for how the nation might respond to the hardships incurred by the populace as it lurches toward a postindustrial service economy. The saving and regenerative power of the private realm effectively eclipses notions of the public.

As a result, while the private family is invoked as a site of populist protest, Dobson reorients the force of this protest in ways that sacralize the morality-inducing disciplines of the private sphere—both the family and the free market. Dobson's call to save America by focusing on its families presupposes a public that denies its broad interconnectedness. When it comes to empowering people personally in ways that disempower them politically, there is no medium better suited than family photography and the family photo album.

Focusing on the Family in Pictures and in Politics

Family photography and the family photo album have been crucial to Focus on the Family's construction of the family as an image of resistance that disciplines popular protest. Photos of happy families fill the organization's magazines, brochures, and videos. Moreover, pictures from the family of founder and current president James Dobson are prominently featured in promotional materials that narrate institutional memory. For example, the video that the organization produced to commemorate its new forty-seven-acre campus in Colorado Springs contains home footage of Dobson as a child. Little Jimmy Dobson toddles in the park with his parents while the voice-over attributes the organization's inspiration to Dobson's relationship with his father (a Nazarene minister) and his resulting commitment to give every child a childhood like his.

Each month Dobson writes a letter that is sent for free to everyone on the mailing list (which includes over two million names). This newsletter is one way Dobson keeps in touch with his vast constituency, reiterating his central mission: namely, to discipline the nation by calling on its people to regulate their affectional and sexual preferences in submission to a Christian norm for family life. As Dobson sees it, only Christian sexual norms can stop the national

decline that began during the 1960s.[8] Christians have a duty, not simply to become involved in politics, but to Christianize the political sphere. Thus Focus on the Family's Public Policy Division sees the religious right as "not just another special interest group, but everyone's best interest group."[9]

Remembering 1954

In June 1994, Dobson styled his newsletter to resemble a family photo album commemorating his fortieth high school reunion. The first page appears as a grainy leather cover, on which are embossed the words: "The year was 1954, and we were all very young . . ."

The letter opens by placing readers on the beach with Dobson's senior class just one week before graduation. The account is golden-toned as only nostalgia can be: a carefree day of sun and surf, made even more precious because Dobson writes in the past tense from a standpoint of seeing this day as "the twilight of an era . . . and the end of a marvelous childhood." Although Dobson and his friends did not realize it at the time, this day was one of the last days before they assumed "endless adult responsibilities," in whose shadow these golden sun-bathed memories "eventually dissolve[d] into black and white."[10]

Indeed, all that remains of these golden memories are black-and-white photos, which the newsletter reproduces as if they were pictures on the pages of a family photo album, complete with pretend picture corners. Alongside the text of Dobson's letter, we see Dobson's high school as it looked in 1954, the high school cheerleaders ("this is how I remember the girls in my class," reads the facsimile hand-written caption), his wife Shirley's homecoming queen picture, his college tennis team, Dobson driving a 1949 Mercury, his graduation picture, and a group shot of his classmates at their 1994 reunion.

These photographs bring home the powerful sense of loss Dobson strives to communicate in his words. Photographs embody a contradictory dialectic. They confront the viewer with a resounding presence: in the upper right-hand corner, we see the girls from 1954, posed in pyramid formation flashing cheerleader smiles, the brightness and vitality of which shine forth undimmed by time. But their presence is built on absence and loss: while these bright smiles are how Dobson remembers the girls in his class, the caption underscores that these young cheerleaders no longer exist. In case readers miss the undertones of loss, the lower right-hand corner of the same page features a picture of Dobson's classmates taken during the reunion, the caption of which reads: "We had all changed a bit by 1994."

The ironic juxtaposition of presence and absence, fullness and loss, that characterizes old photographs is crucial to Dobson's project of linking concern for the family with national decline. By foregrounding a sense of loss, Dobson represents his nostalgic reminiscences of 1954 as a testimony to the past that

exerts a claim upon the present. Dobson explicitly offers his family photo-graphs and the reminiscences that surround them as a rebuttal to "liberal his-torians who have tried to re-write the record of the 1950s" (5). These historians have deconstructed the Ozzie and Harriet family of the 1950s as a fiction— "The Way We Never Were" (to quote the title of Stephanie Coontz's best-selling book). Take it from the "eyewitness account of a teenager who was there in 1954," Dobson counters, "it was a very good year" (5). He devotes this June newsletter to providing that eyewitness testimony—not through statis-tics and sociological studies, but through an elaborate family fiction: readers are invited to join the family circle and listen as Dobson turns the pages of his family photo album and reminisces about old times.

Such an elaborate representational strategy is necessary in part because Dobson promotes his version of the Bible-based family across a generation gap. While the cover reads, "we were all very young," the majority of Dobson's readers were too young to have been cavorting on sunlit Texas beaches at the cusp of adulthood in the summer of 1954. Surveys reveal that the average Dob-son listeners are in their mid to late thirties. Thus Dobson directs his message primarily to the generation that came of age in the aftermath of the 1960s, the generation whose changing family arrangements are chronicled in books like Donald Katz's *Home Fires*.[11] Katz chronicles the fate of a working-class Jewish couple who move to the New York suburbs in the 1950s (marvelling that an electrician can escape the Bronx and give his family the beauty and comfort of the country) only to watch uncomprehendingly while their dream family dis-solves. New opportunities push their children into a different world of middle-class subjectivity that included fast-paced careers, drugs, divorce, therapy, Hare Krishna communes, feminism, and coming out as gay.

The genre of the family photo album enables Dobson to fashion his vision of the 1950s family not as an antiquarian past with no relevance to the 1990s, but as a remembered truth that exerts a powerful claim on subsequent genera-tions. In her introduction to *Family Frames*, Marianne Hirsch argues that the family photo album creates an "affiliative look" that focuses on similarities.[12] We say, for instance, "Look how much I look like Grandmother!" less because we have discovered traces of a physical resemblance and more because the context of the family album engenders a particular sort of looking, which fo-cuses on likeness rather than difference. By fashioning his newsletter as a family photo album, Dobson cultivates this affiliative look. This look positions readers to identify with the ideological point of view shaping Dobson's vision in both family pictures and national politics—even if his vision contradicts their own family structures or their own memories. This identification takes place less because their family arrangements really do look like this family and more because the context of the family album and the power of the conven-tions that shape family photography engender an affiliative look.[13]

Dobson offers these pictures as fact, not as wish-fulfillment: an eyewitness

account of a very good year. Yet no photograph simply records what is "there." Encoded in the act of representation is the perspective of the person using the camera.[14] The eye of the camera implies the I of the subject taking the picture. A photographer brings a family photograph into focus in part by means of mental images and social conventions of what a family looks like.

People most often see their families indirectly, through a screen onto which they project an image of the family they want to be. Family photography literalizes this psychic screen. We pose for the camera by composing our features and bodies in order to present the "proper" image, conforming to genre conventions for what a family photo looks like. When we look at these photos later, we look to recognize ourselves as family. Such pictures can function within the family in the way that more public monuments can function within national culture: professing ideals through a rhetoric of remembrance that is less concerned with reconstructing the past and more concerned with constructing screen memories that protect us from a history that questions our present.[15]

In his newsletter/photo album, Dobson multiplies the screens through which we view the family. He splices personal memories from his high school years and pictures from his private life with public media memories. The newsletter features a snapshot of Bill Haley and the Comets as well as a still photo of Ozzie, Harriet, and their two kids. The latter photo was taken to simulate Christmas, a holiday condensing the complex nexus connecting religion, family, and consumerism. The Nelsons are grouped in front of the fire, with wrapped packages at father's feet. The family is ostensibly reading together, only no one is looking at the book. Instead Ozzie gives all his smiling attention to the younger son, who basks in the twinned gaze of father and older brother, while Harriet looks lovingly at her husband looking at their son. This picture enacts a family romance: how the boy-child is called into being as a subject through an interlocking system of private looks. These mutually confirming looks construct a hierarchy of gender roles: the male gaze bestowing subjectivity; the wife's adoring look providing support and sustenance. In this picture, focusing on the family means focusing on the birth into subjectivity of the little boy and, presumably, the reproduction of heterosexual patriarchy, which Dobson deems necessary for national strength.

Strangely enough, the Ozzie and Harriet publicity picture is the only photograph depicting a family moment in the newsletter/photo album. Instead of portraying Dobson clad in graduation gown and cap sandwiched between proud parents—the traditional graduation family moment—the newsletter features Ozzie, Harriet, and their two sons. Dobson acknowledges the less-than-documentary status of this photo. The facsimile hand-written caption reads: "'Ozzie and Harriet,' yesterday's ideal, today's joke." The newsletter includes this "screen" memory with no apology. The Nelsons stand amid Dobson's family memorabilia as an overt invocation of the ideological screens

by means of which people bring their real-life families into focus. Its presence in this family photo album alongside authentic snapshots from Dobson's private family testifies to the way that family pictures are mediated through ideals, fantasies, and conventions.

I emphasize this complex dynamic of mediation because people often try to resist the religious right by exposing the counterfactual and contradictory nature of its claims. While such analysis is important, uncovering the counterfactual and simulated nature of family values does not dispel the power of these nostalgic images. The Ozzie and Harriet family might indeed be fictional—"the way we never were" biologically, historically, or biblically. Yet in an information society saturated with media images, the simulated relation of this fantasy to the world can be more powerful than the way we were—or are. Focus on the Family's surveys suggest that not only are the majority of Dobson's constituents too young to remember Ozzie and Harriet, most do not live in families that mirror the Nelson norm. Yet this lack of fit does not seem to prevent Dobson's constituents from identifying with that family.

Postmodern theory suggests that it might be precisely the emptiness of the family that enables Dobson to deploy this image as an affective magnet, which constellates people around its heart/hearth. Jean Baudrillard argues that postmodern images are powerful precisely because of their ability to be separated from reality in what are often wrenching contradictions.[16] In a media-saturated culture, media images can blend into people's lived memories, so that it becomes difficult to distinguish what one saw on TV from what one experienced.

Because of its overtly simulated character, it is the Ozzie and Harriet family picture that connects Dobson's private family pictures with national politics. In the paragraphs framing Bill Haley and the Nelson family, Dobson's text shifts from recounting personal memories of his teenage years in the 1950s (such as the day he exploded all four shocks on his father's new Ford) to reflecting upon "how dramatically the world has changed since 1954." From this vantage point, the world was not just different in 1954. "In many ways, it was better" (4).

Looking at the Nation through the Familial Gaze

In keeping with Roland Barthes's claim that photographs block mourning, Dobson articulates loss into a conservative politics that protests modernity in the name of the Bible-based family.[17] From the Ozzie and Harriet family to the Christian family to the human family: the superficial conventionality of the family photo album as a genre erases the power relations at work in this family tree. Indeed the links in this great chain of being are predicated on identifying the middle-class WASP family as the family. This conventionality makes the family appear all-inclusive, as if transcending the social divisions of race,

class, and gender. While the conventionality of family photographs enables Dobson to represent his family as natural law rather than social convention, the exclusions that enable these representations are expressed quite powerfully in the narrative about "America" that surrounds these pictures.

What characterizes Dobson's representation of 1954 as "the good ol' days" is a double gesture by which Dobson appears to recognize others, but only by rendering differences invisible. As evidence that 1954 was "a very good year," Dobson cites the fact that Christian morals were not contested publicly. While he acknowledges that some kids did more than think about sex, when "a girl came up pregnant," Dobson informs us, "she was immediately packed off to some secret location" (5). What was right and blessed and good about 1954 was not that teenagers did not get pregnant. What was right and blessed and good was that pregnant teenage girls were so stigmatized they were removed from sight.

Likewise, Dobson celebrates 1954 as a year in which religion had not yet been trivialized in American culture. As evidence that "expressions of faith were woven into the fabric of our lives," Dobson notes that "my father prayed a beautiful prayer at our graduation ceremony and there were no objections to it" (6). Dobson cites Chief Justice Earl Warren (as quoted in the February 1954 issue of *Time*) affirming that "no one can read the history of our country . . . without realizing that the Good Book and the spirit of our Savior have from the beginning been our guiding geniuses . . . [in the effort to create] a Christian land governed by Christian principles" (6). Dobson acknowledges that his fellow students "were not all Christians, of course, but many were."

What made 1954 such a good year was that Dobson did not have to hear objections from his classmates who were not Christian. Nor did he have to focus on the relation of power at work in proclaiming America a Christian nation. While Dobson acknowledges that not all his classmates were Christian, he includes them only in order to affirm the invisible workings of majoritarian power. "Not all, of course, but many": the phrase testifies to a desire for the tyranny of the majority to pass unnoticed and unprotested.

From a different perspective, however, one could remember 1954 not as the year when majority rule went unprotested, but as the year when fissures publicly began to erode the hegemonic power of white supremacy as a benevolent social order. In 1954 the Supreme Court declared "separate but equal" schools unconstitutional. While Dobson acknowledges that "the scourge of racism was well entrenched in Western countries," he deems racism an "imperfection" of slight significance: "But the Fifties were not yet besieged by the moral freefall we are witnessing today" (7). In the same paragraph in which Dobson mentions the Supreme Court's 1954 decision declaring segregated schools unconstitutional, he argues that what made America great in the 1950s was not her economic or military power, but her moral goodness. For Dobson, the national insistence on reinscribing white supremacy in the aftermath of the Civil

War (an insistence epitomized by separate but equal practices) does not lead him to question his memory of 1954 as a year when "America was great because America was good"(7). Racism is obliterated in the whitewash of moral goodness.

Rather than overtly denying or prohibiting difference, Dobson cultivates an affiliative look through which he strives to render differences not worth talking about: "not all [were] Christians, of course, but many were." Dobson acknowledges difference, but his focus on the Christian majority as the norm for American life excludes difference from public impact, thereby politically neutralizing it. While Dobson acknowledges that racism was a problem (although not, he declares, in the integrated Texas town where he grew up), he claims that any legitimate problem was immediately recognized and speedily rectified. Thus he sees no need for loud political movements demanding changes such as multicultural education, affirmative action, and welfare rights.

In *The History of Sexuality*, Michel Foucault argued that power in modern societies is exercised less as a prohibition ("Thou shalt not follow thy heart's desire") and more as a productive norm ("Thou shalt consume!").[18] In keeping with Foucault's insight, I suggest that Dobson encourages people to focus on the family in ways that discipline difference by demonizing political movements. Inscribed within the family as a norm is the dream of an acceptable other who self-disciplines so successfully that he or she can be added to the social order without changing, discomforting, or disrupting those who identify as the majority. Underneath this fantasy of the acceptable other whose difference is so slight that he or she need not be granted "special" rights in order to succeed lies a fantasy of social consensus facilitated by a familial look. Cultural critic Lawrence Grossberg suggests that

> the real source of both contemporary forms of depoliticization and of
> the increasingly conservative tone of life in the United States depend
> on the production of a new regime of everyday life . . . Everyday life be-
> comes the site for and the mode of a new apparatus of power, aimed at
> depoliticizing significant segments of the population by erasing the
> lines that connect everyday life to the political and economic realities
> that are its conditions of possibility.[19]

The family is a primary image through which this separation is effected. Focusing on the family provides a way for people to exclude, evade, and efface difference while professing connection and compassionate inclusion. Dobson's promotion of the family as a productive norm empowers conservative Christians to feel a duty to press their moral beliefs on their communities—and to feel this duty in such a way that ending welfare, for instance, feels more like loving their neighbor than like taking away their neighbor's rights.

Just as people perceive their families through the screen of the family they wish they were, so a politics of family values mediates our vision of that imagined community we call "America." That vision is produced by projecting a fantasy of social consensus in which white middle-class Protestant hegemony is represented, not as a relation of power, but as an innocent act of benevolence: not all were Christians, but most were. The strategy is soft-sell. Just as his ministry promotes the family as an indirect strategy to Christianize America, so Dobson does not so much exclude difference as he indirectly redeploys it. By invoking the family, Dobson disciplines differences as he scapegoats political movements. The net effect of this alleged inclusion is to depoliticize structural injustices such as racism, so that, finally, no difference can make a difference. In this way, Dobson skillfully deploys family photography and the family picture album to reinscribe a fantasy of social consensus for the 1990s.

Whither Nostalgia? Back to the Future

For however much Dobson extols 1954 as America's Golden Age, he does not focus on the 1950s family in order to return us to its bygone socioeconomic arrangements. Even in a letter oozing with nostalgia—indeed, perhaps *especially* in such a letter—Dobson explicitly eschews a traditionalist approach to the past. While he uses his high school pictures to evoke the sense that "we are no longer who we once were," he concludes his newsletter/family photo album by proclaiming: "Can we return to the 'Happy Days' of the Fifties? No. It is still impossible to back up on a freeway. As the late novelist Thomas Wolfe wrote, 'You can't go home again.'" (7). One might not be able to go home again—but one can certainly appeal nostalgically to the past in order to clear a space from which to protest the present.

The point of Dobson's nostalgia is not the content of the past he recalls, but nostalgia's ability to function as an affective structure that positions people to refuse to identify with the present. There is an Eden myth at work here, but Dobson's invocation does not primarily seek to restore a primordial time. In fact, while in his June 1994 newsletter Dobson invokes the 1950s as that mythical moment when America fell from Eden, in other writings he might identify the Golden Age as the 1920s, and at still other times as the Victorian era. These multiple invocations reveal that what matters most is not any specific historical period, but the gesture of invoking a utopian moment. What is at stake in these multiple Edens is a kind of "nostalgia for nostalgia." Lawrence Grossberg interprets this form of nostalgia as a longing to believe in the possibility of belief.[20] 1954 functions as an empty placeholder, a screen that Dobson can fill with quite contradictory historical content, because Dobson is primarily oriented not toward remembering the past but toward disciplining the future.

Dobson confronts a postmodern world where people resist the deluge of information that bombards them by developing a stance of active indifference. Faced with such a present, Dobson's appeal to the family through the golden lens of nostalgia enables him to construct the possibility of caring about anything at all. Dobson is able to call people to turn their hearts and convert to political action, despite how insurmountable and incomprehensible social problems seem, by offering the family—and particularly the position of parent—as a place from which they have an unquestioned right and ability to take a stand. However complicated the world may have become, Dobson asserts that parents can, must, and do assert power over their children. As surely as parents exercise authority over children, so surely do parents have the right—indeed, the duty—to exercise ownership over the culture in which their children are being raised, actively resisting all public policies (whether regarding taxes, nonprofit status for churches, or multicultural curricula) that threaten their own. Dobson uses the rhetoric of "saving your children" to reverse the sixty-year-old evangelical tradition of seeing the world as a "wrecked vessel" from which Christians should save only souls. In the current cultural climate, Dobson argues, Christian parents cannot save their children's souls without first waging a culture war to save the nation that places their children at risk. Dobson's appeals to the family wage a public war for private ends.

Resisting Nuclear Politics

I want to conclude by invoking another picture of the 1950s family, one not included in Dobson's newsletter/photo album. The picture comes, instead, from the cover of *Homeward Bound: American Families in the Cold War Era*, by Elaine Tyler May, one of those liberal historians whom Dobson suspects of rewriting the record of a very good year. In this picture, Mom, Dad, and their three kids pose amid an astonishing array of commodities in the family fallout shelter. There are stacks of blankets to keep them warm, candles and flashlights in case the power goes out, a Coleman stove on which to cook the rows of brand-name canned goods that line the shelves, Scrabble and Clue to while away the hours until the radioactivity subsides, and a shovel to dig their way clear when it is safe to come out. Unlike the smiling faces in the 1950s photos in Dobson's newsletter, this family stares out at the camera grimly.

This picture resists affiliative looks. It is not the sort of family picture one finds in a family album. I invoke this picture because it refuses to erase the lines connecting everyday life to the economic and political realities that are its condition of possibility. Instead, this picture's focus on the nuclear family reveals the sentimental invocation of the family norm as a domestic strategy of power with complex connections to the foreign policies of the Cold War. Abroad, the specter of nuclear weapons was deployed to discipline foreign

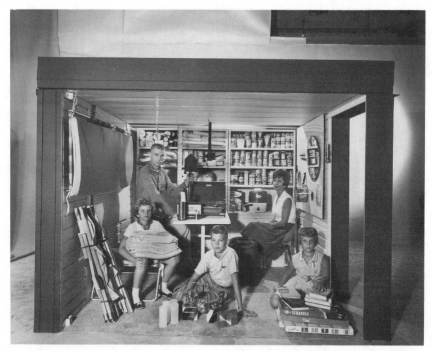

A 1950s family poses in their home fallout shelter. Photo by Dmitri Kessel, *Life Magazine*, © 1961, Time Inc.

threats while at home the nuclear family with its rigid gender roles was constructed as a bulwark against Communism, class conflict, and internal subversion.[21] By resisting the golden-toned nostalgia that dominates the pictures in Dobson's newsletter/family photo album, this picture can, I hope, join with the other resisting images featured in this volume to evoke resistance to a politics of family values that cynically invokes the family in order to depoliticize popular protest.

Notes

1. Rolf Zettersten, *Dr. Dobson: Turning Hearts Toward Home* (Wheaton, Ill.: Tyndale House, 1989), 151–52.

2. Marc Fisher, "The GOP, Facing a Dobson's Choice," *Washington Post*, July 2, 1996.

3. "Focus on the Family: Who We Are and What We Stand For," *Focus on the Family Magazine* (August 1993): 10.

4. Glenn Stanton, "Guess What? God Knows Best: Scientific Research Vindicates the Creator's Idea of the Family," *Focus on the Family Magazine* (August 1995): 4.

5. "Focus on the Family: Who We Are and What We Stand For," 11.

6. James Dobson and Gary Bauer, *Children at Risk: The Battle for the Hearts and Minds of Our Kids* (Dallas: Word, 1990, 1992), 19, 37–39.

7. *Focus on the Family: Our Faith, Values, Mission and Guiding Principles*, n.d., received with the November 1995 newsletter, 5.

8. Dobson, *Children at Risk*, 46–60.

9. John Jessup and Greg Eldredge, *Community Impact Seminar* (Colorado Springs: Focus on the Family, 1993), 51.

10. James Dobson, June 1994 Focus on the Family newsletter, 2. Hereafter cited in text.

11. Donald Katz, *Home Fires: An Intimate Portrait of One Middle-Class Family in Postwar America* (New York: HarperPerennial, 1992).

12. Marianne Hirsch, *Family Frames: Photography, Narrative and Postmemory* (Cambridge: Harvard University Press, 1997).

13. Interestingly enough, Dobson does this not by presenting his baby pictures (as in the promotional video mentioned earlier), but by styling his newsletter as a high school picture album featuring optimism, energy, a generation about to leave home and take up leadership roles in society. At about the same time as Dobson sent out this newsletter, Focus on the Family launched a series of new youth ministries geared to "Generation X." These ministries included book and video series with titles like "Sex, Lies and the Truth" and "Life on the Edge," all of which represent Generation X as a generation with no identity, threatened with destruction through drugs, AIDS, teen pregnancy, and popular culture. Thus Dobson's June newsletter offers parents the smiling optimism of teens whom they wish their kids would grow up to be—ready to take on positions of leadership in the world.

14. Victor Burgin, "Looking at Photographs," in *Thinking Photography* (London: Macmillan, 1982), 146.

15. James E. Young, "Introduction," *The Texture of Memory: Holocaust Memorials and Meaning* (New Haven: Yale University Press, 1993), 1–15.

16. Jean Baudrillard, *Simulations* (New York: Semiotext, 1983), 30.

17. Roland Barthes, *Camera Lucida: Reflections on Photography*, trans. Richard Howard (New York: Hill & Wang, 1981), 91.

18. Michel Foucault, *The History of Sexuality*, vol. 1, trans. Robert Hurley (New York: Vintage 1978).

19. Lawrence Grossberg, *We Gotta Get Out of This Place: Contemporary Conservatism and Postmodern Culture* (New York: Routledge, 1994), 294; and citing Henri Lefebvre, *Everyday Life in the Modern World*, trans. S. Rabinovitch (New Brunswick: Transaction, 1984), 61, 64.

20. Grossberg, *We Gotta Get Out of This Place*, 267.

21. Elaine Tyler May, *Homeward Bound* (New York: Basic, 1988), 16; and see also John D'Emilio, *Sexual Politics, Sexual Communities: The Making of a Homosexual Minority in the U.S., 1940–1970* (Chicago: University of Chicago Press, 1983).

Conclusions Based on Observation

ANNE HIGONNET

In January 1995, a long child pornography case finally ended. *Knox v. United States* had bounced from the District Court of Pennsylvania to an appeals court to the Supreme Court and back again to the Third Circuit Court of Appeals, after which the Supreme Court refused to hear it again. The vicissitudes of the case magnified *Knox* into a national debate over child pornography. By the time it ended, *Knox* had altered First Amendment free speech law, enflamed public opinion, pitted virtually the entire Congress against the justice Department, and launched child pornography into the 1994 Republican "Contract With America" alongside issues such as welfare and the national deficit. Meanwhile, *Knox* let images of children, and potentially all images, slip from the category of "speech" protected by the First Amendment into the unprotected category of "action."

Childhood has become sacrosanct. Americans place a high value on childhood not only because we care about how actual adults treat actual children, but also because we freight childhood so heavily with ideals. Once upon a time, the values of innocence, purity, and nature could be variously located. Now we seem able to find them only in what we imagine to be the beleaguered bastion of childhood. If natural pure innocence is equated with a complete absence of sexuality—as it commonly is now in the United States—then sexual abuse of children violates the ultimate social taboo. From there it takes one step to blame child pornography. And one step more to censorship. Two dangerous steps.

Our current cultural climate made *Knox* an accident waiting to happen. Scandalous Calvin Klein ads and FBI stings of Internet offenders are only the

latest manifestations of a growing national obsession with images of children. For years, Americans have been becoming increasingly sure that they can and should interpret images of children, distinguish right images from wrong images, and punish offenders. In every case, this certainty is fueled by the assumption that images bridge reality and representation, and that therefore actual children will be protected by the censorship of images. Kathryn Harrison's 1993 novel *Exposure*, for instance, warned that photography can damage real children both physically and psychologically. The novel spins a story of an abusive father-photographer whose invasive image-making nearly kills his daughter and leaves her on the verge of insanity. The book became a best-seller and many reviews of it extended the messages of its narrative, explicitly linking *Exposure*'s fiction to actual photographers, most often to Sally Mann, a controversial contemporary young artist who uses her own three children as models.

Photography, of course, is the problem. Child pornography cases now always turn out to be photography cases. The impulse to censor images of children in order to protect actual children depends entirely on a belief in photography's realism. To be convinced by photography's realism, in turn, requires certainty about some difficult questions. Are photographs poised exactly on a boundary between reality and representation? To what extent do photographs belong to the realm of the imaginary, and to what extent do they record events or persons? Can we know what a photograph "really" represents?[1] These questions are old and basic; though exacerbated by the medium of photography, they apply to any work of art, visual or verbal; they could be, and have been, debated in modes ranging from the philosophical to the practical. So far, however, these basic questions have not been part of a debate called child pornography.

Child pornography became an issue only recently. Not until 1984 was child pornography legally distinguished from other pornography and defined according to a stricter standard. This first 1984 child pornography law mandated the prosecution of anyone engaged in the "lascivious exhibition of genitals." The "factors" which make an image of a child illegal in this country now include

> whether focal point of visual depiction was on minor's genitalia or pub-
> lic area, whether setting of visual depiction was sexually suggestive,
> whether minor was depicted in unnatural pose or in inappropriate attire
> considering his age, whether child was fully or partially clothed or
> nude, whether visual depiction suggested sexual coyness or willingness
> to engage in sexual activity, and whether visual depiction was intended
> or designed to elicit sexual response in viewer . . .

and finally the defendant's use of the image regardless of the photographer's intent. In contrast with adult pornography: "constitutional requirements for

child pornography are much simpler and more susceptible to credible asser-
tion . . . [a] conclusion based on observation, not one based on evaluation."[2]

The law reads like a laundry list of vague terms. What does "sexually sug-
gestive" mean, applied to places, poses, or attire? Has Congress invented a
kind of Geiger counter for "sexual coyness"? "Sexual response" is remarkably
singular. Our legislators feel confident that they can see right through images
to someone's unambiguous thoughts, but who is that someone, and how many
someones need to be involved—will one suffice, and which one? Most dis-
turbingly, the frame of legal interpretation slips and slides in every direction;
"design," "intent," and "use" are treated interchangeably, but somehow "obser-
vation" remains reliable, precise, and consistent.

The word "exhibition" alone signals a visuality the law assumes and con-
demns but never confronts. Legal logic evades its crucial equation of child
pornography with "visual depictions," and of images with photography. Only
the realism that photography is supposed to guarantee could logically allow
judges, lawyers, and legal scholars to withdraw images from the category of ex-
pression they call speech and place them instead in a category legally called
action. Debates about adult pornography often make the same unexamined
assumption, but child pornography can now terrify anyone into blindness.
Take for example Catherine McKinnon's and Ronald Dworkin's notorious ex-
change in the 1993 pages of the *New York Review of Books*. Neither recognized
a distinction between verbal and visual representation they both implied. This
was not so surprising on McKinnon's part. The title of her recent book *Only
Words* notwithstanding, she tends in practice to attack images rather than
words (images such as exhibitions at the University of Michigan Art Gallery).
Dworkin, too, however, though a staunch a defender of free speech, was quick
to make one exception to his position, the exception of child pornography, a
child pornography whose visuality he also both assumed and ignored.[3]

Perhaps because everyone feels they understand photography perfectly
well, no one trained in visual issues or visual history has participated in draft-
ing, deciding, or debating child pornography law. No one wants to be branded
a child abuser (even by association). It does not feel good to be implicated by
opinions such as that voiced by Andrew Vachss, a lawyer specialising in child
abuse cases: "In truth, when it comes to child pornography, any discussion of
censorship is a sham, typical of the sleight-of-hand used by organised paedo-
philes as part of their ongoing attempt to raise their sexual predations to the
level of civil rights."[4] So the assumptions go unchallenged.

Moral panic prevails. Little of what used to be called child pornography cir-
culates now in the United States, and less of it is produced. Already by 1980
the official and very thorough "report to the General Assembly" by the Illinois
Legislative Investigating Committee called *Sexual Exploitation of Children*
dismissed the myths of 300,000 children involved in multi-million-dollar child
porn rings run by the mafia. The report did discover child pornography, most

of it made for private use or circulation by "individual child molesters."⁵ According to the report, in 1980 the FBI completed a two-and-a-half-year porn sting operation. "None of the 60 raids resulted in any seizures of child pornography, even though the raids were comprehensive and nationwide."⁶ The longest lasting, biggest-selling underground child porn magazine of the 1970s, the *Broad Street Magazine*, (of which one out of twelve pages in a typical issue included images) never sold to more than eight hundred individuals nor grossed more than $30,000 a year.⁷ Then came the crackdown of the early eighties. Even a spokesman for the National Law Center for Children and Families, a conservative children's advocacy group, said to the *New York Times* in February 1994: "There's really no commercial child pornography in the United States."⁸ Anxiety has shifted to a supposed black market exchange in images, particularly in computer images. Yet when, in September 1995, the FBI announced the results of an investigation into the viewing habits of 3.5 million America Online subscribers, they had been able to locate only 125 potential child pornography offenders, which included people soliciting sex acts with children as well as persons trafficking in images.⁹ A sting appeal for images of children engaged in sex acts reportedly received eight replies.¹⁰ Would we be shocked if we learned that 125 people in America might be guilty of any other crime? Do eight images constitute a cultural crisis?

Fear of child pornography continues to escalate. Ian Hacking has reminded us in his essay "The Making and Molding of Child Abuse" that we only recently invented current definitions of child abuse.¹¹ Yet the evil of child abuse now wields an axiomatic moral force powerful enough to override many arguments, including the argument that there is a boundary between reality and representation.

"We further assert that child pornography is the documentation of child abuse and, therefore, cannot be considered protected speech and/or a Constitutional right." This is the typical argument in favor of censorship, here articulated by Sara O'Meara, the cofounder, chairperson, and CEO of Childhelp USA, an organization devoted to "abused and neglected children."¹² Because this argument is not only compressed, but relies on compression, I want to restate it more slowly, step by step. Children are inherently powerless and therefore cannot give consent to sexual acts. Sexual acts with children are therefore criminal sexual abuses. The conditions under which children are photographed to produce sexual images are a form of child abuse, therefore the making of sexual images of children is a criminal act. Sexual photographs of children document their own making, therefore they are documents of a crime. Therefore the photographs themselves become criminal actions. Speech is protected by the First Amendment, but actions are not. Therefore sexual images of children, being actions, are not protected by the First Amendment and can be prosecuted as crimes.

This logic should be difficult to follow, because in its fully articulated form

it includes some difficult steps. Are the documents of an action equivalent to that action? If the action is a crime, are documents of it a crime? Are all visual representations of an action documents? The assumption that allows these questions to go unanswered is the assumption that photographs are documents, as opposed to representations.[13] Of course photographs can and do serve documentary functions. To adapt Abraham Lincoln's famous adage, some photographs document reality all of the time, and all photographs document reality some of the time, but all photographs don't document reality all of the time. Alas, our lawmakers now are all fooled all of the time.

Completely justified concern for real children has brought censorship of representation in its wake. By 1982, *New York v. Ferber* denied child pornography the possibility of artistic significance. By 1989, *Massachusetts v. Oakes* included children's nudity within the definition of pornography, provided the image showed "lascivious intent." The crucial case, however, is *Knox v. United States.*

Stephen Knox was a history graduate student at Penn State with a previous conviction for possession of child pornography when, in 1991, his apartment was searched, and the images in question, videotapes produced by a company called Nather, were seized along with supporting evidence. On October 11, 1991, Knox was convicted of possessing child pornography, a crime punishable by up to ten years in prison under federal law.

Knox v. United States set a legal precedent. The genitals of the children pictured in the Nather tapes were covered, the children were wearing what the court called "normal" clothing, and the children were not engaged in explicitly or implicitly sexual conduct, though often judges and reporters referred vaguely to "sexually suggestive poses." The children pictured had not been posed, had not been brought anywhere to be pictured, and were not even aware they were being taped. The Nather tapes were condemned as pornography because a zoom lens had been used to create extended close-ups of the children's clothed genital areas. Framing had made content illegal.

Knox had crossed a dangerous line. I would certainly accept a judgment on the circumstances in which a photograph was made based on the documentary a photograph might supply. I would reluctantly consider the judgment on an image's meaning based on its content. But I absolutely reject judgments on an image's meaning based on the framing of its content, or based on any other stylistic or technical aspect of an image. However marginally, the Nather tapes were not being used as documentary evidence. They were being judged as representations.

While the courts do not agree with my distinction, *Knox* gave them enough trouble to produce some curious reasoning. The U.S. District Court of Pennsylvania, where Stephen Knox was first tried, ruled against him on the grounds that the upper thighs of the children, which were sometimes exposed, were part of the pubic area. Stephen Knox received a five-year sentence. His appeal

to the Third Circuit Court of Appeals was denied on October 15, 1992. The upper thigh was not a part of the pubic area, the appeals court ruled, but exhibition of the genitals did not require that the genitals be visible.

Knox was appealed to the Supreme Court. As is customary in controversial or legally difficult cases, the Solicitor General wrote a brief to the Supreme Court advising it of his opinion. Unlike the Attorney General, under whom he nominally serves, the Solicitor General is not a political appointment and acts almost as an additional Supreme Court Justice. In his brief of September 17, 1993, Drew Days, III, for the first and last time in *Knox*'s history, addressed the central issue of the case. Although he did not make his point with force, Days argued that "lascivious exhibition" did require visibility *because* some aspect of the documentary content of the images, as opposed to their technique or effect, was required to constitute pornography. (Days's argument has frequently been caricatured as saying that all nude photographs of children are pornographic.) Days consequently argued that *Knox* had been judged on incorrect grounds. *Knox* was accordingly sent back (remanded is the legal term), with new instructions, to the Third Circuit Court of Appeals on November 1, 1993.

Knox exploded. Religious groups, child-advocacy groups, and almost the entire U.S. Congress claimed to represent children's interests by attacking Days's position. Tapping into their grass-roots organization, right-wing religious groups jammed Congressional circuits with their phone calls. Within three days of *Knox*'s remand, on November 4, 1993, the Senate passed a nonbinding resolution censuring the Justice Department position, 100 to 0. According to a constitutional law scholar, such censure is "almost unprecedented."[14] Eight days after the Senate censure, on November 12, President Clinton publicized a letter to Attorney General Janet Reno ordering tougher child pornography laws to obviate the Days brief. On April 8, 1994, a Federal Judge allowed a "friend of the court" (amicus curiae) brief criticizing the Days brief to be filed at the Third District Court of Appeals by 173 Republican and 61 Democratic members of Congress, joined by several organizations describing themselves as children's advocates, including the national organization Law Center for Children and Families. Twelve days later, on April 20, the U.S. House of Representatives echoed the Senate's censure of the Justice Department, voting 425 to 3. The Third District Court reaffirmed its ruling on June 9, 1994. The court rejected the argument of Days's brief, citing the intent of Congress when it passed the original law, an intent clarified by Congress in its censures and in its friend of the court brief.[15] Immediately following the mid-term elections, on November 10, 1994, the Justice Department reversed its position on *Knox* in a brief signed by Attorney General Janet Reno. Because it is legally unprecedented for such a brief to be signed only by the Attorney General, and not by anyone else in the Solicitor General's office, we can assume that Reno's position was supported not by her own department, but by the White House. The lawyer for the Law Center for Children and Families, John D. McMickle,

reacted to this last *Knox* brief by saying to the *New York Times*: "This case is the first indication of how the Justice Department and the Clinton Administration will react in a conservative world."[16]

Obviously *Knox* raised questions bigger than itself. For Congress, several federal courts, and thousands of citizens, *Knox* served to take a stand on the entire issue of child pornography. I, too, think *Knox* deserves a stand on principle. But the principle I want to defend is a principle of interpretation. *Knox* located a fixed meaning within an image. Yet *Knox* itself proves how difficult it is to do any such thing—impossible, I would argue. The arguments of the District Court and the Court of Appeals both relied heavily on the context of the Nather tapes, especially on the titles of the individual tapes, on the texts that advertised the tapes for sale, and on the audience those titles and advertisements designated. Yet this reliance was never acknowledged, and all legal decisions purported to be based on the images alone. Press accounts, moreover, handled *Knox* in the same way, relying on the tapes' context yet pretending to see self-sufficient visual content. The mistake both judges and the press made was not about Knox's guilt, or about whether the Nather tapes were pornographic. Their mistake was a confusion between the frame of interpretation they used and the frame they turned into law.

The Nather tapes were not themselves intrinsically pornographic. The terms on which they were marketed made them pornographic. Titles such as "Young and Sassy," descriptions such as "Just as good as nudity, some say better," and promises of adult masculine heterosexual arousal made their intentions explicitly clear. Child pornography designates itself. Or, as *Time* magazine reports the words of Robert Thomas, described as "the online-porn leader" (now in jail): "The trick, he says, is in how you write the pitch lines that describe your pictures. This is especially true in the case of child pornography, which apparently pulls many of its images, which are of nude children, from nonpornographic contexts. Thomas, for instance, alleges that his more than five thousand images of nude children "are from nudist colonies. Many of them are family snapshots."[17] *Knox*, like all child pornography cases, should have been decided not on the basis of images, but on the basis of the practices that structure the meanings of images. *Knox* encourages Americans to castigate images and to deny practices. It thereby perversely sacrifices Freedom of Speech in vain. For the only effective control over action is the regulation of practices. Precisely because speech and action are categorically different, it is inefficient at best to pursue action through speech.

Child pornography cases should be sexual child abuse cases. Because I believe that children are inherently powerless in relation to adults, and cannot therefore "give consent" (especially not to their parents), I do think we should outlaw all adult sexual acts (heterosexual and homosexual) between children and adults. (Though drawing a line between child and adult will always, I admit, be somewhat arbitrary.) As I have already conceded, photographs or

films might provide documentary evidence of sexual acts between children and adults. Images might be used to prosecute actions. Interpretations of ambiguous visual sexual meanings, however, besides not being themselves actions, are not documentary evidence of anything. Interpretations are, and should be, subjectively and elusively imaginative. The image of a child, dressed or naked, might arouse many kinds of fantasies and desires. And that's just the point—many different kinds.

Take only one example, a 1925 photograph by Edward Weston titled *Neil, Nude* (illus. 1). According to today's standards, the image could easily be classified as child pornography. The image is fairly obviously an unaltered photograph. Therefore a real child, Neil, had to have posed for the photographer. Clearly the photographer was fascinated by the child's body, including by his genitals which are at the center of the image; the tight framing of the child's body could be interpreted to document prurience, just as it was in *Knox*. This photograph, moreover, is one of a series in which the photographer took multiple shots of the boy's torso, both from the front and from behind.[18] It would be no defense, today, to point out that Neil was Edward Weston's son. On the contrary: the specter of parental child exploitation would only fuel a censor's wrath. If a court were in doubt, it could rely on a convergence of opinion between two knowledgeable people who have little else in common. The art critic Douglas Crimp has written that the *Neil* series arouses homosexual desires,[19] while *Exposure's* Kathryn Harrison chose a *Neil* for an issue of *American Photo* magazine devoted to erotic photographs.[20]

Times have changed. For decades, *Neil* was interpreted as an artistic masterpiece, in two related but quite distinct modes. The first phase was modernist. By the time Edward Weston had reached what he considered his artistic maturity, he was committed to formalism. He adamantly rejected photography's documentary capacity in favor of abstraction. The beauty of his images, he insisted, resided in what he called "my vision," and in the autonomously aesthetic quality of the prints he made from his negatives. In his *Daybooks*, which became a bible for modernist photographers, he writes about the *Neil* series. January 6, 1926:

> If I am ever temperamental as story book artists are, it is while printing. The reason is based on economics. The first print must be perfect, which is of course expecting the impossible . . . One nude of Neil is "almost right." Should I reprint it? or is it "good enough?"

Next entry, January 7:

> Printing of yesterday yielded five more prints, the most pleasing, another nude of Neil, though I must say that I am not happy with the rendering of deep black in the white stock, which seems to solarize more easily

1. Edward Weston, *Neil, 1925.*
Gelatin silver print. © 1981 Center
for Creative Photography, Arizona
Board of Regents.

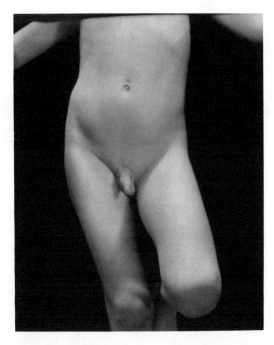

than the buff. The deepest blacks are not clean—they have a chemical
quality—yet Neil's whitest of white bodies should be printed on white.[21]

Later in the same entry, he repeats with pride the Mexican muralist Diego
Rivera's praise: "Your work leaves me indifferent to subject matter."[22]

The art world responded accordingly. Nancy Newhall, an architect of Wes-
ton's modernist reputation, described his nudes in 1952, carefully contrasting
them with documentary photography:

> The light he loves best is almost axial with his lens—the same light-
> angle at which a news photographer's flash bulb flattens faces and col-
> lapses space with its fake shadows. Here the luminous flesh rounds out
> of shadow; the shadow itself, from subtle recession to deep void, is as
> active and potent as the light. In the torso of his little son Neil, where
> he indicates how that long-neglected theme, the Male Nude, might be
> approached, sinuous shadows give life to delicate whites.

Newhall continued, referring to the inspiration by ancient Greek art that Wes-
ton himself had admitted in the early twenties:[23]

> In these, as often in Weston's work, the beholder sometimes recognizes,
> with a tingle down his spine, the originals from which various centuries

launched whole schools of thought. Here is a torso with the pure calm flow the Greeks took as ideal. The photograph is not Greek; it does not need to be. The reality it reveals existed before the Parthenon; it is continuous with man.[24]

True to her words, Newhall reproduced a *Neil* in the *Daybooks* side by side with an equally abstract nude of a woman. Two bodies, child and adult, where shown as formal analogues of each other.[25]

The second phase of *Neil*'s status was postmodernist. In 1980 Sherri Levine rephotographed six of the *Neil* nudes from a commercial poster and exhibited them in a Manhattan gallery. Her gesture became famous among art critics and historians when Douglas Crimp theorized it later the same year. In his article "The Photographic Activity of Postmodernism," Crimp explained how Levine had undermined a modernist cult of authorship by demonstrating that images are as much found as made, and found not in nature but in other images. Even photographs, Crimp argued, are about not reality, but ideas, an unending chain of idealizing desires. Like Newhall, he too used a comparison of the *Neil* photographs with ancient Greek sculpture, but for a different purpose:

According to the copyright law, the images belong to Weston, or now to the Weston estate. I think, to be fair, however, we might just as well give them to Praxiteles, for if it is the *image* that can be owned, then surely these belong to classical sculpture, which would put them in the public domain. Levine has said that, when she showed her photographs to a friend, he remarked that they only made him want to see the originals. "Of course," she replied, "and the originals make you want to see that little boy, but when you see the boy, the art is gone." For the desire that is initiated by that representation does not come to closure around that little boy, is not at all satisfied by him. The desire of representation exists only insofar as the original always be deferred. It is only in the absence of the original that representation may take place. And representation takes place because it is always already there in the world *as* representation. It was, of course, Weston himself who said that "the photograph must be visualized in full before the exposure is made."[26]

In retrospect, the modernist and postmodernist interpretations of Weston's *Neil* series do seem closely hyphenated. Modernists like Newhall—and, notably, Weston himself—did place a cult value on the authorship and originality of images (culminating in hierarchical distinctions among photographic prints from the same negative) that postmodernists like Crimp successfully deflated. Conversely, postmodernist theory never could match modernism's visuality. No one needs to see (a reproduction of) a Levine *Neil* to understand Crimp's argument about Weston's authorship. No one needs to

see anything to understand the argument. Nonetheless, considering these two arguments about the *Neil* series from the perspective of the mid-1990s, they have something crucial in common. Both modernism and postmodernism insist on the formal autonomy of images, on the value of aesthetic integrity, on a categorical distinction between reality and representation.

Writing during a panic about child pornography, I am struck by how equally indifferent Newhall and Crimp were to the content of the *Neil* series. Newhall did mention the "Male Nude," and Crimp did discuss a disembodied "desire," including a desire "to see that little boy," but it was simply beside either of their points to care that the *Neil* photographs were close-up images of a naked little boy's flesh. It seemed so irrelevant that, since 1925, the *Neils* with penises, the *Neils* with buttocks, and the *Neils* showing no genitals have been published interchangeably, as if this were not an issue. Now a penis is an issue.

I hope I have made it clear that arguments like Newhall's and Crimp's cannot be forgotten or dismissed. The argument I have made so far about *Knox* depends on their logic. In retrospect, however, I do also think that such arguments, including the one I have made so far about *Knox*, are necessary but not sufficient. For what we can see very clearly in the acute case of debates over child pornography is that logic cannot match the passions of the moment. Abstractly correct arguments do not evaporate historically specific concerns. Theory does not trump practice.

The argument now is not whether there is or isn't any artistic value in any image accused of child pornography. Proponents of censorship now weigh their goal of protecting children against artistic value. Already in 1987, Abigail Solomon-Godeau pointed out that Levine's appropriation of Weston's photographs would mean nothing to anyone outside the small circle who knew and cared about Weston's authorship.[27] Now it doesn't matter to many Americans who authored any image or whether an image is a work of artistic genius. Images are now being judged on the basis of the desires their content might arouse. Andrew Vachss, once more, provides a representative expression of this attitude:

> Are such depictions "art"? Again, the paedophile community seeks to make us complicitous in begging the question. The issue is not "what is art?" but "what is victimisation?" I can no more accept a child pornographer saying he is a victim of censorship than I could a mugger claiming his field of activity was performance art.[28]

Modernist and postmodernist art criticism now proves inadequate. It cannot ward off any argument like the current child pornography argument. However theoretically admirable, it simply doesn't function well enough now, especially not in the political and legal cultural arenas that subsume and control

the professional art world. Modernist and postmodernist art criticism explains the condition of aesthetics, or, to put it more broadly, the condition of representation. It fails, though, to account for or deal with the effects of aesthetics, of representation.

Effect hardly precludes condition, any more than history precludes theory. Swinging the critical pendulum back all the way toward arguments about effect, let alone about the accuracy or validity of any one effect, achieves little. I would never have devoted so much time to the abstract logical flaws of child pornography law if I believed that thinking about images should be either/or: either about condition or about effect.

Back to the *Neil* series. In 1990, Douglas Crimp recanted his position on Weston's and Levine's *Neil*s, writing of "blindness" and "a failure of theory generally." He had decided that the content of the *Neil*s did matter. "The men in my bedroom were perfectly able to read—in Weston's posing, framing and lighting the young Neil so as to render his body as a classical sculpture—the long-established codes of homo-eroticism." Crimp proceded to argue against homophobia and for the political right to protection of homoerotic images.[29] My problem with Crimp's revised argument is not its homoerotic interpretation of the *Neil*s. My problem is its suggestion that any one interpretation is definitive, a meaning someone could be "perfectly able to read" in the image itself, finding signs within the image to decode. For this is the logic that allows exactly the kind of censorship Crimp fights against.

Interpretive "codes" are not inherent in images. Radically divergent codes can find equally good fodder in the same image. I could, and will, offer an alternative code to Crimp's, which can be proved as well as others, without in any way denying Crimp's. To be committed to any one meaning, to insist on the validity and on the right to freedom of any one meaning, does not require rejection of other meanings. On the contrary. The condition of freedom for my interpretation of the *Neil*s is the freedom of Crimp's interpretation, and the freedom of a heterosexual pedophile's potential arousal by the *Neil*s. Criticism committed to a point of view—which analyzes, discovers, or promotes an effect particular to a time, place, or kind of person—cannot afford to lose sight of the condition on which it is allowed to see. Committed criticism has to be both committed and critical. Passion demands that its reasons be heard.

In addition to their other meanings—modernist, postmodernist, and homoerotic—Edward Weston's *Neil*s can be seen as images of parental passion. Biographical sources agree that Weston was a devoted, if unconventional, father to his four sons. It was with his children that Weston maintained the steadiest and most durable emotional relationships of his life (outlasting his many intense love affairs with adult women). His feelings for his boys had a banal physical dimension; like most parents, he believed his children were beautiful and was mesmerized by their carnal charm. This, for instance, is how he remembered taking the *Neil* negatives:

Besides Neil's companionship . . . he afforded me a visual beauty which
I recorded in a series of Graflex negatives of considerable value. He was
anxious to pose for me, but it was never a "pose," he was absolutely nat-
ural and unconscious in front of the camera. When I return he may be
spoiled, if not bodily changed, in mental attitude. Last spring in San
Francisco at eight years, he was in the flower of unawakened days be-
fore adolescence: tall for his years, delicately moulded, with reed-like
flow of unbroken line: rare grey eyes, ingenuous, dreaming, and a crown
of silken blond hair. He is a lovely child.[30]

Unlike most parents, Edward Weston had the skills and talent to represent a
parental gaze.

Long before he distilled his vision into abstract modernism, Weston was an
accomplished professional portrait photographer, with a special gift for por-
traits of children. Early in his career, in 1912, Weston went so far as to publish
an article on "Photographing Children in the Studio," which he called, "the
most interesting, fascinating, and one of the best paying branches of the busi-
ness (excuse me, profession!)"[31] Throughout the article he expresses an un-
usually genial fondness for all children, and a keen appreciation of their visual
appeal to parents. "Another way," he mentioned in passing, "to sell more than
one position is to suggest a nude study, if the child is well formed."[32] Weston
knew his subject intimately. Ever since the birth of his first child, he had been
filling albums with photographs of Chandler, Brett, Neil, and Cole: the usual
poses, settings, angles, and outfits, including no outfit.[33] Weston's *Neils* hover
on a cusp between parental photography and formalist photography.

To me, the *Neils* look parentally erotic. To me—I know I am speaking per-
sonally—they represent my maternal passion for my son's body. How many
times have I stared adoringly at him, caressed him, kissed him, hugged him,
inhaled his infant breath like the smell of life? I long for him physically when
we are apart; to hold him close is bliss. During the first years of his life I spent
most of my time with him caring for his body: feeding him, cleaning him, rock-
ing him to sleep—not out of obligation but with love. The *Neils* seem to me to
turn that experience of love into something exterior to myself, clearly visible
and supremely ordered, at once idealized and tangible, into misty greys, a rip-
ple easily defining one side of shadowed form, the body poured thickly, lumi-
nously, swayingly through the image, as if never-ending, never marred. The
Neils offer me a vision of plenitude, a token of untrammeled maternal joy.

Postmodern theory may correctly insist that all images defer desire, yet some
deferrals of desire act more effectively than others. The ineffable difference
between the beauty of a great print and an ordinary print may be a difference
only of degree, but desire too increases, or is deferred, by degrees. A great Wes-
ton print is just one degree more magical (a slightly more persuasive fetish?)
than any other Weston print, and many more degrees more magical than most

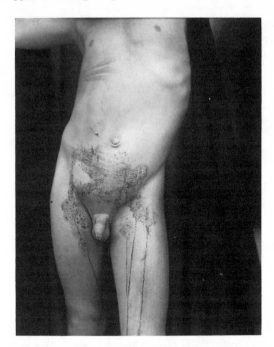

2. Sally Mann, *Popsicle Drips*, 1985.
© Sally Mann. Courtesy: Edwynn
Houk Gallery, New York.

other photographs. Of course I like photographs of my own child, but there is so much more to my maternal passion (call it experience or fantasy) than could be satisfied by clumsy references to his appearance. All those snapshots seem to me too obviously lacking, straining perpetually, asymptotically, toward an impossible (I know it's impossible) replication of what my child's being means to me.

My maternal longing finds only a temporary resting place at Weston's *Neils*. Desire drives me onward, pursued by the loss my child haunts me with ever since he was born and ceased being a part of me. Sometimes all the *Neils* frustrate me with their lyrical, liquid, elegiac elegance. Weston's vision of his child corresponds to a parental ideal I cannot always identify with. My maternal passion is only sometimes so limpid. I could find expressions of darker, more complicated, more visceral parental passions in many images. A growing number of gifted photographers, both women and men, are expanding the ways adults imagine their relationships to children far beyond the conventions of the past.[34] But in Sally Mann's 1985 *Popsicle Drips* I find another interpretation of Weston's *Neils*, which confronts everything about my maternal passion that Weston glides by, and which matches Weston's visual prowess (illus. 2).

Mann's photograph cites one of Weston's *Neils* exactly, but marks it as her own.[35] As if the Weston image were seen through a flame, Mann's image twists where Weston's sways, with a luminosity, blacker and brighter, smoky at the edges, and in the place of sharpest focus, clearest light, the mark. What is that fluid on the boy's body, smeared sideways across his chest like dirt ribs,

splashed below his navel, trickling down his thighs, framing his penis? The mark demands to be scrutinized, the photograph requires careful looking. Is it blood? My terrified maternal gaze at first assumes the worst, and rushes back and forth, looking for a wound. No wound—a thudding relief relaxes my eye, it's only the usual mess. My passion for my son's body is often so flickeringly pitted against dark fear, alternately assailed by and exorcising visions of damage. Sometimes I want him gone, out of my sight, not under my supervision (so I can write this essay), in someone else's photograph. And sometimes I can see with humor the flaws in my fantasy of his perfection, like a great photograph spoiled by a popsicle.

Like many of Mann's photographs of children, *Popsicle Drips* is not pretty, sentimental, or simple. It is not merely a photographic document, but a complex image that works self-consciously with its photographic medium and with the history of photography. And to me it is sexual, in the broadest and most life-enhancing way. I do not mean sexual in the way the word is usually used, and in that sense I think Sally Mann is quite right when she says her images are not sexual. She uses different words, words less narrowly construed. Her images, she says, are about "the grand themes: anger, love, death, sensuality and beauty," "told without fear and without shame."[36] Fear and shame are what child pornography hysteria heaps onto images of children to which the word sexual could be applied. Yet I will say it again. My passion for my child is sexual. I conceived, carried, and gave birth to my son with my body and I love him with my body. I cherish his body, in endless, daily ways. Like all irrational passions, mine has its many sides: selfless, proud, protective, it is also fierce, possessive, narcissistic, guilty, and mournful. Only passion could drag me through the sleepless nights, the tantrums, the resentments, and the boredom. A pretty, sentimental, simple, and desexualized maternity is what women have been confined to by a world they have little control over. I choose a version of parenting I see in images like Weston's and Mann's.

Many people loathe Mann's photographs. They would like to censor them. The concept of free speech was designed to protect political speech, which might not immediately appear to include images of children, especially not ambiguous and difficult images like Mann's. But I claim the parental desires Mann's work represents to me as a political right. I claim a political right to debate the definitions of parenting and childhood, including through images. My claim comes not from a belief in the superiority of my maternal desire over any other, but from the differences between the many interpretations images of children elicit. Child pornography law shuts down images of children to their lowest common denominator. Current law would like us to believe that it can ordain a "conclusion based on observation, not one based on evaluation" and maintain the essential democratic value of free speech. Only censored observation, however, does not evaluate or interpret; free observation always does. In the words of Yogi Berra: "You can observe a lot by watching."

Notes

This essay came out of a seminar I taught at Wellesley College in the spring of 1995 called "Imagined Children, Desired Images," and I owe an intellectual debt to all its members. I am grateful to James D. Herbert for giving me the opportunity to try out an account of *Knox* at the 1995 College Art Association meeting, as well as for his comments. Andrew McClellan's invitation allowed me to test an initial version of this paper at Tufts on an exceptionally responsive audience. A lunch with Sarah Winter put the paper in its current form. Thanks also to Wayne Koestenbaum and Laura Wexler for their excellent editorial suggestions. In another version, this essay appeared in *The Yale Journal of Criticism* 9, 1 (1996): 1–18.

1. As all photography critics know, responses to these questions have been many and various, as well as powerfully argued. Among the most famous is Roland Barthes's *Camera Lucida: Reflections on Photography*, trans. Richard Howard (New York: Hill and Wang, 1981). [*La Chambre claire*. (Paris: Seuil, 1980).] Barthes clings, however vestigially, to photography's indexicality, though he reduces that indexicality to a "punctum," and inflects his argument with a recognition that his investments on meaning in photographs are very personal. Whereas someone like Umberto Eco argues that a belief in indexical photographs is only the most tenacious of illusory beliefs in what (after Peirce) he calls "iconic signs."

> The theory of the photo as an *analogue* of reality has been abandoned, even by those who once upheld it—we know that it is necessary to be trained to recognise the photographic image. We know that the image which takes shape on celluloid is analogous to the retinal image but not to that which we perceive. We know that sensory phenomena are *transcribed*, in the photographic emulsion, in such a way that even if there is a causal link with real phenomena, the graphic images formed can be considered as wholly arbitrary with respect to these phenomena. Of course, there are various grades of arbitrariness and motivation, and this point will have to be dealt with at greater length. But it is still true that, to differing degrees, *every image is born of a series of successive transcriptions.*

See Umberto Eco, "Critique of the Image," in *Thinking Photography*, ed. Victor Burgin (London: MacMillan, 1982), 32–38.

2. Title 18 of the United States Code amended by the Child Sexual Abuse and Pornography Act of 1986, Chapter 110, Sexual Exploitation of Children, and later by the 1988 Child Protection and Obscenity Act, which was revised in October 1990. Enforcement of these laws was carried out by National Obscenity Enforcement Unit created in 1986 by then Attorney General Edwin Meese, and now by the Child Exploitation and Obscenity Section.

3. Ronald Dworkin, "Women and Pornography," *New York Review of Books*, Oct. 21, 1993; Ronald Dworkin and Catherine McKinnon, "Pornography: An Exchange," *New York Review of Books,* March 3, 1994, 47–49.

4. Andrew Vachss, "Age of Innocence," *The London Observer*, April 17, 1994.

5. *Sexual Exploitation of Children. A Report to the Illinois General Assembly.* Illinois Legislative Investigating Commission, 1980, 27.

6. 1980 Illinois *Report*, 30.

7. 1980 Illinois *Report*, 59–61.

8. Doreen Carvajal, "Pornography Meets Paranoia," *New York Times*, Feb. 19, 1995.

9. David Johnston, "Use of Computer Network For Child Sex Sets off Raids," *New York Times*, Sept. 14, 1995.

10. Stephen Labaton, "As Pornography Arrests Grow, So Do Plans for Computer Stings," *New York Times*, Sept. 16, 1995. Repeated written queries to two FBI offices about the results and costs of their child pornography investigations have gone unanswered.

11. To some Europeans, an intense preoccupation with child abuse seems particularly American. Jean Baudrillard, for example: "The latest obsession of American public opinion: the sexual abuse of children. There is now a law that two people must be present when very young children are being handled for fear of unverifiable sexual abuse. At the same time, supermarket carrier bags are adorned with the portraits of missing children.

"Protect everything, detect everything, contain everything—obsessional society." From *America*, trans. Chris Tuner. (London and New York: Verso, 1988), 40.

12. Sara O'Meara, quoted in "Childhelp Strongly Disagrees with Justice Department, Applauds Senate's Unanimous Condemnation," *PR Newswire*, Nov. 5, 1993. O'Meara was reacting to *Knox*.

13. Of course a related issue would be what kinds of depicted actions are considered criminal. Should all child nudity, for instance, be considered equally pornographic?

14. Interview with Professor Harold Koh, Yale Law School, December 1994.

15. Implicitly recognizing Days's argument, however, the court of appeals also maintained for the first time in *Knox*'s history that the movements of the children in the tapes seemed to be directed by someone outside the image frame, and might therefore be "unnatural."

16. Linda Greenhouse, "U.S. Changes Stance in Case on Obscenity," *New York Times*, Nov. 11, 1994.

17. Wendy Cole, "The Marquis de Cyberspace," *Time*, July 3, 1995, 43.

18. At least nine negatives were made in 1925. Of these, six were printed. In 1977, all six were published in a portfolio titled *Six Nudes of Neil*. Two, including the one discussed here, were printed by Brett Weston as "Project Prints," a collections of what Edward Weston considered his finest work. Amy Conger, *Edward Weston—Photographs: From the Collection of the Center for Creative Photography* (Tucson: Center for Creative Photography, University of Arizona, 1992), 43, figs. 170–75/1925.

19. Douglas Crimp, "The Boys in My Bedroom," *Art in America* 78, no. 2 (Feb. 1990): 47–49.

20. Stephanie Dolgoff, "Eros Explored," *American Photo* 4, no. 6 (Nov.–Dec. 1993): 15–16.

21. Edward Weston, *The Daybooks of Edward Weston. I. Mexico*, ed. Nancy Newhall (New York: Aperture, 1990), 146.

22. Ibid., 147.

23. Conger, *Edward Weston*, 7.

24. Nancy Newhall, "Edward Weston and the Nude," from *Modern Photography* 16

(June 1952), in *Edward Weston Omnibus: A Critical Anthology*, ed. Beaumont Newhall and Amy Conger (Salt Lake City: Gibbs M. Smith, 1984), 103.

25. Weston, *The Daybooks*, vol. 1, plates 20, 21.

26. Douglas Crimp, "The Photographic Activity of Postmodernism," *October* 15 (Winter 1980): 98–99. Crimp's position was expanded by Rosalind Krauss in "The Originality of the Avant-Garde: A Postmodernist Repetition," *October* 18 (Fall 1981): 47–66. It has recently been again taken up by Howard Singerman in "Seeing Sherrie Levine," *October* 67 (Winter 1994): 78–107.

27. Abigail Solomon-Godeau, "Living with Contradictions; Critical Practices on the Age of Supply-Side Aesthetics," *Screen* (Summer 1987). Reprinted in *The Critical Image: Essays on Contemporary Photography*, ed. Carol Squiers (Seattle: Bay Press, 1990).

28. Andrew Vachss, "Age of Innocence."

29. Douglas Crimp, "The Boys in My Bedroom." The original *Art in America* article used a *Neil* showing no genitals; when "The Boys in My Bedroom" was reprinted several years later in a gay anthology, it was illustrated by two *Neils*, one showing the boy's buttocks, and another his penis.

30. Weston, *The Daybooks*, vol. 1, 118–19.

31. Edward Weston, "Photographing Children in the Studio," *American Photography* 6, no. 2 (Feb. 1912). Reprinted in *Edward Weston on Photography*, ed. Peter C. Bunnell (Salt Lake City: Gibbs M. Smith, 1983), 4.

32. Weston, "Photographing Children," 4.

33. Now in the collection of the J. Paul Getty museum. See also Theodore Stebbins, *Weston's Westons: Portraits and Nudes* (Boston, Museum of Fine Arts, 1989), 11–12. Stebbins sees a direct connection between Weston's early family album photographs, including some ambitious works such as the c. 1913 nude of Chandler, *I Do Believe in Fairies*, and Weston's modernist nudes.

34. Among them: Patti Ambrogi, Judy Black, Charlee Brodsky, Vance Gellert, Nancy Honey, Joanne Leonard, Wendy Snyder MacNeill, Robert Mapplethorpe, Denise Marika, Sheila Metzner, Andrea Modica, Nicolas Nixon, and Jock Sturges. And why limit the list to fine art photography? Rock imagery by groups such as Babes in Toyland, Bikini Kill, Hole, Nirvana, and Van Halen are also radically revising our vision of adult relationships to children.

35. Emily Apter is also now writing about Mann's maternal marking of images, in a more psychoanalytic mode. Her paper is not yet published.

36. Sally Mann, *Immediate Family* (New York: Aperture, 1992), n.p.

Blurring the Familial: An Afterword

LAURA LEVITT

The Familial Gaze is a book about longing and the desire for community and connection. By presenting carefully imbricating accounts of a series of intimacies, it also enacts such a vision. Through essays and images, this collection offers readers different ways of seeing those all-too-familiar images of the family and home, Madonna and Child, husbands and wives, lovers and friends.

What follows is a rather intimate reading of this collection. The odd intimacy out of which I write these reflections is itself a testament to what this collection does. It itself stages a more public form of familial gazing.

This collection enacts a different kind of intimacy from the one it purports to represent. By opening up the familial to include the kinds of intellectual and creative exchanges that went on at the conference that was its source,[1] as well as within the production of the volume itself, it extends the bounds of the normative "family." It does this even as it asks us to look closely at precisely that all-too-familiar institution. Here family photographs are only a starting point, not an end in themselves. When scholars and artists get personal, when, as in this collection, they offer their family photographs to public scrutiny, they blur the familial gaze. This process can be both exciting and deeply uncomfortable.

A More Intimate Take

My friend Ruth and I attended the conference, "Family Pictures/Shapes of Memory," held at Dartmouth in May 1996.[2] Actually it was through this conference that Ruth and I became close friends. Although Ruth had sat in on my graduate seminar in feminist theory, it was at Dartmouth that I saw whole sides of Ruth I had not really known. Of the two of us Ruth is the visual person, having done much of her graduate work at the intersection of religion and visual anthropology. As we sat together passionately passing notes and whispering comments back and forth through all of the presentations, I learned a lot about Ruth and a lot about visual culture. I mention this moment of burgeoning friendship because, like much of what I have to say about this volume, it attests to the kinds of intimacies that can take shape in the public spaces of academic conferences and art exhibitions.[3]

I first learned about the Dartmouth conference from Marianne Hirsch after a lecture she gave at Haverford College earlier that spring. The question-and-answer period after the lecture led from a discussion of the tower of family photographs at the Holocaust Museum in Washington, D.C., to a broader

account of the familial gaze, a topic that had become increasingly important to my own work.[4]

That spring I had been reading Annette Kuhn's *Family Secrets*, Valerie Walkerdine's *Schoolgirl Fictions*, and essays by Jo Spence.[5] I came to these works as I was completing the final edits of my first book, *Jews and Feminism: The Ambivalent Search for Home*.[6]

In editing the introduction to my book I found myself writing about a photograph of my grandmother. In this photograph, taken in the late 1970s, my maternal grandmother "is dressed in red, white and blue. Her arms are outstretched. The dome of the Capitol building is behind her. My mother recalls that her mother cried for joy having finally made it to the Capitol." (5) This photograph had become terribly important to me, so much so that I had decided that, somehow, I wanted to include it in my book. I came to Kuhn, Walkerdine, and Spence, and later the conference, in order to think more critically about why this particular family image had come to haunt my work. I needed to understand how this family photograph could so powerfully describe my own ambivalent relationship to America.

In my introduction I used the photograph to illustrate my grandmother's love of this country, her desire to be an American. I then contrasted this longing for inclusion with the more precarious historical status of Jews within this country's promises of home. "Like my grandmother, many Jewish women fought hard for a place within the American dream and, despite their loyalty, these women, their daughters and granddaughters have had to face time and again strategic limitations and prohibitions built into [American] liberalism's promise of home" (5).

The conference as well as the works by Spence, Walkerdine, and Kuhn helped me appreciate the extent to which my own sense of self had been formed in relation to a shared Jewish repertoire of family and, indeed, communal images. Through these discussions I came to see how my place in America had been formed not only by my grandmother's stories but also in relation to various images that continue to connect me to her even now, many years after her death. For these reasons, the image of my grandmother posing as the model American citizen serves as the frontispiece of my book.[7]

The Familial Gaze invites a broader readership into these kinds of discussions about family pictures and their allure. It invites readers to become part of an intimate and critical conversation that began in the context of friendship and collegial relationship. By gathering an eclectic group of literary scholars, art historians, curators, and artists,[8] Hirsch asks readers to reflect on our own family pictures. She also asks us to reconsider what constitutes "the familial gaze." We are invited to look at these intimate engagements as a public practice. In this way the volume itself becomes a kind of odd and all-too-public family album.

Reimagining Community

> Again, my history of multiple displacements has prepared me to con-
> ceive of identity as fractured and self-contradictory, as inflected by
> nationality, ethnicity, race, and history. But it has also made me appre-
> ciate those moments of commonality which allow for the adoption of
> a voice on behalf of women and for the commitment to social change.
> —Marianne Hirsch, *Family Frames*

The Familial Gaze aims to open up familial discourse to critical interrogation.
It does so out of a desire for a different kind of critical community. For Hirsch
such a community has always had to be able to address larger historical lega-
cies.[9] An interrogation of the family is for many of these authors, and for me,
an act of feminist commitment.

In this collection all visions and versions of the familial are haunted by his-
torical traumas, displacements, promises, and disappointments. Such legacies
cannot be seen as separate or distinct from even the most private of images or
recollections. Thus, the legacy of slavery and racism in America looms large
over many of these essays, including those by Smith, McDowell, Chong, Wex-
ler, Willis, Abel, and Liss.

The works by Spiegelman, van Alphen, and Spitzer are each, in different
ways, about the Shoah and its visual legacies. Pieces by Sultan, Novak, Miller,
Gallop, and Leonard offer insights into a postwar American landscape of dis-
appointed promise especially for American Jews. These essays speak directly
to the kinds of ambivalences I write about in relation to the photograph of my
grandmother.[10] As I read it, through the dark shadows not only of the Holo-
caust and immigration but also of America's ongoing racial prejudice, many of
the essays in this volume speak to the urgency and impossibility of assimila-
tion into an idealized picture of the American family.

The collection as a whole does not allow readers to take comfort in any sim-
ple reading of the family anywhere as a respite from history or politics. There
is no such thing as "the family" in postwar America, nor is home easily found
in the promises of European cultural inclusion or class mobility. These ambiv-
alent legacies demand that we see "the familial gaze" as self-contradictory.
Like identity, it too is inflected by nationality, ethnicity, race, and history. De-
spite and because of this, this collection asks us not to give up on community.
Instead it asks us to appreciate all the more those rare moments of intimacy
and connection wherever they occur.

This volume is such a moment. By reconsidering the power and allure of
family photographs, this collection demonstrates what can happen when these
stories and images are shared. In the process of exchange, a different kind of

intimacy is enacted. In the public space of an academic conference, an exhibit, and now a book, *The Familial Gaze* blurs the boundaries between public and private images and domains. In other words, by gathering the voices and visions of a broad range of scholars and artists and placing them in conversation with each other, Hirsch extends our notion of who is family. By transgressing those boundaries, this volume creates a different kind of intimacy, opening up the familial gaze to new forms of intimate engagement in a public forum.

NOTES

1. As I note below, this was the "Family Pictures/Shapes of Memory" conference held at Dartmouth College, Hanover, N.H., in May 1996. Along with the conference there was a photography exhibit called "The Familial Gaze," on view at the Hood Museum of Art at Dartmouth College. During the conference there were a series of lectures and gallery talks as well as a screening of Camille Billops and James Hatch's films *Susanne Susanne* and *Finding Christa*, followed by a discussion with the filmmakers. The filmmakers also attended the conference. For more on these films, see Valerie Smith's essay in this book.

2. I attended all of the events associated with this conference with Ruth Ost, associate director of Honors at Temple University.

3. My comments reflect the mood and tone of these occasions as I experienced them. At these events, all participants—not only speakers, artists, and those with official positions—were welcomed into any number of discussions. Ruth and I were very much a part of these activities at Dartmouth. We have continued these conversations in Philadelphia where we are both at work on new projects. I am currently working on a book about American Jews and family photographs, tentatively entitled *Picturing American Jews: Photography, History, and Memory*, and Ruth is working on a series of articles on feminist art and the uses of photography focusing on specific works by Hannah Wilke (the Intra-Venus series), Helene Aylon ("The Women's Section"), and Sally Mann (*Immediate Family*).

4. The lecture was culled from her account of postmemory in what would become Marianne Hirsch, *Family Frames: Photography, Narrative and Postmemory* (Cambridge: Harvard University Press, 1997).

5. Annette Kuhn, *Family Secrets: Acts of Memory and Imagination* (London and New York: Verso, 1995); Valerie Walkerdine, *Schoolgirl Fictions* (London and New York: Verso, 1990); Jo Spence, *Cultural Sniping: The Art of Transgression* (London and New York: Routledge, 1995). When Hirsch told me at Haverford that Annette Kuhn would be presenting at the conference, I knew I had to go.

6. Laura Levitt, *Jews and Feminism: The Ambivalent Search for Home* (New York: Routledge, 1997).

7. I should also note that this photograph makes a second appearance within the prose of my conclusion where again I highlight the ambivalence of its legacy. Finally, I also feel obliged to recognize and comment on the other photograph connected to this volume, the picture of me on the back cover of my book. That photograph was taken in my home by Ruth Ost in the fall of 1996.

8. Some of those in attendance were each others' close friends and/or partners. These couples included Jane Gallop and Dick Blau, Camille Billops and James Hatch, Marianne Hirsch and Leo Spitzer, and Mieke Bal and Ernst van Alphen, as well as a number of longtime feminist friends and colleagues. Particularly noteworthy at the conference were interactions among and between Gallop, Miller, and Hirsch. For an earlier exploration of these critical interactions, see Jane Gallop, Marianne Hirsch, and Nancy K. Miller, "Criticizing Feminist Criticism," in *Conflicts in Feminism*, ed. Marianne Hirsch and Evelyn Fox Keller (New York: Routledge, 1990), 349–69. Also in that volume is a powerful essay by Elizabeth Abel that connects back to the themes of her essay in this volume, "Race, Class, and Psychoanalysis? Opening Questions," *Conflicts in Feminism*, 184–204. I would also like to note that Marianne Hirsch's parents and Joanne Leonard's sisters, Barbara Handelman and Eleanor Rubin, also attended the conference and were a part of these discussions.

9. See Marianne Hirsch, *Family Frames*, and Marianne Hirsch, *The Mother/Daughter Plot: Narrative, Psychoanalysis, Feminism* (Bloomington: Indiana University Press, 1989). The quote with which I open this section is taken from the chapter "Pictures of a Displaced Girlhood" in *Family Frames*, which, along with the haunting photograph on the cover of *The Mother/Daughter Plot*, offers readers glimpses into Hirsch's own abiding interest in and fascination with family photographs.

10. Here I want to note that many of the contributors I identify as Jewish do not explicitly position themselves as Jews in these essays nor did they necessarily position themselves as Jews at the conference. I am suggesting that, in less overt terms than in my own work, here Jewishness figures as both a deeply familial and powerfully American site of ambivalence. For a different account of the specific differences between Nancy K. Miller and myself on Jewishness, see chapters seven and eight of *Jews and Feminism*.

Contributors

ELIZABETH ABEL is a professor of English at the University of California at Berkeley. She is the author of *Virginia Woolf and the Fictions of Psychoanalysis*, the editor of *Writing and Sexual Difference*, and the co-editor of *The Voyage In, The Signs Reader,* and *Female Subjects in Black and White*. She is currently at work on a manuscript entitled *Signs of the Times: The Visual Politics of Jim Crow*.

MIEKE BAL is the director of the Amsterdam School of Cultural Analysis (ASCA) and professor of the theory of literature. Most recently, she is the author of *Reading Rembrandt: Beyond the Word-Image Opposition, On Meaning-Making: Essays in Semiotics, Narratology, Double Exposures: The Subject of Cultural Analysis,* and *The Mottled Screen: Reading Proust Visually*.

DICK BLAU is chair of the film department at the University of Wisconsin at Milwaukee. He is coauthor, with ethnomusicologists Charles and Angeliki Vellou Keil, of a photo/text titled *Polka Happiness*. Blau has recently completed another book-length collaboration with the Keils; its working title is *The Living Moment: Romani Instrumentalists in Greek Macedonia*.

ANN BURLEIN teaches world religions at Meredith College in Raleigh. She recently received her doctorate in religious studies from Duke University. She is currently working on a comparative study of white supremacy and the religious right entitled *Lift High the Cross: Where White Supremacy and the Religious Right Converge*.

ALBERT CHONG teaches photography at the University of Colorado, Boulder. His work has been widely exhibited nationally and internationally. Recent venues include "Winged Evocations," Allen Art Museum, Oberlin, Ohio; "Ancestral Dialogues," Ansel Adams Center for Photography, San Francisco; "Albert Chong: New Works," Porter Randall Gallery, La Jolla; and "Imagining Families: Images and Voices," curated by Deborah Willis at the Center for African American Art at the Smithsonian Institution. A book of his photographs, *Ancestral Dialogues: The Photographs of Albert Chong*, was published by the Friends of Photography, San Francisco.

JANE GALLOP teaches in the Modern Studies Graduate Program at the University of Wisconsin at Milwaukee. Her most recent book is *Feminist Accused of Sexual Harassment*. Her essay in this collection will be part of a book on Dick Blau's photographs, to be entitled *Living with His Camera*.

349

ANNE HIGONNET teaches in the art department of Wellesley College. She is the author of many articles on modern visual culture, two books on the Impressionist Berthe Morisot, and, most recently, *Pictures of Innocence: The History and Crisis of Ideal Childhood*.

MARIANNE HIRSCH teaches French and comparative literature at Dartmouth College. Her recent books are *The Mother/Daughter Plot: Narrative, Psychoanalysis, Feminism*, and *Family Frames: Photography, Narrative and Postmemory*. She also co-edited *The Voyage In: Fictions of Female Development, Conflicts in Feminism*, and *Ecritures de femmes: Nouvelles Cartographies*.

ANNETTE KUHN is a reader in film and television studies in the Institute for Cultural Research, Lancaster University, and an editor of *Screen*. Her books include *Women's Pictures: Feminism and Cinema, The Power of the Image: Essays on Representation and Sexuality*, and *Family Secrets: Acts of Memory and Imagination*.

JOANNE LEONARD teaches at the University of Michigan where she is professor in the School of Art and Design and in the women's studies program, as well as an associate of the American culture program. Her work was exhibited most recently in the 1997 "Eye of the Beholder" at the International Center of Photography in New York. Her photographs and photo-collage works have been published in Gardner's *Art Through the Ages*, Janson's *History of Art, Time Life Library of Photography*, Lucy Lippard's *From the Center*, and Domna Stanton's *Discourses of Sexuality, from Aristotle to AIDS*. Her own writing appears in *Modern Fiction Studies* and *Michigan Feminist Studies*. She lives in Ann Arbor, Michigan, and her daughter, Julia, is an art student in San Francisco.

LAURA LEVITT teaches in the religion department and the women's studies program at Temple University. She is the author of *Jews and Feminism: The Ambivalent Search for Home*, and co-editor, with Miriam Peskowitz, of *Judaism Since Gender*. Her new work, *Picturing American Jews: Photography, History, and Memory* will be on American Jews and family photography.

ANDREA LISS teaches in the visual and performing arts program at California State University, San Marcos. She is the author of *Trespassing Through Shadows: Memory, Photography and the Holocaust*. Her research focuses on contemporary representations of history, and she is currently working on a book about feminist motherhood and cultural negotiations of gender.

DEBORAH MCDOWELL is a professor of English at the University of Virginia. She is the founding editor of the Beacon Black Women Writers Series, co-

editor with Arnold Rampersad of *Slavery and the Literary Imagination*, and period editor of the *Norton Anthology of African American Literature*. She is the author of *The Changing Same: Studies in Fiction by Black American Women*, *Leaving Pipe Shop: Memories of Kin*, and numerous essays and reviews on African American literature.

NANCY K. MILLER is a professor of English at the Graduate School and Lehman College, City University of New York. Her recent books include *Getting Personal: Feminist Occasions and Other Autobiographical Acts* and *Bequest and Betrayal: Memoirs of a Parent's Death*.

LORIE NOVAK is an artist who has been using family snapshots in her work since the early 1980s. She is a professor of photography at New York University's Tisch School of the Arts. Her work has been included in numerous exhibitions, volumes, and collections. Her current project, *Collected Visions*, can be found on the World Wide Web at http://cvisions.cat.nyu.edu.

VALERIE SMITH is a professor of English and chair of the program in African-American studies at the University of California at Los Angeles. She is author of *Self-Discovery and Authority in Afro-American Narrative*, *Not Just Race, Not Just Gender: Black Feminist Readings*, and numerous articles on African-American literature and film. She is the editor of *African American Writers*, *New Essays on Song of Solomon*, and *Representing Blackness: Issues in Film and Video*.

ART SPIEGELMAN is the author of *Maus*, which received a special Pulitzer Prize and has been translated into twenty languages. His comix have appeared in the *New York Times*, the *Village Voice*, and numerous other publications. With Françoise Mouly, he is the founder of *Raw Magazine*, and is currently cover artist and contributor to the *New Yorker*. His recent books include an illustrated edition of Joseph March's *The Wild Party*, a children's book *Open Me . . . I'm a Dog*, and a catalogue of a retrospective exhibition of his work, *Art Spiegelman: Comix, Essays, Graphics and Scraps*.

LEO SPITZER teaches comparative history at Dartmouth College. He is the author of *The Creoles of Sierra Leone* and *Lives in Between: Assimilation and Marginality in Austria, Brazil and West Africa*. His most recent book, *Hotel Bolivia: The Culture of Memory in a Refuge from Nazism*, is based on personal history, videotaped oral accounts, photographs, and family albums.

MARITA STURKEN teaches at the Annenberg School for Communication at the University of Southern California. She is the author of *Tangled Memories: The Vietnam War, the AIDS Epidemic, and the Politics of Remembering*.

LARRY SULTAN resides in Northern California with his wife and two sons. He is chair of the photography department at California College of Arts and Crafts and the recipient of numerous awards, including five NEA awards and a Guggenheim fellowship. His work has been included in numerous anthologies, collections, and exhibitions, most recently at the Queens Museum, the Corcoran Museum of Art, and the San Diego Museum of Contemporary Art. He is currently concentrating on public arts projects.

ERNST VAN ALPHEN is director of communication and education at the Boijmans van Beuningen Museum in Rotterdam. His most recent books in English are *Francis Bacon and the Loss of Self* and *Caught by History: Holocaust Effects in Contemporary Art, Literature and Theory*.

LAURA WEXLER teaches American studies and women's studies at Yale University, and writes about women's cultural production, including photography, at the turn of the century. She is the author of two forthcoming books, *Tender Violence: Domestic Visions in the Age of U.S. Imperialism* and, with Sandra Matthews, *Pregnant Pictures: Representing Pregnancy in the Age of Mechanical Reproduction*.

DEBORAH WILLIS is both an art photographer and one of the nation's leading historians of African American photography and culture. Among her most recent projects are *Visual Journal: Harlem and DC in the Thirties and Forties, Imagining Families: Images and Voices*, and *VanDerZee*. Her most recent books are *VanDerZee: The Portraits of James VanDerZee, The Family of Black America*, and, as editor, *Picturing Us: African American Identity in Photography*.

UNIVERSITY PRESS OF NEW ENGLAND publishes books under its own imprint and is the publisher for Brandeis University Press, Dartmouth College, Middlebury College Press, University of New Hampshire, Tufts University, and Wesleyan University Press.

LIBRARY OF CONGRESS CATALOGING-IN-PUBLICATION DATA
The familial gaze / edited by Marianne Hirsch.
 p. cm.
 "This volume originated in an exhibition entitled 'The familial
 gaze' and a conference on 'Family pictures/shapes of memory' held at
 Dartmouth College's Hood Museum of Art in the spring of 1996"—Pref.
 ISBN 0–87451–895–4 (alk. paper)
1. Photography of families—Congresses. 2. Family—United States—
Folklore—Congresses. I. Hirsch, Marianne.
TR640.F337 1999
779'.930685—dc21 98-29579